Designing a New Tradition

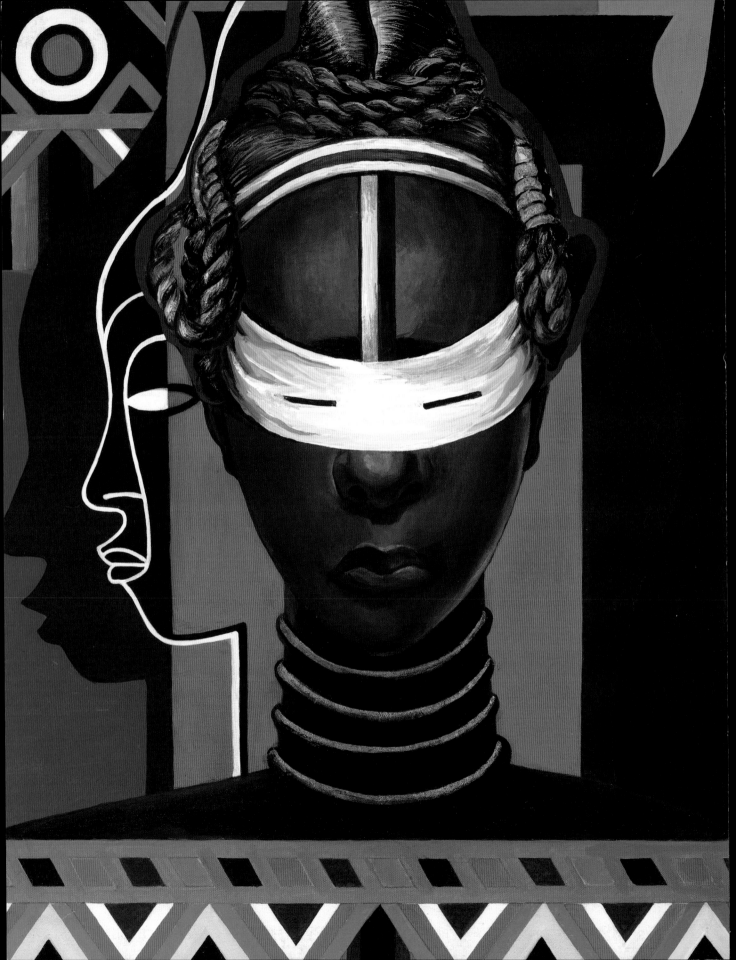

Designing a
New Tradition

Loïs Mailou Jones
and the Aesthetics
of Blackness

Rebecca VanDiver

The Pennsylvania State University Press
University Park, Pennsylvania

Publication of this book has been aided by a grant from the Millard Meiss Publication Fund of CAA.

Library of Congress Cataloging-in-Publication Data

Names: VanDiver, Rebecca, 1982– author.
Title: Designing a new tradition : Loïs Mailou Jones and the
 aesthetics of Blackness / Rebecca VanDiver.
Description: University Park, Pennsylvania : The Penn-
 sylvania State University Press, [2020] | Includes
 bibliographical references and index.
Summary: "A critical analysis of the art and career of African
 American painter Loïs Mailou Jones (1905–1998). Exam-
 ines Jones's engagement with African and Afrodiasporic
 themes as well as the challenges she faced as a black
 woman artist"—Provided by publisher.
Identifiers: LCCN 2020001402 | ISBN 9780271086040
 (cloth)
Subjects: LCSH: Jones, Lois Mailou—Criticism and interpre-
 tation. | African diaspora in art.
Classification: LCC ND237.J76 V36 2020 | DDC 759.13—dc23
LC record available at https://lccn.loc.gov/2020001402

10 9 8 7 6 5 4 3

The Pennsylvania State University Press is a member of the
Association of University Presses.

It is the policy of The Pennsylvania State University Press to
use acid-free paper. Publications on uncoated stock satisfy
the minimum requirements of American National Standard
for Information Sciences—Permanence of Paper for Printed
Library Material, ANSI z39.48–1992.

For
Alden
and
Darby

Contents

Illustrations

Acknowledgments

This book was only possible due to the generous intellectual and financial support I received from a host of individuals and institutions along the way. At Duke University, Richard J. Powell challenged me to look closely and to think deeply about Jones's practice. I am most grateful for Rick's continued encouragement and for the model of intellectual inquiry he provides for the field of African American art history. Kristine Stiles, Patricia Leighten, and Carol Magee also offered insightful feedback and guidance. At the University of Virginia, Deborah McDowell provided valued counsel and, along with Celeste Day Moore and Tyler Fleming, pushed me to think about the book's engagement with the interdisciplinary field of African American studies. At Vanderbilt University, my current institutional home, my colleagues in the history of art department—Leonard Folgarait, Vivien G. Fryd, Kevin D. Murphy, Christopher Johns, and Betsey Robinson—have read chapter drafts, given sage advice, and cheered me on in ways I did not think possible. Although no longer at Vanderbilt, Halle O'Neale continues to be a source of constant support, and I miss her terribly. Special thanks to my non-art history colleagues Aimi Hamarie and Jessie Hock, whose weekly writing dates have kept me motivated. Thank you also to former undergraduates Haley Brown and Kaitlin Joshua for their research assistance.

I am perhaps most indebted to the artist of my study, Loïs Mailou Jones Pierre-Noël, whose legacy is found in the legion of her paintings scattered throughout public and private collections but also in her meticulous records, now housed at Howard University's Moorland-Spingarn Research Center. Thank you to Meaghan Alston and Joellen El-Bashir of the Moorland-Spingarn Research Center for helping me during my many trips to her archives at Howard. Leslie Leonard of the Charlotte Hawkins Brown Museum provided assistance in fleshing out Jones's time at the Palmer Memorial Institute, while former students Ron Akili Anderson and David C. Driskell graciously agreed to interviews in which they offered key insights into Jones as an instructor. I am most appreciative of the long-standing and unwavering encouragement to pursue this book from the Loïs Mailou Jones Pierre-Noël Trust—especially Dr. Chris Chapman and Larry Frazier—who facilitated access to archival materials, granted image permissions, and offered support.

Generous start-up funds from the Arts and Science Dean's Office at Vanderbilt University as well as a 2016 summer stipend from the Office of the Provost provided vital research support. Publication subvention funds from the College Art Association's Millard Meiss Publication Fund; the Society for the Preservation of American Modernists; and Bonnie Dow, Dean of the Humanities in

the Vanderbilt College of Arts and Science and the Vanderbilt history of art department ensured that this book was properly illustrated to showcase Jones's tremendous use of color.

The subfield of African American art history is unique in a number of ways, one of which is the generosity of scholars working in the field. Over the years I have benefitted tremendously from conversations with Renée Ater, Jennifer DeVere Brody, Kristen Pai Buick, Adrienne Childs, David C. Driskell, Gwendolyn DuBois Shaw, Nicholas Miller, Ellen Tani, John Ott, Carmenita Higginbotham, Lyneise Williams, and others. It was Gwendolyn DuBois Shaw who first inspired me to pursue an undergraduate art history degree, and I am delighted that we are now both colleagues and friends. Thanks also to my dear academic friends Alexis Clark and Celeste Day Moore, who read various iterations of the manuscript in progress, as did Matthew Somoroff. An article adapted from the manuscript's third chapter appeared in the Spring 2018 issue of *American Art*; thank you to Robin Veder, Marie Ladino, and the anonymous reviewers who helped shape my final thoughts on Jones's praxis. At a time when the publication of single-artist studies is waning, I am most thankful to the excellent and enthusiastic team at the Penn State University Press, especially my editor, Ellie Goodman; the editorial assistants, Hannah Herbert and Alex Vose; and the copyeditor, Annika Fisher, who answered my queries and shepherded this project to fruition. The finished book has benefited greatly from the insights offered by generous peer reviewers and their anonymous reader reports.

As those of us in academia know, cultivating a healthy work-life balance is challenging. I have only succeeded in achieving such balance with help from my family, friends, and four-legged companions. Laura Belmont, Claudine Emeott, Kate Gerenscer, Caitlin Reichstein, Chrissy Schwartzstein, and Anne Walter have each opened their ears, hearts, and homes on countless occasions. I knew Loïs and I were kindred spirits when I uncovered a set of professional photographs she commissioned of her two beloved canine companions. My own two dogs—Fenway and Wrigley—have been under my feet (literally) since the book's inception and continue to fill my heart with joy. My parents, John and Christine, and my brother, Brian, have loved me unconditionally. Most of all, I am thankful for the love and support shown by my husband, Bryce, and our two beautiful children, Alden and Darby—for loving me despite it all.

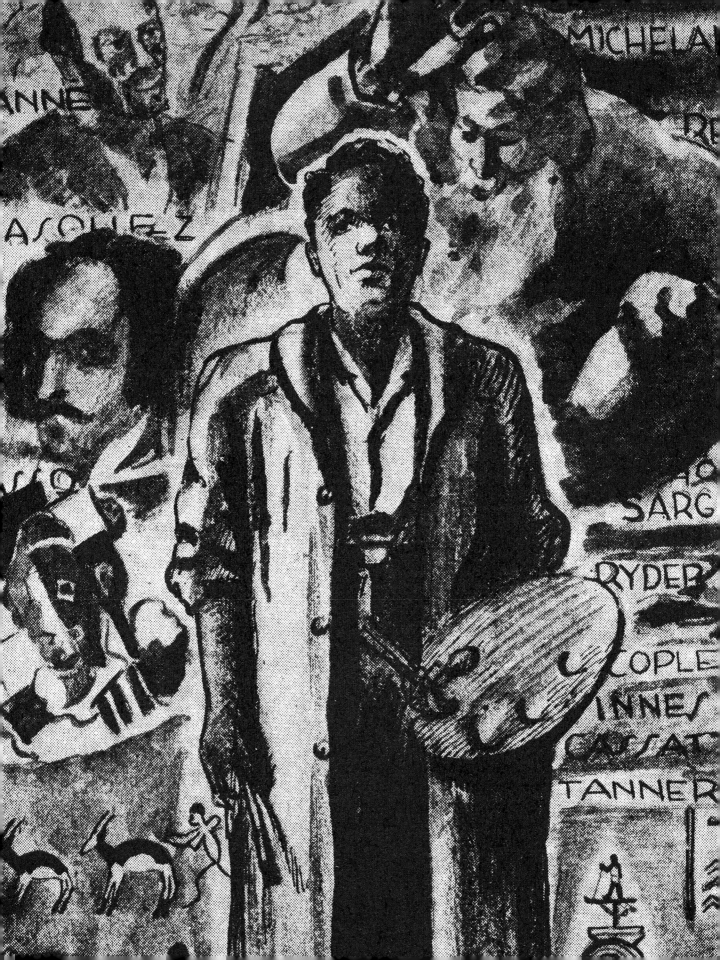

Introduction

Claiming Middle Ground

In 1939, Loïs Mailou Jones (1905–1998) painted a gray-wash watercolor entitled *Under the Influence of the Masters* (fig. 1). Poised in front of a canvas with the sleeves of her smock pushed up past her elbows, paintbrush and palette in hand, an androgynous and anonymous artist stands at a creative crossroads. The names of canonical Western artists—Picasso, Corot, Cézanne among them—swirl around her, fanning out like the branches of a tree. Michelangelo, the Renaissance master, floats directly above her head with his hand raised as if anointing the unnamed artist with artistic genius. At her feet references to African art—Egyptian hieroglyphs and cave drawings of hunters and animals—spread out like roots. Four frieze sections filled with the names of key African American artists from the nineteenth and twentieth centuries flank the central panel.

The artist in *Under the Influence of the Masters* claims the middle ground amid the names and images of four artistic traditions—European, American, African, and African American. The

THE NEGRO HISTORY BULLETIN

Published Monthly

Vol. II, No. 7 WASHINGTON, D. C. April, 1939

Distinguished Painters Inspire Those of African Blood

PAINTING and sculpture, as we understand these arts, grew out of architecture. In the beginning, however, these forms were not life-like or real, but the Greeks began to make their art realistic. As Morey once wrote, "The artists' skill in representing actual things is illustrated in the story often told of the great painters Zeuxis and Parrhasius. They were rivals, and agreed to make a test of their relative skill. Zeuxis painted a cluster of grapes that deceived the birds, which came and pecked at them. He reported his success to Parrhasius, who told him that his own work could be seen behind a curtain. Zeuxis attempted to draw this aside, and found it was only a painted curtain. And so while Zeuxis had deceived the birds, Parrhasius had deceived the rival painter himself."

Today we think of painting mainly as the work of an individual in his art studio with his canvas on his easel, his brush in one hand and the palette for his colors in the other. We see him mixing his colors, touching his canvas with his delicate brush, while watching the development of the painting as each touch brings it nearer and nearer to the design originally worked out in his mind. We are acquainted also with painting in its other aspects, but this is the picture which the name of this art generally suggests to the average mind.

The world has made much progress in reaching this stage of modern painting. Painting attained a high position in the life of the Greeks and the Romans who added something to pass this and other arts on to the nations which arose thereafter, but not much could be done to advance art during the dark age which followed the destruction of the Roman Empire. In the East, in Africa and Asia, however, the people were making some progress in raising higher standards which Europeans learned later to follow. The monks of Europe did a little to keep the light of civilization burning while they were shut in their monasteries to seclude themselves from the wicked world of the middle ages. In copying manuscripts, the monks decorated them with artistic monograms and ornamental figures. By and by when the darkness of the middle ages tended to pass away and men became more enlightened by contact with the East, artists began to build and decorate as had done the Egyptians, the Greeks and the Romans. The one thing in which most European people could be interested at

that time was religion, and artists came forward to beautify the churches with statues and statuettes, with frescoes and murals. This was a part of the movement called the Renaissance, which turned people toward doing things as they had been done so much better ages before.

In the Renaissance the Negro himself figured in Europe. In Spain, to which Africans were brought in larger numbers than elsewhere on that continent the evidences were very frequent. Juan de Pareja, born a slave in Granada, in 1606, was liberated by Velasquez and taught the technique of painting. He left to his credit "The Calling of St. Matthew," "Santa Catalina," "The Baptism of Christ," "The Presentation of the Child of God," "Provincial of the Capuchin Order," "St. John the Evangelist," "San Oronico," and "Our Lady of Guadeloupe." It is said that J. Herbert Watson, of Brooklyn, New York, owns another of his paintings, "The Annunciation."

Sebastian Gomez sustained to Murillo the same relation as did Juan de Pareja to Velasquez in having been Murillo's slave and then elevated to the dignity of his student and coworker. He produced by the time of his death in 1682 such precious productions as "Christ bound to the Column with St. Peter Kneeling," "St. Joseph," "St. Anne," and

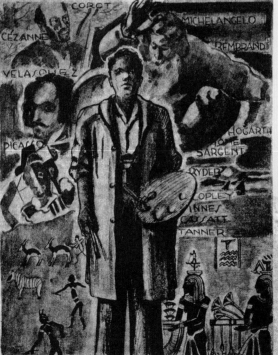

BANNISTER HAYDEN
DUNCANSON MOTLEY
TANNER SCOTT
WARING A. SMITH
HARLESTON WOODRUFF
HARDRICK FREELON
DOUGLAS M. JOHNSON

W. H. JOHNSON ALSTON
WELLS CRITE
PORTER PIOUS
L. JONES COOPER
BROWN R. REID
H. B. JONES D. REID
FAX FARROW
DIGGS DAWSON

UNDER THE INFLUENCE OF THE MASTERS

Negro History Bulletin published the illustration on the front page of its April 1939 issue. The accompanying article, "Distinguished Painters Inspire Those of African Blood," discusses the influence of canonical Western artists on those of African descent.[1] Yet in the paired illustration, African aesthetics, which are alluded to in the lower half of the composition, are posited as another potential root from which African American artistic production stems.

A year later, Jones painted a self-portrait in which she pictured herself in a similar smock and collared shirt and with the same short hairstyle as the anonymous painter, suggesting that she had depicted herself in the earlier watercolor (fig. 2). Jones bore more than a physical resemblance to the artist. She, too, was forging a path that required negotiating those same four traditions while explicitly staking her own ground in the history of modern African American art. *Under the Influence of the Masters* poses questions about the roots and routes of nineteenth- and twentieth-century African American artists and, as such, serves as a point of entry and departure for this manuscript's examination of Jones's own roots and routes. In time, Jones would become a master in her own right and, indeed, a master to subsequent generations of African American artists.

Under the Influence of the Masters appeared at a moment when the mainstream art world was debating the genealogies of modern art. For example, in 1936 the director of the Museum of Modern Art (MoMA), Alfred Barr Jr., traced the origins of modernism in art in an oft-reproduced diagram. Using bright red arrows, Barr plotted the influence of outside elements on the key modernist movements. At the top of left corner of the chart, arrows indicate connections from Japanese woodblock prints to both Paul Gauguin's late nineteenth-century synthetism and to fauvism in the early twentieth century. Shorter lines connect the category of "Negro Sculpture" to fauvism and cubism. In 1933, *Vanity Fair* published Mexican illustrator Miguel Covarrubias's *The Tree of Modern Art—Planted 60 Years Ago*, a diagram of a leafy tree whose twisted branches represented various movements of modern art (fig. 3). The roots of modern art, according to Covarrubias, include the work of late eighteenth- to mid-nineteenth-century painters Eugène Delacroix, Jacques-Louis David, Jean-Auguste-Dominique Ingres, and Gustave Courbet. The trunk or core of modern art came from the late nineteenth-century impressionist and postimpressionist movements. The tree's intertwined branches have labels that include cubism, surrealism, and dada. Green leaves with the names of major white, male artists sprout from all of the tree's surfaces. To the left of the tree, past, sits an African sculpture and the head of a classical marble sculpture. On the right, in the shade of the tree, a white man lays supine, holding an empty gilt frame in his hands, looking toward the future. These visuals sought to reductively chart the advancement of modern art by looking at its influences, its development, and its art-historically acclaimed practitioners. Significantly, in both of these examples, the pioneering

Fig. 1 Loïs Mailou Jones, *Under the Influence of the Masters*, 1939. Watercolor. Published in the *Negro History Bulletin* 11, no. 7 (April 1939), cover. Courtesy Library of Congress and Loïs Mailou Jones Pierre-Noël Trust.

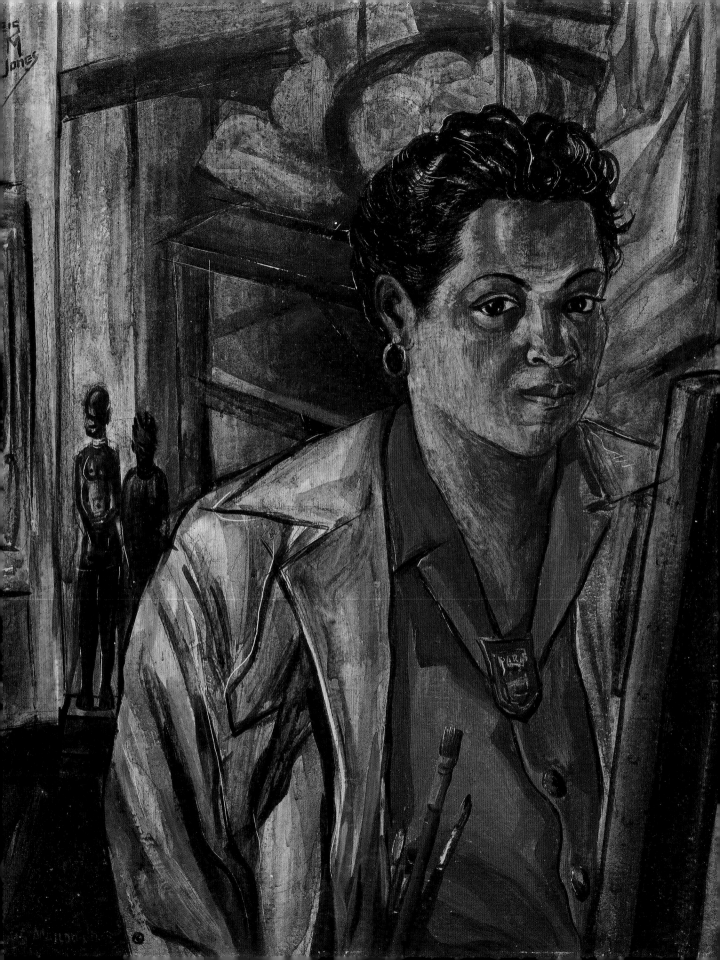

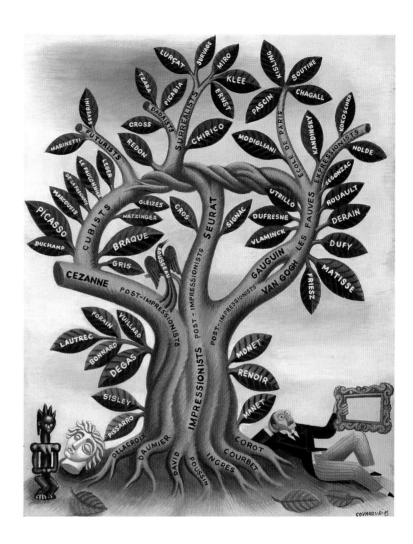

Fig. 2 Loïs Maïlou Jones, *Self-Portrait*, 1940. Casein on board, 17 ½ × 14 ½ in. Smithsonian American Art Museum, Washington, D.C., 2006.24.2. Bequest of the artist. Courtesy Loïs Maïlou Jones Pierre-Noël Trust.

Fig. 3 Miguel Covarrubias, *The Tree of Modern Art—Planted 60 Years Ago*. In *Vanity Fair* 40, no. 3 (May 1933): 36. Courtesy Miguel Covarrubias Estate / Maria Elena Rico Covarrubias.

navigators of modern art are overwhelmingly white, male, and European.

In *Under the Influence of the Masters*, Jones proposes a potential genealogy of African American art in which a black woman claims the center. Jones seeks to chart not only the larger development of African American art but also her own specific path. Moreover, Jones does not offer a chronological mapping but rather a self-conscious revealing of her own influences and sources of inspiration. Jones's picturing of herself occupying the central position gains significance given how frequently African American women artists are sidelined in histories of art, museum exhibitions, and gallery shows. The paucity of Jones's female contemporaries is reflected in the fact that only two other women are listed in the cadre of names in the panels that border the main illustration.

Under the Influence of the Masters draws attention literally and figuratively to expressions of identity and race in art, the perceived role of African art to African American artists, and the marginalization of women artists—particularly women artists of color—who remained pushed to the fringes of art history.

Artistic roots are the points of origin—the starting point or foundation from which artists forge their practice and the cognizance of the artistic legacies to which they are heirs. For many artists, outside factors dictate the construction of these artistic foundations—their geographic locale, their exposure to art, their access to artistic training, their socioeconomic status, and their race and gender. A route is a path or direction taken over the course of their career.[2] Where the root grounds, the route moves. As this overview of Jones's career trajectory will demonstrate, barriers—institutional and otherwise—at times impede these routes. In 1983, Jones explained, "Women artists, white or black, have had it hard and it was doubly hard for the black woman. I know I have had to work twice as hard to make it because of that barrier."[3] A hurdle authors face when working on single-artist studies is the frequent desire for comparisons to showcase the artist's contributions. African American women artists working in the first half of the twentieth century had more male contemporaries than female. Because I do not want to read Jones's praxis through that of her male colleagues, this manuscript privileges Jones's voice and focuses on her art, her career, and her development while acknowledging the obstacles outside forces placed in her way.

Designing a New Tradition: Loïs Mailou Jones and the Aesthetics of Blackness positions Jones as a central figure through which to explore facets of African American artistic identity in the twentieth century. Scrutinizing Jones's roots and routes illuminates the institutional and systemic challenges that she adroitly negotiated by taking mediatory positions. Her artistic choices reveal the complexities of being a black artist in the twentieth century. Despite a prolific career that spanned the 1920s through the 1990s and an almost fifty-year tenure at Howard University, where she trained a number of prominent African American artists, art historians have thus far overlooked Jones's vanguard position in twentieth-century American art; they have often relegated her to the middle or back of the pack. Jones's very "middle-ness"—her middle-of-the-road politics, her middle-class upbringing, and her aesthetic position that straddled avant-garde experimentation and conservative academicism—has resulted in her contributions to the field being cursorily cited and not fully or critically explored. What would the history of African American art look like if we considered those who are in the middle rather than just the avant-garde or the naïve?

To guide this close reading of Jones's art and career, I weave together two threads of inquiry—the role that Jones's gender, race, and class position played in the development of her art and career and her long-standing artistic engagement with the African diaspora. Jones's ongoing use of African and Afrodiasporic symbolic content was one way in which she was able to make a name for herself. In many cases, Jones was not on the margins but rather, as we shall see, in the middle of the action.

Throughout her career Jones sought institutional recognition. At the age of ninety, the Studio

Museum in Harlem named Jones as their 1996 Artist of the Year. Accepting the award, Jones boldly told the audience, "My friend Dorothy West tells people she's the last surviving writer from the Harlem Renaissance. Well, I'm the last artist."[4] Two years later, Jones died of a heart attack in her Washington, D.C., home. In her obituary, *New York Times* art-critic Holland Cotter described her as "an iconic figure and an important historic link in a path-breaking generation of black artists."[5] Cotter wrote of Jones's "eclectic, academic work . . . [that] ranged from impressionistic landscapes to political allegories, and from cubistic depictions of African sculptures to realistic portraits."[6] What Cotter does not explain, however, is that the diversity of Jones's artwork—evinced in both subjects and styles—stemmed from a series of transformative experiences, including her early stint as a textile designer in the late 1920s, her 1937 Parisian sabbatical, her extensive travels to Haiti at midcentury, her tenure at Howard, and her trips to Africa in the 1970s.

I outline three phases of Jones's career, roughly 1920–50, 1950–70, and 1970–90, which not only bore witness to dramatic changes in the production and reception of African American art but also coincided with larger discursive shifts in cultural conceptions of blackness and associated definitions of what constitutes black art. Jones was well aware of how the labels "black art" and "black artist" served different ideological aims over the course of her career. The power of these terms is manifest in the United States–based Harlem Renaissance of the 1920s that saw the emergence of the all-black group exhibition and the call to produce positive representations of blackness. The Harlem Renaissance was followed by the Négritude movement birthed in Paris in the 1940s that promoted transnational racial solidarity, the Civil Rights movement of the 1950s and 1960s, and the Black Arts and Pan-Africanist movements of the 1960s and 1970s, with their concurrent, more politicized calls for black art. Through it all, Jones established her own position; while at times she incorporated some of the newer thinking, she did not automatically fall in line with or subscribe to the definition du jour. Examining Jones's life and art reveals new dimensions in the history of women artists, particularly women of color, nuances in the history of African American modernism, and innovative ways to see connections across cultures and places.

Biographical Sketch

Jones was born in 1905 into an upper-middle-class African American family in Boston that summered on Martha's Vineyard, where she rubbed shoulders with members of the black elite. Given the small African American population of Boston in the first decades of the twentieth century, Jones became adept at navigating predominantly white academic institutions. She attended the mixed-race, all-girls High School of the Practical Arts before becoming the first black graduate of the School of the Museum of Fine Arts, Boston (SMFA) in 1927. It is not surprising that Jones achieved this distinction, given that she came from a family of trailblazers. In 1915 at the age of forty-one, her father, Thomas Vreeland Jones, was the first black graduate of Suffolk Law School.[7] Meanwhile her mother, Carolyn Dorinda Jones, maintained a successful cosmetology business in Boston and on Martha's Vineyard. Jones's

maternal grandmother, Phoebe Moseley Adams Ballou, had been one of the Vineyard's first black summer residents.[8]

After her 1927 SMFA graduation, Jones briefly pursued work as a textile designer before seeking employment at her alma mater. With no positions available, her former instructors told her to "go South to help her people."[9] Jones, consequently, headed below the Mason-Dixon line and spent two years teaching art in Sedalia, North Carolina, at the Palmer Memorial Institute. In 1930, she joined the art department at Howard University, where she remained until her 1977 retirement. During her tenure at Howard, the university was the center of black intellectualism in the United States. Her association with the school and its faculty placed her in the middle of major cultural debates. Along with her colleagues James A. Porter (1905–1970) and James Lesesne Wells (1902–1993), Jones trained multiple generations of African American artists, several of whom went on to have illustrious careers as artists and art historians, such as Akili Ron Anderson, Tritobia Benjamin, Starmanda Bullock, Elizabeth Catlett, David Driskell, Malkia Roberts, and Sylvia Snowden, to name just a few. As a longtime professor at Howard and with a presence on the national art scene, Jones helped carve a path for younger black women artists.

Travel played an important part in Jones's artistic development. She returned to her beloved Martha's Vineyard frequently throughout her life but also explored Europe, the Caribbean, and various African countries, indicating her desire to understand the black experience abroad and at home in the United States. During the 1937 to 1938 academic year, Jones traveled to France

with the support of a General Education Board fellowship. In Paris, Jones painted her best-known work, *Les Fétiches* (1938; see fig. 33), which, with its African mask subject matter and loose brushstrokes, combined her growing interest in African art with her recent adoption of the impressionist style. After her 1953 marriage to Haitian graphic designer Louis Verginaud Pierre-Noël (1911–1982), Jones spent significant amounts of time in Haiti. Although Africanist themes had been present in her art since the 1920s, it was not until 1970 that Jones would travel to eleven countries in West Africa as part an ongoing, Howard-funded research project. She would visit Africa again in 1972 as the faculty host for a Howard alumni tour and yet again in 1976 when she served on Howard's delegation to the symposium celebrating Senegalese president Léopold Senghor's birthday. In 1977 Jones participated in and exhibited her work at the Second World Black and African Festival of Arts and Culture (FESTAC), held in Lagos, Nigeria. These four African trips made a lasting impression on her art.

Jones's experience with the African diaspora was not limited to Haiti and France. At the start of the 1960s, Jones was involved in a series of events at African embassies in Washington, D.C., and her activities (artistic and otherwise) implicated her in an expanding cross-cultural network of African, Afrodiasporic, and African American intellectuals, artists, and politicians. As the 1960s and 1970s progressed, Jones continued to make her mark both as an artist and as a budding art historian. She lectured widely on the African influence in Afro-American artistic production, and she initiated several art-historical research projects that centered on the black visual artist and, in

particular, black women artists in Caribbean, North American, and African contexts.

Throughout her life, Jones faced obstacles due to the intersectionality of her identity, and she frequently found herself as one of a few women artists in a sea of male contemporaries. During the later stages of her career, the black feminist art movement began to formalize, and Jones became a vocal member within it. She participated in the 1972 Corcoran Gallery Conference on Women in the Visual Arts and exhibited in a host of feminist exhibitions both in New York and in Washington, D.C. For instance, in 1975 fellow artist Faith Ringgold included Jones's work in the *11 in New York* exhibition held at the Women's Interart Center.[10]

Gaining visibility in the mainstream art world was challenging. Throughout her lengthy and prolific career, Jones never had significant representation by a private gallery, a fact that she attributed to starkly disparate factors: her lack of critical recognition and her comfortable class position, which granted her financial security. Jones was right: her race and her gender hindered her widespread acknowledgment in the art world, and it was only in the twilight of her career that institutional recognition came her way. In the 1970s, Jones was offered several opportunities to preserve her legacy. In 1973 the Museum of Fine Arts, Boston, mounted a retrospective of her work (the first solo show given to an African American female artist at an American museum). In 1977 historians associated with the Schlesinger Library at Harvard University interviewed Jones as part of the Black Women Oral History Project. In 1979, after the success of a recent exhibition of Jones's art at the Phillips Collection in Washington, D.C., the Library of Congress invited the artist to

deposit her papers in the renowned institution's manuscript division.[11] Ultimately, Jones's papers were archived at Howard University, where she had taught for so long.

On April 2, 1980, President Jimmy Carter presented Jones with the Award for Outstanding Achievement in the Visual Arts at a White House ceremony. Jones was in good company: fellow African American artists Richmond Barthé, Romare Bearden, Margaret T. Burroughs, Jacob Lawrence, Archibald Motley, James Lesesne Wells, Charles White, and Hale Woodruff were also honored.[12] Carter introduced Jones as "a painter, a designer, an illustrator, and also an educator [who has] mixed Haitian emphasis with the black experience."[13] Thus at the age of seventy-five, Jones finally received the national acknowledgment she had long sought.

The event marked a turning point in her career. Jones would spend the next few years on a victory lap, traveling the country to give lectures, attending exhibition openings, and networking. Not even the heart attack she suffered on the morning of her eighty-fourth birthday, in November 1989, slowed her down. In January 1990 a solo retrospective, *The World of Loïs Mailou Jones*, opened in Washington, D.C. The exhibition traveled to sixteen other venues across the country where Jones gave lectures.[14] The following year, she returned to Boston where she served as a visiting professor at Harvard University and Radcliffe College. In the summer of 1993, President Bill Clinton and First Lady Hillary Rodham Clinton met Jones on her beloved Martha's Vineyard and chose her seascape *Breezy Day at Gay Head* to hang in the White House. The next year the Corcoran celebrated Jones's birthday while

hosting her traveling retrospective. During the festivities, the institution offered Jones a belated apology for their racist behavior in the 1930s and 1940s when Jones was barred from participating in their exhibitions and competitions due to her race.[15] Jones died four years later, on June 9, 1998.

Critical Interventions

In recent years, scholars have called for publications that move beyond reclamations of artistic biographies and introduce critical and theoretical approaches to African American art.[16] As a result there has been a move away from single-artist monographs in favor of more thematic texts. As *Designing a New Tradition* demonstrates, however, it is possible to both restore a marginalized artist's biography and critically engage with her art. In what follows, rather than utilize a top-down approach in which a conceptual overlay is applied to the objects at hand, I leverage close readings and contextual analysis to illuminate the theoretical implications of Jones's practice.

The way in which Jones inserts her own body as a central yet unnamed focus in her own illustration mirrors how African American and American art histories have treated her—she is cited but not explained. Such an interpretation of her self-portrait reflects my methodology, which looks at the social life of objects infused with formalism—combining the social history of Jones's art with close readings of it. I aim to elucidate how her art is not simply a reflection of her biography by showing how any examination of her artistic production must be refracted through the intersectional lens of contemporary issues related to race, gender, class, and geography.

Jones foregrounded her significance to the history of African American art by placing herself literally in the middle, surrounded by a cast of contemporaries who are relegated to the sidelines. *Designing a New Tradition* is a single-artist study that, like others of its kind, must strike a balance between analyzing the art and the life of one artist.[17] My reading of the illustration *Under the Influence of the Masters* as a self-portrait underscores the various ways the watercolor manifests the composite identities present in Jones's body of work and biography.

I am indebted to the prior scholarship on Jones by her former student Tritobia Benjamin published in 1994.[18] Benjamin's *The Life and Art of Loïs Mailou Jones* laid essential groundwork in its overview of Jones's biography and artistic career. A 2009 retrospective of her work, *Loïs Mailou Jones: A Life in Vibrant Color*, traveled to several major art museums in the United States and showcased Jones's diverse aesthetics and her prolific production.[19] Expanding significantly on Benjamin's scholarship, which has been until now the only extant monograph on Jones, I argue that the artist served an important role as mediator of visual aesthetics and artistic traditions. I highlight how her race, gender, and class position all influenced the direction of her career, the reception of her work, and her place in institutionalized histories of art, African American or otherwise. A consideration of the whole of Jones's artistic production reveals that she created work in a variety of genres—notably, landscapes, portraits, and still lifes.

The chapters of this book investigate the correlation between the development of Jones's modernist aesthetic and the artist's encounters with African art objects, the southern United

States, Afro-Caribbean religious traditions, the interwar Afrodiasporic cultural community in France, and ultimately the African continent. I track Jones's interest in Afrodiasporic themes as they took myriad forms in her work—African masks, abstract design motifs, Caribbean market scenes, and portraits—enabling her to adopt a new composite visual language to capture the changing definitions of black identity over the course of the twentieth century. This book thus provides an important recovery of Jones's artistic contributions while also incorporating the artist into larger critical debates concerning blackness and the African diaspora in the twentieth century.

While part of this book traces Jones's access to Africa and African aesthetics, I am not interested in proving an intrinsic or heritage-based link between Africa and African Americans.[20] Nor is this book a theoretical intervention into the African American artist's relationship to Africa. However, the black artist's imaginary embrace of Africa plays a large role in a number of twentieth-century definitions of black art. The positing of African American artists as heirs to the cultural heritage of "Africa" worked to counter the assumption that, as art historian John Bowles notes, the "European tradition is the subject and African Americans are the objects on which it acts."[21] One way for African American artists to move from object to subject was by introducing classical Africa as a site of artistic heritage. This shift can also happen when we study black artists' lives. We have to understand them as people, as actors, as agents, and, of course, as artists in order to retrieve their place in the history of modernism. Jones herself formed part of the forefront of black artists who, beginning in the

1920s, sought a deeper understanding of Africa. Frequently the "Africa" these artists explored corresponded to a monolithic geography that existed in their imaginations rather than in the realities of the continent, with its multitude of cultural and ethnic groups and their associated traditions. African American artists, like their white counterparts, were subsumed with what Valentin Mudimbe terms "the idea of Africa."[22] Based in reality or not, artistic engagement with Africa took on increased political meaning as the twentieth century progressed. Such heightened consciousness was due in part to the black world's interest in the struggles for independence and the celebrations of the postcolonial era. As I will explain, Jones's continued return to Afrodiasporic themes and subjects over her longer career suggests that the role Africa played in twentieth-century black art needs to be reevaluated and reexamined by artists and art historians alike. Art historian Richard Powell advises, "Rather than be intellectually bound by the perceived race or nationality of the creator . . . look to the art object itself, its multiple words of meaning and its place in the social production of black identities."[23]

As such, this book engages in a series of close readings of Jones's art that emphasize her willful utilization of African and Afrodiasporic sources in the form of African objects, motifs, peoples, geographies, and their diasporic complements as part of her modernist practice. It is Jones's ongoing exploration of African, African American, and Afrodiasporic themes and subjects that allowed her to visualize the changing contours of black identity while also continually reinventing her artistic self. Such concentrated focus on Jones's oeuvre reveals how she grappled with the burden

of representation in her work at each stage of her career.

Jones's diverse engagements with ideas about objects and people from locations throughout the continent of Africa likewise enable us to use her experiences and artwork to study the evolving nexus of Africa, its diaspora, and African American art with modernism, which she illustrated in *Under the Influence of the Masters*. Ultimately, the ramifications of these historic encounters and Jones's aesthetic solutions raise critical questions not only about African American artistic engagements with Africa but also about definitions of African American and black art as well as art history's relationship to African American art as a whole.

The theoretical underpinnings for this project can be found in the scholarship on diasporic art history produced by art historians Kobena Mercer and Krista Thompson along with that of literary scholars Paul Gilroy and Brent Hayes Edwards on the internationalization of black modernity. Gilroy envisions the African diaspora as a series of dual-sided interchanges between Africa, the United States, and Europe. He posits that these interchanges function as vehicles through which modernist cultural production can be analyzed. Jones's travel from the United States to France, Haiti, the Caribbean, and Africa implicate her as a participant in the Black Atlantic and as an individual who experienced a number of different cultural exchanges.[24] As I argue, Jones's many Atlantic crossings are central to her artistic formation, and Gilroy's model of the Black Atlantic resonates. Gilroy also rightly calls into question the belief that African Americans possessed an essentialist relationship to Africa. He contends, as

do I, that modern black identities are fluid and influenced by social and cultural milieus.[25] Gilroy considered Jones's 1932 painting *The Ascent of Ethiopia* for the cover of his now-foundational study, *The Black Atlantic: Modernity and Double Consciousness*, although he ultimately chose a painting by Jones's contemporary Aaron Douglas. I will later analyze how *The Ascent of Ethiopia* is a critical step in Jones's ongoing project of visualizing a modern black identity and exploring the aesthetics of blackness.

More recently, Brent Hayes Edwards examines acts of black cultural and literary translation during the interwar period, providing another model for investigating Jones's work that is grounded in the diaspora.[26] Edwards traces acts of intercultural exchange but also of cultural and visual translation between figures active in the United States, Paris, the Caribbean, and the African continent; in doing so, he highlights the transnationality of diasporic modernism. With her Atlantic crossings, Jones is a figure of the Black Atlantic in Gilroy's terms; with her ongoing depiction of her African diasporic experiences, she is a participant in and visual interlocutor of the transatlantic diasporic modernism Edwards describes and theorizes.

While the term *diaspora* is frequently understood as the forced dispersal of individuals, beginning in the mid-twentieth century, the term, particularly when applied to the African diaspora, began to expand and include the movement, dislocation, and relocation not only of bodies but also of objects and ideas.[27] As artworks are objects and aesthetics are philosophical ideas concerning the visual, extending the definitions of *diaspora* beyond bodies to visual culture results in a

consideration of what constitutes African diasporic or black aesthetics.

As Jones's career progresses and her aesthetic evolves, I chart her increasingly diasporic praxis. To explicate her developments in style and subject matter, I introduce two distinct yet related concepts: "blackness in triplicate" and "diasporic grammar." Blackness in triplicate is a trope that emerges in Jones's art in the 1940s as she begins to explore the many facets of black identity and the black experience at home and abroad. It demonstrates the nonbinariness of black and white racial structures and identities, creating a triangle or triad that also speaks to the navigation and/or negotiation of traditions and cultural spheres that Jones encountered throughout her career. The triad might at times be applied to three geographic locales—the African continent, the North American mainland, and the African diaspora in Central and South America.[28] It also connects different chronological eras in which the discourse of blackness dominated. The paradigm operated in Jones's post-1937 oeuvre in a variety of ways—at times she grouped three black bodies, three material objects prominent in cultures belonging to the African diaspora, or the assemblage of three "signs" of blackness. With her triplicate motif, Jones created a way in which to explore multiple meanings and differing incarnations, be they complementary or contradictory versions of a given idea, image, or object.

In Jones's art from the late 1950s and 1960s, I locate another aesthetic intervention I dub diasporic grammar to name the additional processes she used to visualize her experiences outside of the United States. Diasporic grammar refers to the syntaxes or compositional innovations artists develop after exposure to visual languages utilized within Afrodiasporic communities. Diasporic grammar functions as a transmutation of an extant grammar. The inherent cultural mixing in the language of Haitian Creole is a linguistic example of what I describe. As a set of rules governing structure and composition, grammar is often considered in linguistic rather than visual terms. Once cognizant of how visual vocabularies are deployed in situ, artists like Jones utilize a diasporic grammar when they draw from their newly acquired visual languages and mix and deploy such forms in ways that retain vestiges of their original use. Such diasporic artworks, which at times pull from a range of diasporic visual languages, respond to the combinatory nature of black culture—which, in a North American context, has always involved piecing together elements from both a black and an American experience to create distinctly modernist forms.

Yet how does diasporic grammar manifest visually? In Jones's case, it involves her manipulation of the symbolic grammar of Haitian Vodou coupled with her use of collage that renders the material legible to multiple audiences with various levels of cultural comprehension and allows the work to operate on multiple planes. In her study of Harlem Renaissance–era literature, Rachel Farebrother deploys a metaphor of collage "with its crossing geographical and disciplinary boundaries, [putting] cultural exchange at the heart" to explain the mixing that occurs in the African American culture of the period.[29] Collage emerges as a solution for dealing with such cultural exchanges. The deliberate refashioning of a visual grammar in a diasporic context is necessary, in part, because, as art

historian Nicholas Mirezoff reminds us, diaspora "cannot be represented from the viewpoint of one-point perspective."[30] The diasporic visual image requires "multiple viewpoints."[31] Diasporic grammar and blackness in triplicate become vehicles through which Jones's art expresses these compound perspectives.

Jones's exposure to diasporic visual languages occurred in a variety of places and cultures both at home in the United States and abroad: Paris at the end of the 1930s, Port-au-Prince in the late 1950s and 1960s, and various West African countries during the 1970s. In Paris, Jones became aware of this diasporic visual vocabulary through European modernist aesthetic trends and African art she encountered in Parisian galleries. Years later while in Haiti, Jones learned another "visual vocabulary." Her experimentation with diasporic grammar is manifest most clearly in her Haitian collages from the late 1950s and early 1960s that derived from the multilayered ceremonial practices of Haitian Vodou. Jones combined her new visual vocabulary associated with the religion and her understanding of the rituals themselves in her experiments with collage techniques. Her use of collage stems directly from her exploration of Afrodiasporic visual vocabularies and associated syntaxes. First assembling collages using cut papers, paint, and other materials, she later developed a painted collage aesthetic that she deployed to articulate the composite aesthetics of blackness.

Organization

This book consists of four chapters that show the imbricated relationship Jones identified between Haiti, Africa, and black America by using the biological and ecological language of roots, ties, and links. As Cotter's aforementioned obituary reminds us, Jones herself was a crucial link in the development of modern African American art. In the four chapters that follow, I trace Jones's footsteps and brushstrokes to reveal her roots, ties, and links first to Boston and North Carolina in the 1920s, then to Howard University and Paris in the 1930s and 1940s, then to Haiti during the midcentury, and ultimately to Africa in the 1970s. The book is thus organized chronologically in order to elucidate how her biography and art intersect with her formation of blackness in triplicate and diasporic grammar.

The first chapter begins in Boston, Jones's birthplace, by situating her within New England's black bourgeoisie and positioning her early art production within the context of the social and cultural expectations of an upper-middle-class black woman. Jones came of age during the first two decades of the twentieth century, which bore witness to the ongoing migration of Southern African Americans to Northern industrial enclaves, as well as the start of the Harlem Renaissance and the emergence of new expressive modes in African American culture.[32] During the first phase of her career, Jones's drive to succeed and her adaptability, both socially and professionally, made it possible for her to chart a path to professional success first in North Carolina and then at Howard University in Washington, D.C. Notably, Jones did not foreground race as a common subject in her art of this period. When Jones did pursue African American subjects, her paintings captured the distance (both psychological and physical) that she as a Northerner felt from the rural African American culture she encountered down South.

In the second chapter, I explore Jones's continued negotiations of her black identity in the 1930s and 1940s soon after she began work at Howard University. After a brief discussion of Jones's first years at Howard in the early 1930s as the lone female faculty member in the department of art, I turn to her 1937–38 sabbatical in Paris, which I consider fundamental to her identity and exploration of transatlantic blackness. The year abroad played a pivotal role in altering Jones's interactions with Africa as both a geographic place and an imagined homeland. While in France, Jones encountered African art objects and Afrodiasporic peoples. In contrast to her time in the American South, in Paris Jones felt comfortable within the Afrodiasporic artistic and intellectual community. Her Parisian coterie included the key postimpressionist artist Émile Bernard and Afrodiasporic intellectuals such as Paulette and Jane Nardal, the Martinican sisters responsible for publishing the literary and cultural journal *La Revue du monde noir*. In this chapter, I explicate how Jones celebrated diasporic subjecthood in her portraits from the late 1930s and 1940s, rendering visible the possibility of multiple black identities.

Chapter 3 focuses on Jones's transformative experiences in Haiti in the 1950s and 1960s. Soon after her 1953 marriage to the Haitian graphic designer Louis Verginaud Pierre-Noël, Jones began spending school breaks in Port-au-Prince. Between 1954 and 1968, she also returned frequently to France and toured Europe with Howard University students and alumni. Tracing the evolution of her aesthetic in her Haitian-themed art works, this chapter argues that a new visual vocabulary of Vodou appears in Jones's work between 1954 and 1964. Comprising

figural representations of Vodou deities, ceremonial performances, three-dimensional assemblages of ritual offerings, and emblematic drawings known as *vèvès*, the visual language of Vodou propelled Jones's aesthetic move from representational forms to increasing abstraction. Haitian visual culture also stimulated her adoption of a "highly-keyed color palette," while her "special study" of Vodou symbolism ultimately led her to experiment in a different manner with collage.[33] Jones's turn to collage, heretofore unexamined, is connected to a multilayered diasporic literacy and a diasporic grammar first acquired through her interactions with the cosmopolitan artistic and intellectual circles at Howard University, in Paris during her 1937 sabbatical, and then in Haiti. Jones's subsequent adoption of mixed media in her Haitian and politically charged American artworks raises a larger set of questions about how one might connect the production of collage to conceptions of African American and diasporic identity, artistic or otherwise. Her travel and increased exposure to African diasporic cultures provided another route for an African American artist to reach the roots of African culture.

In the fourth chapter, attention turns to Jones's navigation of the changing political climate on Howard's campus and her travels to the African continent. While Jones was not overtly political, the research project she developed at the end of the 1960s on black visual art in African, Haitian, and African American contexts addressed the rising student demands at Howard University for a black-centered curriculum. The research project also exposed Jones's interest in delineating the contours of contemporary

black art in a global context. When tasked with making sense of her ideas about Africa after her travels through the continent, Jones turned to pastiche and collage as aesthetic responses to her many African and Afrodiasporic experiences and encounters. The visual language of collage facilitated her understanding of the layers of experiences she had over the course of her career while also speaking to the presence of multiple black identities at the end of the twentieth century. Despite a desire among some art historians to see African American artists reconcile Africa seamlessly in their work or to discover an innate kinship with African peoples and aesthetic traditions, I argue that Jones's choice to pursue a collage or composite aesthetic reflected the multilayered nature of her experiences as well as the multifaceted nature of blackness itself. Jones's paintings from the 1980s, which are characterized by their visible seams stitching together diverse black motifs, construct late twentieth-century conceptions of black identity.

Rejoining the themes of composite aesthetics and identities in twentieth-century African American art, the conclusion considers Jones's mid-career addition of a tréma accent to her first name, transforming it from Lois to Loïs. The name change resonates with Jones's own composite identity as well as her ongoing self-reinvention. I analyze the insertion of this diacritical mark, typically used to keep adjacent vowels separate,

in light of her design sensibilities, her interest in French culture, and her marriage to Pierre-Noël. Exploring Jones's self-naming invites a discussion of naming practices within twentieth-century African American art history more generally.

Jones's *Under the Influence of the Masters* mirrors the composite artistic and personal identities that the artist cultivated. The following chapters detail how Jones negotiated these diverse identities and traditions in her artistic career to understand the complex dialogues she and her contemporaries had between African, American, and European sources and ideals. She employed African and Haitian aesthetics to create her distinct version of modernist artistic practices that addressed blackness in triplicate and notions of diasporic aesthetics. I argue that in her African and Afrodiasporic-themed paintings, which proliferate in her oeuvre, Jones negotiated these various artistic traditions and designed a new composite tradition that not only reflects her own medial position but also mirrors the increasingly fragmented nature of black identity and diasporic experiences. Jones's middle-of-the-road position should not be understood as a compromise: one can occupy the middle ground and still innovate.

Seeking Success

School, Society, and Career Aspirations

1

Loïs Mailou Jones was born in Boston in 1905 (fig. 4). Her parents, Thomas Veerland and Carolyn Dorinda, were firmly ensconced in the professional class, and Jones enjoyed access to an impressive social network in black Boston as well as to the black elite who summered with the Joneses on Martha's Vineyard. Despite the limitations imposed upon her due to her race and her gender, from an early age Jones drew on the model of her ambitious parents to pursue an artistic career and achieved an impressive level of professional

success. Throughout her childhood and young adulthood, Jones navigated her way through predominantly white academic and artistic institutions. At the same time, she established herself within the larger African American cultural networks in Boston, New York, and ultimately Washington, D.C. Failing to obtain a teaching job in Boston after her art school graduation, Jones called upon these networks to first gain employment at the Palmer Memorial Institute, a black finishing school in North Carolina, and then at

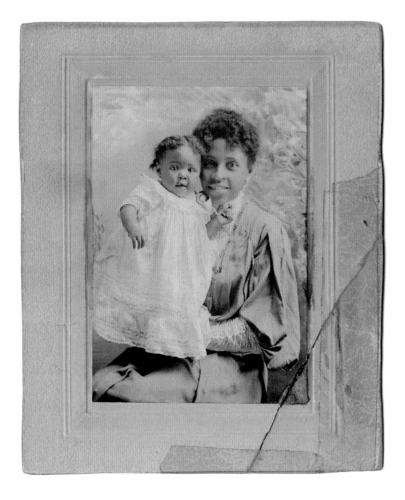

Fig. 4 Loïs Mailou Jones and her mother, Carolyn Dorinda Jones, ca. 1908. Courtesy Moorland-Spingarn Research Center, Manuscript Division, Howard University, Washington, D.C.

the mecca of African American higher education, Howard University in Washington, D.C.

Jones's journey to professional success was also a process of self-discovery, as her travels outside of Boston to New York and North Carolina exposed her to new facets of the black experience, both urban and rural. Moreover, the professionalism, flexibility, and determination Jones's parents demonstrated empowered Jones to find her way professionally at a time when very few black women were able to do so. As Jones pursued career options first in the field of textile design, then in high school education, and ultimately in college-level art instruction, she also took the opportunity to investigate different aspects of the black experience. Her art serves as a record of her academic training and these early explorations. Jones's socioeconomic and cultural background coupled with her personal qualities gave her the ability to succeed in these efforts. Looking at Jones's biography in tandem with her art gives us a more complete understanding of the inherent variations within the black experience and the aesthetics pursued by African American artists

during the twentieth century. During her child-hood and young adulthood, Jones frequently found herself in the middle—socially, culturally, aesthetically, and professionally—and her adapt-ability would help her seek a path to success.

In 1919, a New England newspaper reported, "At Boston there is a Brownie 14 years of age, who has won her second scholarship at the Museum of Fine Arts. Her name is Lois M. Jones, and she's an honor student at the High School of the Practical Arts [HSPA] in Boston."[1] In 1927, the *Boston Herald* announced that the very same Loïs Mailou Jones had become the first "colored" person to graduate from the illustrious School of the Museum of Fine Arts, Boston (SMFA).[2] Upon her graduation, Jones became one of the few documented professional black women artists working in Boston. While the city possesses a rich history of white American artists and writers, African American cultural producers were few.[3] As such, Jones's negotiations of the art world offer new insights into who made art and why during this period.

From the post-Reconstruction era through the first decades of the twentieth century, the achieve-ment of a "Negro first" carried with it personal and community significance. Director of the Boston-based National Center of Afro-American Artists and Jones's longtime personal friend, Edmund Barry Gaither, notes, "Such status not only broadened the options for all who would follow, it also validated courage and competency. Loïs was responsive to these forces in deliberate and inadvertent ways and was frequently among the 'first' in her field of fine arts."[4] Understand-ing the social milieu of early twentieth-century black Boston and the socioeconomic circum-stances in which Jones was raised helps explain

how she understood what it meant to be black, a woman, and an artist during her childhood and young adulthood. Jones came of age at a critical historical juncture, bearing witness to the rising feminist movement and the concurrent yet separate New Negro movement. As an African American woman, she located her sense of self at the implicit yet socially unarticulated intersection between these two movements.

Attending to the first phase of Jones's life and career, from her 1905 birth in Boston to her 1930 arrival at Howard University in Washing-ton, D.C., this chapter commences by situating Jones within Boston's black bourgeoisie. Jones's tenacity in pursuing her career becomes appar-ent if her artwork and her career decisions from this early period are read against the socie-tal and cultural expectations she faced as an upper-middle-class black woman. Beginning with her childhood in Boston and on Martha's Vineyard, the chapter considers her artistic training at the SMFA and her short-lived career as a textile designer after her SMFA graduation, and concludes with Jones's first teaching job in Sedalia, North Carolina.

While the 1910s saw large numbers of African Americans leaving the rural South in favor of the promise of improved economic opportunities in urban enclaves in the North, Jones's family had arrived in Boston by way of New Jersey. Jones did not have any Southern roots, and so her two-year stint at the Palmer Memorial Institute (PMI) in Sedalia, North Carolina, was an eye-opening experience both professionally and personally. As Jones moved to and from the Northern urban centers of Boston and New York to rural North Carolina at the end of

the 1920s, she formed connections with intel-
lectuals, artists, writers, and others. Her art
from the late 1920s evinces both her growing
interest in African art and her alienation from
the Southern African American communities
she encountered. Jones's embrace of African
aesthetics can be seen as a stepping stone in her
acquisition of a diasporic visual vocabulary that
eventually demanded her utilization of a dias-
poric grammar. The physical and psychological
distance she felt from the African American
South expanded her understanding of the black
experience and would later figure into her use of
the blackness-in-triplicate motif.

 During Jones's childhood and adolescence,
her race was, paradoxically, both of little and of
central concern. Of her high school years at the
mixed-race HSPA, Jones recalled that she did
not have "a feeling of any particular direction
of 'blackness.' . . . I was an 'American child' and
worked right along with my white classmates."[5]
While Jones's race was not a factor in the class-
room, her social and class position within the
larger black Boston community did guide her
career trajectory. Gaither acknowledges, "The
community in which she worked insisted that
a good education conferred upon the African
American recipient—regardless of his or her
chosen profession—the obligation to lift the
race."[6] Jones was also subject to a specific set of
social codes and behavioral expectations due to
her gender.

Boston Beginnings

At the time of Jones's 1905 birth, Boston was well
established as a relatively progressive city, and
black Bostonians benefited from the city's aboli-
tionist heritage. The freedom African Americans
enjoyed in Boston was due in part to the minus-
cule size of its African American population in
comparison to other similarly sized cities. By 1900,
Boston was the fourth-largest urban metropolis in
the United States, with a population of 560,892.[7]
Although the city's African American population
doubled between 1890 and 1920, growing from
8,125 to 16,350, African Americans still only made
up 2.2 percent of city's residents. In fact, peoples
of African descent made up just more than 1
percent of the entire state's population. In 1920,
Massachusetts reported an African American
population of 45,466 out of its 3,852,356 residents.

 Jones's parents were among the city's recent
transplants. The Joneses arrived to Boston from
Paterson, New Jersey, in 1896, with their newborn
son, John Wesley. The family joined a small but
powerful coterie of African Americans living and
working in the city. A motivating factor for the
family's move was the promise of improving their
social status. According to the 1900 census, the
Joneses settled first in Cambridge before moving
to 28 School Street, near Boston's City Hall, where
Thomas accepted a position as the building super-
intendent. The Jones's downtown neighborhood
was adjacent to the sprawling Boston Common
and near the West End neighborhood, where a
number of black Bostonians gravitated before
moving on to the South End and the back of
Beacon Hill.[8]

 With lofty ambitions, Thomas Jones enrolled
in night classes at the nearby Suffolk Univer-
sity Law School. Loïs was ten years old when he
graduated in 1915, and she reaped the benefits as
her father's new professional status as a lawyer

and subsequent real estate dealings improved the family's social standing within the black community.[9] Jim Crow America tended to view black Americans as a single-classed mass—ignoring social and economic stratifications within the race. But in truth black families occupied a range of positions along the class spectrum, from the elite to the working poor.[10] While the Jones family lacked the extreme wealth of some of their friends and neighbors, they were financially comfortable with professional jobs. Their increasing financial stability enabled the Joneses—both parents and children—to move freely within the upper echelons of black Boston society.

While undoubtedly aware of the racism her fellow African Americans faced during the progressive era, Jones remarked on "the general feeling of equality which prevailed" in Boston during her childhood.[11] According to historian Mark Schneider, the small size of Boston's black population protected African Americans there from the "more blatant forms of racism that afflicted other urban centers."[12] Though few in number, black Bostonians were radical and very politically active. Capitalizing on a divided and weak white upper class and their own history of resistance, black Bostonians formed a variety of community organizations and "provided a vital link to the modern civil rights movement."[13] Jones was born at an auspicious moment as the city's "illustrious African American past and abolitionist tradition offered particular encouragement to ambitious women of color."[14]

The growing feminist movement cleared some further obstacles out of her way as Jones transitioned from girlhood to womanhood. As a girl on the verge of her teenage years, Jones witnessed the fight for the women's vote first-hand. In May 1914, the Boston Women's Suffrage Parade marched right by the foot of her street in downtown Boston. With a reported nine thousand marchers, two hundred automobiles, elaborate floats, and more than a dozen bands, the parade was quite a spectacle. When the *New York Times* reported on the day's activities, the paper estimated that more than two hundred thousand spectators lined the route.[15]

The Jones family was well connected to the city's black social and political elite. As such, Jones grew up in a socially conscious and perhaps politically active household. Thomas Jones considered William Monroe Trotter, the real estate magnate and founder of the *Boston Guardian*, a close friend. Trotter gained acclaim for his opposition to Booker T. Washington's approach to racial uplift and President Woodrow Wilson's segregationist policies. Washington advocated a strategy of accommodation—the acceptance of racial prejudice and the focus on economic improvement via vocational instruction. Jones remembered that her father was "very much interested in the various movements that Monroe Trotter carried on in Boston," among them the formation of the National Association for the Advancement of Colored People (NAACP).[16] Boston became home to the first chartered branch of the NAACP in 1912, an honor announced at the Park Street Church located around the corner from the Jones residence. Thomas Jones was also friendly with Cliff Wharton, a younger law student during the 1920s. Wharton served in the embassy in Liberia in the late 1920s as the first African American diplomat and later as ambassador to Norway. The Joneses' political connections stretched across racial lines,

as Jones would also recall her father's interactions with the controversial Boston mayor James Curley, with whom he was "very good friends."[17]

Jones's father was not the only mover and shaker in the family. Her mother, Carolyn Jones, maintained a healthy cosmetologist business and was active in the black women's club scene. She frequently toted young Loïs to club meetings at the League of Women for Community Service (LWCS). These organizations, whose membership included the cultural, political, and social elite of black Boston, promoted a politics of respectability as part of a strategy of racial uplift and offered Jones further insight into the goings-on of upper-class black society.[18]

The black women's club movement began in the late 1890s as black women banded together in campaigns to end lynching practices. These organizations sought to ameliorate social conditions in line with the ethos of the progressive era. Though often instituted by upper-class and elite women, the clubs catered to members of the middle class as well.[19] Because black women were excluded from white women's groups and from black men's groups, black women's clubs like the LWCS were key sites for initiating social change and also for establishing camaraderie. The fact that the Jones women were active clubwomen signaled their social standing and commitment to bettering conditions for their race.

While in high school, Jones founded and served as president of the Pierrettes Club at the LWCS on Massachusetts Avenue.[20] Little is known about the Pierrettes Club members or the group's specific activities—though Susan Earle has suggested it may have originated as a mystic society.[21] For ten years Jones led the group of thirty young girls in activities every Saturday. The group's host organization, the LWCS, played an important role in black Boston in the late 1910s. Jones's work with girls in the Pierrettes and her interactions with the LWCS in the early 1920s marked the beginning of a career-long interest in the women's movement.

Established in 1918, the LWCS was run by upper-class black women who sought to provide comfort to African American soldiers housed at nearby Fort Devens. The club was headquartered in a mansion at 558 Massachusetts Avenue. After World War I, the LWCS turned its attention to recent women migrants to Boston. The Joneses had a personal connection to World War I soldiers: the family's oldest son, John Wesley Jones, served in the army. However, the appeal of the LWCS to the female Joneses probably had more to do with the organization's affiliation with a group of upwardly mobile, politically connected individuals. LWCS founders included several prominent members of black Boston's upper crust, including Maria Baldwin (1856–1922), the first African American school principal in New England, and Florida Ruffin Ridley (1861–1943), editor of the African American women's newspaper the *Woman's Era* and daughter of the first black judge in the United States.[22] In the mid-1920s, Ridley and Jones would both become members of the same literary group, the Saturday Evening Quill Club. In addition to frequenting the LWCS, Jones also attended events at the Women's Service Club located just across Massachusetts Avenue. Her teenage years required her to negotiate mixed-race educational spaces and all-black social organizations—both fraught with different sets of demands and behavioral expectations.

While the overwhelming majority of early twentieth-century America was racially segregated, Jones's Boston upbringing was a blessing in that it provided the young artist with an interracial education. Jones cited her public schooling as critical to her sense of equality with whites. For her elementary years, Jones attended the Bowdoin School located at 45 Myrtle Street in Boston's Beacon Hill neighborhood. While Jones did not comment on the school's racial makeup, she would later classify the area as a "Jewish neighborhood."[23] The Boston neighborhoods with the large concentrations of African Americans—notably the South and West Ends—were nevertheless interracial.[24]

Jones credited her parents for facilitating her interest in the visual arts. She recounted, "Very early they gave me colored crayons, and at seven I had my first set of watercolor paints, still my favorite medium."[25] After finishing elementary school, Jones was recruited to attend the newly opened High School of the Practical Arts (HSPA) in the Roxbury neighborhood where the Joneses had recently moved.[26] The HSPA, the first all-girls public vocational school in Boston, opened in 1907 and sought "to develop womanly attributes and to train for distinctly feminine occupations and offered instruction in English, history, modern languages, science, math, art, household science, dressmaking, and millinery."[27] Although there were a number of black students enrolled at HSPA, the majority were white. Jones noted that her fellow black students tended to focus on home economics. During their second year, students were to "elect either household science, dress-making, or millinery as a focus in addition to their academic studies."[28] Jones later said that

HSPA was an "unusual school" because it offered her the "opportunity to do special study in art."[29] She was eventually named editor of the school's art magazine and designed greeting cards as part of the annual fundraising campaign.[30]

While at HSPA, Jones won several scholarships to take the Boston Museum Vocational Drawing Class at the SMFA. She recalled, "I made the museum my home, drawing from works until it closed."[31] Jones was particularly interested in the textiles department and executed many studies of fabric designs as well as of Eastern porcelain and tapestries.[32] Jones was awarded an internship with costume designer Grace Ripley in high school, which, together with her afternoons at the SMFA, was instrumental in introducing the young artist to non-Western cultures. Ripley taught at the Rhode Island School of Design and ran the eponymous costume design company, Ripley Studios, in Boston. While working for Ripley on Saturdays, Jones helped design a series of masks for the New York–based Ted Shawn Dance Company (also known as the Denishawn Dance Company).

Working for Denishawn was quite a coup, as the troupe's owners, Ted Shawn and his wife, Ruth St. Denis, were pioneers in modern dance. North Africa was a particular source of inspiration for the duo. While the specific Denishawn production on which Jones worked is unknown, Jones frequently cited the Ripley Studios internship as one of her first encounters with non-Western art, specifically African masking traditions.[33] Her work could have contributed to any one of the Egyptian-themed dances Denishawn performed in the late 1910s, among them "Dance egyptienne" (1914), "Ancient Egypt: A Ballet of the Tamboura (1915), "A Dance Pageant of Egypt, Greece, and

India" (1916), and "Dance from an Egyptian Frieze" (1918).[34] Slowly Jones was building a visual vocabulary informed by both Western and African diasporic artistic traditions.

Oak Bluffs

While her schooling and extracurricular activities in Boston provided opportunities for Jones to strengthen her artistic skills, the island of Martha's Vineyard also played an important role in her artistic development. Every summer, Jones's mother would take Loïs and her older brother and decamp to their coastal escape. Jones recalled, "What a thrill it was to leave the smoky city of Boston . . . [where] my playground was the roof of [our] building . . . and go to Martha's Vineyard."[35] It was on the island that Jones first began to paint, and she spent countless hours capturing the island's picturesque vistas on canvas and paper. In 1923, at age seventeen, Jones had her first solo exhibition in Vineyard Haven, one of Oak Bluffs' neighboring villages.[36] During Jones's childhood, notable visitors to Oak Bluffs included beauty entrepreneur Madame C. J. Walker, composer Harry T. Burleigh, and sculptor Meta Warrick Fuller. Jones frequently recounted her interactions with Fuller and Burleigh, both of whom urged Jones to consider studying abroad to further her artistic training.[37]

In addition to their passion for art, Jones and Fuller had similar upbringings—both belonged to the black upper-middle class, were raised by parents who supported their daughters' artistic pursuits, and demonstrated artistic acumen at a young age. Fuller was just a high-schooler when one of her works was selected for the 1893 World's Columbian Exposition in Chicago. The following year she was awarded a scholarship to the Pennsylvania Museum and School of Industrial Art, from which she graduated in 1898. Fuller then continued her studies in Paris from 1899 to 1902. Fuller's time in Paris was transformational—she was mentored by family friend and renowned African American painter Henry Ossawa Tanner, had the opportunity to meet W. E. B. Du Bois, with whom she would correspond for many years, and studied the great French sculptors, becoming particularly enamored with the work of Auguste Rodin.[38] It was Fuller who would later encourage Jones to study in Paris, where she, too, hoped to sit at the feet of Tanner.

The Joneses were one of many African American families who flocked to Martha's Vineyard during the summer months. In the early nineteenth century, Martha's Vineyard attracted people of all races eager to benefit from the prosperous whaling industry head-quartered on the Vineyard and Nantucket. By the end of the 1800s, the whaling industry had waned, and the region was rebranded as a resort area. Historian Dona Brown notes that Martha's Vineyard was more accessible than the neighboring Nantucket and appealed to those "poised at the edge of the middle class."[39] Jones's maternal grandmother, Phoebe Moseley Adams Ballou, first went to the island in the late 1800s to work as a domestic servant for a wealthy white family, the Hatches. Ballou used her earnings to purchase land in Edgartown and property in Oak Bluffs.[40] Ballou was not alone in her real estate endeavors. She was one of a number of African American laborers who bought land from white landholders.

Because blacks could not stay in hotels on the Vineyard at the start of the twentieth century, the steady increase in property ownership among African Americans in Oak Bluffs was critical in turning the former Methodist camp meeting community into a welcome summer enclave for the black elite. Phoebe Ballou's climb up the property ladder on the Vineyard would set the stage for her family's growing wealth. Her grandson and great-grandson would go on to become real estate developers. Owning property in Oak Bluffs placed the Jones family staunchly within the growing contours of the black social elite. While they might not have had the same financial means of the more moneyed summer residents, they could take comfort in the fact that they were "originals."[41]

Jones reveled in her Vineyard summers, which were spent swimming, playing, and socializing. Jones was four when her family moved into an Oak Bluffs duplex that they shared with another socially ambitious, well-to-do African American family from Boston, the Wests. The Joneses would later move to a single-family dwelling on Pacific Avenue. Isaac and Rachel West had a daughter just a few years younger than Jones, and the two girls became fast and lifelong friends. Dorothy West (1907–1998) would go on to become a major novelist during the Harlem Renaissance of the 1920s.[42] A 1913 photograph shows an eight-year-old Jones (upper right) posing with West (lower left) and two other young girls (fig. 5). Although the two families shared a roof, their family structures and parenting styles were quite different. The West children had an unconventional upbringing. Dorothy's father was relatively absent as he grew his fruit distribution business, and her

Fig. 5 Loïs Mailou Jones (upper right), Dorothy West (lower left), and friends in Oak Bluffs, ca. 1913. Courtesy Moorland-Spingarn Research Center, Manuscript Division, Howard University, Washington, D.C.

mother, Rachel, was strong-willed and ran with a progressive social circle that shunned heteronormative social codes. In fact, it is thought that the duplex burned as a result of a cigarette dropped during one of Rachel West's all-female soirees.[43]

Although the Wests lived next to the Joneses for only a short period, Jones's proximity to the West family gave her access to this group of radical and creative women. At the start of the twentieth century, two generationally defined types of feminism shaped the contours of modern womanhood. The first dated back to the Victorian era of the late nineteenth century and consisted largely of college-educated women who elected not to marry and who frequently maintained strong relationships, platonic or romantic, with

other women. The second, more recent type comprised of "bohemian" women, for whom "heterosexual intimacy and sexual freedom were central to redefining their worlds."[44] Jones straddled the two generations both chronologically and socially; she was neither a bohemian nor a Victorian. Unmarried until her late forties, Jones became part of the roughly 40 to 60 percent of women who graduated from college between the 1870s and 1920s and chose not to marry immediately.[45] Prioritizing her career over her romantic life, she did maintain a number of intimate female friendships in the 1920s and 1930s that appear to have sustained her emotional needs. Perhaps the West family offered an alternative to Jones's traditional family structure and served as a model for her own life.

While Jones did not report encountering racism in Boston, she did recount feeling a sense of racial and class inequity while spending summers in Oak Bluffs. During the summer months, her mother continued to work as a hairdresser and counted a number of black and white summer residents as customers. Jones recalled how some of the wealthy white clients required her mother to enter through the side door or service entrance rather than through the front door. This request "annoyed" Jones because, as she reported, "in Boston proper, going to the public schools, I felt really on an equal basis with whites."[46] Regardless, Jones did acknowledge that spending time in these well-to-do homes exposed her "to the luxury of their living, the beautiful interior decoration and paintings and sculpture," which she came to appreciate.[47]

Jones also found inspiration outside. Coastal landscapes and fishing scenes were commonplace in her oeuvre. She pictured the hamlet's harbor in the 1924 watercolor *Vineyard Haven Harbor* (fig. 6). Using a muted color palette of grays, browns, rusts, and deep blues, Jones's landscape evokes a blustery coastal day. A crescent beach begins at the center foreground, arcing along the left side of the composition and drawing the viewer's eye to the cluster of boathouses in the background. In the middle, a group of sailboats appear moored in the harbor and docked on a set of piers. By creating a composition devoid of human figures with the wide harbor vista as her primary subject, Jones subscribed to the conventions of picturesque landscape painting and demonstrated her skill. Her ability to use the whiteness of the paper in the composition and to apply the blues to create varied shades of gray is not only impressive but also articulate. Jones's early interest in landscape painting impacted her later art not only because of the genre's documentary function but also because of its use of wide-angle perspective. Such conventions of landscape painting would later play a part in her depictions of the South.

There is a long tradition of landscape painting on New England islands, including Martha's Vineyard, Nantucket, and Mount Desert. The artist colonies housed on these various islands were great for networking, and Jones benefited from the professional connections she forged during her summer vacations.[48] It was in the fishing village Menemsha that Jones would meet Jonas Lie, then president of the National Academy of Design. Lie spotted the young artist hard at work on a watercolor. Impressed with her talent, Lie invited Jones to bring her portfolio and visit him in New York at the National Academy of Design.[49] Jones heeded his advice, and

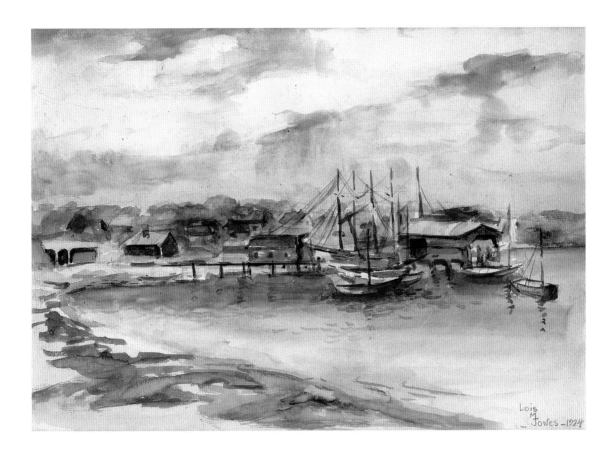

Fig. 6 Loïs Maïlou Jones, *Vineyard Haven Harbor*, 1924. Water-color on paper, 10 × 14 in. (25.4 × 35.6 cm). Courtesy Swann Auction Galleries and Loïs Maïlou Jones Pierre-Noël Trust.

after graduating from high school she applied to art school.

The SMFA

In October 1923, on the heels of her first exhibition on Martha's Vineyard (held in the garden of one of her mother's clients), Jones enrolled as a design student at the highly regarded School of the Museum of Fine Arts, Boston.[50] Founded in 1876 as the School of Drawing and Painting,

the SMFA awarded its first diploma in 1885 and began its formal affiliation with the Museum of Fine Arts, Boston, in 1901. In the 1920s, it was not uncommon for women to attend art school. The SMFA reported in 1923 that only "in the painting classes the men outnumber the women."[51] Jones was one of 166 women in her entering class, with 125 male students completing a cohort of 291. To finance her education, Jones was awarded four consecutive Susan Minot Lane Scholarships in Design. The scholarship, established in 1918, was earmarked for "deserving poor young women students."[52] Given the middle-class standings of the other awardees—the daughters of a lawyer, a wholesale salesman, an Episcopal minister, a real

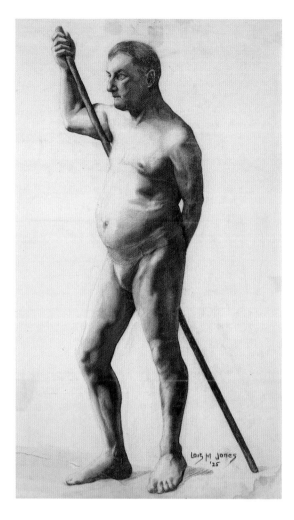

Fig. 7 Loïs Mailou Jones, *Nude Study*, ca. 1925. Charcoal, 24 ¼ × 14 in. Courtesy Loïs Mailou Jones Pierre-Noël Trust.

estate agent, and an engineer—one gathers that the general student population of the SMFA must have been quite wealthy if Jones and her fellow awardees were the "poor young women."[53]

In a later interview, Jones noted that receiving the scholarship made her work "very, very hard," as she was always "on the spot."[54] The pressure Jones placed on herself while at the SFMA

mirrored the larger societal emphasis that was, in her words, "placed on a Negro 'to go that extra mile.'"[55] Jones was the only African American student during her tenure. The other known African American graduate of the SMFA from the era, Allan Rohan Crite (1910–2007), finished some ten years after Jones.

At the SMFA Jones received a very traditional artistic training. During her first year she focused on life drawing, while her concentration in years two and three was design. In her final year, perhaps in an effort to ensure she could make a living when she got out, Jones added a specialization in portraiture.[56] Her teachers—among them Anson Cross, Philip Hale, Alice Morse, and Henry Hunt Clark—were part of the conservative Boston arts establishment, which frowned upon abstraction and other forms of modernism in art. The instructors' artistic conservatism bled into the types of courses offered at the SMFA. For example, modern art was not introduced into the curriculum until 1931, several years after Jones's graduation. Instead, the school's pedagogical method followed its European counterparts with its emphasis on training in life drawing and perspective, moving from copying plaster casts up to the use of live models.[57] As such Jones was well-versed in figural representation at the conclusion of her SMFA education. Jones's 1925 charcoal drawing *Nude Study* was most likely made in one of her life-drawing classes (fig. 7). In the drawing, a portly, middle-aged white man wearing a loincloth stands grasping a long wooden pole with his right arm raised, bent at the elbow. The pole extends behind his back, and he grabs it with his left arm, showcasing the musculature of his left shoulder and bicep. The life

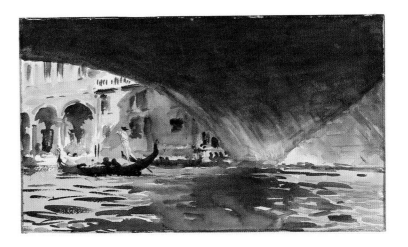

Fig. 8 John Singer Sargent, *Venice: Under the Rialto Bridge*, 1909. Translucent watercolor, with touches of opaque watercolor, over graphite on paper, sheet: 10 ⅞ × 19 in. (27.6 × 48. 3 cm). The Hayden Collection-Charles Henry Hayden Fund, 12.203. Photo © 2020 Museum of Fine Arts, Boston.

classes at SMFA were segregated by sex. While the women models posed nude for both the male and female classes, male models wore loincloths when posing for the female students.[58]

It is perhaps unsurprising that the SMFA and its instructors subscribed to a more conservative aesthetic. European modern art had only been introduced to American audiences in 1913 when the Armory show opened in New York. Following the shocking exhibition, many American painters abandoned their commitment to naturalism and figural representation in favor of abstraction. As part of the avant-garde, modernist painting was not commonplace in European or American art academies in the first half of the twentieth century. Moreover, the conservatism of the SMFA was also found in the galleries of the MFA, which during Jones's tenure focused on art from the nineteenth century and earlier, with the exception of a 1926 exhibition of contemporary Italian art.[59]

A facet of Jones's SMFA education included courses involving museum research, which encouraged object-based study of items in the MFA's expansive collections. During her first year, she produced two charcoal drawings based on Auguste Rodin statues: *The Flight of Love* and *Young Girl*.[60] These courses encouraged her exploration of the MFA's encyclopedic collections. She would later note that the watercolors of renowned transatlantic portrait artist John Singer Sargent and the works of Winslow Homer were "a great inspiration" during her time at the SMFA.[61] She described how "their explorations of nature reinforced my own love of the landscape and the ocean."[62] Sargent's watercolors in the MFA collection such as *Venice: Under the Rialto Bridge* captured vistas and vignettes from his European voyages (fig. 8). With their European subject matter, such paintings would have stoked Jones's growing desire to study abroad, while at the same time Sargent's predilection for unusual vantage points and dramatic use of color would have fueled Jones's artistic imagination.

Like so many Boston school painters, Jones was drawn to MFA's Asian art and textile

Fig. 9 Loïs Mailou Jones, *Chinese Embroidery (copied from a Han Chinese woman's domestic skirt, embroidered with silk thread, in MFA collection)*, 1924. Transparent and opaque watercolor with graphite underdrawing on paper, sheet: 12 ³⁄₁₆ × 8 ⅛ in.(31 × 20.7 cm). Museum of Fine Arts Boston. Gift of the Loïs Mailou Jones Pierre-Noel Trust, 2005.341. Courtesy Loïs Mailou Jones Pierre-Noël Trust. Photo © 2020 Museum of Fine Arts, Boston.

Fig. 10 Loïs Mailou Jones, *Japanese Waterfall (repeat pattern based on Ukiyo-e Japanese print)*, 1925. Opaque watercolor on board, sheet (irregular): 20 ⅛ × 18 ⅞ in. (51 × 48 cm). Museum of Fine Arts, Boston. Gift of the Loïs Mailou Jones Pierre-Noel Trust, 005.341. Courtesy Loïs Mailou Jones Pierre-Noël Trust. Photo © 2020 Museum of Fine Arts, Boston.

collections. In 1924, she copied in watercolor a detail of a Han Chinese woman's domestic skirt (fig. 9). She also found inspiration in Japanese Ukiyo-e prints (fig. 10). In 1927, she produced a pair of works that depict objects from the MFA's Asian collection. Her pen and ink drawing *The Japanese Garden* captured one of the museum's popular Japanese galleries (fig. 11). Her composition relays the multileveled nature of the installation—the foreground is dominated by a sculptural display plinth, and a foo dog stands guard on a platform that bears Japanese characters. In the background is an elevated, seated Buddha surrounded by decorative wall panels. The drawing possesses a level of detail and a sense of distance that is reminiscent of landscape painting.

In her watercolor *Buddha*, also painted during her SFMA days, Jones maintains the detail found in *The Japanese Garden* but moves closer to her subject, a carved bodhisattva statue (fig. 12). The figure is shown cross-legged in prayer, draped in teal fabric, and seated on a platform covered with an elaborately patterned Persian carpet of reds, dark blues, and golden yellow. Four variously shaped ceramic vessels surround the sculpture. In the background, a brightly colored wall hanging showcases a repeating abstract design of a temple with large flowers and plumed tropical birds. While the Buddha, the vases, and the foreground are heavy in weight and color saturation, the background wall panel is light and bright, rendered in pale aqua, blue, orange, and yellow to complete the design. The background bears an uncanny similarity to one of Jones's textile designs of the same year, *Chinese Birdhouses* (fig. 13). It utilizes a rich color palette of coral, peacock

Fig. 11 Loïs Mailou Jones, *The Japanese Garden*, 1927. Pen and ink, 16 × 12 ¼ in. Courtesy Loïs Mailou Jones Pierre-Noël Trust.

blue, and aqua, while for the *Buddha* painting, Jones altered the colorway, rendering the design in shades of orange, aqua, and yellow. Given its aesthetic similarities to Jones's textile designs, it is possible that Jones used the *Buddha* watercolor as an opportunity to showcase her textile design work and to transition from designer to painter.[63]

While *The Japanese Garden* and *Buddha* illustrate Jones's engagement with the MFA's Asian collection, there is a conspicuous absence

of any visual proof that the artist interacted with the museum's African art holdings. The dearth of African-themed works is surprising for several reasons. First, Jones's time at the SMFA coincided with the MFA's acquisition of a sizable Egyptian collection and the 1920s Egyptomania craze that spread across the United States and Europe. Second, Jones's formative years as an art student corresponded to the rise of the

Harlem Renaissance, also called the New Negro movement or New Negro renaissance, a period of intense black cultural production based largely, but not exclusively, in the upper Manhattan neighborhood of Harlem.[64] During this period, an African American connection to Africa and especially Egypt became something to embrace rather than disavow.[65] Yet Jones's paintings from this period indicate that she did not yet share the

same impulse to explore the varied dimensions of the African diaspora.

Charting the contact zones African American artists had with African art illuminates how, increasingly during this period, African Americans were encouraged to view Africa as the source of their heritage and as a largely mythologized ancestral homeland. The traces of this ostensible homeland became more tangible as excavations of ancient Egyptian sites flooded European and North American museums with the region's ancient art. While Jones did not incorporate the Egyptian collection at the MFA, she would come to weave African aesthetics into her artworks throughout her career, and her engagement with such themes would become one of her artistic hallmarks.

Contact Zones: African Art and the New Negro

The first major installation of Egyptian artifacts at the MFA occurred in 1922, a year before Jones started at the SMFA. The material's acquisition in 1921 and subsequent display garnered much public interest and was widely reported in the Boston media.[66] In December 1922, Howard Carter (1874–1939) made archeological history with his discovery of the intact tomb of Tutankhamen, a pharaoh of Egypt's eighteenth dynasty, in Luxor. For the next two years, cable news wires reporting the latest finds were published in the United States as well as in Western Europe and the United Kingdom. The discovery of Tutankhamen's tomb coincided with the advent of new theories by anthropologist Franz Boas (1858–1942) that attributed human

Fig. 13 Loïs Mailou Jones, *Chinese Birdhouses (design for silk)*, 1927. Opaque watercolor with graphite underdrawing on paper, sheet: 16 15/16 × 11 in. (43 × 28 cm). Museum of Fine Arts, Boston. Gift of the Loïs Mailou Jones Pierre-Noel Trust, 2005.344. Courtesy Loïs Mailou Jones Pierre-Noël Trust. Photo © 2020 Museum of Fine Arts, Boston.

differences to variations in history and culture. These theories were consumed alongside the work of German archeologist Leo Frobenius (1873–1938), whose late nineteenth-century and twentieth-century publications also emphasized the existence of an ancient African civilization on par with other celebrated classical Western civilizations.[67]

Carter's discovery had considerable impact on the African American public, with far-reaching implications. Unlike Ethiopia, which had long served as a mythical locale in the African American imaginary, Egypt was now touted as a physical site at which African Americans could locate the birth of "black" culture.[68] Some African Americans were quick to identify with the Egyptian treasures being unearthed; new knowledge about an ancient culture belonging to "dark-skinned" peoples made it difficult to refute that African Americans were the heirs of a sophisticated history and a culture on par with that of the Greeks and Romans. Despite having access to excellent examples of Egyptian art at the MFA, while at the SMFA Jones seemed unaffected by the discoveries and their resultant impact on African American art.

While Jones may have been the lone African American woman in her class, she did find a local role model in renowned sculptor Meta Warrick Fuller (1877–1968), whom Jones knew from her summers on Martha's Vineyard. Fuller moved to Massachusetts from Philadelphia in 1909 on the occasion of her marriage to a Liberian doctor.[69] In 1921, Fuller cast her now-canonical sculpture *Ethiopia Awakening* perhaps after being inspired by the Egyptian sculpture of King Menkaura and his queen, which was acquired in 1911 by the MFA in Boston (fig. 14).[70] W. E. B. Du Bois and NAACP executive secretary, James Weldon Johnson, approached Fuller to produce the allegorical figure for the 1921 exhibition *America's Making*, which was cosponsored by New York City and the New York State Department of Education. The life-sized bronze sculpture was prominently featured in the African American section of the exhibit. A photograph of the sculpture illustrated the group's page in the exposition catalogue, *The Book of America's Making Exposition, October 29–November 12, 1921*, where it appeared with the caption: "'Ethiopia,' A symbolic statue of the EMANCIPATION of the NEGRO Race."[71] Jones may have encountered the sculpture in the fall of 1922, when selections from Fuller's oeuvre were included in a Boston Public Library exhibition entitled *Work of the American Negro*.[72]

Shown standing on a small plinth, Fuller's *Ethiopia* depicts an African woman whose lower half is wrapped tightly in strips of fabric forming a crisscross pattern. She wears the striped nemes headdress associated with Egyptian pharaohs. Looking over her left shoulder, she clutches a piece of fabric to her heart with her right hand, in effect holding the key to her freedom. Captured in the process of liberating her body, Ethiopia's ceremonial unwrapping speaks allegorically to the emancipation of African Americans and to the growing awareness of African heritage within the African American community.[73] Although her feet are bound and rooted in the traditions of ancient Egypt, her heart and mind seem free to take advantage of America's offerings. Ethiopia takes control of her own body, an act of self-awakening and liberation. The sculpture embodied the romantic notions of Africa held by African Americans in the early decades of the twentieth century.

With its combination of Egyptian and Ethiopian referents, Fuller's *Ethiopia* exemplifies the literary and religious tradition of Ethiopianism popular in the 1920s. Ethiopianism enabled African Americans to forge an identity based upon ancient African cultures, situating Ethiopia as a site of black liberation. The contemporary

Egyptian excavations unearthed a long-standing artistic and architectural tradition that placed ancient Egyptians on equal footing with their classical European counterparts. In the 1920s, Ethiopia was unique in its independence from the colonial rule that plagued the African continent for much of the twentieth century (though Italy would invade and colonize the nation in 1935). As an independent country with an established cultural history, Ethiopia was an "Africa" of which African Americans could be proud.[74] Fuller's *Ethiopia* foreshadowed both the influx of newly excavated Egyptian objects into American collections and the calls for an African American artistic embrace of all things African that would occur in the mid-1920s during the heyday of the New Negro movement.

The New Negro movement was spearheaded in part by Howard University professor Alain Locke, who posited Africa, and specifically Egypt, as the classical foundation for black culture. Locke promoted African art as one prong of the development of a truly African American modernist aesthetic. Jones did acknowledge her awareness of Locke during this period, so it is worth lingering on why she did not immediately heed his calls to explore an African aesthetics in her own work. Art and visual culture played a large role in Locke's vision for the New Negro movement. Having spent considerable time in Paris during the early 1920s, Locke witnessed firsthand the veritable fad for all things black that swept France and the rest of Europe during the period.[75] He believed that African American artists could and should capitalize on the critical and commercial success European modernists (such as Picasso and Matisse) had achieved after incorporating African

Fig. 14 Meta Warrick Fuller, *Ethiopia Awakening*, 1921. Bronze, 67 × 16 × 29 in. Art & Artifacts Division, Schomburg Center for Research in Black Culture, New York Public Library.

art into their practice. Locke held that African American artists, such as Jones, should participate in a modernist primitivism.[76] African Americans, however, did not possess an innate awareness of African visual traditions, and like their white European counterparts, they sought out access to largely decontextualized African art objects.

While Jones was starting at the SMFA, the foundation for the New Negro movement was being laid in New York. On March 21, 1924, *Opportunity* editor Charles Johnson hosted a dinner at the Civic Club on Twelfth Street in New York to celebrate the publication of *There Is No Confusion* by Jessie Redmon Fauset as a type of "coming out" party for African American writers. The dinner party turned into one of the decade's most important literary and cultural events, with a "who's who" of black intelligentsia and prominent white patrons in attendance. Paul Kellogg, editor of the sociologically oriented journal *The Survey* and its monthly supplement, *Survey Graphic*, approached Locke about guest-editing a special issue of *Survey Graphic* because he felt that the scholarly, literary, and cultural work presented during the dinner deserved a wider audience.[77]

The resultant special issue of *Survey Graphic*, "Harlem, Mecca of the New Negro," was published in March of 1925. With three essay-filled sections on "The Greatest Negro Community in the World," "The Negro Expresses Himself," and "Black and White—Studies in Race Contexts," the volume tackled a wide range of topics. The pages of the *Survey Graphic* special issue contained a compelling intersection of the sociological and the artistic—poetic, photographic, visual, and literary—that would characterize the era now known as the Harlem Renaissance.[78] Tellingly,

Countee Cullen's poem "Heritage," with its query "What is Africa to me?" highlighted in poetic form the imaginary nature of Africa while serving as the capstone to four pieces on Negro art.[79]

A few months later in November 1925, Locke published his now-foundational anthology, *The New Negro: An Interpretation*. The anthology became a manifesto of sorts for the New Negro movement, or Harlem Renaissance.[80] Locke defined his "New Negro" in opposition to the trope of the "Old Negro," who was uncultured and uncouth, embodied by the "uncles, mammies, and chillun' [who] dressed, talked, behaved, and thought in ways that lacked the kind of sophistication and refinement generally attributed to Anglo America."[81] In comparison, the "New Negro" was urban, sophisticated, smooth, and sleek. Locke's foundational essay on the "New Negro" was followed by a series of treatises on "Negro" art and culture.[82] In his "Legacy of the Ancestral Arts," Locke called upon African American artists to explore their African heritage in pursuit of a truly African American artistic tradition. In the essay, Locke acknowledged the trauma transatlantic slavery had on African Americans, which resulted in the severing of visual, cultural memory. He also continued to highlight the success of the European modernists' appropriations of African art as one of the main reasons why African American artists should also look at African art. He even went so far as to suggest that without European artists' successful use of African motifs, African art might not appeal to African American artists.[83] For Locke African art was a vehicle for modernist expression, not just a legacy or birthright. However, Locke was forced to acknowledge that the African American audience was not readily

familiar with African aesthetics and that African art was just as foreign to African Americans as it was to white Europeans.

It is unclear if Jones read the first version of Locke's essay in the March special issue of *Survey Graphic* or discovered it a few months later in *The New Negro: An Interpretation*. In later interviews, she claimed that she heard Locke speak in Boston.[84] The most compelling evidence of Jones's awareness of Locke and his publications can be found in one of her SMFA notebooks from 1925 to 1926, which bears an inscription from an acquaintance, J. Edmond Moses of Liberia, Africa. Moses wrote a poem about Jones, noting at its end, "Who said Countee Cullen could write poetry? Shux!"[85] The sketchbook inscription signals Jones's consciousness of the ideas of Africa being promoted by the literati of the Harlem Renaissance as well as her personal engagement with African peoples living in Boston, all of which suggests that her understanding of and exposure to Africa may have taken several different forms. Moreover, the notebook is one of a few early examples in which Jones's worlds collided—her academic training at the SMFA, where she was the lone student of color in her cohort, and her life outside school as a black woman born and raised in Boston.

Locke's writings on Africa and African art offered malleable young artists like Jones a new approach to their practice. In "Legacy of the Ancestral Arts," Locke stated his hope: "From a closer knowledge and proper appreciation for African art must come increased efforts to develop our artistic talents in the discontinued and lagging channels of sculpture, painting, and the decorative arts."[86] Locke argued that African American artists, like the European modernists before them,

should turn to and capitalize on African art not only as a project of cultural heritage reclamation but also for artistic inspiration in their efforts to produce a distinct "Negro" artistic tradition. Locke's Negro aesthetic was predicated upon the continued positive representation of the black subject in authentic situations rather than the ubiquitous stereotypical portrayals that perpetuated prejudice. Locke's call for "closer knowledge" begs the question—how did Jones and her fellow African Americans actually see and access African art up close?

In May 1929, the mainstream magazine *Vanity Fair* published a black-and-white cartoon by Mexican caricaturist Miguel Covarrubias (1904–1957) (fig. 15). The illustration showed a well-dressed black couple looking at an African female figurine displayed on a labeled plinth.[87] The cartoon raises critical questions related to American and specifically African American knowledge of African art in the first decades of the twentieth century. It captures the evolving perceptions of African art during the 1920s and 1930s that transformed African objects from ethnographic curiosities to foundational pieces of African American cultural heritage and modernism. "To Hold, as t'were the Mirror Up to Nature" appears in large type at the bottom of the illustration. The caption beneath the couple's feet reads: "GENTLEMAN, for the first time viewing a work of African sculpture: 'What sort of a woman is that?'" The cartoon captures a point of contact, the moment when a young black man and his black female companion first encounter African art. The man's quizzical response, wide eyes, and open mouth signal his unfamiliarity with the African object. While his female companion is

GENTLEMAN, for the first time viewing a work of African
sculpture: "What sort of a woman is that?"

"To Hold, as t'Were the Mirror Up to Nature"

Fig. 15 Miguel Covarrubias, *To Hold as t'Were the Mirror Up to Nature*. In *Vanity Fair* 32, no. 3 (May 1929): 64. Courtesy Miguel Covarrubias Estate / Maria Elena Rico Covarrubias.

silent, her physical features suggest a biological connection to the figurine. Her pronounced forehead augmented by her cloche cap, along with her elongated lips and her angular chin, resemble the carved features of the African female statue that stands in front of her.

The large-font quotation along the bottom comes from Shakespeare's *Hamlet*, when Hamlet urges his actors to perform authentically as if they are "holding a mirror up to nature."[88] The caption's mirror metaphor is rife with possibilities for interpretation. For Hamlet, the theatrical stage is where audience members see the reflection of their morals. The stage is a mirror to real life. In the Covarrubias illustration, the museum gallery becomes Hamlet's stage, and the African American couple and the African sculpture are the actors. Following Shakespeare, the shock of the couple reflects the reality that, at the end of the 1920s, African Americans were unfamiliar with and unsure of how to interpret African art, despite any perceived biological connection between the two cultural groups. Conversely, one can interpret the quote literally and read the African figurine as a mirrored reflection of the African American woman and, by extension, the larger African American community of which she is part. In this reading, African art becomes an extension of the black body, be that body African, Afrodiasporic, or African American.

Closer examination of the image reveals that the African figurine is not completely inanimate— Covarrubias accented its eye socket with white and punctuated it with a pupil. With its "eyes," the statuette's pose takes on new meaning. Its jutting chin, intense gaze, hands-on-hips pose, and squared shoulders seem to respond to its African American viewers, "What do you think you are looking at?" Thus two sets of black bodies—separated by geographic, temporal, material, and cultural boundaries—engage in an act of mutual gazing in which both seem unsure of what to make of the other.

Exhibition spaces, such as the one depicted in the Covarrubias image, function as contact zones. Contact zones are a "space of colonial encounters, the space in which peoples geographically and historically come into contact with each other and establish ongoing relations."[89] In the *Vanity Fair* cartoon, the contact zone is the physical, psychic, or printed space in which African Americans are put into direct contact with cultural objects produced by others of African descent. Though frequently theorized in terms of European expansion, the contact zone can also be "extended to include cultural relations within the same state, region, or city . . . [where the] distances at issue are more social than geographic."[90] Jones's childhood and young adulthood saw her navigate several different contact zones—black Boston, Martha's Vineyard, and the storied classrooms of the SMFA.

Although much attention has been paid to African American artistic production from the 1920s and 1930s, few efforts have been made to document or trace where the African American population, and particularly the African American visual artists associated with the Harlem Renaissance, made contact with African art.[91] In other words, how did artists like Jones come to see African art as the root of an African American aesthetic tradition?

The first contact zone for African Americans and African art occurred at a Southern university, during the nineteenth century. Founded in 1868 in Hampton, Virginia, Hampton University is one of the oldest historically black colleges and universities in the United States.[92] General Samuel Chapman Armstrong, the school's founder, established the school's museum in its inaugural year. Armstrong seeded the museum collection with objects sent to him from Hawai'i by his mother and quickly expanded it to areas beyond the Pacific.[93] In 1873 the school started an African Studies program and added a few African cultural objects to the museum collection.[94] Although these African objects were first housed in a "Curiosity Room" rather than an art gallery, the museum's collection of non-Western objects formed a critical piece of Hampton's pedagogy. In 1911, the school's African collection was substantially increased by the acquisition of the William H. Sheppard collection, which included approximately five hundred objects. Sheppard, a Hampton alumnus, collected the pieces between 1890 and 1910, when he was a missionary in the Kuba kingdom (now part of the Democratic Republic of the Congo). The Sheppard acquisitions were the first documented collection of African objects organized by an African American.[95] It was only in 1914, three years after Hampton's purchase of the Sheppard collection, that African objects were first put on view as art, rather than ethnographic objects, in New York City.

In November 1914, art dealer and photographer Alfred Stieglitz (1864–1946) mounted the exhibit *Statuary in Wood by African Savages—The Root of Modern Art* with the help of the Mexican artist and writer Marius de Zayas (1880–1961).[96] While the African creators were pejoratively referred to as "savages," the exhibit's subtitle conveyed that African art was the root system from which modern art had sprouted. Although the American Museum of Natural History in Manhattan displayed African art in its African ethnology hall, the Stieglitz show was held at 291,

his downtown gallery on Fifth Avenue, making this show the first exhibit of African objects in a designated art space in the United States.[97] Art historians have placed additional significance on this show because it was mounted at a time when American art museums were not actively collecting African art.[98] There is no record of African American visitors to the 291 show, and its primary audience was most likely members of the Stieglitz circle.

At the end of the 1910s, African art began to be exhibited in spaces frequented by African American audiences. In the summer of 1918, de Zayas's Modern Gallery lent a selection of African sculpture to the newly opened Carleton Avenue branch of the YMCA in Brooklyn. In 1921 and 1922, there were also reports that African art was included in "Negro Art" exhibits held at the 135th Street branch of the New York Public Library.[99] In the spring of 1923, New Yorkers could see African art at the Brooklyn Museum of Art exhibition *Primitive Negro Art Chiefly from the Belgian Congo*, which comprised approximately 1,450 objects. This exhibition is significant because it represented the physical movement of African art from the purview of the white avant-garde and spaces like 291 to a publicly accessible, government-funded art museum that catered to a wide range of audiences.

Although it is impossible to estimate the number of African American visitors to the Brooklyn Museum show, African Americans were aware of the exhibition. In a short piece titled "Brooklyn Jottings," the *Chicago Defender* reported that the daughter of an unidentified African chieftain had visited the show. The daughter commented that the exhibition "proved of more

than unusual interest" and that a number of visitors were coming to the Brooklyn Museum "solely to see the exhibition."[100] Further evidence of African American knowledge of the show is a more formal review of the exhibition, written by NAACP Press Secretary Herbert J. Seligmann (1891–1984), which was published in the *Amsterdam News* and mentioned in both the *New York Times* and the *Chicago Defender*.[101] The following year prominent Philadelphia chemist and art collector Albert C. Barnes (1872–1951) opened the Barnes Foundation outside of Philadelphia to display his collection of modern European and traditional African art. The Barnes Foundation was the first permanent display of African art on American soil.[102] While these exhibits exposed American audiences to the visual vocabulary of African art, they reified the absorption of form rather than the understanding of cultural context.

Though Jones was living in Boston, she would have heard dispatches from New York. Her childhood friend Dorothy West had moved to Harlem in 1926, where she took up residence in the YWCA. Their summer playdates had evolved to incorporate their literary and artistic ambitions. Both women were inaugural members of the Saturday Evening Quill Club, a literary organization founded by *Boston Post* editor Eugene Gordon. The organization published its members' work in three limited-run annuals in 1928, 1929, and 1930. Jones contributed a number of illustrations to these volumes, foreshadowing her later work as an illustrator for Carter G. Woodson in the late 1930s (discussed in chapter 2) (fig. 16). Though led by the male editor, the Quill Club's membership included a number of "progressive, artistic women," who provided invaluable support to

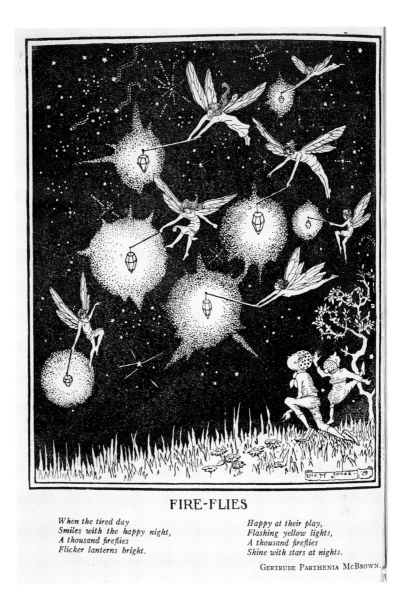

Jones and West as they navigated the waters of young adulthood and art making.[103] Jones, West, and West's cousin Helene Johnson were the youngest members of the group. It was through the Quill Club that Jones met poet Gertrude Parthenia McBrown (1909–1989), with whom she remained extremely close both personally and professionally throughout the 1930s. Jones illustrated several of McBrown's poems for the *Saturday Evening Quill* and in 1935 collaborated with McBrown on the latter's *The Picture-Poetry Book*. Other members included Gordon's wife, Edythe, who wrote poetry, poet Alice Chapman Furlong, teacher turned playwright Alvira

Hazzard, teacher and club secretary Grace Vera Postles, renowned Boston socialite Florida Ruffin Ridley, and Gertrude "Toki" Schalk, editor of the literary magazine *Sunburst*.[104] The Quill Club, like its fellow urban literary salons, "provided crucial opportunities for the kind of social and artistic exchange that nourished creative production."[105]

Shortly after the group first convened, West and Johnson left Boston for New York, where they eventually sublet anthropologist and author Zora Neale Hurston's flat on West Sixty-Sixth Street. Hurston immediately took the pair under her wing and introduced them to her growing coterie of important African American artists, musicians, and writers.[106] As Johnson and West mingled with the literati of the New Negro movement, the pair forged a connection between the Boston-based Quill Club members and the cultural scene in New York. The interactions with Quill Club members would aid Jones as she made critical decisions regarding her future.

Career Designs

As the New Negro movement gained traction in New York, Jones was in Boston making career plans. In addition to her drawing and painting classes, Jones pursued design coursework. During the 1926–27 academic year, she supplemented her coursework at the SMFA with evening classes at the Boston Normal Art School (now the Massachusetts College of Art) in the hopes of pursuing a career as a textile designer, a field in which she attained a certain level of success. In 1926 one of her designs produced for an SMFA competition was purchased by the Nashua Manufacturing Company.[107] That same year Jones also won a

contest for original design in rayon sponsored by Shepherd Stores and the Rayon Institute of America. These accolades, which conferred success and with it a respectability that would have resonated with Jones's family and community, no doubt helped cement her initial decision to become a designer rather than a painter. Upon her 1927 graduation from the SMFA, Jones won a scholarship to the Designers Art School of Boston, where she trained under European designer Ludwig Frank. She achieved some measure of success— her designs were purchased and manufactured by the likes of the F. A. Foster and Schumacher Company. The summer of 1927 saw Jones's textile designs put on display in New York City at the La Bohème Tea Room on West Thirtieth Street.[108]

While Locke advocated an African American turn to African art beginning in the mid-1920s, Jones did not begin to incorporate African visual imagery into her own praxis until the late 1920s and early 1930s. Several of Jones's textiles from the period include African and other non-Western motifs, suggesting that she was interested in exploring what these cultures offered from a design perspective. In an untitled textile design from about 1932, Jones includes a clear reference to an African source (fig. 17). The overall patterning of the textile bears an affinity to cloth produced by Kuba peoples. Hidden among the antelopes, palm fronds, and geometric patterning is an African Ci Wara crest. The Bamana peoples of Mali produce Ci Wara masks for rituals and performances related to agriculture. When used in Bamana masquerades, a dancer shrouded in raffia affixes the Ci Wara mask to a basket worn atop the head. Western viewers at the time appreciated African art for

Fig. 17 Loïs Mailou Jones, textile design, ca. 1928. Tempera on paper board, 25 ½ × 17 ⅞ in. (64.8 × 45.5 cm). Museum of Fine Arts, Houston. Museum purchase funded by the African American Art Advisory Association, 98.224. Courtesy Loïs Mailou Jones Pierre-Noël Trust.

its formal rather than cultural significance, and Jones followed Western convention by including only the wooden elements of the Ci Wara mask.[109] The encounters Jones and her fellow artists had with African objects in Western spaces—galleries, museums, etc.—were predicated upon such decontextualization.

In this textile, African art is in both the foreground (the Ci Wara mask) and background (in the form of the abstracted Kuba cloth design). Jones's textile designs of this type supply strong evidence that she had access to Locke's *New Negro* anthology and other African art texts. It is highly likely that she saw photographs of Kuba cloth

Fig. 18 Loïs Mailou Jones, *Totem Poles*, ca. 1928. Tempera, 17 × 17 in. Courtesy Loïs Mailou Jones Pierre-Noël Trust.

and Ci Wara masks in books rather than original objects in Boston art museums. While Jones could have seen Egyptian art objects, the Kuba cloth in the MFA's collection was not on display.[110] Jones would have had to actively search out the objects in person and in print in order to study them.

Earlier examples of Jones's textile designs include other forms of indigenous imagery. Her colorful 1928 textile design *Totem Poles* directly references Pacific Northwest American Indian cultures with its elaborately carved pink, yellow, and red totem poles (fig. 18). Another cretonne design from about 1928 reads more like a landscape than a textile with its depiction of a lush, brightly colored tropical seaside location (fig. 19). Loud, pink palm tree fronds and oversize orange

lilies frame the top, left, and bottom edges of the composition. In the center, a carpet of chartreuse grass lies under more pink palm trees while in the background the ocean appears with blue palm trees silhouetted against a yellow sky.[111] Jones's far-reaching interests in non-Western art continued as her career progressed. Her exposure to and artistic experimentation with such varied non-Western art forms during art school and her early career laid the foundation for her later exploration of Afrodiasporic artistic traditions in Europe, Haiti, and on the African continent itself.

At a time when African American painters and sculptors faced ongoing discrimination in the art world, Jones believed textile design to be a color-blind industry in which an African

Fig. 19 Loïs Mailou Jones, untitled design for cretonne drapery fabric (palm trees: oranges, yellows, green), ca. 1928. Tempera on paper, 24 ½ × 19 in. Courtesy Loïs Mailou Jones Pierre-Noël Trust.

American designer could succeed. Jones joined a number of American and European women who, as the twentieth century progressed, chose careers in a field of design (ceramics, fashion, furniture, textile, etc.). In Europe, a number of avant-garde women artists, among them Sonia Delaunay, took up design in the early decades of the twentieth century.[112] It was commonplace for women designers to have their designs produced without being credited by name. This practice did not hold for male designers such as the Frenchman Paul Poiret, whose work was on view in New York and Boston during the 1920s.

For African American designers, the anonymity associated with textile design, in which no name other than the brand is associated with the design, proved to be a double bind. On one hand, anonymity prevented discrimination

against the designers, who could not be singled out due to their race. On the other hand, the lack of authorship attributed to textile designs makes the contributions of African American designers difficult to determine.[113] Jones took her portfolio to New York and visited the studios of the F. A. Foster Company, where she found one of her textile designs, *Ganges*, on a set of furniture in the showroom. When she realized that her name was in no way associated with the pattern, she was disheartened; this experience forced Jones to realize that she "would have to think seriously about changing [her] profession if she were to be known by name."[114]

Summer 1928: New York / Boston

After completing her graduate work at the Designers Art School in the spring of 1928, Jones split her summer between Boston and New York City. Over the course of three short months, the budding painter honed her social skills as she navigated a diverse range of cultural spheres, moving between the society bridge set, the New Negro Harlemites, and the erudite scholars at Harvard, where she enrolled in the summer session. The society pages of several black newspapers record her attendance at various bridge parties and events for notables of the Harlem Renaissance, Aaron Douglas and Claude McKay.[115]

Her time in New York was so successful that Jones considered moving there to explore artistic opportunities. She hoped to "have a studio and free-lance and/or work in a [design] studio."[116] The triumphs of her childhood pal West—who was working as both a writer and an actress and was fresh off a stint in the popular Broadway smash

Porgy and Bess—fueled Jones's desire. During her summer in New York, Jones developed a taste for some of that same success. At the end of June, an exhibition of her art was held at the popular Hobby Horse bookstore located at 205 West 135th Street in Harlem. The bookstore's Sunday evening literary events, at which poets and writers such as Langston Hughes and Zora Neale Hurston shared their work with the public, had a large and loyal following. Jones's show was said to have drawn more than two hundred visitors.[117]

The summer ended with the publication of Jones's watercolor on the cover of the August issue of *Opportunity* (fig. 20). The watercolor depicts three African figures from various angles, set against a background filled with palm fronds. The center of the composition is dominated by a woman whose wavy, stylized hair is cut off at the eyebrow. Her angular face, with schematic eyes, high cheekbones, and dramatically arched eyebrows, is reminiscent of formal elements associated with several types of African masks and figurative sculpture. Elaborate earrings dangle from her ears, drawing the viewer's eye downward to a light-colored necklace. While the figure's facial features are clearly feminine, her torso is decidedly more androgynous with clearly outlined pectoral muscles. She sports bulky shoulder pads and a circular chest plate. A second figure, to the right, is shown in profile with a bald head, slitted eyes, and arched eyebrows. A third figure, to the left, enters the composition with four metal rings encircling her neck. Elongation

Fig. 20 Loïs Mailou Jones, cover of *Opportunity*, August 1928. Courtesy Loïs Mailou Jones Pierre-Noël Trust.

PPORTUNITY
JOURNAL of NEGRO LIFE

August :·: Fifteen Cents a Copy :·: 1928

was a hallmark of figural modernism in the 1920s, and so Jones's stretching and distortion of the figures in the *Opportunity* watercolor demonstrate that she was conversant in current Euro-American modernist trends. In addition to the masklike faces of the three figures, Jones's rendering of their skin with a highly glossy or shiny appearance was similar to the patina of ebonized African figurines. With this watercolor, Jones blurs the lines between human being and inanimate object, the "primitive" and the modern. The watercolor provides further evidence of her early interest in African subjects and her cognizance of Locke's prescriptions for African American aesthetics.

Jones's August 1928 *Opportunity* cover provided her entry into the cultural sphere of the Harlem Renaissance. For Jones, then the young age of twenty-three, having her work on the cover of a major periodical was a huge coup. The visibility such a cover afforded Jones cannot be underestimated: in 1928, the journal was at the height of its popularity, with a circulation of around eleven thousand.[118] Jones's submission of her work to *Opportunity* indicates her awareness of the publication, its contents, and its readership. A publication of the Negro Urban League, *Opportunity* was one of two Harlem Renaissance–era journals that covered issues related to black culture (the other was the *Crisis*, sponsored by the NAACP). With its literary and cultural focus and wide readership, *Opportunity* was a prime venue for African American writers, poets, and visual artists to showcase their work. Though based in New York, *Opportunity* editors and contributors kept tabs on what was happening in Boston's literary circles. The activities of the aforementioned

Quill Club were often recounted in the pages of *Opportunity*, and several of its members published pieces in the journal. Jones would have certainly celebrated with friend Dorothy West, who in 1926 tied with Zora Neale Hurston for second place in one of the magazine's writing contests.[119]

Jones's travel to and from New York City during the Harlem Renaissance of the late 1920s was surprising in light of how American society frowned upon and frequently restricted female travel during this period. Her presence in New York also raises questions about other African American women artists and cultural producers who may have contributed to the movement despite not having permanent residence in New York. While these women may have lacked Harlem addresses, they nonetheless participated in the various cultural activities of the era.[120]

Given her success and visibility in New York, it is not surprising that Jones considered moving to the city. While in New York, however, she had the fortune to meet William Leo Hansberry, then a professor at Howard University. Over the course of their conversation, Hansberry encouraged Jones to apply to the institution.[121] The vacant position in the department of art to which Jones applied ultimately went to recent Howard graduate James A. Porter (1905–1970).

Having seemingly abandoned a career in textile design, Jones turned her attention to finding a teaching position. She attempted to secure employment at her alma mater, the SMFA. The program director, her former professor Henry Hunt Clark, informed Jones that no positions were available. Jones later recalled that Clark suggested she consider "going south to help [her] people."[122] She continued her recollection to art

historian Tritobia Benjamin, "Well, that was a rather shocking response because in Boston we didn't know too much about the South. We knew about Fisk and the singing groups, and a little bit about Tuskegee. We did not think too much of the schools in the South, so to think of sending me, after all my exposure in Boston, down south was a little bit embarrassing."[123] Jones's reaction to this encounter, which strongly suggested institutional racism, also hints at the artist's own preconceived notions about the Southern black population and belied a snobbery bred by her upper-middle-class New England roots.

Back in Boston, Jones heard the Southern educator Charlotte Hawkins Brown (1883–1961) speak at a lecture given for the Women's Service Club located at 464 Massachusetts Avenue in Boston's South End, across from the LCWS headquarters that Jones frequented throughout high school. At the event's conclusion, Brown issued a call to action: "We *need* you young people in the South. You must think to come down and help us."[124] Brown's call to the educated black Boston youth had appeal. With no immediate employment in Boston forthcoming, Jones approached Brown about a job. Though she was initially rebuffed, Jones's persistence won over Brown, and she soon found herself driving to Sedalia, North Carolina, to assume a teaching post at Brown's Palmer Memorial Institute (PMI). Jones's arrival in North Carolina marked her first foray south of the Mason-Dixon Line. As she later told interviewer Charles Rowell, "I recall buying a little car and making preparations for that voyage, which was going to be quite an experience for me."[125] Although ultimately limited to just two years, Jones's time down South opened the Boston-born artist's eyes to the range of the African American experience.

Southern Sojourn: From Sedalia, North Carolina, to Washington, D.C.

Jones's move south and involvement with the PMI and Brown placed her in the middle of two more important cultural milieus—the burgeoning black education movement and the rural African American South. Spearheaded by the likes of Charlotte Hawkins Brown, Mary McLeod Bethune (1875–1955), and Nannie Helen Burroughs (1861–1961), the black school movement believed education was the way to achieve racial equality.[126] With her arrival at PMI, Jones entered the orbit of these key black women educators who have been called the "female talented tenth."[127]

Brown established the PMI in 1902, naming the school after former Wellesley College president and education innovator Alice Freeman Palmer (1855–1902). Originally funded through the American Missionary Association (AMA), at its outset PMI offered an industrial education to black women similar to that promoted by Booker T. Washington's Tuskegee Institute in Alabama. While originally a rural vocational institution, the PMI became a leading black finishing school that attracted the daughters of the black elite.[128] Brown modeled her institute after storied New England prep schools such as Phillips Andover and Northfield Mount Hermon. When the AMA withdrew its support of PMI, Brown was able to retain control of the school by relying on the philanthropy of her Boston friends. Her speaking engagement at the aforementioned Women's Service Club in the late 1920s is perhaps

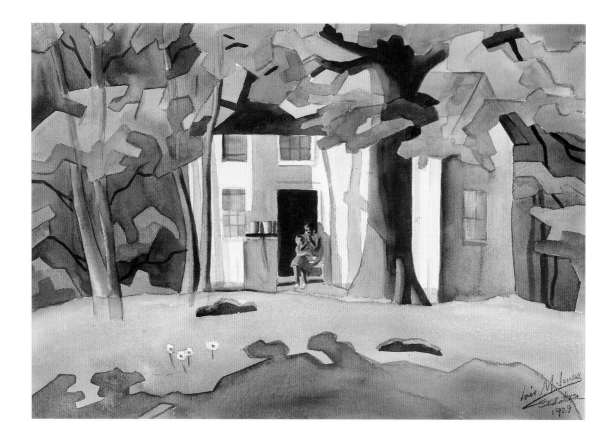

Fig. 21 Loïs Maïlou Jones, *Sedalia, North Carolina*, ca. 1929. Watercolor on paper, 13 ¾ × 19 ¾ in. Collection of the Mint Museum, Charlotte. Gift from Drs. Marilyn and Chris Chapman. Courtesy Loïs Maïlou Jones Pierre-Noël Trust.

an example of her fundraising efforts in the North.[129]

Jones arrived at PMI along with two other Boston-based black women—Gladys M. Herndon and Jones's Quill Club comrade Gertrude McBrown.[130] Working for Brown and living with her in the same on-campus house turned PMI into a postgraduate finishing school for Jones as well. Although Brown and Jones agreed that Jones would head the art department, there seem to

have been some surprises for Jones about how she would be spending her downtime outside of the classroom. She chafed at the restrictions Brown placed upon her—curtailing her extracurricular explorations of the region by garaging her car and enforcing strict adherence to behavioral codes.[131] Brown was a stickler for propriety and published the etiquette manual *The Correct Thing to Do—to Say—to Wear* in 1941. Brown's desire to keep Jones and her female colleagues on campus had gender and racial implications. As a proponent of female respectability, Brown advocated a notion of "correctness" regarding black women's behavior. But keeping her black staff members on campus also protected them from experiencing Jim Crow

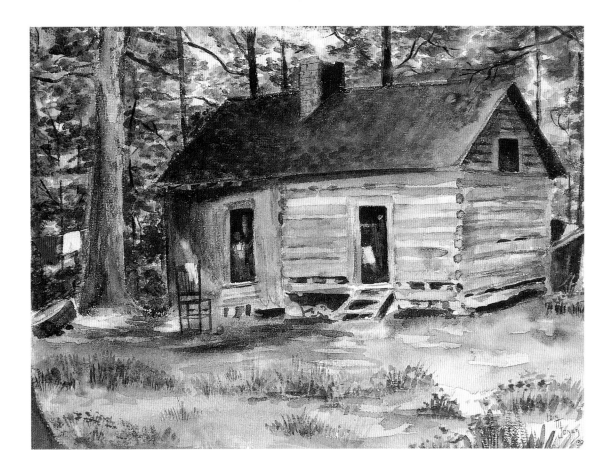

Fig. 22 Loïs Mailou Jones, *Negro Shack I, Sedalia, North Carolina*, 1930. Watercolor, 15 × 20 in. From Benjamin, *Life and Art of Loïs Mailou Jones*, 17. Courtesy Loïs Mailou Jones Pierre-Noël Trust. Photo: Marvin T. Jones.

aggression. The constraints kept Jones relatively isolated from her surroundings and significantly inhibited her ability to explore her new Southern environs. The fact that her dear friend McBrown was also living and teaching at PMI must have provided some solace.

While teaching art and coaching the school's fledgling basketball team kept Jones occupied (during high school Jones played both basketball and tennis), she did find time to paint the students and the new landscapes she was encountering. She also had unrestricted access to the PMI's impressive art collection, which included close to two thousand objects and was the largest available to black audiences in the region.[132] Two of Jones's watercolors from this period, the 1929 *Sedalia, North Carolina* (fig. 21) and *Negro Shack I, Sedalia, North Carolina* (fig. 22) from 1930, document her limited Southern tourism and reflect Jones's quasi-anthropological approach to her subject matter. Both watercolors deal with rural African

American family life via depictions of domestic architecture.

In *Sedalia, North Carolina*, Jones pictures a simple two-story white domicile. In its open doorway, a black woman wearing a green dress sits with a young child in blue on her lap. Leafy trees and a lush green lawn surround the house. Jones executed the foliage in shades of green, creating an almost geometric interlocking pattern reminiscent of her earlier textile designs. In the later *Negro Shack*, the viewer also looks across a yard, here predominantly dirt with patches of grass, past an empty wooden chair, and toward a single-room log cabin with two open doors. Smoke billows from the chimney, and clothing hangs on a line, indicating a human presence. A young boy in denim overalls stands in the left-hand door, looking out into the yard and, beyond the canvas, at the artist and the viewer. In contrast to her earlier *Sedalia, North Carolina*, in *Negro Shack I* Jones hones in on the residence's relationship to the surrounding landscape while the human figure play second fiddle. Jones's title for the work, *Negro Shack I*, suggests that there may have been other residences she painted as well.

The pair of paintings illustrate the arm's-length distance at which Jones held her temporary home and surroundings in the South.[133] Her visual interest is almost journalistic, down to the careful detailing of the buildings' constructions. Perhaps unwittingly, Jones's two watercolors illustrate the changes taking place within African American domestic architecture. Following Emancipation and into the twentieth-century, domestic architecture functioned as a vehicle for social and class assimilation. African Americans began to shun calling their homes "cabins" and began to build framed cottages and bungalows.[134] Jones's choice to use the derogatory term *shack* in her title is surprising given her later use of *cabin*.

Although Jones's works pictured the exteriors of the residences, she eventually made her way inside. Jones would later tell journalist Sherry L. Howard, "I had never seen Negro cabins. . . . The interior of their houses, all the walls were covered with the funny sheets [Sunday comics] for wallpaper. That was very curious to me. How could they live with all these colored funny sheets bordering the wall? They didn't have wallpaper and they didn't have money and they liked color."[135] Jones's designation of the newspaper-cum-wallpaper as "curious" bears unpacking. Such makeshift wallpaper was anathema to the upper-middle-class aesthetic with which Jones was familiar, cultivated in the urban apartments of Boston and in the luxurious Martha's Vineyard estates she visited growing up. Her subsequent query as to "how could they live" with such an unconventional wallcovering could strike the reader as callous and perhaps naïve, as it indicates her unfamiliarity with the strictures of Southern African American rural life.

Jones did not have familial roots in the South through which she could have been exposed to the African American cultural traditions of the region. In North Carolina, she found herself in foreign territory. It is perhaps unsurprising that the few extant examples of Jones's picturesque paintings of rural African Americans demonstrate how she depicted these individuals as timeless, static, and outside the progression of history. The watercolors possess the same level of detail and distance found in her earlier museum

studies of the MFA's collection. Jones's Southern sojourn and her employment at the PMI fulfilled a professional need and became a key stepping stone in her career.

Although ensconced in the rural South, Jones continued to remain active in the art scene of the North. In 1929, she submitted a painting titled *Ande* (current location unknown) to the annual Harmon Foundation awards. Nurseryman-turned-land-developer William Elmer Harmon founded the Harmon Foundation in 1922 to support the poor and disabled. Under the directorship of Mary Beattie Brady, the foundation becamebest known for its support of African American art and culture. In 1926 the foundation began giving out cash awards to black individuals in the fields of visual arts, literature, and music, as well as education, science, race relations, and industry. Because Harmon was not known to be a collector or a connoisseur of African American art, the awards were judged by a jury of five "experts," one of whom was black. The awards' popularity led to the creation of a traveling exhibition of the winning works. By 1931 these exhibitions were touring the country, exposing the American public to contemporary African American artistic production. For the 1929 cycle, Jones's fellow Massachusetts artist and sometime mentor Meta Warrick Fuller served on the selection committee. Jones's piece toured with the 1930 exhibition, where it was shown alongside James Porter's *Sarah* (1930, location unknown), Hale Woodruff's *Banjo Player* (1929, Virginia Museum of Fine Arts), William H. Johnson's *Self Portrait* (1929, Smithsonian American Art Museum), Elizabeth Prophet's *Head of a Negro* (ca. 1927, Rhode Island School of Design), and

Augusta Savage's *Gamin* (ca. 1929, Smithsonian American Art Museum).[136]

The following year, Jones submitted her 1929 charcoal drawing *Negro Youth* (see fig. 23) to the Harmon Foundation. *Negro Youth* pictures a young black boy—ostensibly a student at PMI—shown in profile, devoid of any contextual background. The young pupil sports a white shirt with a crisp collar and a rib-knit sweater. The stripes of a school tie are visible at his neck. The boy's face is one of solemn concentration with almost a hint of nervousness, perhaps the anxiety of being asked to sit still. Positioning the sitter in profile allowed Jones to deftly articulate the shadows across his face from the light source to the left, showcasing her talent as a draftsman. For her efforts, Jones was rewarded with an honorable mention at the 1930 awards. Receiving an honorable mention from the Harmon Foundation was a significant achievement and would have brought Jones to the attention of those interested in African American art across the country.

Jones knew how to take advantage of opportunities when they presented themselves. In the spring of 1929, Howard University professor James V. Herring visited PMI and was so impressed with Jones that he agreed to help her get out of her two-year contract so that she could join the faculty at Howard. She arrived on Howard's campus in the fall of 1930 at the age of twenty-five.[137] Jones's employment both at the PMI and Howard shielded her from the devastating aftermath of the 1929 stock market crash and ensuing Great Depression. While many of her New York–based contemporaries found solace and community in projects sponsored by the

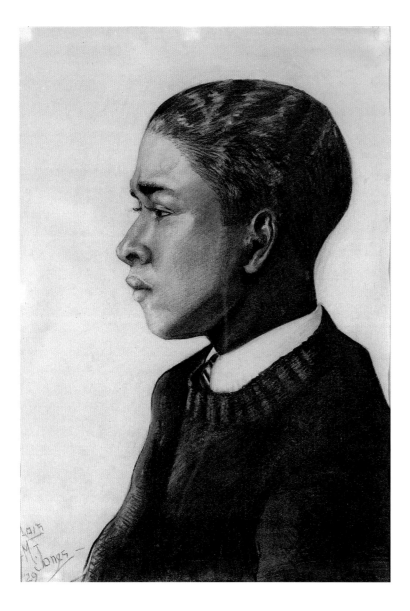

Fig. 23 Loïs Mailou Jones, *Negro Youth*, 1929. Charcoal on paper, 29 × 22 in. Smithsonian American Art Museum, Washington, D.C., 2006.24.11. Bequest of the artist. Courtesy Loïs Mailou Jones Pierre-Noël Trust.

Works Progress Administration in the mid-1930s, Jones would spend the decade in the classroom at Howard, molding a future generation of African American artists.

The experiences and encounters Jones had during the first quarter century of her life were crucial in laying the groundwork for her future artistic career. Jones grew up in a middle to upper-middle-class family in which she developed an ability to engage with people both above and below from her position in the class hierarchy, albeit with some judgment. From a young age, she learned how to navigate different sets of societal expectations, different artistic traditions,

and different cultural spheres. She also began to develop a visual vocabulary imbued with African aesthetics and to picture different facets of the black experience, which she would later use in her formulation of a diasporic grammar and blackness-in-triplicate motif. Her consistent positioning of herself in various "middles" gave her the ability to successfully negotiate the different traditions (aesthetic, cultural, and social) that would come to characterize her career as a whole.

In March 1930, PMI director Brown began soliciting leads for Jones's replacement. She wrote, "I have known Lois [sic] practically all her life, but you cannot keep a genius tied down to this sort of thing. The monotony of it galls their creative spirit. By monotony I mean going over the minute details in classroom work day after day, marking papers, etc."[138] Little did Brown know that Jones's two years at the PMI were an important episode that jumpstarted her illustrious career as an art instructor. While the African American South did not spark Jones's artistic innovation, it did set her on a journey to other places in the African diaspora where she continued to express her medial position and develop her art.

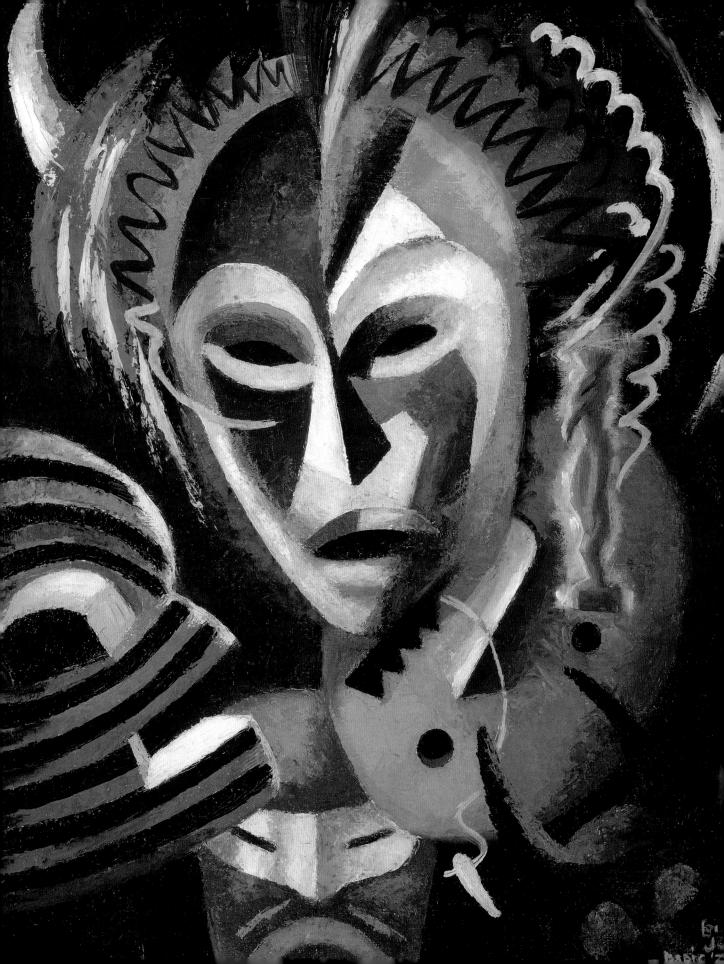

Routes to Roots

From Black Washington to Black Paris

2

When Jones arrived on Howard University's campus in the fall of 1930, she had a spring in her step (fig. 24). As a new instructor in the growing department of art of the historically black college and university (HBCU), her faculty appointment gave her entrée into the school and Washington, D.C.'s vibrant black intellectual and cultural scene. Then only twenty-five years old, Jones could not have anticipated that she would spend most of her next forty-seven years in the classroom. During her first twenty years at Howard, Jones's career

and her artistic practice underwent a series of transformations. She fought for a place at the table both at Howard, where sexism prevented regular promotions, and in the larger Washington art world, where the doubly binding tethers of racism and sexism barred Jones from full participation and recognition. While her academic year was filled with teaching design and watercolor classes, Jones spent summers in New York City, taking classes at Columbia University's Teachers College, and on Martha's Vineyard, where her

Fig. 24 Loïs Maïlou Jones at Howard University, ca. 1930. Courtesy Moorland-Spingarn Research Center, Manuscript Division, Howard University, Washington, D.C.

social and professional networks continued to expand. In 1937 Jones received a General Education Board fellowship, which enabled her to take a sabbatical year in Paris. Jones's year abroad proved to be pivotal to her artistic development as a painter as well as to her understanding of the black world in contexts outside the United States.

This chapter follows Jones's art and career choices from her 1930 arrival on Howard's campus, through her 1937 Parisian sabbatical, and on to her experiences back in the United States during the 1940s. During this phase of her life, Jones navigated the differing forms of racism and sexism she encountered in the art worlds at home and abroad. Undeterred, Jones painted on and produced canvases that probed the content and contours of the black experience on American and European soil. Several of these paintings utilize a blackness-in-triplicate motif in which Jones pictures three facets of black identity.

Making Her Mark: The Early Years in Washington, D.C.

The start of Jones's employment at Howard coincided with the rise of the art department. As artist and Howard University graduate David C. Driskell notes, "The place to examine African American art theories in the 1930s [was] the Department of Art at Howard University, not the ivory towers of the Ivy League schools of the East."[1] Jones's appointment at Howard, a school hailed as the "capstone of Negro education," opened the door to an influential black intellectual scene and placed the young artist-teacher at its center.[2]

Founded in 1921 by James V. Herring, the department of art at Howard University was the first standalone art department at an HBCU and one of the first to train African American artists at a college level. Herring, who studied at Harvard and Syracuse, joined the faculty in 1918. While teaching in the department of architecture, he offered studio classes in drawing (including drawing from life), perspective, and watercolor.[3] Initially given a single room in the school of architecture and engineering, Herring would make the department of art into a bustling center of artistic and scholarly production. In 1924, the abstract color field artist Alma Thomas became the department's first graduate. Herring found Thomas pursuing a degree in costume design and persuaded her to switch majors. Herring saw

his department as more than an academic unit that provided training for future art teachers; he instead envisioned a hub of art and cultural production capable of making waves beyond Howard's campus. In 1932 Ruby Kendrick, writing for the *Crisis*, elucidated Herring's grander vision when she wrote: "Cut-and-dried, humdrum pedanticism is forgotten when he teaches art, and from his own ideals and experiences the spark of enthusiasm is passed onto his students: the waves of idealism spread when he envisages the possibility of the diffusion of culture generally and of art especially from the center at Howard University."[4]

Herring's department of art was unique on both local and national levels. Although the black population in Washington, D.C., doubled between 1930 and 1950, the city remained segregated, which limited the access that budding African American artists had to both training and art objects. The Corcoran Gallery, founded in 1890, ran the only fine arts school in Washington until the 1930s; but while African Americans were allowed in its gallery spaces, they were barred from its art classrooms.[5] The Phillips Collection had a free painting school in the early 1930s that was forced to close during the Great Depression. Records are unclear as to whether any black students were enrolled.[6] In contrast to dedicated art schools such as the Pennsylvania Academy of the Fine Arts in Philadelphia or the SMFA in Boston, where several prominent African American artists trained at the turn of the century, the department of art at Howard was situated within a larger institution of higher education.[7] Herring himself rose quickly within the ranks of the art world. In 1924, he joined the College Art Association, and by 1931 he was a member of its

governing board. In 1930 the New York–based Harmon Foundation selected him to serve on the jury of its influential Harmon Foundation awards in fine art.[8] By establishing himself as a key figure in both mainstream and African American art worlds, Herring helped to carve out a niche for his fledgling department.

In its early years, the department's illustrious faculty included the first black female graduate of the Pennsylvania Academy of the Fine Arts, May Howard Jackson, and the renowned Harlem Renaissance artist and poet Gwendolyn Bennett.[9] In the late 1920s Herring assembled a core group of faculty members, a triumvirate of artist-teachers who would remain at Howard well into the 1960s. In 1929 James L. Wells, a graduate of Columbia University, and James A. Porter came on board. Porter studied with Herring while an undergraduate at Howard, and Herring recruited Wells after viewing his work in a Harmon Foundation annual exhibition. Jones had applied unsuccessfully for the 1928–29 vacancy that Porter ended up filling; but after Herring observed Jones teaching during his visit to the PMI in North Carolina, he offered her a position for the fall of 1930.

During the decade that followed, the department of art at Howard became a center for both the study and production of African American art—combining studio practice with art history courses taught by major figures in the African American art world. Its comprehensive studio art curriculum prepared students for a range of professional careers in the fields of art instruction, jewelry making, painting, printmaking, and textile and graphic design. Jones was responsible for the design curriculum, which included courses on color theory, textile design, lettering,

and commercial and poster design. In time Jones would also come to teach a variety of watercolor courses. Porter handled the drawing and painting classes, while Wells taught printmaking and crafts, including ceramics and clay modeling.[10] Along with Howard University philosophy professor Alain Locke, Porter became a pioneering historian of African American art.

The department's faculty spent considerable time in the classroom. Howard course catalogues indicate, for example, that Jones offered anywhere from six to eleven classes per year. In the absence of detailed lecture notes, discerning the specifics of their classroom pedagogies proves difficult. Interviews with former students, parsing of Jones's library, and review of her collection of student work disclose snippets of Jones's approach to teaching. For instance, a copy of Eliot O'Hara's 1935 *Making the Brush Behave: Fourteen Lessons in Watercolor Painting* appears in a stack of gradebooks and other unidentifiable titles Jones carried on campus (see fig. 24). O'Hara's book perhaps served as the primer for Jones's undergraduate watercolor classes. In her personal library she annotated a copy of Mexican painter Adolfo Best Maugard's influential *Method for Creative Design*, published by Knopf in 1926. The Best Maugard method encouraged exploration of indigenous art forms. For a period in the early 1920s, all Mexican schoolchildren read the text as part of the country's art curriculum.[11] Jones would have amended such readings with in-class demonstrations, museum visits, and reportedly tough student critiques. Importantly, all the art teachers at Howard did not stop creating their own work once they stepped into the classroom. Jones, Porter, and Wells would

number among the most significant artists of their generation.

After first vying for the same faculty appointment, once they were colleagues, Jones and Porter competed for students. Renowned sculptor and printmaker Elizabeth Catlett studied with both instructors before her 1935 graduation. She recounted that while Jones encouraged her to study design during her junior year, Porter convinced her to switch from design to painting.[12] Jones felt Porter regularly poached her promising pupils. Driskell, another former student of both teachers, noted that Jones took her students' decisions to study with other faculty quite personally.

The pay gap between Jones and her male colleagues undoubtedly exacerbated the perceived slight she felt when students elected to work with Porter and Wells. Though the three were hired within a few years of one another, Jones was consistently paid less than her male colleagues and had to fight for her promotions. She would later tell interviewer Theresa Danley, "At Howard, the women were really not paid the equal salaries of the men. . . . I think I must have been an instructor for some, maybe fourteen to eighteen years."[13] She approached Herring in 1950 and later Porter in 1959 and 1961 about promotions and raises; each time her appeals were rebuffed.[14] Meanwhile, Porter rose through the ranks quickly and, upon Herring's retirement in 1953, was named chair of the department. While Jones may have found herself on equal footing racially at Howard, her gender continued to hinder her aspirations. Throughout her career, Jones pined for recognition, not only in the department at Howard where she was the lone female instructor

during the 1930s, but also within the field of African American art more generally.

During her early years in Washington, D.C., Jones was active in the black intellectual and social scene outside Howard's campus. The guest books she kept for her apartment near Howard on Girard Street list a steady stream of callers, including a group of visiting South Africans and Locke.[15] Jones's membership in the prestigious Alpha Kappa Alpha sorority, the first Greek-letter black sorority founded at Howard in 1908, further extended her social reach, as the sorority was a "magnet for not just the intellectual elite but also the economic elite."[16] She also worked to make inroads with other important African American intellectual organizations near campus.

Soon after her arrival at Howard, Jones painted a portrait of Carter G. Woodson, a cofounder of the Association for the Study of Negro Life and History (ASNLH) who is often considered the father of African American history.[17] Established in 1915 and headquartered at Woodson's home just south of Howard's campus, ASNLH is devoted to the study and celebration of black history and culture. In 1916 ASNLH began publishing the *Journal of Negro History*, the first scholarly journal dedicated to African American history. Negro History Week, launched by Woodson in 1925, grew into the now nationally observed Black History Month.[18]

Connections between Howard and the ASNLH ran deep. When Woodson died in 1950, history professor at Howard University Rayford Logan became director of ASNLH, strengthening the ties between the two institutions. During the 1930s and 1940s, Jones was one of the most active Howard faculty members within ASNLH. In addition to teaching courses for the association, she served on the Fine Arts Committee for the organization's annual meeting in 1933. In 1937 she joined the board of the newly inaugurated *Negro History Bulletin*, a publication targeted at secondary school teachers and the general public.[19] Jones also did freelance illustrations for Woodson's publishing house, the Associated Publishers. Her work graced the covers of Sadie Daniel's 1931 *Women Builders* as well as Jones's longtime friend Gertrude McBrown's 1935 *The Picture-Poetry Book*, both produced by Woodson's Associated Publishers. Woodson himself also hired Jones as an illustrator for his own projects, including his 1939 *African Heroes and Heroines*.

In her cover for Daniel's *Women Builders* (fig. 25), Jones paid homage to a group of seven African American women pioneers including Charlotte Hawkins Brown, the educator responsible for giving Jones her start in the world of art education. On the front dustjacket, a crowd of men in overalls and women in skirts stand facing a trio of buildings on which the words "Business," "Education," and "Social Services" are etched. Figures are shown ascending the stairs to gain access to what is housed within the architecture. A row of seven black heads, ostensibly the seven women profiled within the book, extend on a diagonal toward a rising sun on the horizon.[20] On the back cover, a winding stream of black figures depart the rural countryside dotted with wooden cabins and march toward the growing crowds. The cover's implied movement from the rural-agrarian to urban-industrial service was in line with Jones's own middle-class values. She would have seen the seven women Daniel profiled as embodying the movement of African Americans.

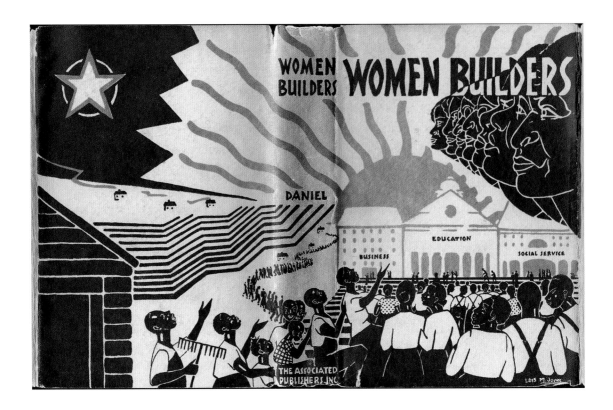

Fig. 25 Loïs Mailou Jones, cover of Sadie Daniel's *Women Builders* (Washington, D.C.: Associated Publishers, 1931). Courtesy Rose Library, Emory University.

It was not unusual that Jones moonlighted as an illustrator throughout much of her career. A number of her fellow artists pursued commercial endeavors while simultaneously engaged in their fine arts careers, including Laura Wheeler Waring, whose illustrations graced the covers and interiors of the *Crisis*. Aaron Douglas was particularly sought after, and his illustrations appeared regularly in the *Crisis* and *Opportunity*. In 1927 he provided the illustrations that accompanied James Weldon Johnson's long poem *God's Trombones*.[21]

Jones's affiliations with Howard and ASNLH placed her in the orbit of another key player in the African American intellectual scene: Alain Locke. Though aware of Locke during her years at the SMFA in Boston, Jones had made his acquaintance early in her tenure at Howard—a guest book notes that she entertained him at her home in 1934. Although Locke was not formally affiliated with the department of art, he was a force with which the faculty had to contend. As the de facto spokesperson for the Harlem Renaissance, Locke voiced his views on the direction of African American art throughout the 1920s and 1930s. As discussed in the previous chapter, of particular interest to Locke was the relationship between African art and African American artistic production.[22]

As the decade progressed, Locke would clash with Jones's colleagues Herring and Porter, who believed in a more assimilationist approach to African American art. As she forged her own path at Howard, Jones had to tread carefully—she needed the support of Locke, a gatekeeper of sorts, and that of her Howard colleagues.

The Ascent of Ethiopia

Once settled at Howard, Jones began to experiment with oil paint and returned to the African subject matter of some of her earlier work. Her 1932 oil painting *The Ascent of Ethiopia* is rendered in a stark palette of bright yellow, black, and royal blue that causes the work to seemingly pulse with energy (fig. 26). The mix of curvilinear and angular shapes enhances the painting's sense of vibration. At the top left is a yellow sunburst with a five-pointed black star in its center. A similar star appeared on Jones's 1931 cover of Daniel's *Women Builders*. Silhouetted figures emerge from beside Ethiopia's body to climb a flight of stairs to a skyscraper-filled city, which rests symbolically on the hill atop her head. The rising figures, shown in supplicant positions, walk toward a stream of yellow rays. Notably, after stepping through the yellow shower, their positions become erect and confident. A newly reborn pair walks hand in hand above a set of miniature pyramids toward the towering cityscape. They stand at the top step and look up at the urban environment in front of them. The figure to the left stands with a hand on the hip while the companion's right arm reaches outward in a gesture capable of multiple interpretations. Are the figures charging forward in the direction of the outstretched

arm? Or does the gesture indicate awe or shock at the scene? A series of orbital, two-dimensional spheres are paired with the truncated words "ART," "DRA[MA]," and "MU[SIC]." Figures performing these genres—painting at an easel, acting out scripted scenes, and playing instruments—picture the magnetism of the city. The composition is divided between the allegory of Ethiopia with the pyramids at the bottom and the illuminated urban cityscape above. At the bottom right, in profile, is the bust of Ethiopia, who dons an Egyptian headdress. Ethiopia anchors the composition and personifies the African root system from which the black individuals proceed and rise up into American urban culture. In the early 1930s, Jones was working with the concept of a largely imagined, monolithic Africa. In Jones's rendering, *The Ascent of Ethiopia* not only recognizes but also pays explicit tribute to the foundational role of Africa in African American culture. In *The Ascent of Ethiopia*, cultural expression enables African Americans to soar.

With *The Ascent of Ethiopia*, Jones signaled her engagement with her African American artistic contemporaries. The title references Fuller's well-known 1921 sculpture, *Ethiopia Awakening* (see fig. 14), with which Jones was surely familiar. Where Fuller's *Ethiopia* wears the striped nemes headdress associated with Egyptian pharaohs, Jones's *Ethiopia* sports a headdress adorned with a hooded cobra known as a uraeus, a symbol of the Egyptian goddess Wadjet. The presence of the star in the top left, coupled with the painting's theme of regeneration, suggests Jones is referencing Isis, the goddess of rebirth, often depicted with a star representing the start of a new year. Like the Boston-based Fuller, Jones would have been

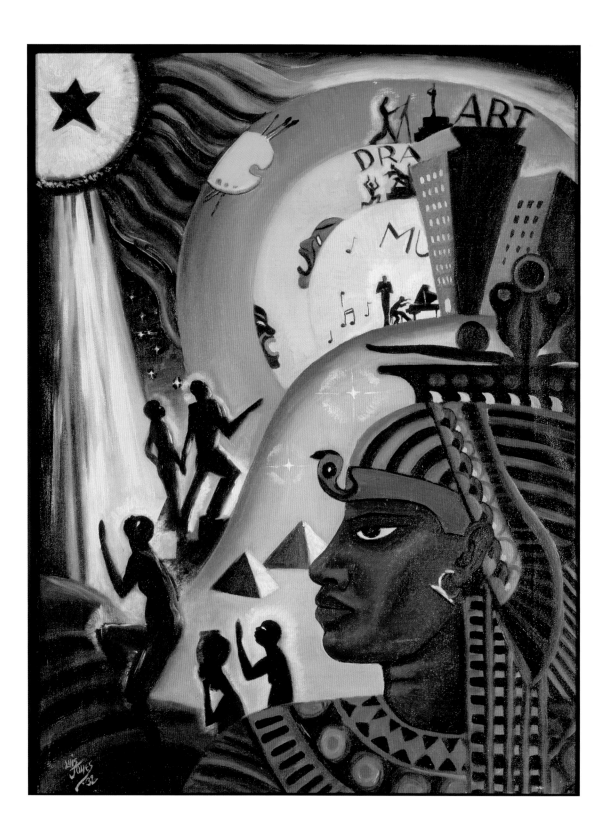

familiar with the extensive Egyptian collection at the Museum of Fine Arts in Boston.[23] The title of Fuller's work spoke to the awakening of African Americans in the post-Emancipation period, since Ethiopia takes control of her own body, an act of self-awakening and liberation. Fuller's Ethiopia gazes to the viewer's right, toward an unseen future. Produced a decade later, Jones's Ethiopia is awake and faces the future as she watches her people rise.

While Jones found titular inspiration in Fuller's sculpture, the composition of *The Ascent of Ethiopia* shares an affinity with a number of Douglas's Harlem Renaissance–era pieces. The tonal concentric circles, geometric cityscape, and silhouetted figures found in *The Ascent of Ethiopia* were hallmarks of Douglas's aesthetic in the 1930s and 1940s. Cognizant of Douglas's position as the quintessential Harlem Renaissance artist, Jones would later claim (in an act of misremembrance) that upon viewing Douglas's 1934 mural suite, *Aspects of Negro Life*, she "felt strongly and instinctively that Africa held deep inspiration for me and I created [*The Ascent of Ethiopia*.]"[24] The four-part mural series, which Douglas painted in 1934 under the auspices of the Public Works of Art Project, depicted the historical trajectory of African Americans from their ancestors' enslavement on the African continent through the emergence of the urban New Negro of the 1920s. In *The Ascent*

Fig. 26 Loïs Maïlou Jones, *The Ascent of Ethiopia*, 1932. Oil on canvas, 23 ½ × 17 ¼ in. (59.69 × 43.82 cm). Milwaukee Art Museum, Purchase, African American Art Acquisition Fund, matching funds from Suzanne and Richard Pieper, with additional support from Arthur and Dorothy Nelle Sanders, M1993.191. Courtesy Loïs Maïlou Jones Pierre-Noël Trust. Photo: John R. Glembin.

of Ethiopia, Jones collapses or, perhaps more accurately, anticipates the four-panel narrative with one canvas. She would later hail Douglas as "a master and an inspiration to many young black artists such as myself."[25]

Yet Jones's *The Ascent of Ethiopia* predates Douglas's *Aspect of Negro Life* murals by two years. Thus Jones's 1970s-era recollection of events reflects her ongoing desire to connect herself artistically to the major players in the African American art scene and to etch her own name into the annals of African American art history. As mentioned in chapter 1, during the heyday of the Harlem Renaissance, Jones was either in Boston finishing art school or in North Carolina teaching the next generation of the black elite at the PMI. She maintained ties to the cultural happenings in New York through personal visits to the city and through the submission of her art to various exhibitions and key publications (e.g., *Opportunity*) that allowed her to be visible artistically if not in person. Because so much scholarship on African American art from the 1920s and 1930s privileges those artists living and working in New York City, among them Douglas, Jacob Lawrence, and Augusta Savage, artists like Jones, who domiciled elsewhere, are frequently seen as fringe participants rather than full-fledged members of the movement.

In 1993 acclaimed cultural theorist Paul Gilroy considered using *The Ascent of Ethiopia* for the cover of his now-foundational book *The Black Atlantic*, in which he envisions the African diaspora as a series of interchanges between Africa, the United States, and Europe in order to analyze black modernist cultural production. When soliciting the image, Gilroy explained that *The Ascent*

of Ethiopia "encapsulated everything I had been working with in the book."[26] Ultimately, Gilroy selected Douglas's 1944 *Building More Stately Mansions* instead (fig. 27). Both paintings speak to the passage of time, the movement of black bodies, and the evolution of modern black culture. The artworks located the sites of blackness vis-à-vis architecture—the pyramid and the skyscraper. In *The Ascent of Ethiopia*, Jones's imagining of black cultural evolution unfolded vertically, with Africa at its base. In contrast, Douglas's *Building More Stately Mansions* offered a more horizontal and layered progression, with Africa embodied by a pyramid and a silhouetted pharaoh's head placed in the background. Like Jones, Douglas combines the classical and the modern, seen here in the complementary architectural forms—an ancient triumphal arch and modern skyscraper—which occupy the middle ground. In the foreground, two young children stand at a low table, spinning a globe, as five adult figures toil. It is perhaps unsurprising that Gilroy considered these works for the cover of his book; in their respective paintings, both Douglas and Jones flattened their figures into silhouettes, employed concentric circles of color, and drew from the same trove of African imagery and facial features to probe the contours of black modernity.

Douglas and Jones employed a "predictable vocabulary" of visual images that the general audiences could easily consume.[27] As Jones's worldview enlarged, her visual vocabulary expanded and became multilayered. Both compositions, furthermore, envisaged a black route system with roots in biblical, historical, and contemporary narratives of culture origination. The figures emerging from a head recall both the Greek myth of Zeus giving birth to Athena and biblical stories that describe people climbing a stairway to a celestial city.[28] The placement and iconography of the sun and star conjure a host of possible allusions: among them, the stars and stripes of the American flag (transmuted into yellow, black, and blue); the North Star, which guided enslaved African Americans to freedom; and also the Pan-African ethos embodied in Jamaican-born, Harlem-based black nationalist Marcus Garvey's 1920s Back to Africa campaign and Black Star Line shipping company.[29]

Where Jones's painting imagined a route from Africa to black America that celebrated black cultural production, during the 1920s Garvey sought to bring African Americans back to Africa. Garvey's Back to Africa campaign had roots in the nineteenth century, when the American Colonization Society (ACS, 1816–1964) sought to establish an American colony in what is now Liberia. The members of the ACS were predominantly white abolitionists and slave owners who believed that free blacks could not be integrated into white society. Under the ACS's auspices, around twelve thousand African Americans emigrated to Liberia, with the last group of settlers leaving the United States in 1904.[30] Between 1919 and 1922, Garvey incorporated the Black Star Line, a shipping company designed to promote commerce between global black communities via the transport of goods and African Americans to Africa. Garvey's proposed trade routes purposefully countered the trade routes of the nineteenth century, which effectively stole non-Western peoples and their culture in service of the colonialist project. The Black Star Line created new avenues of travel and thought as African

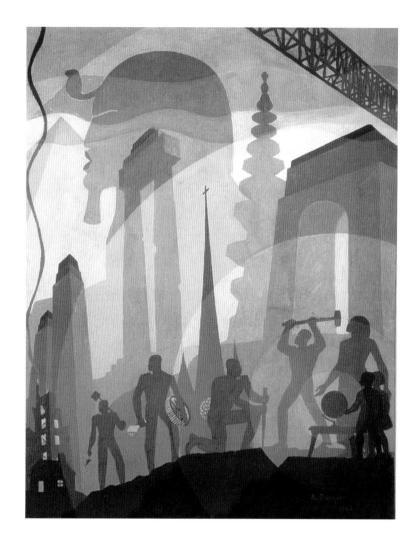

Fig. 27 Aaron Douglas, *Building More Stately Mansions*, 1944. Oil on canvas, 20 × 16 in. Fisk University, Nashville, Tennessee. © 2019 Heirs of Aaron Douglas / Licensed by VAGA at Artists Rights Society (ARS), New York.

Americans reconsidered their ancestral homeland. Likewise, Jones's early African and Afrodiasporic themed art visualized these routes.

Jones submitted *The Ascent of Ethiopia* along with a watercolor, *Menemsha by the Sea*, to the 1933 Harmon Foundation annual award competition, perhaps hoping to better her prior record. (In 1931 she had won an honorable mention for her 1929 charcoal drawing *Negro Youth* [see fig. 23]).[31] The foundation displayed the winning

fine arts submissions in a series of six traveling exhibitions (1928–1931, 1933, 1935) that toured throughout the United States from New York to California, with numerous venues in between. These all-black exhibitions not only provided the American public an important opportunity to view contemporary African American artistic production but also enabled artists to sell their work to a wider audience.[32] The shows were not without issue, however. Art historians Mary Ann

Fig. 28 Palmer C. Hayden, *Fétiche et Fleurs*, 1932–33. Oil on canvas, 23 ½ × 29 in. Palmer C. Hayden Collection, Museum of African American Art, Los Angeles. Courtesy of the Hayden Family Revocable Art Trust.

Calo and Jacqueline Francis have noted that the Harmon Foundation promoted a "particularist discourse of racial art."[33] Francis argues, for example, that African American artists of the era, cognizant of the jurors' predilection for black genre portraiture and symbolic racial imagery, frequently entered works that matched the jurors' preferences. Definitions of racial art formulated by non-black critics were based upon the perception "that minority artists had atavistic access to such visual expression . . . racial art was welcomed as the translation of exotic heritage."[34]

Visitors to the 1933 exhibition would have seen Jones's *The Ascent of Ethiopia* alongside the award-winning still life *Fétiche et Fleurs* by Palmer C. Hayden (1890–1973) and *Negro Masks* by Malvin Gray Johnson (1896–1934).[35] The three paintings utilize Africa and African art to

different ends. They speak to the varied roles of Africa in constructions of modernist African American art and showcase how artists made individual decisions about incorporating ideas of Africa into their practice.

Hayden, a self-taught artist, garnered fame (as well as criticism) within African American artistic circles when he won the first Harmon Foundation award in 1926. With his winnings, Hayden traveled the next year to Paris, where he remained until 1932.[36] *Fétiche et Fleurs* is Hayden's only known work to include African art objects explicitly (fig. 28).[37] Depicting a residential interior, the center of *Fétiche et Fleurs* is filled with a wooden table topped with a Fang reliquary statue next to a blue vase of orange and yellow tiger lilies. The vase and statue sit on patterned raffia Kuba cloth, which is draped diagonally over a wooden table. An ashtray, with a lit cigarette resting in its bowl, appears toward the front of the table. The combination of the African objects, tropical flowers, and cigarette in the foreground speaks to the formation of a modern identity in Paris during the 1920s and to the role played by the exotic, here represented by African art, in signifying modernity. The African elements in the painting are decorative home accessories symptomatic of French society's *negrophilia*, the obsession with all things black that served as a mainstream corollary to the avant-garde's primitivism. African sculptures, masks, and textiles were known as *fétiches* (fetishes) and were popular accessories for the Parisian avant-garde.[38] The fact that the African elements in Hayden's *Fétiche et Fleurs* are easily removable speaks to the transience of the fad.

In contrast, Africa took center stage on Johnson's and Jones's canvases. Johnson's *Negro Masks*

Fig. 29 Malvin Gray Johnson, *Negro Masks*, 1932. Oil on canvas, 20 × 18 in. Collection of Hampton University Museum, Hampton, Virginia.

contains two masks, one from the Belgian Congo and another from Nigeria, which fill the entire frame and sit cheek to cheek on a piece of diagonally strewn, Kuba-inspired fabric (fig. 29). This painting appears (reversed) in the background of Johnson's 1934 *Self-Portrait: Myself at Work* (fig. 30). In the *Self-Portrait*, executed in the same year of Johnson's untimely death, the artist placed himself along the same register as the African masks he had depicted two years earlier. In doing so, Johnson creates a visual link between African art and his own African American visage.[39] Parsing the portrait closely, one notes that the painting is a stylistic mix—combining academic traditionalism in his treatment of the head with more modern cubist- and expressionist-derived

Fig. 30 Malvin Gray Johnson, *Self-Portrait: Myself at Work*, 1934. Oil on canvas, 38.25 × 30 in. Smithsonian American Art Museum, Washington, D.C., 1967.57.30. Gift of the Harmon Foundation.

elements evinced by the flattened space.[40] African art and aesthetics were a route toward modernity for artists like Johnson.

Jones's brightly colored and graphic *The Ascent of Ethiopia* would have appeared garish in comparison to the muted color palettes of Hayden's and Johnson's canvases and their nuanced incorporation of African objects. Yet *The Ascent of Ethiopia* was but an early stop in Jones's exploratory route. At the end of the 1930s,

Jones revisited the relationship of Africa and African aesthetics to African American artists. These later paintings not only demonstrate changes in Jones's experimentation with African themes but also hint at a shift in the discourse of "Africa" within African American art that was moving beyond simple incorporation of patent African referents to the use of Africa to signify a globalized, modernist, African American artistic identity. The evolution of Jones's thinking

about Africa in relation to her own praxis was stimulated in part by her expanded social and intellectual networks.

New York Summers

After Howard's spring semester ended, Jones was free to leave Washington, and she spent her summer vacations of 1934, 1935, and 1936 in the classroom as a student at Columbia University's Teachers College. These summers afforded Jones the opportunity to develop further her pedagogical and artistic skills. At Columbia, she took classes in art appreciation, art education in secondary schools, clay modeling, educational psychology, and English composition.[41] One summer she enrolled in the class of famed anthropologist Franz Boas, and for her final project she wrote a paper entitled "Mask Making," which included a lesson plan for teaching young children about different masking traditions. The resultant teaching folio included a number of sketches rendered on index cards depicting masks from Africa, New Guinea, the Aztec civilization, and medieval Europe.[42]

Additionally, Jones's experiences outside of the classroom facilitated her continued exploration of African cultural expression. She and her contemporaries accessed ideas about Africa and Afrodiasporic culture through books, the stage, galleries, and personal interactions on the street. In the summer of 1934, Jones made the acquaintance of Asadata Dafora, the musician and dancer from Sierra Leone credited with introducing African drumming to American audiences in the 1930s. Dafora was enjoying a wave of success following the May debut of his musical drama

Kykunkor (*The Witch Woman*).[43] Some scholars suggest that Dafora invited Jones to watch rehearsals in order to design masks and costumes for the production, yet Jones is not listed as doing so in any extant material.[44] A playbill in Jones's archive suggests that she attended at least one performance while residing in New York City. Since the show debuted in May 1934, and Jones arrived in New York after the end of Howard's academic year in mid-May, it seems unlikely she could have contributed to the designs.[45] Dafora influenced a host of other dancers and choreographers, among them the Trinidadian Pearl Primus and the African American Katherine Dunham, whose riveting performances in pieces like *La Guiablesse* (1934), *Rara Tonga* (1937), and *L'Ag'Ya* (1938) brought African and Afrodiasporic dance to American audiences. While Jones's direct involvement with Dafora's production might be up for debate, her contact with him and others in New York that summer increased her exposure to African cultural traditions.

In the summer of 1935, Jones may have caught MoMA's groundbreaking *African Negro Art* exhibition, which closed in mid-May. If she did not view the show in New York, she certainly saw it in October, when Howard University presented the smaller traveling selection of works from the original exhibition. In fact, Howard hosted the traveling show twice during its twenty-one-month tour of HBCUs: in October 1935 and again in June 1936.[46] *African Negro Art* played a major role in bringing African art to the mainstream American public on a large scale. Attracting a large African American audience was important to MoMA officials.[47] A statement on attendance in the March–April issue of the *Bulletin of the*

Museum of Modern Art noted, "The museum felt that the exhibition would be of great interest to the Negroes of New York and has made efforts to bring it to their attention."[48]

With money from the General Education Board (GEB), MoMA hired Walker Evans to create a photographic portfolio of the objects on view. For the portfolio, which included 477 prints, Walker photographed the objects from multiple viewpoints in an effort to accurately document their three-dimensional characteristics in a two-dimensional medium. The finished portfolio was sold to libraries and donated to seven HBCUs, including Howard.[49] Driskell and other former Howard students have recalled that Jones used the Evans portfolio in her studio classes.[50]

Jones's encouragement of students to explore African objects and scenes, however, seemingly predated the display of the MoMA traveling exhibition. A pair of student textile designs from 1930 to 1933 by Mabel Williams and Lawrence Edelin take African themes as their subject. Williams's design includes a vertical repeating pattern comprised of a Kota Mbulu-Ngulu reliquary figure of an antelope, perhaps borrowed from the same Ci Wara dance crest Jones depicted in her own African-themed textile design discussed earlier (see fig. 17). In Edelin's composition, a number of black silhouetted hunters carrying spears and archery equipment dot a landscape of palm trees. The setting sun appears on the horizon while a quartet of lions occupy the foreground. Undoubtedly Jones's pedagogical and personal artistic interests would have intertwined.

While Howard's copy of the Evans portfolio cannot be located, the catalogue's photographs surely had an impact on Jones. Art historian Wendy Grossman convincingly suggests that Jones may have based her now-canonical 1938 painting *Les Fétiches* on photographs from Evans's 1935 portfolio.[51] It is also tempting to see Jones's 1935 oil painting *Africa* as evidence of the *African Negro Art* exhibition's influence (fig. 31). However, the painting, which depicts three stylized African female figures surrounded by lush green foliage, bears an uncanny resemblance to Jones's 1928 watercolor that appeared on the cover of *Opportunity* magazine, as discussed in chapter 1 (see fig. 20).

The GEB, which funded the production of Evans's portfolio, would also play a decisive role in the advancement of Jones's career. Founded in 1903 with seed money from the New York–based Rockefellers, the GEB originally focused on the racial conditions in Southern schools. It soon turned its attention to supporting African American colleges. In 1924, the GEB began doling out fellowships to promising "Negro instructors in Southern higher education."[52] By the conclusion of the program, the GEB's "directory of fellows would read like a Who's Who among Negro American educators."[53] Although the majority of fellowships were awarded in the fields of education (802), between 1922 and 1950, twenty-three fellows in art and architecture were named. Jones was one of two lucky recipients in 1937. Renowned dancer and anthropologist Dunham received the other award that year.[54] Eighteen months after viewing Evans's photographs at Howard, Jones was able to see African art in Paris, the city where American and European modern artists' love affair with African art began.

Paris, City of Light

In September 1937, Jones set sail for France on the S.S. *Normandie* and disembarked in the port city of Le Havre, where her education in the contours of black identity continued. Friends and family fêted her departure; Carter G. Woodson and prominent Harlem Renaissance bibliophile Arturo Schomburg sent flowers to her onboard cabin.[55] By the 1920s, Paris had long been established as the capital of the art world. American artists of all races flocked to the city to train with French masters and "refine their craft."[56]

The city's positive reception of many African American artists before Jones—Henry Ossawa Tanner, Meta Warrick Fuller, Palmer Hayden, Hale Woodruff, and more—confirmed its place as the top rung on the ladder of artistic success.[57] Moreover, France's mythical status as a country of open-mindedness, hospitality, and tolerance encouraged many African American artists to seek an escape from American racism there.[58] In her final report to the GEB, Jones acknowledged the importance of feeling free, "In Paris the American Negro is loosed from all shackles, and has the opportunity to develop to the fullest. . . . His color is in no way a barrier. It is this type of freedom of expression which enables the Negro artist to give birth to those thoughts within him which perhaps have been held back by oppression."[59]

Paris, of course, was also the site of Pablo Picasso's mythologized "discovery" of an African mask in the dusty corridors of the Trocadero Ethnographic Museum, an unearthing that shifted the trajectory of "primitivism" and magnified the utility of Africa for artists associated with modernist primitivism. These artists appropriated and assimilated non-European art and aesthetics into their work in search of a modern aesthetic.[60] At the time of Jones's arrival in Paris, the city's galleries overflowed with African objects. But in addition to facilitating contact with African art and masterpieces of European art, Paris afforded African Americans the opportunity to interact with people of African descent from all over the world. Paris became an "international meeting place for blacks" on a grand scale in the 1930s, and Jones was able to "link up" with a host of African Americans, Antilleans, and Africans who were living there.[61] Among them were the

American expat artist Albert Alexander Smith, Martinican professor of French at Howard University Louis T. Achille, and his cousins Paulette and Jane Nardal, who published the black internationalist journal *Revue du monde noir*.

Jones's September arrival in Paris enabled her to catch the immensely popular Exposition Universelle, which attracted millions of visitors before it closed at the end of November 1937.[62] Although she missed the opportunity to hear the Senegalese poet Léopold Senghor speak at one of the exposition's congresses, she did see Picasso's famed *Guernica*, which hung in the Spanish pavilion. She would also have walked through the galleries of the newly reopened Musée de l'homme, where the spoils of the 1932 Mission scientifique Dakar-Djibouti and other African objects were displayed.[63] In an undated letter to her mother, Jones exclaimed, "It is a pity that it [the exposition] had to close."[64]

Jones had hoped to study with Tanner, but he passed away three months before her arrival. She found a pair of artistic mentors in fellow African American Albert Alexander Smith and the French postimpressionist symbolist painter Émile Bernard. The same age as Jones's older brother, Smith was the first African American to attend the National Academy of Design in New York. His studies had been interrupted by his military service during World War I. After a brief stint back at the National Academy, he returned to France and maintained a career there as an artist and a performer. Like Jones, Smith moved between artistic mediums, producing paintings, prints, and drawings that were sold on both sides of the Atlantic.[65] While Smith was just a decade ahead of Jones, Bernard, then in his

early seventies, was nearing the end of his career. Defined by his ardent Catholicism, Bernard remained important, albeit markedly conservative in comparison to his avant-garde roots. He invited Jones regularly to his studio and to parties he hosted at his apartment.[66] Jones corresponded with both men after her return to the United States, until Smith died in 1940 and Bernard in 1941. She would later recount that meeting Smith "in a way took the place of meeting Tanner."[67]

Jones followed in Tanner's artistic footsteps by enrolling in the Académie Julian, where he had studied in 1891.[68] Founded twenty-odd years earlier in 1868, the Académie Julian admitted female students at a time when they were still barred from the École des Beaux Arts. At the turn of the century, the school had welcomed several other African American students including Annie E. Anderson, who took courses until 1902, and William Edouard Scott, who attended in the 1910s.[69] By Jones's arrival in the 1930s, the school was one of the foremost art schools for American women artists.[70]

Jones's decision to undertake further art instruction was unusual. She already had a degree from the SMFA, and she had pursued postgraduate work in Boston and New York. Moreover, she was employed as a college-level instructor at Howard University. Her enrollment at the Académie Julian demonstrated a desire to expand her understanding of European art and to become equal to the masters she would later depict in *Under the Influence of the Masters* (see fig. 1).

On October 5, 1937, the eve of her first day at the Académie Julian, Jones wrote to her mother, "I start school tomorrow. No one seems to speak Eng[lish]. . . . I hear there is a girl at the school

from Washington, [s]he's from the Corcoran Art School, so I know she is a cracker. The[y] don't let Negroes right in that school. I'll see what she is like tomorrow."[71] Born and raised in progressive Boston, Jones still chafed at the racism she encountered living in the Southern United States. Her time in Washington, D.C., was not without incidents of prejudice. Jones would years later list a number of such episodes that occurred during her first ten years at Howard at places like the Corcoran Gallery of Art, Peoples Drug store, and various department stores around the city.[72] However, her use of *cracker* to describe the white American student is remarkable: such racially charged language is rare in her correspondence. After a month free from the racist attitudes of white Americans, Jones seems apprehensive about encountering prejudice from a classmate. The letter divulges much about Jones's psychological state after her first month in Paris, including her mounting anxieties about living alone in the city and her frustration over her inability to speak French. Another white student, Frenchwoman Céline Tarbary, who first helped Jones by translating their French instructor's critique into English, would become Jones's closest Parisian confidant.[73]

Jones's 1937–38 sabbatical proved to be a particularly productive period for her; she completed more than forty paintings during the course of nine months. A photograph of the artist in her Left Bank studio, located at 23 rue Campagne Première, shows her seated among twenty of these canvases (fig. 32). The works are a mixture of street scenes, many completed en plein air, a variety of still lifes, and a handful of portraits. A number of them adhere to the academic style—with tight brushstrokes and traditional subjects—that was taught in European art academies like the Académie Julien. At the far right, leaning against the floor-to-ceiling window that faced the Eiffel Tower, is the oil panting *Les Fétiches*, today perhaps Jones's best-known work (fig. 33).

In the painting, a large African mask with an elaborate headdress and angular features rendered in shades of brown and cream dominates the composition's center. The oval mask, which bears an affinity to Congolese chowke masks, possesses schematized, almond-shaped eyes, a sharp nose, and an open mouth. Jones's brushstrokes on the headdress animate the stationary piece; the lines springing from the mask into the dark background, coupled with its slightly off-center position, give the mask the appearance of being in movement. For instance, along the right side of the mask, two white, seemingly concentric lines fade into the backdrop—as if the mask is shaking to life. Rising up beneath the central mask is an unadorned, light purple mask with an angular nose, circular mouth, and round eyes, possibly a rendition of a Hemba mask. Jones inserts a black serrated form between the two masks to distinguish the pieces from one another. Atop this second purple mask floats an orange hornbill statuette outlined in white. The figurine is suspended in midair and floats above the eye opening of the purple mask. The orange figurine could be Jones's interpretation of a West African Sankofa bird or, as Wendy Grossman suggests, a rendition of a Baule male figurine from the collection of Charles Ratton.[74] The presence of these two sculptural forms—the jagged black form and bird statue—gives Jones's two-dimensional canvas a sense of three-dimensional space as the

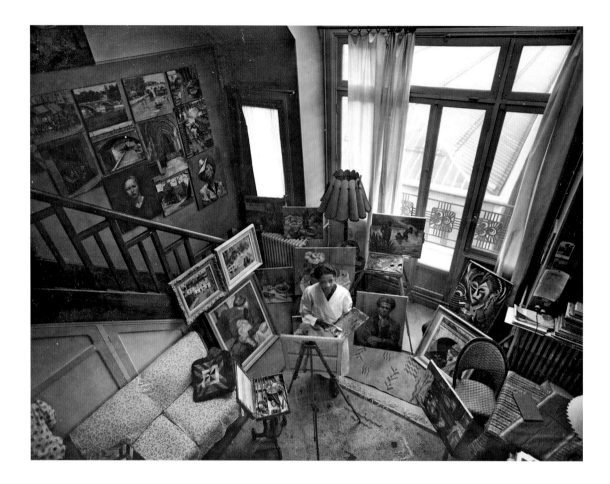

Fig. 32 Loïs Mailou Jones in her Parisian studio, ca. 1938. Courtesy Moorland-Spingarn Research Center, Manuscript Division, Howard University, Washington, D.C.

Fig. 33 (opposite) Loïs Mailou Jones, *Les Fétiches*, 1938. Oil on canvas, 24 ½ × 21 ¼ in. Smithsonian American Art Museum, Washington, D.C., 1990.56. Museum purchase made possible by Mrs. Norvin H. Green, Dr. R. Harlan, and Francis Musgrave. Courtesy Loïs Mailou Jones Pierre-Noël Trust.

viewer understands how the orange figure would appear in front of the purple mask, and the black pointed form would jut out into the viewer's space.

Toward the lower right of the shadowy composition, a third horned mask of blackish-gray is faintly visible. The spiky horns jut up into the cheek area of the purple mask. Jones's signature and the words "Paris, '38" obscure the lower half of the mask. The viewer's eye rests at the bottom-center of the canvas, where a fourth mask characterized by a white band around the eye area and a grey-reddish mouth is found beneath the chins of the light purple mask to the right and the fifth and final mask to the left. The left-hand mask appears in profile, differing from the frontal position of the other masks. With

Fig. 34 Loïs Mailou Jones, *Les Pommes vertes*, 1938. Oil on canvas, 36 × 28 ¼ in. Location unknown. From Benjamin, *Life and Art of Loïs Mailou Jones*, iv. Courtesy Loïs Mailou Jones Pierre-Noël Trust. Photo: Marvin T. Jones.

graphic horizontal stripes in black and whitish purple, this final mask appears more sculptural than masklike. Due to the mask's profile position its mouth opening appears as a rectangular cut, not a hollow opening through which a wearer could breathe, as seen in the brown and purple masks. Jones accentuates the carving of this mask with her use of white and pinkish paint to depict three-dimensionality and depth along the edges of the mouth and eye. The way in which the masks cascade and collide suggests that the painting is as much about African art as it is about space, form, and reality—hallmarks of the cubist and

surrealist aesthetics that dominated European modern art in the first decades of the twentieth century. Jones's choice of title made reference to the term French artists ascribed to the African art objects at the start of the twentieth century.[75]

Upon her arrival in Paris, Jones recalled, "Africa was everywhere, it was just the thing. . . . All the galleries, the museums were featuring African sculptures, African designs, and I sketched, I sketched everything."[76] In some accounts, Jones reports that she painted *Les Fétiches* after an inspiring stroll perusing galleries along the Boulevard Raspail.[77] With its somber palette of grays, purples, and browns and its African subject matter, *Les Fétiches* marks a dramatic break from Jones's other French paintings, whose classical subject matter and tight brushwork were decidedly more academic. *Les Fétiches* instead continues in the vein of the paintings Jones had done earlier, such as *The Ascent of Ethiopia*, in its focus on African subject matter.

Regardless of where Jones encountered the masks she pictured—be it in the pages of Evans's *African Negro Art* portfolio or on the walls of the Parisian galleries she visited—the objects she saw were displayed out of context. As colonial booty, the masks suffered a forced displacement. By overlapping the masks in her canvas, Jones insists on reintegrating the diasporic objects that were pulled apart. In doing so she articulates a visual statement about Pan-Africanism that is predicated upon overlapping identities.

Jones's aesthetic departure in *Les Fétiches* was startling. In fact, her instructors at the Académie Julian did not understand it, and Jones reported that she "had to remind [her French instructors, including Jules Adler, Joseph Bergès, G.

Maury, and Pierre Montézin] . . . of all the French artists using the inspiration of Africa, and that if anybody had the right to use it, I had it, it was my heritage."[78] *Les Fétiches* may have shocked Jones's teachers because her other celebrated Parisian paintings, among them her contemporaneous fruit-filled still lifes *La Cuisine dans l'atelier de l'artiste, Paris* and *Les Pommes vertes* (fig. 34) adhered in content and style to the traditional methods taught at the Académie Julian. In these two paintings, which were selected in 1938 for the oldest and most highly regarded French salon, the Société des Artistes Français, Jones painted conventional still lifes, replete with interesting angles, fruit perched on a flat service, and artfully draped fabric.[79] Jones's choice to pursue the African subject matter and a new modernist aesthetic in *Les Fétiches* at the same time she was also painting more conservative European works signals the dexterity with which she could move between artistic styles.

Moreover, *Les Fétiches* visually stakes Jones's claim to European *and* African artistic traditions. Created one year before her *Under the Influence of the Masters* illustration, the painting can be seen as part of her effort to reconcile the two aesthetics, an early experimentation with the diasporic visual grammar that emerges more fully in her later work. In highlighting the relationship of *Les Fétiches* to the legacy of European modernism as well as the then-current state of African American art, in which racial heritage was being widely celebrated, Jones positioned the painting to be considered a success in the European, American, and African American art worlds of the 1930s. Its subject matter and aesthetic style were legible to different audiences.

Given its date and subject matter, *Les Fétiches* might be read as exemplifying Locke's 1925 call to African American artists to capitalize on the success of the European modernists and explore African art.[80] In such interpretations, *Les Fétiches* is the finale of the Harlem Renaissance and of Jones's Parisian experience: a sojourn that gave her full access to her "African" roots as manifested in African art objects. Although the painting is often hailed as the culmination of Jones's Parisian experiences, in fact *Les Fétiches* marks a major aesthetic transformation and engagement with African art that occurred at the midpoint of her stay.

For this reason, identifying precisely when *Les Fétiches* was completed is important. The correct timeline demonstrates that Paris not only gave her an opportunity to view the African art objects that filled the Louvre, Trocadero, Fontainebleau, and other galleries and museums but also expanded her understanding of Africa to include not only African objects but Afrodiasporic bodies as well. According to letters exchanged between Jones and her mother, she painted *Les Fétiches* within the first four months of her Parisian tenure.[81] At the end of February, Jones reported: "I've been up to my neck in work. . . . I'm also exhibiting in the Independent Exposition which opens next Friday. I have two oils in it, I think I told you—one a creative painting—'Fetiche' (Afrique) and a very large nature morte [still life] with fruit."[82] In the same February letter, Jones exclaimed to her mother: "You can imagine how much I love Paris—it is wonderful! Why do I have to return so soon . . . ? My work in oil has progressed 100%."[83] The letter suggests a dramatic shift in perspective from the loneliness and isolation she had described a few months earlier.

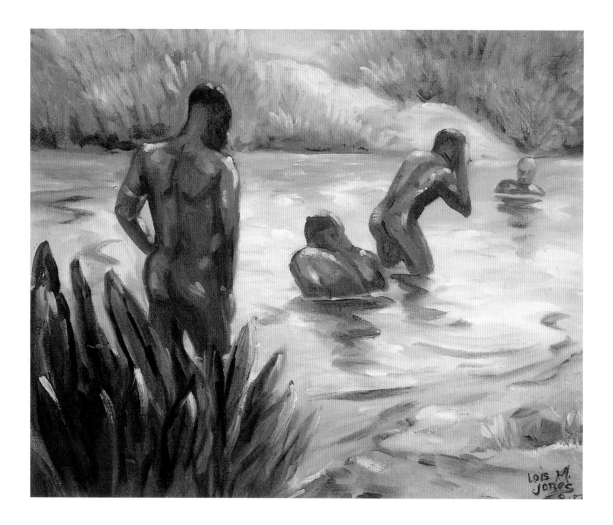

Fig. 35 Loïs Mailou Jones, *African Bathers*, 1937. Oil on canvas. Location unknown. From Benjamin, *Life and Art of Loïs Mailou Jones*, 32. Courtesy Loïs Mailou Jones Pierre-Noël Trust. Photo: Marvin T. Jones.

A close look at the paintings surrounding Jones in the photograph of her studio reveals *Les Fétiches* as but one of several African-themed paintings that surround the artist (see fig. 32). Another of these works is Jones's *African Bathers* from 1937 (fig. 35). In the horizontal painting, the viewer's perspective is situated on a river's edge, watching a quartet of black men bathe. On the left, a figure wades into the water to join his companions, who are in various stages of submersion. As a bathing scene, Jones's *African Bathers* has many art-historical antecedents. The nude in nature was a common theme in French art of the late nineteenth and early twentieth centuries.[84] The pictorial language Jones employs in *African Bathers*—the positioning of the

figures, her use of planar brushstrokes and solid modeling lines—harks back to works by Frédéric Bazille, Paul Cézanne, Henri Matisse, and other late nineteenth-century postimpressionists, some of whom even looked to African art for inspiration. For example, Maurice de Vlaminck used a Fang mask collected by Andrew Derain to complete his 1907 painting *The Bathers*.[85] The compositional cropping of Jones's *African Bathers* resembles Bernard's *Bagineuses à la vache rouge* (ca. 1887–89). After meeting the artist on the bank of the Seine, Jones visited his studio frequently and familiarized herself with his aesthetic.[86] It appears, however, that the primary inspiration for *African Bathers* came from a set of images Jones found in a serial French travelogue, *A Travers l'Afrique*, by Lieutenant Colonel Albert Baratier, illustrated by Gaston de Burggraff.[87] Despite this colonial source and the classical academicism of Jones's rendition, the fluidity of the image, with its extended brushstrokes, multitoned brown skin, and unidentified tropical locale, suggests that it can be read as both a New Negro provocation and a diasporic image.

It is not surprising that Jones combed sources from the colonial era for African imagery during her time in Paris. Although on sabbatical from Howard University, she continued to work as an illustrator for Associated Publishers. While in Paris, she produced illustrations for Woodson's *African Heroes and Heroines* (1939). According to the book's preface, Jones's "worked out [the drawings] from source materials."[88] Woodson cites the aforementioned Baratier text throughout *African Heroes and Heroines*. While the names of other specific texts from which Jones drew are unknown, perhaps her Howard University colleague Locke, who was also affiliated with the ASNLH, made some suggestions.

The illustrations Jones produced for the book, created for a juvenile audience and rendered in pen and watercolor instead of oil paint, represent yet another venue through which she pursued her interest in African subjects. The text's dust jacket is a striking mix of text, figures, objects, and patterns (fig. 36). The front cover includes the book title in white capital letters running across the top and right edges. Author Carter G. Woodson's name appears in smaller text along the bottom. In the center, a male Zulu warrior wields an iklwa stabbing spear and an isihlanga shield. Next to him stands his female counterpart. Both look to the right, as if daring the viewer to open the book. Behind them, the schematic eyes of an African mask are visible next to the book's spine. On the back cover, a warrior on horseback charges forward, sword raised. The cover images reflect the illustrations found inside, the majority of which were didactic and fell into two distinct categories: portraits of key African rulers and action scenes depicting either African interactions with white colonizers or African leaders heading to battle.

While educational in nature, Jones's illustrations for *African Heroes and Heroines* were unique in that the content bled over into her personal art practice. Like her paintings, the illustrations mark a movement from African objects to African bodies. As evinced in *Under the Influence of the Masters*, the formal qualities and themes of Jones's illustrations often made their way into her paintings. Her work for *African Heroes and Heroines* is no exception, and several illustrations demonstrate that Jones's painting and illustration practices were intertwined.

Fig. 36 Loïs Mailou Jones, cover for Carter Woodson's *African Heroes and Heroines* (Washington, D.C.: Associated Publishers, 1939). Courtesy Rose Library, Emory University and Loïs Mailou Jones Pierre-Noël Trust.

In the preface to *African Heroes and Heroines*, Woodson explained that the text was not a history of Africa per se but "a biographical treatment of heroes and heroines."[89] Jones's illustrations were for the most part portraits of various African leaders. Some show the rulers in action, and others were more straightforward examples of portraiture, like her rendition of *Benhazin* (fig. 37). In this portrait, the nineteenth-century potentate of Dahomey is pictured against a solid, muted background. His body comprises the bulk of the composition. His torso is draped in a striped fabric that leaves his muscled chest exposed; he holds a long wooden pipe to his lips. The source for Jones's Benhazin appears to be an image from the 1895 book *La France au Dahomey* by Alexandre d'Albéca (fig. 38).[90] While Albéca's portrait of Benhazin is crisp and possesses photographic clarity, Jones's use of watercolor imparts a softness and sensitivity to the likeness. With the Woodson illustrations, which were printed in black and white, Jones was forced to think about the materiality of dark-complexioned skin against the white ground of the paper. She would further investigate the aesthetics of black skin in her portraits of the late 1930s and 1940s in which we see her develop the blackness-in-triplicate motif.

Fig. 37 Loïs Mailou Jones, *Benhazin*, in Carter G. Woodson's *African Heroes and Heroines* (Washington, D.C.: Associated Publishers, 1939). Courtesy Loïs Mailou Jones Pierre-Noël Trust.

Fig. 38 Alexandre d'Albéca, *Behanzin*, in *La France au Dahomey* (Paris: Hachette, 1895). From the New York Public Library.

A Portrait of Négritude: Jones and the Nardal Sisters

Jones's late-1930s arrival in Paris coincided with the first stirrings of the intellectual current that would develop into the literary Négritude movement. This literary and political endeavor, initiated as a rejection of French colonial racism by Martinican poet Aimé Césaire, French Guinean poet Léon Damas, and Senegalese president

Léopold Sédar Senghor, was adopted as a means of fostering racial solidarity. The term *Négritude*, coined by Césaire, can be loosely translated as "blackness." Négritude began in the 1920s, as African and Caribbean students arrived in Paris and formed salons to discuss their common plight. The presence of Harlem Renaissance–era writers such as Langston Hughes, Claude McKay, and Countee Cullen in Paris in the 1920s and 1930s contributed to the theoretical underpinnings of the movement. Their informal conversations in cafés during the 1930s took a more institutionalized form in the 1940s.[91]

Jones's familiarity with critical figures associated with the movement began as soon as she set foot in France. When Jones disembarked in Le Havre in September 1937, fellow Howard

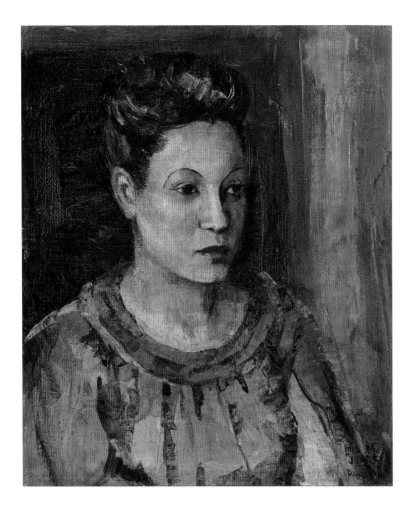

University professor Louis Achille was there to greet her, and Jones would spend her first few weeks in Paris living with his parents.[92] Achille is one of several "overlooked . . . early Francophone Antillean" intellectuals in Paris.[93] He was born in 1909 in Martinique but educated in France. He joined Howard's department of Romance languages in 1932, when he first met Jones. Living in a West Bank neighborhood, the Achille family was decidedly bourgeois. Achille's father was the first Antillean to receive the French equivalent of a Ph.D.[94] Even after Jones moved into a place

of her own at the start of October, her association with Achille no doubt facilitated access to a constellation of Afro-Caribbean and African intellectuals who were living, studying, and writing in Paris. Jones's time with the Achille family not only provided her an opportunity to ease into Parisian life but also proves that she was acquainted with the Afro-Caribbean and African intellectual set in Paris from the outset of her time there. Visual evidence of such interactions can be found in a trio of portraits from the 1937–38 period: *Babelle*, *La Tête d'un nègre* and *Jeanne, Martiniquaise*.

Fig. 40 Loïs Mailou Jones, *La Tête d'un négre*, 1938. Oil on canvas. Location unknown. From Benjamin, *Life and Art of Loïs Mailou Jones*, 40. Courtesy Loïs Mailou Jones Pierre-Noël Trust. Photo: Marvin T. Jones.

Babelle depicts Achille's sister Isabelle, who would go on to marry Léon Damas (fig. 39). In the vertical portrait, an attractive young woman, around Jones's own age at the time, sits for the artist in a three-quarter pose wearing an ornate red frock with slits on the sides. Her hair is gathered in an elegant updo, and her eyebrows arch dramatically. Jones carries red throughout the composition, highlighting the sitter's rouge-stained lips and using the rosy pigment as an undertone for Babelle's light brown skin.

A muted red fabric draped in the background frames the slightly off-center figure. Beneath Jones's signature in the bottom right of the canvas, she added "Paris '38," marking the painting both geographically and chronologically. For paintings executed outside of the United States, Jones would often note the location in her signature line. These geographic markers, which later grew to include Haiti and various African nations, charted her exploration of the African diaspora.

Fig. 41 Jean-Léon Gérôme, *Bashi-Bazouk*, ca. 1868–69. Oil on canvas, 31 ¾ × 26 in. (80.6 × 66 cm). Metropolitan Museum of Art. Gift of Mrs. Charles Wrightsman, 2008, 2008.547.1. Image copyright: Metropolitan Museum of Art. Image source: Art Resource, New York.

In *La Tête d'un nègre* (fig. 40), another of Jones's portraits from 1938, the bust of a young black man fills the entire canvas. The top of his natural hairstyle and outsides of his upper arms push against or exceed the painting's edges. The sitter wears a student uniform: a gray-blue blazer over a white shirt with a red necktie. He does not engage the viewer, resting his gaze, rather, slightly to the viewer's left. As a portrait of an unnamed man rather than a specific person, *La Tête d'un nègre* connects to a strain of Orientalist portrait painting and to ethnographic photographic practices of the early twentieth century.

So-called ethnographic or type portraits, like Nazzareno Cipriani's *Head of a North African Woman* (1878) or Gérôme's *Bashi-Bazouk* (ca. 1868–69; fig. 41), conveyed the kind of objectified portrayal of racial difference that late nineteenth-century white audiences craved.[95] In Gérôme's half-portrait, a young man of African descent sits with his back to the viewer; in his lap are an assortment of musical instruments while the barrel of a rifle rests against his left shoulder. His head turns over his right shoulder, allowing the viewer to catch his gaze. His embroidered salmon-colored coat and multicolored, tasseled headdress pop against the muted grey background. Gérôme's title for the work, translated loosely as "headless" or "disorderly," makes reference to the irregular soldiers fighting in the Ottoman empire.[96] The title of Jones's work similarly evokes the head and its associated anthropological or ethnographic categorizations. Jones's production of a singular painted image of the unnamed black sitter in France, a major colonial power, occurred at a moment when individuals and institutions amassed vast collections of ethnographic photographs in service of the imperialist colonial project.

With her portrait, Jones participates in the political positive imaging of blackness—an action facilitated not only by the diasporic community in Paris but also by her own shift from interrogating African art objects to studying living black bodies (be they African, Afro-Caribbean, or African American). The imagery of orientalists and phrenologists focused on highlighting the racial and cultural differences between their subjects and their audiences in order to create categories in which black bodies occupied the lowest ranks.

La Tête presents the viewer with a subject who is racially and culturally hybrid. He is not pictured in some exotic locale to which the artist has traveled; rather, his clothing strongly suggests he is Parisian, a member of the city's burgeoning Afrodiasporic population. The hybridity of the figure and the portrait's lack of specific location problematizes the term *nègre* by exposing its global connotations and fluidity. With this artistic actualization, Jones joined forces with a group of Francophone black writers who were in the process of reclaiming a positive identity for the word *nègre* and for blackness in general.

In another contemporaneously painted portrait *Jeanne, Martiniquaise*, Jones again plays with ethnographic titling practices, here indicating her sitter's country of origin (fig. 42). In the horizontal portrait, Jeanne sits against a wall of flesh-colored stripes that range from light caramel to dark brown. Her clothing signals her diasporic roots—a red and green headscarf matches a wrap pinned loosely around her shoulders, and on her wrist the light catches on a bangle of shell or quill. In this portrait, Jones makes powerful use of impasto, literally building up the folds of the cloth and edges of the jewelry with paint.

The painting is striking for several reasons. First, Jones's choice of a horizontal composition is unusual, as her portraits tend to be vertical in orientation. Second, her attention to the sitter's accessories (the bracelet, shoulder pin, and gold hoop earring) and their compositional draw is remarkable. With her positioning of Jeanne against a wall whose colors cover the spectrum of black skin tones and her focus on Jeanne's visage, clothing, and accessory choices, Jones emphasizes the combinatory effect on the formation of her sitter's identity.

Jeanne functions as more than just a portrait of a black individual whom Jones encountered while in Paris; the painting illustrates her awareness of and involvement withthe Afrodiasporic intelligentsia. In an undated letter to her mother, Jones described an evening out, attending a production of *La Mère* starring the famed African American contralto Marian Anderson. Bearing Jones's studio address, the letter was written after she moved out of the Achille family home in October 1937. In addition to mentioning Anderson, Jones told her mother that the famous African American expatriate Josephine Baker had married a "wealthy Frenchman this week."[97] Baker wed the French industrialist Jean Lion on November 30, 1937.[98] The letter thus most likely dates to the end of November or beginning of December.[99] Jones told her mother that she, along with her companions, had sent Anderson a "petite box of roses" and had been invited backstage. Anderson, as an esteemed classical singer, and Baker, as an entertainer celebrated for her caricatural performances of blackness, represented nearly polar opposites along the spectrum of black artistic production. While Jones immersed herself in the French art world, it is significant that she paid attention to the European successes and press coverage of the two world-famous African American female performers at a time when she herself was negotiating her own black identity and cultural production.

In the aforementioned letter to her mother, Jones also casually noted: "We went with two girls from Martinique. One is a graduate of The Sorbonne, Jeanne Zamea [*sic*] (now married to a

Fig. 42 Loïs Mailou Jones, *Jeanne, Martiniquaise*, 1938. Oil on canvas, 24 × 28 ½ in. (61 × 72.4 cm). Museum of Fine Arts, Boston. Gift of the Loïs Mailou Jones Pierre-Noël Trust, 2016.1440. Courtesy Loïs Mailou Jones Pierre-Noël Trust. Photo © 2020 Museum of Fine Arts, Boston.

doctor in Guadeloupe) who is visiting her sister, Mademoiselle Nardelle [sic] who is to see the minister of the colonies. I am doing a portrait of Jeanne."[100] *Jeanne, Martiniquaise* is a portrait of Jane Zamia, née Nardal, who would have been in Paris visiting her sister, Paulette Nardal.[101] The Nardal sisters, cousins of Achille, hosted a weekly literary salon and founded the publication of *Revue du monde noir*, a short-lived bilingual journal that was influential in theorizing and promoting black internationalism.[102] Achille most likely facilitated Jones's introduction to his extended family. In the 1930s the Nardal salon was a critical site of cultural exchange between members of the proto-Négritude circle and visiting African American artists, critics, and writers, such as Langston Hughes, Alain Locke, and Claude McKay and the sculptor Augusta Savage.[103]

Jones's connection to Howard University, her relationship with Achille, and (perhaps) her proximity to Locke would have been deeply appealing to the Nardal sisters. Jane had first made contact with Locke in 1927, when she wrote to him about the possibility of translating *The New Negro* for a Francophone audience. Moreover, her 1928 article, "L'Internationalisme noir," published in the inaugural issue of *La Dépêche africaine*, laid the conceptual foundation for the black internationalism that would undergird the Négritude movement in the coming decades.[104]

The identification of Jane Nardal as the sitter in *Jeanne, Martiniquaise* demonstrates that Jones encountered Afrodiasporic individuals from an early stage of her time in Paris, but it also suggests her cognizance of the larger concerns that preoccupied the Nardal sisters, including the global nature of black identity. As the 1940s

wore on, Jones would piece together her ideas on the subject and begin placing them in artistic conversation visually using her blackness-in-triplicate motif. The portrait shows that she, like her African American literary counterparts, engaged with members of the Négritude movement and suggests that works like *Jeanne* should be read through the concepts advanced by the Afrodiasporic theorists with whom Jones interacted. Together, *La Tête d'un nègre* and *Jeanne* should be viewed as Jones's early attempts to explore notions of the African diaspora via the interrogation of human bodies located in interwar Paris. Significantly, this new interest in diasporic subjecthood occurs at the same moment as Jones continued her exploration of African art, begun in the States, on European soil.

Singled Out: The Locke Period

In the fall of 1938, Jones returned reluctantly to her post at Howard University and to the United States' "environment of racial prejudice."[105] Her diaries suggest that she was anxious about her homecoming. Prior to leaving Paris, she wrote, "It's 1938. I'm going back to Washington DC. They're going to discriminate against me when I get back. They're not going to show my paintings. I need to believe in myself. I need to believe that I am a great artist, or I won't survive when I go back. I need to know it's going to be rough."[106] Having given up her Girard Street NW apartment, Jones settled into a new residence at 1858 California Street in the upmarket Kalorama neighborhood and returned to campus.

At this time, Locke approached Jones seeking to reproduce one of her Parisian cityscapes

in his forthcoming *The Negro in Art: A Pictorial Record of the Negro Artist and Negro Theme in Art*. Locke, working with a curator from the Baltimore Museum of Art (BMA), also selected Jones's watercolor *Quarry on the Hudson* for the upcoming exhibition *Contemporary Negro Art*, scheduled for the winter of 1939. Locke included James Lesesne Wells, a colleague of Jones's at Howard, in the show. Undoubtedly Locke took pleasure in excluding Porter, who had negatively reviewed Locke's writing a few years earlier. Jones referred to Locke and Porter's relationship as a "virtual battleground."[107] Her entry into Locke's fold would have pushed her further away from Porter. As the decades wore on, Jones and Porter's relationship would become increasingly strained. By excluding Porter from *Contemporary Negro Art*, Locke sought to control the narrative of African American art told by the exhibition.[108]

Jones's inclusion in *Contemporary Negro Art*, one of the first major exhibitions of African American art put on by a mainstream museum, was critical. It validated her prominent position within the larger field. However, the fact that Jones, along with Baltimore-based artist Florence V. Purivance and New York artist Louise E. Jefferson, were the only women out of the twenty-nine artists illustrated the gender disparity Jones continued to navigate.[109] The lack of female representation in these large survey shows should not be construed as indicating a general lack of black women artists but rather the male domination of the field. Given the role exhibitions and their assorted ephemera play in the construction of art histories, the absence of black women artists has resulted in the ongoing scholarly emphasis on black male artists. Jones's contemporaries

Purivance and Jefferson are but two artists who warrant further study.

Two years after returning from Paris, Jones stood in her studio in Washington, D.C., and painted a self-portrait (see fig. 2). In the resultant work, she positioned herself in the center of the vertical canvas, standing behind an easel and looking unflinchingly out at the viewer. While Jones omits her hands in the bust-length self-portrait, a quartet of upturned paintbrushes extend upward along her right side, waiting to be put to use. She wears a red collared shirt underneath a blue artist's smock. With her short, pressed hair pulled off her face, gold hoop earring, and amulet necklace, Jones presents herself as a modern black woman.

By 1940, having joined the Howard University art department faculty ten years earlier, Jones was thoroughly ensconced in the campus's intellectual and cultural scene. When she completed the self-portrait, she was a confident, young artist working diligently to secure a lasting position within the canon of African American art. She pictures herself in the act of engaging multiple artistic traditions—one European and one African. By painting herself in her studio, denying the viewer access to her canvas in progress, and positioning the viewer as both voyeur and potential subject, Jones places herself in a lineage of Western artists who have worked to elevate the status of the artist through self-portraiture, manifest, for instance, in Diego Velázquez's famous 1636 *Las Meninas* and Artemisia Gentileschi's 1639 self-portrait *La Pittura*. Jones's *Self-Portrait* is her own demonstration piece showcasing her skills, influences, and desire to retain control over her trajectory.

While she peers out over the unseen canvas, the background of the portrait hints at her inspiration, with references to both African and Western artistic traditions. Jones's own 1937 still life *Les Pommes vertes* hangs on the wall behind her (see fig. 34). The painting depicts a basket of apples perched on a wooden chair alongside a white sheet. The work, strongly reminiscent of Cézanne, was exhibited at two prominent Parisian exhibitions—the Société des artistes indépendants and the Société des Artistes Français—and serves as a symbol of her European success. Just over Jones's right shoulder, two wooden African figurines hold guard, evidence of her ongoing interest in African themes and personal collection of African objects. Over the course of her career, Jones acquired a number of African works—including a variety of wooden sculptures, a Dogon granary door, and painted masks from Dahomey. Though the dates of acquisition are unknown, many of these objects are visible in later photographs of Jones in her studio space.[110] Jones locates both her body and her canvas at a crossroads—sandwiched between Western and non-Western artistic traditions and between produced work and work yet to be created.

The multiplicity of paintings and African objects in Jones's *Self-Portrait* is reminiscent of Johnson's 1934 *Self-Portrait: Myself at Work* (see fig. 30), in which the artist portrays himself in his studio before a rendition of his 1932 painting *Negro Masks* (see fig. 29). Johnson's *Self-Portrait* offers another way of reading Jones's 1940 *Self-Portrait*, in which the inclusion of Africa functions as a sign not only of modernity but also of self-referential blackness. In Jones's and Johnson's paintings, the artists are situated in a trajectory in which Africa is in the background or past, operating as artistic inspiration as well as a critical marker of the artist's racial identity. Yet Jones signals an allegiance to European art as well. It is unsurprising that Jones and Johnson would refer to the African roots of African American artistic identity, as both artists came of age during the Harlem Renaissance of the mid-1920s, an era that saw many African American artists called upon to tap into their African heritage vis-à-vis African art in order to cultivate a modern black aesthetic.

The year before completing this *Self-Portrait*, Jones painted the *Under the Influence of the Masters* illustration that graced the cover of the April 1939 issue of the *Negro History Bulletin* (see fig. 1). The artist depicted in *Under the Influence of the Masters* bears a resemblance to Jones. While in her later *Self-Portrait* Jones is located in her studio surrounded by her own sources of artistic inspiration, in *Under the Influence of the Masters* the surnames of major European and American artists swirl around the upper portion of the pictured artist, from her head down to her upper legs, a veritable who's who of Western art history (from left to right): Pablo Picasso, Diego Velázquez, Paul Cézanne, Jean-Baptiste-Camille Corot, Michelangelo Buonarroti, Rembrandt van Rijn, William Hogarth, Winslow Homer, John Singer Sargent, Albert Ryder, John Singleton Copley, George Inness, Mary Cassatt, and Henry Ossawa Tanner. References to Egyptian hieroglyphics and ancient South African cave paintings appear at her feet. From which artistic tradition will inspiration strike? Will the traditions of Western European art history, African art, and American art merge on her canvas? And what direction will the artist take?

Four frieze panels flank the main image, each inscribed with six surnames of African American artists active in the nineteenth and twentieth centuries.[111] Not one to affect false modesty, Jones included her own name in the middle of the third panel below that of her Howard colleague James Porter. Jones's self-inclusion among these key players in the African American art scene proclaims her feminist inclination to write women artists into the art history books.

Only two other women are identified within Jones's illustration. African American realist painter Laura Wheeler Waring (1887–1948) is listed in the first frieze panel, while the name of American impressionist Mary Cassatt (1887–1926) hovers next Jones's palette in the central image. Outside of their shared gender, the trio were unified by their respective trailblazing, artistic contributions, and mutual love of France. The well-heeled, Philadelphia-born Cassatt spent part of her teenage years in Europe before settling permanently in France in 1874, at which time she began exhibiting with the impressionists. In the twentieth century, World War I cut Waring's first visit to France short, and she returned in 1924 and 1929.[112]

Waring, eighteen years older than Jones, offers a compelling corollary to Jones's own career. Both were New Englanders by birth, pursued work as devoted educators at important HBCUs, had great affection for France, and made an artistic career via painting and illustrating. Born in Hartford, Connecticut, Waring spent her adult life in Philadelphia. After her 1914 graduation from the illustrious Pennsylvania Academy of the Fine Arts, she traveled to France. Upon her return, she took a position heading the department of art and music at the African-American Cheyney

Training School for Teachers, later Cheyney University. While Waring spent long hours working at Cheyney, she was able to establish a niche as a portraitist and an illustrator for the NAACP journal, the *Crisis*, and its associated children's publication, the *Brownies*. Her portraits of notable African Americans, which she executed with exacting realism, garnered her acclaim.[113] The *Journal of Negro History*'s 1948 obituary of Waring noted, "She was not influenced by certain popular ideas in art circles and did not participate in the cubist movement or the imitation of African art in vogue. . . . She adhered to classical standards."[114] At times, Jones, too, veered away from artistic fads.

Four months before the *Negro History Bulletin* published *Under the Influence of the Masters*, African American expatriate artist Albert Alexander Smith wrote to Jones from Paris.[115] After a brief exchange of holiday pleasantries, Smith offered Jones some advice: "Don't let them change your style nor your outlook. I thought you may have been 'thumbed down' for not painting African subjects. That is all they expect us to be sufficiently capable of handling."[116] His words referred to the reductive belief held by many white critics that African American artists could only paint "African subjects" and the aesthetic limitations this mistaken idea placed on them. Jones's extensive oeuvre from the 1920s and 1930s, filled with still lifes, landscapes, portraits, and a smattering of African-themed works, demonstrates that she was quite adept at handling a variety of subjects and was unafraid to deviate from expectations.

Jones also experienced the challenges of reentry after time abroad. Smith wrote: "I guess you do feel that invisible curtain between the races whenever you try to step a bit off of our

chosen path. When you have tasted this part of the world and forget your color it is mighty hard to match your thoughts and steps with the American tempo. . . . We can all take a good crack at the African stuff but there are a few of us that can paint a decent picture to hang along the walls favorable with our white brethren."[117] Upon her return from Paris, Jones found herself caught between her Howard colleagues Locke and Porter, who took opposing stances vis-à-vis the trajectory of African American art—Locke advocating for the embrace of African aesthetics and Porter promoting a more homegrown American approach. Jones played to both sides, though she was quick to note, "Professor Herring recruited me in 1929 because of my design work and my French Impressionist studies, not because of my Negro things."[118] Just as the artist stands amid the swirling names in *Under the Influence of the Masters*, Jones pictured herself on her chosen artistic path—one that occupied a middle ground and drew freely from European, American, and African aesthetics.

While Smith's letter suggests that Jones had not been painting African subjects during the 1930s, she was, in fact, interested in such material. African-themed paintings were a significant part of Jones's work from early in her tenure at Howard. Her Parisian sabbatical became the first of several important trips in which her engagement with Africa evolved from contact with African art objects to relationships with Afrodiasporic peoples. Jones's Parisian tenure and subsequent engagement with African art marked the first of several major aesthetic transformations that would occur over the course of her lengthy career. Unlike Jones's Southern landscapes that reflected the

distance she felt from Southern African Americans she met while living in North Carolina, in Paris she found acceptance within two important circles: the emergent Afrodiasporic intellectual community and the white French art world. All of Jones's artistic, cultural, and personal experiences in Paris—her studies at the Académie Julian, her painting in plein air, her exploration of African art, and her interactions with Afrodiasporic peoples—melded and informed her aesthetic. Jones's art from the 1930s onward illustrated the myriad roles Africa took in constructions of modernist African American art.

Smith's yuletide comments reverberated through Jones's painting practice. During the months before *Under the Influence of the Masters* was printed, the African American actor Leigh Whipper posed for Jones at her studio in Washington, D.C.[119] Whipper had starred in the 1927 Broadway hit *Porgy and Bess* along with Jones's longtime friend Dorothy West, who had perhaps facilitated their introduction.[120] In *Dans un Café à Paris* (1939), Whipper sits unhurried at a café table, with a half-empty bottle of rosé and two sandwiches on a plate before him (fig. 43). The café table extends past the edge of the canvas, implying that the viewer, too, is in the café. With his shoulders hunched and his arms crossed in front of him on the table, Whipper looks pensively into the distance beyond the edges of the composition.

Jones's decision to picture Whipper in Paris rather than in New York (where he lived) or Washington, D.C. (where he sat for the portrait) is significant. With Jones's depiction of the solitary café patron and her use of gray tones with sketchy brushstrokes, *Dans un Café* amalgamates elements of impressionist and postimpressionist

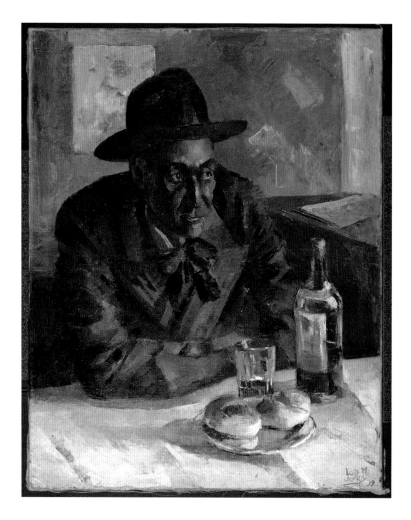

Fig. 43 Loïs Mailou Jones, *Dans un Café à Paris (Leigh Whipper)*, 1939. Oil on canvas, 36 × 29 in. (91.4 × 73.7 cm). Brooklyn Museum, Brooklyn Museum Fund for African American Art and gift of Auldlyn Higgins Williams and E. T. Williams Jr., 2012.1. Courtesy Loïs Mailou Jones Pierre-Noël Trust.

paintings by the likes of Cézanne (*Man Smoking a Pipe*, 1890–92, Hermitage Museum) and Edgar Degas (*Dans un café*, 1876, Musée d'Orsay). In the former, a lone man sits at a table and leans on his elbow with his hand on his hip, his face reflecting his pose's casual ennui. A small still life composed of a pair of glass bottles and a trio of apples appears in the background just over his bent elbow. However, Jones's portrait of Whipper is more than a mere document of her facility with the aesthetic trends in French art. *Dans un Café*

speaks to a sense of longing Jones felt for Paris, its cosmopolitanism, and the freedom the city afforded African American artists like herself. Yet Whipper, as pictured by Jones, also appears lonely, cornered by the tables, and not out practicing his craft. Similarly, Jones was in Washington, D.C., where the trappings of her teaching job at Howard and her lack of recognition left her waiting for an opportunity to go elsewhere. In fact, Jones did want to be somewhere else—Paris—but the turmoil associated with World War II made that

dream impossible to realize. Jones was comforted by her French friend Tarbary, who was living with Jones, having been stranded in the United States as a result of the war.

Jones painted Whipper at a time when Locke was encouraging her to "re-evaluate her subject matter and to take her heritage more seriously."[121] He was referring to African art and culture, Jones's experiences as an African American woman, and the notion of a generalized black experience. The representational paintings of African Americans that Jones produced at the end of the 1930s and into the 1940s—including *Dans un Café à Paris* from 1939, *Jennie* from 1943, and *Mob Victim (Meditation)* from 1944—are thus considered part of her "Locke period," with their careful, realistic portrayals of black subjects.[122] That Jones also painted a number of prominent black cultural figures during this period—among them Cuban actress Eusebia Cosme and African American opera singer Lillian Evanti—indicates the larger social network within which Jones was involved.

Placing Jones's quasi social-realist portraits of the 1940s alongside the portraits she completed in Paris, however, elucidates the simultaneous presence of multiple black identities in her work, some of which are fundamentally American, African, or Afrodiasporic in nature. In other words, Jones's portraits explore the many facets of black identity by including black subjects who are identified via title as being American, African, or Afrodiasporic.

In each of the abovenamed paintings from the 1940s, a single black figure dominates the composition, engaged in an act of internal contemplation. Leigh Whipper waits at a table in *Dans un Café*. The young girl in *Jennie* stands in a kitchen—her eyes cast downward so that only her lids are visible—preoccupied with scaling a fish. In *Mob Victim (Meditation)*, Jones imagines a man in his final moments of life (fig. 44). At first glance this painting appears as a variation on Jones's social-realist motif. Yet upon a second look, one notes that the victim (a man Jones found walking on U Street in Washington) stands erect against a tree with his hands bound by rope and head raised.[123] The man's upward gaze is directed at the branch of a larger tree, in front of him, from which he is about to be hanged. The title suggests not only the imminent act of lynching but also acts of rumination and remembrance.

While there were only two reported lynchings of African Americans in 1944, the vicious practice was not simply part of the historical past. In fact, Howard University students had protested in support of antilynching legislation as recently as 1934—when fifty-nine students stood silently with nooses hanging around their necks in front of Memorial Continental Hall, the Daughters of the Revolution headquarters.[124] Of the portrait session, Jones recalled, "I remember that I first had a rope around his neck, going up and out of the canvas. But that was an overstatement. So I simplified it."[125] If one looks closely at the area under the subject's beard, there are hints as to where she painted over the original noose. Jones pictures the intensely emotional moment when this man retains his dignity as the final act of his life.

Though happily ensconced in the black intellectual enclave of Howard and the broader community of black Washington, Jones was not immune from racism. Despite the fact that African Americans made up roughly 35 percent of Washington's population, segregation limited Jones's opportunities for exhibiting her work. The

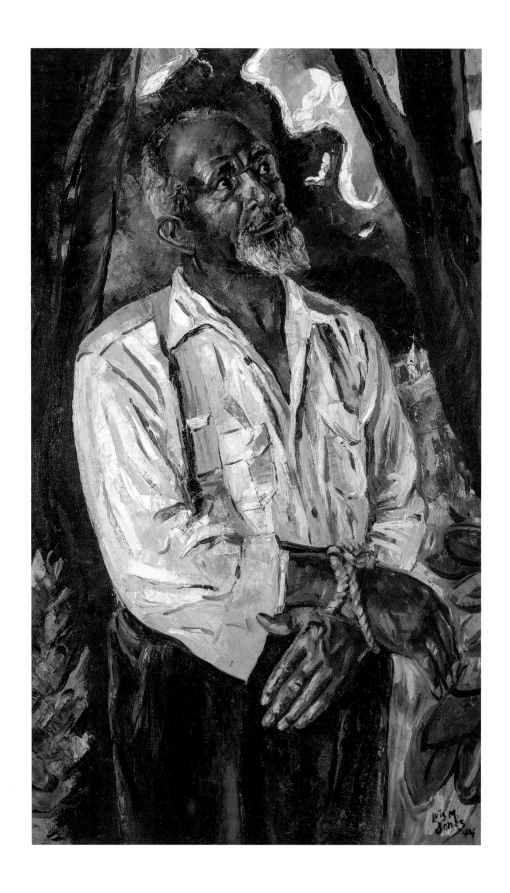

Howard University Gallery and the Barnett-Aden Gallery run by her Howard colleagues James V. Herring and Alonzo Aden were some of the only venues in Washington, D.C., where black artists could present their work and the black public could freely visit. Like many of her contemporaries, Jones had to negotiate a work-around in order to have her art exhibited in mainstream venues. She reported, "I would send or ship my work to the Philadelphia Academy or the National Academy of Design. Invariably, the works would be hung, and they would never know the artist was black. . . . I was exhibiting at all of the big museums, but they never knew that I was black because I either shipped my works or had a white person deliver them."[126] Often it was Jones's Académie Julian classmate and close confidant Céline-Tarbary who submitted Jones's canvases to the white juries of art competitions. Tarbary had fled France at the onset of World War II and returned with Jones to the United States where the pair lived and worked together at Howard.

Seeking Passage to Africa

By 1945 Jones was becoming increasingly restless at Howard and frustrated with the restraints on her ambitions. Ready for a change, in November she applied for a teaching position in the department of design at Brooklyn College.[127] That same year she also sent a proposal to the Julius Rosenwald Fund for additional training in Paris and for further travel to pursue "creative work in

Fig. 44 Loïs Mailou Jones, *Mob Victim (Meditation)*, 1944. Oil on canvas, 41 × 25 in. Courtesy Loïs Mailou Jones Pierre-Noël Trust. Photo © Owen Murphy Jr., 2016.

Painting and studies of the Arts and handicrafts of the Vai and Loma tribes of the North West Province of Liberia, West Africa."[128] President of the Chicago-based retailer Sears, Roebuck, and Co., Julius Rosenwald, founded the eponymous Rosenwald Fund in 1917. The Rosenwald Fund focused its attention on equalizing opportunities for all Americans and is perhaps best known for its support of African American schools in the rural South. Later the Rosenwald Fund provided financial support for African American artists in the form of fellowships during the Great Depression and World War II. In total, the Rosenwald Fund awarded thirty-two fellowships to African American visual artists between 1929 and 1948, when the organization ceased operations.[129] Jones's application suggests that representing and tracing the "idea" of Africa as manifested in the African objects and bodies she experienced in Europe and the United States was not enough for her. Given the racial freedom and artistic inspiration she found in France, it is unsurprising that she sought a way to fund a return to Paris. Although the Rosenwald Fund rejected Jones's proposal, she nonetheless spent the summer of 1945 in her beloved France together with Tarbary. Jones would not realize her goal of traveling to Africa for another twenty years.

Over the decades of her career, Jones became more comfortable in her own blackness and more aware of the different facets of African and Afrodiasporic identities. In the first phases of her career, when she encountered African art and Southern African Americans, she treated these subjects with a sense of studied distance as an outsider. From the 1940s onward, Jones begins to explore the complexities of blackness in her art.

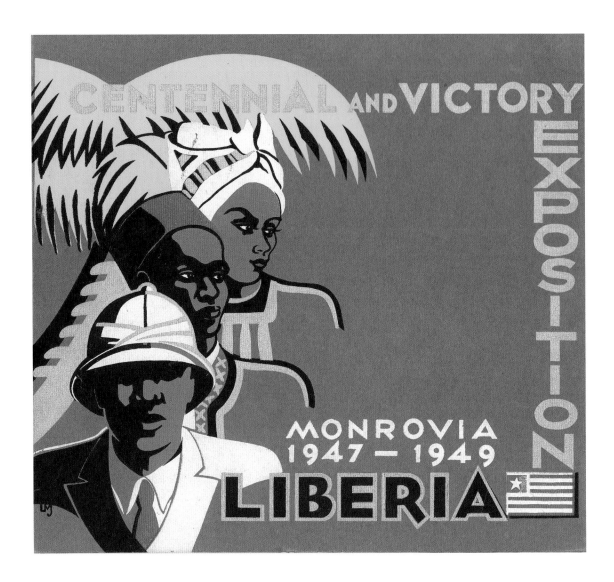

Fig. 45 Loïs Mailou Jones, cover for the Centennial and Victory Exposition pamphlet, ca. 1947. Courtesy Loïs Mailou Jones Pierre-Noël Trust and the Moorland-Spingarn Research Center, Manuscript Division, Howard University, Washington, D.C.

This evolution required her to further investigate black artworks, artifacts, and black bodies.

While she waited for a reply from the Rosenwald Fund, Jones busied herself with work for the Liberian Centennial Commission, which was preparing for the Centennial and Victory Exposition to be held in Monrovia, Liberia, from 1947 to 1949.[130] She and Tarbary also organized a weekly meeting of public art teachers known as the "Little Paris Studio." Her involvement with the Liberian centennial explains her Liberian interest mentioned in her Rosenwald application. Jones's Howard colleague, architect Hilyard Robinson,

served as chair of the United States–based Centennial Commission. Robinson along with Moss Kendrix sought to promote Liberia to the American, especially the African American, public. The exposition was to celebrate the hundredth anniversary of the founding of Liberia as a sovereign state; its additional aim was to promote world peace, based on "cooperation, mutual understanding and progressive enterprise."[131] Ultimately, the exposition never materialized, but Jones's illustrations graced the cover and pages of the hardcover exposition pamphlet published in 1946 to garner publicity (fig. 45).

On the blue linen cover of the volume, Jones utilized a compositional trope I call blackness in triplicate; it portrays three distinct figures and associated identities that press for a move beyond a binary conversation—be it black and white or African and African American. A trio of faces (one female and two male) overlap along the left side of the composition, following the curve of a palm tree. Each visage represents a particular African type. At the bottom, a "colonial" type wears a white pith helmet and a crisp white suit with red tie. Although he is black, his military-inspired uniform suggests ties to colonialism and Western penetration of the African continent. Above him is a "traditional" type, who sports a red fez and an embroidered jacket with gold and black designs. The lone female appears at the top. Her tunic, striped in gold, mirrors the traditional dress of the man directly below her. Her white headscarf is tied with a strip of striped cloth. With its representation of African types, the cover image bears a striking visual affinity to posters produced by the French government for the Exposition Coloniale Internationale in 1931 (fig. 46). Whereas Victor

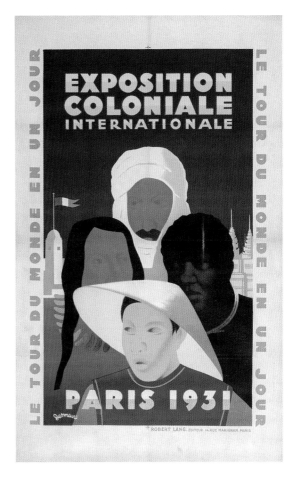

Fig. 46 Victor Desmeures, *Exposition coloniale internationale, Paris*, 1931. Lithograph. Paris: R. Lang, editeur, 1931.

Desmeures's poster for the exposition depicted Asian, native North American Indian, Middle Eastern, and African identities, Jones's Liberian centennial cover celebrated the presence or potential of multiple African identities. The garments of the two top figures blend into the blue ground, whereas the "colonial" figure at the bottom wears a white jacket that is superimposed over it. This design choice results in the separation of the indigenous bodies from that representing the

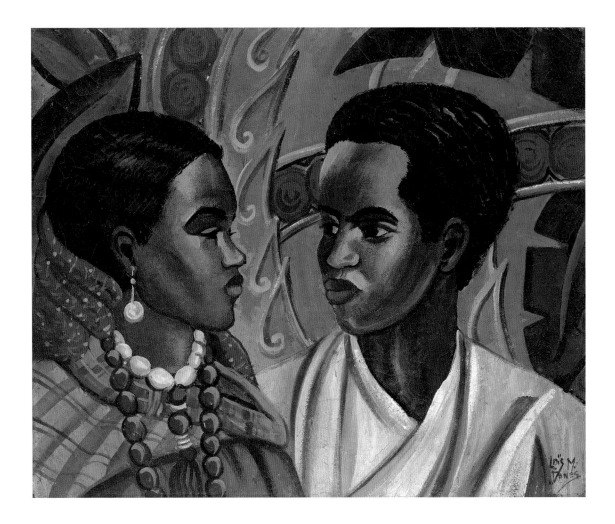

Fig. 47 Loïs Mailou Jones, *The Lovers* (*Somali Friends*), 1950. Casein on canvas, 15 × 18 in. (38.1 × 45.72 cm). National Gallery of Art, Washington, D.C., Corcoran Collection, Museum Purchase from the Estate of Thurlow Evans Tibbs Jr., 2015.19.215. Courtesy Loïs Mailou Jones Pierre-Noël Trust.

oppressive colonial regime. Jones would later expand this visual motif to articulate the African diaspora. Jones's Rosenwald Fund application and her participation in the Centennial and Victory Exposition demonstrate that by the 1940s her conceptions of Africa as an imagined locale were replaced with a strong desire to see the continent firsthand. Neither the Rosenwald grant or the Centennial Exposition materialized, so Jones was forced to find another route to Africa.

Her painting *The Lovers* (1950; also known as *Somali Friends*) evinces a progression in Jones's imagery from African Americans looking at African art objects to people of African descent looking at one another (fig. 47). *The Lovers* is a brightly colored composition that captures the

mutual gaze between a black woman and a black man. Jones's depiction of the couple combines the aesthetic elements developed throughout the first thirty years of her career. The background is graphic and abstract, filled with geometric green palm fronds and an exaggerated curvilinear motif in red and gold, reminiscent of her early textile designs. The pair is clad in clothing that signifies their non-Western status: the young man wears a swath of white fabric wrapped around his body, while the woman is dressed in a mixture of brightly colored and patterned fabrics, her neck adorned with a chunky bead necklace. Jones's treatment of their facial features—highlighted and glossy skin, delineated eyebrows, and angular cheekbones—references the humanized masks of her 1928 *Opportunity* cover. Perhaps not coincidentally, the young woman, with her short, pressed hair, gold earring, and pursed red lips, bears some resemblance to Jones's own *Self-Portrait* from 1940 (see fig. 2). The earlier *Self-Portrait* had a pair of African figurines in the background. With *The Lovers*, Jones signals that she was in contact not only with objects but also with peoples of African descent—here Somalis— in Paris and Washington, D.C.

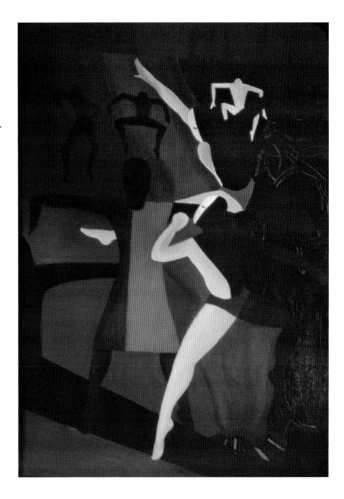

Fig. 48 Loïs Mailou Jones, *La Primus (African Rhythms)*, 1951. Courtesy Moorland-Spingarn Research Center, Manuscript Division, Howard University, Washington, D.C., and Loïs Mailou Jones Pierre-Noël Trust.

La Primus: Bringing Art to Life

In 1952 a French publishing house produced a portfolio of Jones's work entitled *Loïs Mailou Jones: Peintures, 1937–1951*. Jones herself selected the artworks and arranged for one of the introductory essays to be written by her colleague Porter. The book included more than one hundred plates documenting Jones's painting practice from her 1930 arrival in Washington, D.C., through her 1937–38 Parisian sabbatical and subsequent return to Howard in the 1940s. The 1951 painting *La Primus*, known also as *African Rhythms*, is the final work in the oversized volume (fig. 48).[132] Arranged in chronological order, twenty of Jones's French landscapes and still-life paintings precede this composition. In the context of the portfolio, *La Primus* can be read as the capstone of Jones's career

up to that point and the start of a new direction in her artistic trajectory. In title and content, the painting refers to Pearl Primus, the Trinidadian choreographer-turned-anthropologist renowned for her powerful jumps and African-themed dances.[133] Primus, who along with Asadata Dafora played an instrumental role in introducing African dance to the United States, drew inspiration for her choreography from African art. She visited the continent in 1944 and again in 1949. Primus performed her *Dark Rhythms* program at Howard University in late July 1948.[134] The performance most likely inspired Jones's later composition. Many of Primus's dances celebrated the diverse range of Afrodiasporic dance traditions. With *La Primus*, Jones captures both a literal dance performance and the "coming to life" of African art; this painting represents the awakening of an Afrodiasporic art practice of the present moment rather than in the past.

Jones heightened the drama of the composition with her use of light. The billowing orange flames of a burning campfire located at the bottom right of the vertical canvas illuminate the depth of the stage. The backstage area, on the right, is filled with a series of small white-on-black sketches. The imagery, which includes archers hunting antelope and women with enlarged buttocks farming, may allude to the ancient white finger-painted rock art produced by the Bantu-speaking cultural groups of southern Africa. At the top right, a silhouetted white figure is shown midjump. His position is mirrored by a second dancer in all-black. Moving down and forward, another dancer, wearing a black-and-white costume that divides his body in half, leaps toward center stage, legs split. Beneath him, a third dancer, also wearing a

black-and-white costume, steps through the fire onto the main stage. The two leaping dancers are poised to join a fourth figure, who stands at center stage wearing a dress of blue and orange with her arms and legs extended, welcoming them into the fold. Behind this principal dancer, ostensibly Primus herself, appear the silhouettes of two more leaping dancers.

The dancers' split black-and-white bodies possess visual, cultural, and racial significations that, in turn, resonate with Primus's modernizing adaptations of traditional African art forms. Jones's dancers, who are moving from background to foreground and from right to left, are bursting full of life as they step over the flames. As they do so, they are embodying a movement away from ancient Africa, as manifested in the two-dimensional cave paintings (barely discernable in reproductions) and toward the contemporary moment, represented in the center of the canvas. The central figure of *La Primus*, sandwiched between the past and the present, occupies a spatial and conceptual position reminiscent of the artist who stands at the center of *Under the Influence of the Masters*. Both works portray a diachronic progression of the composite black artist. *La Primus* serves as a continuation of the compositional and thematic ideas found in *Under the Influence*. As the capstone of Jones's published portfolio, *La Primus* embodies Jones's own interest in new African and diasporic locales. *La Primus* is one of many examples in which we see Jones experimenting with different modernist aesthetic styles to figure this blackness and to understand its multiple dimensions.

Two years later in 1953, Jones painted an oil painting she titled *Héritage Egyptien* (fig. 49). The

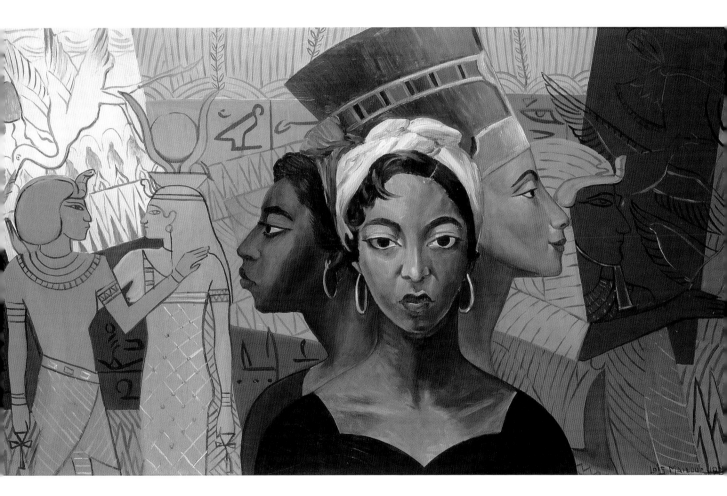

Fig. 49 Loïs Mailou Jones, *Héritage Egyptien*, 1953. Oil on Masonite, 23 ¾ × 40 in. Courtesy Clark Atlanta University Art Collection and Loïs Mailou Jones Pierre-Noël Trust.

busts of three women are set against a graphic backdrop of Egyptian symbols, figures, and glyphs rendered in shades of burnt orange, rust, maroon, and dusty green. Nefertiti, the famed ancient Egyptian queen known for her beauty and power, is shown in profile to the right, wearing her signature crown. In the center, a second woman of African descent is depicted in full-frontal view. In lieu of Nefertiti's regal navy crown, she sports a light-blue headscarf, a curl on her forehead, and large gold hoops that swing from her ears. The sweetheart neckline of her black shirt exposes her décolletage. Her almond-shaped eyes, heavy dark brows, pursed red lips, and delineated cheekbones mirror Nefertiti's features. To the left appears a third female shown in profile, positioned as if she is standing back to back with Nefertiti.

The trio of women might be interpreted as the past, present, and future of the black woman. At first glance, with her blue headscarf, gold hoop, and black shirt, this third woman appears to be the same person as the one pictured in the center. But subtle variations in her facial features indicate that she is a distinct individual. The third woman's nose and chin are slightly more rounded than her counterpart's, and her skin is a few shades darker. Art historian Tritobia Benjamin suggests that *Héritage Egyptien* is another self-portrait of Jones and that "the painting speaks to the symbolic representation of the African in the diaspora, specifically the African American."[135] While the three women, who embody Egypt, Africa, and the black United States, face three different directions with three different shades of black skin, they are connected physically and ancestrally. In her choice of women as the symbols of heritage, Jones

also references the reproductive. Not only are the women in *Héritage Egyptien* "sisters," but they are also potential mothers in their own right, who can create ancestral links and future generations. Of the painting, which won first prize in the 1960 Clark Atlanta Annual exhibition, Jones later wrote, "In *Egyptian Heritage* [sic] . . . I combine the triple influence of Egypt, black America and Africa."[136] With *Héritage Egyptien*, Jones further develops the trope of blackness in triplicate. Whereas Du Bois's notion of double consciousness described the internal conflict of African Americans negotiating their American identities and their Negro souls, Jones offers a new take: the acknowledgment of multiple black identities that possesses African, Afrodiasporic, and African American dimensions—evinced in the three women in the foreground of in the painting.

The interpretation of Jones's work that I present in this chapter, namely that her portraits of black subjects from the 1940s were meditations on blackness in both African American and newly formed Afrodiasporic contexts, draws attention to Jones's growing interest in the myriad faces of blackness. Along with this interest came a related concern with the black body in motion. This new focus mirrored Jones's own expanded travel interests and her new contact with Afrodiasporic peoples. Jones's use of French for the paintings' titles acknowledges her affinity for Paris and nods to the intellectual and artistic importance of the Francophone black world for her art. Jones joined a global conversation on blackness that stretched between the United States, the Afro-Caribbean, France, and the shores of the African continent.

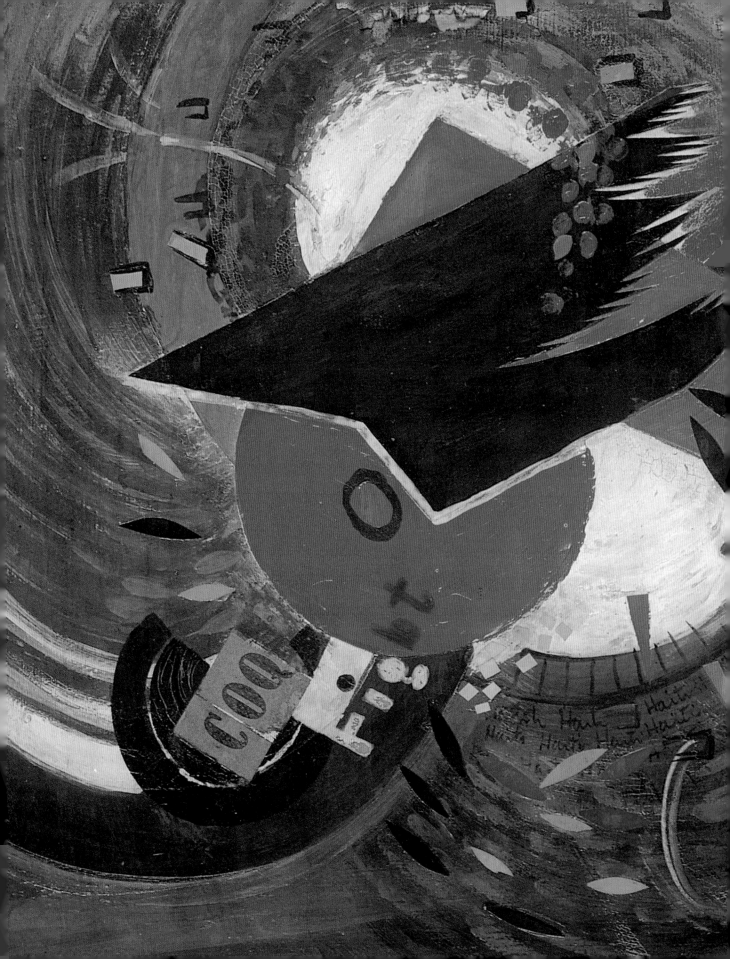

Diasporic Directions
Haiti, Collage, and Composite Aesthetics

3

In 1967, Jones wrote, "I have traveled extensively—finding new material for new expressions."[1] For Jones as well as for a number of her fellow artists who traveled first to France in the 1920s and 1930s, Haiti emerged as a pivotal second waypoint to explore the African diaspora. Jones's trips to Haiti during the 1950s and 1960s in particular proved critical to her praxis. She noted: "My recent paintings of Haitian themes have introduced a decorative trend in a highly-keyed palette, resultant from my special interest in the happy spirit of the people as well as their underlying sorrow, the exotic tropicality evident in the market places and on the sea coast as well as the Vodou symbols of which I have made a special study."[2] Thirteen years earlier Jones had visited Haiti for the first time in service of an artistic commission issued by then-president Paul Magloire. The 1954 trip was the first of many Jones would take over the course of her career. With her Caribbean travel Jones established a triangular route that

crisscrossed the Atlantic, taking her from the United States to Haiti and to continental Europe.[3]

Decades later in a 1995 *Washington Post* interview, Jones named more explicitly the sources for her Haitian-inspired art work—"African aesthetics"—and elaborated on her experiences in Haiti as a time of "learning a new vocabulary: the colors, the patterns, the different cultural traits and practices."[4] Jones's first encounter with this "new vocabulary," which took visual, verbal, and other cultural forms, came in the summer of 1954, when Magloire invited her to Haiti to paint pictures of the landscape and people.[5] The commission was an extension of an ongoing tourism campaign begun under Magloire's predecessor, Dumarsais Estimé, who sought to capitalize on the marketability of Haitian folklore to the American and European tourists who flocked to the island in droves searching for the "exotic" during the 1940s and 1950s.[6] Jones's first trip to Haiti also served as a belated honeymoon: the previous year she had married Haitian graphic designer Louis Vergniaud Pierre-Noël in the South of France. The "new vocabulary" Jones acquired in Haiti included the visual culture of Vodou that gradually influenced her practice between 1954 and 1964. It propelled her aesthetic move from the representational to the increasingly abstract. Her artistic and professional activities both in Haiti and in the United States during the 1953–68 period reveal a dramatic transformation of her aesthetic and an engagement with not only Haitian but also African subjects that became more nuanced.

Jones's marriage to Pierre-Noël brought her into the fold of Haitian society.[7] The pair first met in 1934 during a summer design course at Columbia University. They enjoyed a summer romance and corresponded after Jones returned to Howard but eventually fell out of touch. When Pierre-Noël reappeared in Jones's life in the spring of 1953, she had been engaged to a white man, Eric Feher, a Hungarian artist she had met in France. Quickly smitten once more with Pierre-Noël, Jones wasted no time in breaking off her engagement with Feher. She and Pierre-Noël wed on August eighth in Cabris, France, home to her longtime friend Tarbary. Jones and Pierre-Noël lived apart during the early years of their marriage as Pierre-Noël sorted out visa issues. The 1954 invitation from Magloire was most welcome as it brought the couple together after months of separation. They would spend part of each summer between 1954 and 1962 in Port-au-Prince. In the late 1970s, Jones began spending as much as six months a year working in Haiti, where she maintained a studio.

Like those of many of her artistic predecessors who visited Haiti, Jones's Haitian artworks from her early visits in 1954 and 1955 were a mix of representational landscapes, market scenes, type portraits, and other genre paintings. These watercolors conformed to the objectives of her initial commission, as they presented the Haitian people and countryside in accessible forms pleasing to tourists and non-visitors alike. The paintings formed part of a larger creative ethnography of Haiti produced by artists and writers in the early to mid-twentieth century.[8] But her exposure to Haitian visual culture stimulated Jones to adopt a "highly-keyed palette," while her "special study" of Vodou, comprising figural representations of deities, ceremonial performances, three-dimensional assemblages of ritual offerings, and vèvè (emblematic drawings), ultimately led her to collage.[9]

With several trips to Haiti under her belt in the early 1960s, Jones produced a small number of collages on the subject of Haitian Vodou. In light of her early career, it is tempting to dismiss them as anomalies; before 1954, Jones worked almost exclusively in watercolor and oil, with the occasional foray into charcoal and gouache. At first glance, these collages, apart from their Haitian subject matter, do not appear to fit within Jones's oeuvre. Yet with her collage series, she signals, via title and the incorporation of vèvè drawings, her direct experience and protracted study of Vodou practices. The ceremonial drawings are themselves part of Vodou rituals that layer physical elements; thus Jones's choice of collage is the most appropriate medium for this content.

What are the diasporic connotations of collage? Jones's use of collage to interpret Haitian vernacular religious visual culture into high art was linked to actual cultural practices but also to her struggle to find a suitable visual language for her diasporic encounters. Jones's adoption of collage in the late 1950s, at the very same time that members of the African American avant-garde took up the medium, moved Jones from the middle to the forefront of African American artistic development. In short, her collage works, which first appear in her practice around 1957, represent a period in which Jones was working through changes in her thinking about Haiti and about her art more generally.

Diasporic Literacy: Haiti

The literary critic VèVè A. Clark argues that with the advent of the new international Black Arts and Letters Movement of the 1920s and 1930s, black readers needed "diaspora literacy" in order "to comprehend the literatures of Africa, Afro-America, and the Caribbean from an informed indigenous perspective."[10] Clark describes this literacy as "a skill for both narrator and reader, which demands a knowledge of historical, social, cultural, and political development generated by lived and textual experience. Throughout the twentieth century, diaspora literacy has implied an ease and intimacy with more than one language, with interdisciplinary relations among history, ethnology, and the folklore of regional expression."[11] Literacy speaks to the acts of both consumption (reading) and production or translation (writing); however, because Clark was exploring the diasporic significance of the written word, she made no mention of visual art. One is left wondering how a visual diasporic literacy might look and be achieved. How might an artist demonstrate "an ease and intimacy" with a foreign visual language?

The rise of black internationalism in the 1920s discussed in the previous chapter was characterized in part by the movement of black bodies and black culture within the Atlantic World and as such initiated new discussions around definitions of "diaspora." For my purposes, literary scholar Brent Hayes Edwards's positing of "diaspora [as] a term that marks the ways that internationalism is pursued by translation" is useful.[12] Edwards suggests that the cultural exchanges that diasporas engender necessitate translation between the meeting parties. For Edwards, such translations often took literary form, transforming the foreign language into the native tongue. However, extending the definition of diaspora to include the circulation of aesthetics leads one to question the

contours of diasporic visual aesthetics. Following Clark's definition of a text-based diasporic literacy, a visual diasporic literacy would involve familiarity with diasporic visual languages, an understanding of both their historical significance and their materials, and a basic comprehension of how those visual cultures are deployed.

Clark's definition of diasporic literacy is bound to questions of translation and to those individuals who act as translators among various populations. Due to their facility with multiple languages and cultures, such translators at times inhabit particular subject positions. By commissioning Jones, President Magloire identified her as a suitable translator of tourist-friendly images for American (perhaps specifically African American) consumption. Jones's ability to speak French, a skill she picked up in Paris the previous decade, would prove invaluable given that Haitian French was one of the spoken dialects. In light of Jones's original commission from Magloire, her choice to move from the representational to the abstract is a significant departure.

Clark's conception of diaspora literacy suggests a transformation or an evolution in understanding engendered by such literacy. Dance historian Anthea Kraut, using Clark, has charted the movement from presentations of black primitivism to black diaspora in the dance performances of Josephine Baker, Zora Neale Hurston, and Katherine Dunham.[13] She posits that the "paradigm shift from primitivism to diaspora thus had profound consequences for conceptions of blackness."[14] The evolution of Jones's Haitian painting between 1954 and the mid-1970s also participates in this shift.

In addition to introducing new Vodou-inspired subject matter into her oeuvre, Jones's extended engagements with Haiti altered her view of the African diaspora, which, however, remained reductive at this point. Although her 1953 *Héritage Egyptien* painted a direct line between Egypt, Africa, and black America (see fig. 49), Jones would later say, "For me Haiti is Africa, for it marvelously expresses the roots, links, and ties to mother Africa. I feel that Haiti, black America, and Africa are one."[15] For Jones, Haiti provided one route to her "African" roots. Despite her proclamation, however, Haiti was not Africa, and Jones was responding to cultural retentions and symbolic content that was perceived as representative of Africa by American and European outsiders.

Roots, *links*, and *ties* are all terms for binding agents, but subtle differences distinguish them. A root possesses several connotations. It can refer to the underground ecological support system that gives life to flora, and it is also a point of origin. Roots can be thin, thick, straight, crooked, widespread, or singular. A link is defined both as an individual ring that hooks onto another to form a chain and as a connecting element. A tie is any element used to bind, since tying is the act of binding together, making a bond or a connection. Roots can be read as biological sources, links as connecting chains, and ties as man-made connections or affiliations. Moreover, these roots, links, and ties can take diverse forms. For Jones, Africa was the root, and Haiti was the flower through which the "roots, links, and ties" to Africa were exposed. Yet Americans had a complicated relationship to the nation.

American Perspectives on Haiti and Haitian Vodou

Located 710 miles off the southern coast of Florida, Haiti was both physically accessible to African Americans and, compared to the enormous African continent, easily traversable as well as psychologically manageable. The U.S. occupation of Haiti (1915–34) also kept the country at the forefront of the American national consciousness. The American government had long coveted Haiti as a potential naval base and throughout the nineteenth century sought to prevent foreign occupation or influence by other nations. In the summer of 1915, President Woodrow Wilson approved the dispatch of U.S. troops to Haiti after the assassination of Haitian president Jean Vilbrun Guillaume Sam, ostensibly to restore order. The occupation lasted until 1934, during which time the United States maintained control over the Haitian economy and retained the right to intervene into Haitian affairs whenever it saw fit.[16] African American visitors were fascinated with the country's history as a port of call in the Atlantic slave trade, its successful 1804 slave rebellion that resulted in a black-led government, and its enviable record of independence.[17]

Throughout the first decades of the twentieth century, artists and writers addressed Haiti's connection to the rest of the black world. At the turn of the twentieth century, the African American novelist Pauline Hopkins described Haiti as not just part of the Caribbean archipelago, but as one of "the stepping-stones from the Old World to the New."[18] In 1929 Locke called Haiti "the most favorable reservoir now left of that original

primitive earth religion and fetishism which was transplanted from the old world of Africa in the wake of the slave trade."[19] Writing in 1938, after a seven-week trip to Haiti the year prior, Hurston used familial terms, describing it as "the black daughter of France."[20] Thus by midcentury Haiti occupied a unique position within the Afro-diasporic network. The country had not only historical ties to France and Africa but also political and cultural links to the United States.

When Jones touched down in Haiti in the summer of 1954, she joined a lengthy list of African American cultural producers and artists who had visited the country. For example, choreographer and anthropologist Katherine Dunham first went to Haiti in 1936 with a grant from the Rosenwald Fund. The 1940s and 1950s saw visits from the likes of famed African American theorist W. E. B. Du Bois, experimental filmmaker and anthropologist Maya Deren, and satirist Truman Capote, among others. In subject matter and style, Jones's early paintings followed in the artistic footsteps of other African American visual artists who had traveled to Haiti before her, among them: Robert Douglas, William Edouard Scott, Aaron Douglas, James Porter, and Eldzier Cortor.[21]

Thompson articulates a difference in approach between those artists who traveled to Haiti during the U.S. occupation and those who simply imagined it without ever visiting the country. Those artists who pictured Haiti from afar—Beauford Delaney, Jacob Lawrence, Augusta Savage, and Albert Alexander Smith—tended to celebrate Haiti "as a symbolic rallying point" for the global black community. But the artists who spent time on the ground in Haiti turned their artistic

attention to delineating the differences between themselves and their Haitian contemporaries. Their resultant art "reflected their first hand observations."[22] Thompson concludes that while African American artists who may have sought a "visual language capable of communication with populations across the African diaspora . . . once practiced outside the United States amid lived differences, [the language of pan-Africanism] was unsustainable."[23]

Several years before Jones traveled to Haiti, her Howard University colleague Porter published his travelogue "Picturesque Haiti" in the National Urban League's magazine *Opportunity*. In title, Porter drew upon the aesthetic category of the picturesque. First popularized in late eighteenth-century Britain to describe the allure of seventeenth-century landscape paintings that were all the rage, the picturesque was characterized by its celebration of the wild and pleasing effects of decay that stood in stark contrast to the formal ideals of symmetrical beauty.[24] Thompson has elsewhere argued that within the Caribbean context, artists drew on a different representational language in developing a Caribbean picturesque that highlighted the region as a "picture perfect tropical island."[25] These dueling conceptions of the picturesque offer a framework through which to understand how Porter encountered Haiti. For the essay, Porter personified the island: "Seemingly, nature herself has undertaken the role of welcoming committee, as on either side of the city the traveler observes the slow advance of two great ridges of mountains like the outstretched arms of a body of which the head is the city of Port-au-Prince."[26] Like a favorite aunt, Haiti extended a warm welcome

to Porter and the African American readers of *Opportunity*. Porter brought his readers on a tour from the countryside to the heart of Port-au-Prince in order to illustrate that while Haiti at first appears "picturesque," it is anything but pretty when one becomes aware of the bleak realities of island life.[27] While Jones spent considerably more time in Haiti, her paintings do not expose the harsh living conditions of its people. In contrast, Jones's early Haitian paintings continue to depict the country and its people with the ethnocentric distance that allowed for a picturesque charm. However, as she became increasingly familiar with the country, she moved beyond simple documentation of the Haitian landscape toward a translation of the cultural experience.

Jones's time in Haiti also differed from those of fellow artist Douglas, who visited the country in 1938 under the auspices of a Rosenwald Fund. Douglas's Haiti trip was an extension of a year-long sojourn to the American South. His Rosenwald application materials reveal that he wanted to "record on canvas . . . people of all classes with an eye to revealing racial, social and economic patterns; and pictures of scenes and landmarks, old and new."[28] Douglas's paintings from his Haitian tenure suggest that he was more taken with the country's landscapes than with its lay people. His artistic direction was perhaps due to his lack of language skills necessary to communicate with potential portrait sitters.[29] While *Haitian Street Scene* includes figures, they play second fiddle to the city street, architecture, and vegetation (fig. 50). The shadows that dapple the road and dominate the foreground of the canvas suggest that Douglas captured the activity of the street while perched in the shade. Four black

figures occupy the scene. A Haitian flanêur sporting a light-colored outfit and straw hat enters the street from a path to the left of a garage building with massive green doors. In front of the doors, a man rides a mule, followed by two women who balance baskets laden with fruit and vegetables on their heads, heading along different trajectories. The human figures are small and pictured from such a distance that their unique facial and physical features are indistinguishable. Yet the painting's background is more detailed, filled with a two-storied stucco building, a brick garage with steeply pitched roof, and a stone wall behind which stands a leafy tall tree. The distance of Douglas's compositions, like the Haitian-themed work of other African American contemporaries, kept Haiti at arm's length rather than reflecting sustained engagement with the island's population or culture.[30]

When Locke reviewed Douglas's Haitian paintings for *Opportunity* magazine, he was quick to criticize Douglas for his "retreat from [his] bold earlier style to mild local color impressionism."[31] Locke accused Douglas, then forty years old, of succumbing to an artistic middle age of sorts with his impressionistic Haitian landscapes, which lacked the hard edges and modern zeal of his earlier works that Locke had celebrated during the beginning of the Harlem Renaissance. During the mid-1920s, Locke championed Douglas as the paragon of the African American aesthetic with his silhouetted and stylized figures. Just as Haiti seemed to temper Douglas's palette, Jones's art underwent a dramatic shift as she gradually abandoned her representational, impressionistic style for more abstract, graphic, and brightly colored compositions. By the later years of the decade,

Fig. 50 Aaron Douglas, *Haitian Street Scene*, 1938. Oil on canvas, 18 ⅛ × 20 ¼ in. Collection of the Smithsonian National Museum of African American History and Culture, Washington, D.C., Gift of the Melvin Holmes Collection of African American Art. © 2019 Heirs of Aaron Douglas / Licensed by VAGA at Artists Rights Society (ARS), New York.

Jones's attention had transferred to different aspects of Haitian culture, reflected in her choice of medium.

Jones's travel to and her production of art in varied diasporic locales—be it Paris or Port-au-Prince—necessitates not only the consideration of Jones as a figure of the Black Atlantic but also a consideration of what formal aesthetic elements imbue her art with diasporic qualities. How does Jones's diasporic grammar articulate the disjuncture to which Thompson alludes? Jones's praxis from the late 1950s and early 1960s suggests that the artist had in fact worked out a visual language capable of communicating across multiple planes—collage.

Stereotype-laden, racist imagery of Vodou was pervasive in early to mid-twentieth-century American conceptions of Haiti. Art historian Lindsay Twa describes how cultural productions such as Eugene O'Neill's play *The Emperor Jones* (1920) and Alexander King's illustrations for William Seabrooke's travelogue *The Magic Island* (1928) communicated a host of primitivist tropes for American audiences—blood sacrifice, cannibalism, the traveler as voyeur, to name but a few—that would continue to be taken up in visual and literary forms as the century progressed.[32]

The negative imagery of Haiti was so prevalent in American publications that in 1947 Walter White, executive secretary of the NAACP, noted in a letter to Joseph D. Charles, Haiti's ambassador to the United States, that many Americans viewed Haiti as a "poverty-stricken, illiterate, hopelessly backward country whose people are little removed from the jungle and practically all of whom practice voodoo."[33] The Haitian government responded with a public-relations campaign designed to change the nation's image in the cultural, economic, and political spheres. Poppy Cannon White, Walter White's wife, served as public relations agent.[34] In 1950 the country hosted, at considerable expense, a miniature world's fair of sorts designed to attract tourism revenue. The event was widely covered in *Life* magazine, which dispatched Gordon Parks to produce a photo-essay extoling Haiti's beauty and cultural charms for American readers. The copy, however, included a line that read, "When [the tourist] goes to sleep, in one of Port-au-Prince's old or new hotels, he may hear the faint beating of voodoo drums."[35] The campaign proved successful, as tourism statistics indicate that while only

8,404 people came in 1949, the number of tourists rose to 35,749 by 1953.[36] Thus by the time Jones arrived in the mid-1950s, the tourist campaign to erase the negative stereotypes of Haiti was well underway.

In the late 1940s and early 1950s, the Haitian government commissioned work from three African American artists: sculptor Richmond Barthé, painter Richard Dempsey, and Jones. Barthé, then living in Jamaica, went to Haiti in 1948, asked by then-president Estimé to make two public sculptures for the Palacio Nacional and the Place des Héros de l'Indépendance, one of which was to be a massive equestrian statue of Jean-Jacques Dessalines, the famed leader of the 1804 Haitian Revolt.[37] In 1951 President Magloire invited Dempsey, ostensibly at the impetus of sociologist E. Franklin Frazier, to paint "people and scenes," a mandate similar to the one Jones received two years later.[38] When Dempsey arrived in Haiti, the *Haiti Sun*, the English-language newspaper in Port-au-Prince, reported, "[Dempsey's] work will lead to better cultural relations between Haiti and the United States."[39] Three years later, Jones followed in Barthé's and Dempsey's footsteps. She described her Haitian commission as "a touristic propaganda mission."[40] Jones would go on to become one of Haiti's most prolific African American cultural ambassadors.[41]

First Impressions of Haiti: 1954

Over the course of the summer of 1954, Jones painted close to thirty works in Haiti. Her intense productivity from those few months mirrored that from her 1937–38 sabbatical in Paris. The number of paintings created during these

periods indicate the groundswell of inspiration and creativity these locales offered her. At the summer's end, First Lady Madame Yolette Magloire sponsored an exhibit of Jones's paintings, forty-two in total, completed in Paris, Washington, D.C., and Port-au-Prince at the Centre d'Art, Haiti's leading art school.[42] The First Lady's support for Jones's work was notable, conveying the position of privilege from which Jones encountered Haiti.

Jones's in-laws undoubtedly facilitated some of the artist's connections to the political and social elite in Haiti. Not only was her new husband an internationally known graphic designer, but he was also a member of a prominent Haitian family that was directly descended from Jean Baptiste Point DuSable, the Haitian settler who, in 1779, established the trading post that would become the city of Chicago in Illinois. Pierre-Noël's stepfather, Joseph Cadet Jeremie, was a former chief justice of the Haitian Supreme Court and founded Haiti's first newspaper, *Le Perseverant*.[43]

Before Jones became a student of Haitian culture, her early Haitian watercolors look like ethnographic snapshots. Paintings like the 1954 *Église Saint-Joseph* evince Jones's European training and her status as a touristic observer (fig. 51). In *Église Saint-Joseph*, the yellow church that stands guard over Port-au-Prince appears relegated to the background. Yet Jones places the building at the composition's center, establishing the vanishing point of the orthogonal lines created by the buildings in the foreground. In doing so, she makes the church a subtle organizing element of the picture and of the city. In this way the painting makes Roman Catholicism, then the official religion of Haiti, the heart of Jones's

composition. This focus on the Roman Catholic church embodied the institutional aims of her commission, the creation of a state-sanctioned visual narrative, and gains significance in light of her later engagements with Haitian Vodou.

In another landscape painted that first summer, *Quartier du Fort National*, Jones sketched the goings-on in a residential neighborhood (fig. 52). The peaked roofs of pastel shotgun houses line the right side of a dirt road. In the left foreground, an older black woman sits on her front porch, watching the action in the street. A series of power-line poles dot the dirt road, bringing the viewer's eye from the foreground to the middle of the composition, where a group of women carry goods on their heads. By pairing the modern (the electrical infrastructure) with the rugged (the dirt road), Jones challenges popular conceptions of Haiti as backward and lacking modern progress. The street ends at the ocean, and the horizon line dominates the background. The country's future appears boundless.

As noted in chapter 1, Jones's landscape painting, a mainstay of her artistic practice, dates back to her young adulthood on Martha's Vineyard. Jones's continued return to the genre in European, Haitian, and North American contexts suggests that she was committed to understanding the topography of the places she visited. Jones's perspectival choice in *Quartier du Fort National*, namely an elevated vantage point that appears to be looking down on the vista, resonates with a number of her landscapes completed in France in the early 1950s, among them *Untitled (Landscape France)*, the 1952 *Ville de Houdain*, and her 1955 *Monte Carlo*. In each of these European works, architecture crowds the foreground while

Fig. 51 Loïs Mailou Jones, *Église Saint Joseph*, 1954. Oil on canvas, 23 ⅛ × 28 in. Smithsonian American Art Museum, Washington, D.C., 2006.24.4. Bequest of the artist. Courtesy Loïs Mailou Jones Pierre-Noël Trust.

the background gives way to sweeping vistas of mountains and seascapes. The surveying gaze she adopts in these landscape paintings speaks to her desire to comprehend her surroundings.

Jones's observations of island life continued in *Peasant Girl, Haiti*, also painted in the summer

of 1954 (fig. 53). Here her artistic gaze rests on a young girl seated against a low wall, selling fruit from a basket at her feet. The hustle and bustle of the Haitian marketplace is absent. As in Jones's portraits from the 1940s, the girl's figure fills the compositional frame, and her eyes are averted. But the work's flatness, its pictorial emphasis on the girl's hands and bare feet, and the presence of the rough basket between her legs all indicate a shift from Jones's impressionistic and, more recently, social-realist work from the

Fig. 52 Loïs Maïlou Jones, *Quartier du Fort National*, 1954. Watercolor, 18 × 23 in. Courtesy Loïs Maïlou Jones Pierre-Noël Trust.

1940s. While *Peasant Girl* represents Jones's take on a "type portrait" ubiquitous in Haitian- and American-produced visual imagery, the painting is also an example of her play with space. Her use of a vertical canvas works to compress the composition while the solid block wall in the middle ground presses the figure toward the foreground. Jones could have just as easily encountered the

young girl in the Port-au-Prince marketplace, the front of a postcard, or in the pages of a magazine. In fact, a "type portrait" by photographer Gordon Parks—also titled *Peasant Girl*—depicting a similar young girl leaning against a yellow stucco wall, appeared in the March 13, 1950, issue of *Life* magazine.

Peasant Girl was one of many paintings of women vendors Jones completed while in Haiti. Twa aptly suggests that Jones may have been "sympathetic to the gendered responsibilities and roles she observed in Haitian market women."[44]

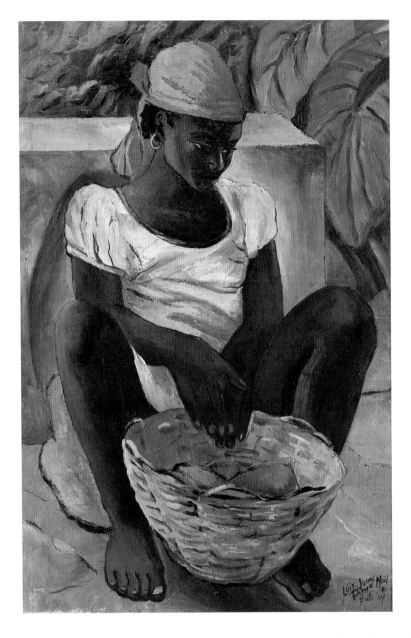

Fig. 53 Loïs Mailou Jones, *Peasant Girl, Haiti,* 1954. Oil on canvas, 31 ¾ × 21 in. Wadsworth Atheneum Museum of Art, Hartford, Connecticut. The Ella Gallup Sumner and Mary Catlin Sumner Collection Fund, endowed by Claire and Millard Pryor in memory of Patricia Wiggins for her years of dedication to the arts and trustee stewardship at the Wadsworth Atheneum Museum of Art and the Amistad Foundation, 1994.1.1. Courtesy Loïs Mailou Jones Pierre-Noël Trust. Photo: Allen Phillips / Wadsworth Atheneum.

Like these women Jones bore the burden of providing financially for her household. In letters exchanged during the first year of their marriage, money appears as a very frequent topic of conversation between Jones and Pierre-Noël.[45] Jones regularly wired money to her husband to help expedite their reunion as he settled debts in Haiti. Like the market women, Jones needed to sell her productions—here paintings rather than picked fruit—in order to survive.

Armed with her social and political connections, Jones had hoped to explore the country in

full. However, writing from Port-au-Prince to Haitian ambassador Jacques N. Léger in Washington, D.C., Jones expressed frustration that a government car had yet to be made available to her, which limited her painting to the confines of the capital city. A vehicle, Jones told Léger, would allow her to paint in the northern coastal city of Cap-Haïtien, in the southern city of Jacamel, and in the western region of Découverte.[46] Such travel would have afforded Jones a fuller view of Haitian topography and culture. In her closing, Jones mentioned that her travel was curtailed due not only to lack of transport but also because she was to begin teaching a course at the Centre d'Art the following week.

Centre d'Art functioned as a key contact zone for Jones during her time in Haiti. It was a place where modernists—Haitian, European, and North American—met. Jones's appointment to teach watercolor painting at the school came due to the absence of its founder, the American DeWitt Peters.[47] Peters had founded the Centre d'Art in 1944, and throughout the 1940s a number of prominent modernist artists and critics visited the school, including the Cuban painter Wilfredo Lam and the French surrealist André Breton. In 1951 African American artist Eldzier Cortor taught at the school for two years. In February 1954, a few months before Jones's arrival, the American collector Joseph Hirshhorn toured the Centre and its galleries.[48] Jones was therefore one of a number of visiting artists and critics who interacted with the Centre's growing student body.

Teaching at the Centre d'Art gave Jones the opportunity to mix and mingle with its artists, among them Robert Saint-Brice, Rigaud Benoit, Wilson Bigaud, and Philomé Obin, who trained,

taught, and sold work at the school. Of her time at Centre d'Art, Jones later said, "The teaching experience . . . put me in touch with the leading artists in Haiti, and I was able to work with them. I found, however, that they were not interested in any training at all. They did not want to know anything about drawing from a model, or about structure, or color theory. They were interested in meeting me as a person, a fellow artist, and in watching me as I taught the younger group of Haitians."[49] Her statement suggests that Jones had expected the "leading artists in Haiti" to be excited about the prospect of being taught by her. The seeming disinterest of the Centre d'Art artists was due in part to Haitian artists' preference for "naïve" rather than academic art, an inclination that the Haitian market supported.[50]

Jones therefore had to shift her perspective, to treat these artists as colleagues and contemporaries rather than students. This shift did not occur overnight. It was the result of Jones's sustained travel to Haiti, which expanded her artistic exploration beyond the bounds of the original tourism-oriented commission that first took her there. During this process, Jones's art moved toward Vodou-themed subjects and the use of collage, leading ultimately to a change in style. In this period, she acquired a new layer of diasporic literacy that built on the cultural awareness she had developed in the art worlds of modernist Washington and Paris.

The summer's end saw the exhibit of Jones's paintings at the Centre d'Art sponsored by First Lady Magloire.[51] The reviews of Jones's early Haitian paintings were positive both in Haiti and in Washington, D.C. When the Haitian newspaper *La Phalange* reported on the First Lady's visit

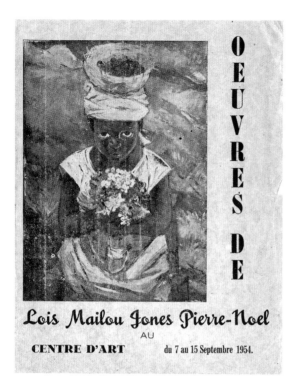

O
E
U
V
R
E
S
D
E

Lois Mailou Jones Pierre-Noel

AU

CENTRE D'ART du 7 au 15 Septembre 1954.

Fig. 54 Exhibition announcement, *Oeuvres de Lois Mailou Jones Pierre-Noel au Centre d'Art*, Sept. 1954. Courtesy Moorland-Spingarn Research Center, Manuscript Division, Howard University, Washington, D.C.

to the exhibition at the Centre d'Art, the writer hailed the show as "an outright success" and said it "could be considered one of the Centre d'Art's most well-organized exhibits."[52] Among Jones's non-Haitian works displayed were the 1944 *Mob Victim* (see fig. 44) and the circa 1950 *Trois Danseurs*.[53] An untitled portrait by Jones accompanied the announcement (fig. 54).[54] The figure of a young peasant girl fills the composition. She sits cross-legged with a woven basket filled with fruit perched atop her wrapped hair. With her head tilted slightly downward, the girl's eyes look upward, squarely engaging the viewer. She

clutches a bouquet of wildflowers in her hands, holding the flowers as if she is about to offer them as a gift to the onlooker.

The Haitian press saw Jones as a gift of sorts to Haiti. Several newspapers that catered to the Haitian elite referred to Jones as *une congénère*, an animal of the same species or fellow creature.[55] In doing so, the newspapers posited Jones as an artist operating within their class-based aesthetics. The Haitian elite revered the European style of painting evinced in Jones's early Haitian works, and the appreciation of European art and aesthetics was seen as a sign of sophistication and class.[56]

As the Centre d'Art exhibition drew to a close, Jones left Haiti in September 1954 to report to her teaching post at Howard University. Soon after her return to the United States, Jones received a commission that asked her to pay homage to the individuals responsible for her initial encounters with Haiti. This time it was American President Dwight D. Eisenhower who did the asking. In January 1955, President Eisenhower hosted Haitian president Magloire and his wife in the United States on an official state visit. The trip took the couple to Washington, D.C., New York, Nashville, Chicago, and Boston.[57] In advance of their visit, Eisenhower commissioned Jones to paint twin portraits of the traveling dignitaries (locations unknown). Jones's rendering of President Magloire depicts the leader wearing a formal black tuxedo and crisp white bowtie (fig. 55). The red and blue presidential sash wraps his torso from shoulder to side, and a string of gold medals referencing his military career is pinned to his right lapel. Magloire's domineering figure fills the canvas. He is pictured against a mountainous background in which Jones has placed

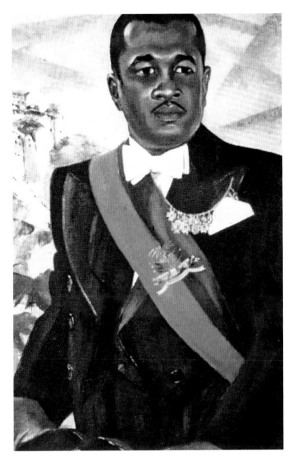

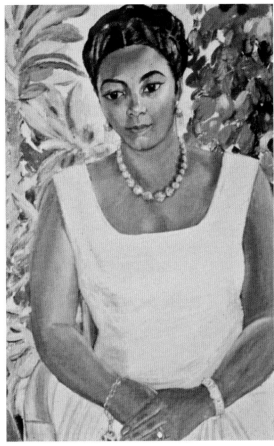

Fig. 55 Loïs Maïlou Jones, *President Paul Magloire*, 1955. Watercolor. Location unknown. Courtesy Loïs Maïlou Jones Pierre-Noël Trust.

Fig. 56 Loïs Maïlou Jones, *Yolette Magloire*, 1955. Watercolor. Location unknown. Courtesy Loïs Maïlou Jones Pierre-Noël Trust.

the ruins of Fort Jacques, a fortification erected during Haiti's nascent independence (1804–6). Located an hour or so outside of Port-au-Prince, the fort was named for Dessalines, the renowned slave-turned-leader of the Haitian Revolution. By pairing the sitting president in the foreground

with the famed landmark in the background, Jones implicitly positioned Magloire in the succession of the important leaders of Haiti's past.

While Jones celebrated President Magloire's leadership, her portrait of his wife focused on the First Lady's feminine qualities (figs. 56 and 57). In the painting, Yolette Leconte Magloire wears a sleeveless yellow dress with her hands crossed demurely in her lap as she sits in a wooden armchair. Heavy gold jewelry adorns her ears and neck, while her wrists each sport golden bracelets. A diamond ring glistens on her the ring finger of her left hand. Jones fills the background with

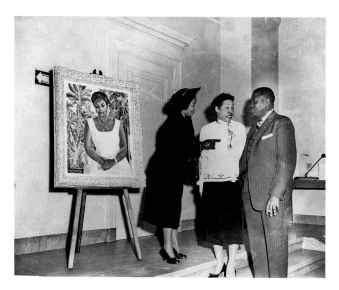

Fig. 57 Loïs Mailou Jones with portrait of Yolette Magloire. Courtesy Moorland-Spingarn Research Center, Manuscript Division, Howard University, Washington, D.C.

and more time in Haiti, new aspects of Haitian culture—specifically the tenets of Vodou—began to appeal to her artistic sensibility.

Jones and Haitian Vodou Post-1954

While Haitian Vodou does not appear in Jones's paintings from her first trip, the religion would come to fascinate her, particularly the vèvè. In a 1974 report prepared for Howard University, Jones called Vodou "the most enriching source of iconography for [Haitian] artists."[59] Widely practiced in Haiti, Vodou is a syncretic religion whose rituals, belief in intermediary spirits, and use of powerful images derive in part from African religious traditions.[60] That Jones would engage with Vodou themes while in Haiti is unsurprising given America's long fascination with the religion and the timing of her trips. But Jones's particular incorporation of Vodou visual motifs and her play with the religion's structural elements or grammar would distinguish her engagement with Vodou from that of her African American artistic contemporaries and facilitate her deployment of a diasporic visual grammar in regards to her compositional construction.

Jones's midcentury arrival in Haiti coincided with a major tourist boom and the associated market for Haitian folklore. As such, Jones's turn to Vodou themes resonated with trends in secular Haitian art of the period. But the Haitian government had not always sanctioned Vodou. In 1935 and again from 1941 to 1942, the Catholic church, in concert with the Haitian government, mounted anti-Vodou crusades that resulted in the destruction not only of places of Vodou worship but also of tens of thousands of objects and

lush flora and fauna executed in burgundies and greens.

Jones painted the sitting president in the months after Hurricane Hazel ripped through the Caribbean and devastated the Haitian economy in the fall of 1954. The portraits of the Magloires were diplomatic gifts and spoke to their ongoing political power at a moment when the Haitian military called that authority into question.[58] The realist watercolors were unveiled after a lunchtime reception at the Pan American Union Building. Two years later in 1956, at the end of his presidential term, Magloire refused to relinquish his position, causing a military reaction that resulted in his resignation and ultimate exile. Despite the political turmoil that would plague Haiti in the coming years, Jones maintained her relationship to the nation. As she spent more

images associated with Vodou practices.[61] In many ways, this war against Vodou forced a secularization of Haitian art. Yet in the 1950s, the Haitian government under the auspices of the ministry of tourism worked with various cultural producers to repackage Vodou as a benign part of Haitian folkloric culture, which enabled it to be marketed to the masses of tourists during that decade.[62]

The burgeoning art market coupled with the earlier anti-Vodou campaign led to a surge in the production of secular Vodou paintings by Haitian artists, artworks not intended for religious practice. Modern Haitian artists such as Castera Bazile, Préfète Duffaut, André Pierre, Rigaud Benoit, Robert Saint-Brice, and Hector Hyppolite, some of whom identified as Vodouists (practitioners of the religion), created a range of Vodou scenes during the late 1940s and 1950s.[63] These paintings ranged from figural representations of *lwas* (deities) to depictions of actual rituals, replete with vèvè drawings, musical instruments, and Vodouists such as the scene in Castera Bazile's 1950 *Petwo Ceremony Commemorating Bwa Kayiman* (fig. 58).

For many Haitian artists, Vodou served as a catalyst for aesthetic innovation.[64] Although some artists, like Saint-Brice, veered toward the abstract in their representations of Vodou, none of them seem to have turned to collage as a vehicle for picturing the religion. Notably, while Jones's visualization of Vodou themes was in step with trends in Haitian art of the era, her special study of vèvès and her later use of collage to depict the subject marked her work as distinctive among her African American counterparts.[65]

Jones's first paintings of Vodou themes subscribe to several of the aforementioned primitivist tropes and differ substantially from her

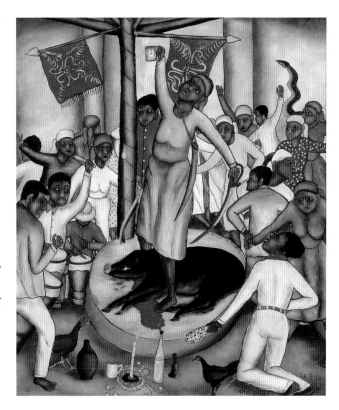

Fig. 58 Castera Bazile, *Petwo Ceremony Commemorating Bwa Kayiman*, 1950. Oil on Masonite, 23 × 19 ¼ in. (58.42 × 48.9 cm). Milwaukee Art Museum, Purchase, Gift of Mr. and Mrs. Richard B. Flagg, M1991.107. Photo: Efraim Lev-er.

later mixed-media engagements with the subject. In her *Voodoo Worshippers, Haiti* (1955), Jones played up the religion's supposedly mysterious qualities in a depiction of three women engaged in a Vodou ritual (fig. 59). Jones's use of perspective and color highlight the allegedly clandestine nature of the ceremony. The spectator is situated behind the three female subjects and sees only their backs. Since the figures are close to the picture plane, the viewer must look beyond the women huddled in a rough circle, heads leaning

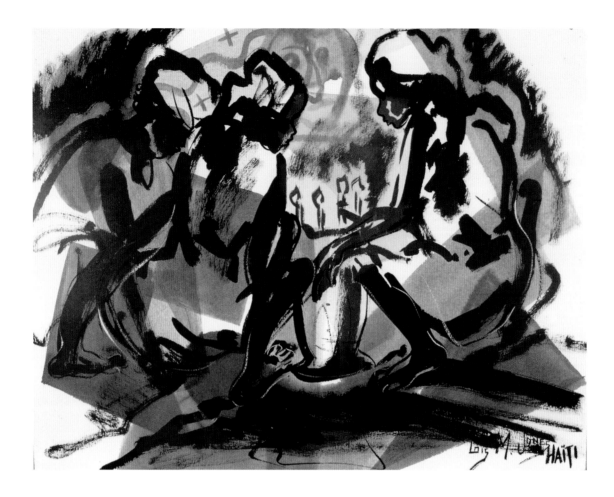

Fig. 59 Loïs Mailou Jones, *Voodoo Worshippers, Haiti*, 1955. Watercolor and brush drawing, 18 ¾ × 23 ½ in. Courtesy Clark Atlanta University Art Collection and the Loïs Mailou Jones Pierre-Noël Trust.

slightly toward its center, to get a partial view of a quartet of lit candles. A gap between the woman on the right and the other two figures on the left gives the viewer a partial glimpse at their clandestine activity. Above and facing outward, an African-inspired mask floats along the top of the composition, partially covered with a light wash of blue paint.

When considered in relation to her later Vodou-themed collages, the distance and figural representation of *Voodoo Worshippers, Haiti* suggest that Jones's awareness of Vodou practices at this point was still linked in part to popular imagery rather than direct observation. Yet the painting's formal qualities indicate her impending move away from the figural to the abstract. Opaque black paint demarcates black skin, whereas the absence of pigment delineates the women's clothing. Jones's visible brushwork lends a sketchy quality to the piece. She painted several flat rectangular areas of unmodulated hues—blue,

pink, purple, and yellow—atop the main scene. With its flat planes of color and the simplified, outlined figures, who can be read as both realistic and abstract, *Voodoo Worshippers, Haiti* incorporates aspects of synthetic cubism popular in the 1910s.[66] The enigma of the painting lies not only with the foreignness of the ritual taking place but also with the challenges of understanding where the figures are in relation to the background and to what is happening. Although the painting is representational, the watercolor marks Jones's transition from genre painting to the beginning of her Haitian-influenced collage aesthetic.

Jones's experimentation with Haitian Vodou and collage appears to have begun in 1956 or 1957. In her 1957 annual report to Howard University detailing her yearly activities in and out of the classroom, Jones lists three Haitian-inspired collage works she exhibited in March 1957—a work titled *Vodoo* displayed at the thirteenth annual exhibition of the Artists Guild of Washington and two others—*Coq Fight* and *Vèvè Voodoo*—which appeared in the *Exhibition of Paintings by Four Area Artists* at the Margaret Dickey Gallery of Art associated with the D.C. Teachers College.[67] The annual report also included reviews of her recent work, one of which described the evolution of Jones's practice. Jones quoted local D.C. reporter Leslie Judd Porter, who wrote, "Jones is moving from an impressionist technique to one with strongly accented patterns which is particularly attractive in the view of the Port d'Haiti and another of Martissant. 'Veve Vodou' is an oil collage in a sophisticated cubist manner, but with voodoo as its subject."[68]

In *Coq Fight* (ca. 1957), Jones employed a collage technique in both title (combining French and English) and form that signaled her shift in approaching her Haitian subject matter (fig. 60). Taken together, the textual elements incorporated into the work indicate its title and the role of cockfighting in Haitian culture. Moreover, in combining French and English text with the popular Haitian pastime, Jones creates a composite that reflects the diasporic nature of her own identity—her facility in French, American English, and Haitian culture. Like her earlier Haitian genre scenes, *Coq Fight* references a popular Haitian pastime. But rather than creating an immediately recognizable subject, here the artist combines painted and mixed-media elements to form the deconstructed rooster that emerges from the kinetic composition. The rooster, fashioned from overlapping black, red, and white shapes, is situated against an earth-toned background of greens and browns. The visible curvilinear brushstrokes Jones employs and floating green and black feather shapes that emanate from the forms in the center signal the swirling chaotic action of the cockfight itself. The word "COQ" (French for rooster) is cut from newspaper and positioned above the painted English word "Fight" in the top right of the vertical composition. The word "Haiti" appears repeatedly in three rows of vertical handwritten text that follow the curve of the circular white form located below "COQ" and "Fight" in the middle-left of the composition. Another newspaper clipping with the words "DU SPORT" appears pasted in the bottom-right corner.

With the collage *Coq Fight*, Jones abandons her concern with the human figure and brings the viewer straight to the action at hand. Her alternating use of black and red shapes creates an oscillating sense of movement. Jones positions

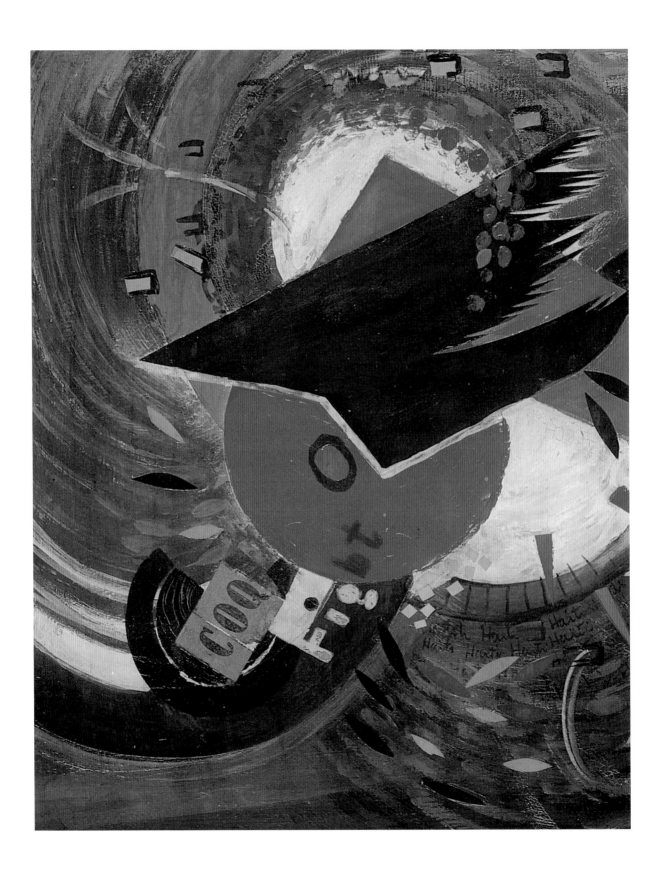

herself not as an outsider looking in on the scene from a distance but as a close observer of the match. Had the previous distance between African Americans and black Haitians eroded in the Haiti of the post-Occupation era? Or did Jones simply feel more comfortable with Haitian culture after five summers in Haiti under her belt? During the 1954–57 period, Jones engaged not only with Vodou themes but also with a synthetic cubist aesthetic that evolved into collage with *Coq Fight*. Jones's experimentation with collage indicates a new interest in the grammar of art making, here inflected with her diasporic experiences. Her production back stateside mirrored this transition as well.

Jones as Diasporic Cultural Ambassador

In the late 1950s and early 1960s, Jones pieced together a range of artistic and personal experiences that hinged upon diasporic encounters both at home and abroad. She and Pierre-Noël continued their practice of spending part of each summer in Haiti. Her direct connection to Ghanaian president Kwame Nkrumah's 1958 visit to the United States (via murals produced for a Washington, D.C., guest house for visiting foreign missionaries), coupled with her ongoing travels to Haiti, hint at Jones's involvement in a cross-cultural network that was developing in Washington among politicians, diplomats, artists, and scholars from the United States, Africa, and

the Afro-Caribbean. She also continued to criss-cross the Atlantic, spending time in the United States, Central Europe, and Haiti. Jones's increasingly peripatetic existence, involving a collage of mixed experiences, made its way into her praxis as well.

Jones painted a pair of murals, *Spirit of Africa* and *A Birth of a New Nation*, in 1953 and 1958, respectively, for the foyer of the National Baptist Convention's Retreat of Foreign Ministries, located at 1022 Maryland Avenue, NE, Washington, D.C. (figs. 61–62). The large works evince the changes occurring on the African continent and Jones's own understanding of them. The residence, located blocks from the Capitol, was at one time a guest house that provided lodging for foreign missionaries on leave from their assignments.[69]

Renowned African American educator and religious leader Nannie H. Burroughs (1879–1961), president of the Woman's Auxiliary of the National Baptist Convention, had commissioned Jones to paint the earlier of the two murals at the Retreat, *Spirit of Africa*. The piece follows the staircase leading to the building's second floor and represents the past, present, and future of Africa (fig. 61). At the top of the stairwell, Jones portrays the continent's past via a group of pyramids and a large African mask; in the middle of the mural, she symbolizes the present with a map of the African continent illustrating the centers of Baptist missionary activity; at the bottom of the stairs, she depicts the future embodied by an African family that reaches upward toward the map and mask. A pamphlet on "The Significance of the Retreat" describes the mural as highlighting "Africa's mighty symbol of STRENGTH, SKILL and

Fig. 60 Loïs Maïlou Jones, *Coq Fight*, ca. 1957. Mixed media on board, 29 × 25 in. Location unknown. From Benjamin, *Life and Art of Loïs Mailou Jones*, 84. Courtesy Loïs Maïlou Jones Pierre-Noël Trust. Photo: Marvin T. Jones.

Fig. 61 Loïs Mailou Jones, *Spirit of Africa*, ca. 1953–54. Mural from the Retreat for Foreign Ministries, 1022 Maryland Ave. NE, Washington, D.C. Courtesy Loïs Mailou Jones Pierre-Noël Trust. Photo: Author.

Fig. 62 Loïs Mailou Jones, *A Birth of a New Nation*, ca. 1958. Mural from the Retreat for Foreign Ministries, 1022 Maryland Ave. NE, Washington, D.C. Courtesy Loïs Mailou Jones Pierre-Noël Trust. Photo: Author.

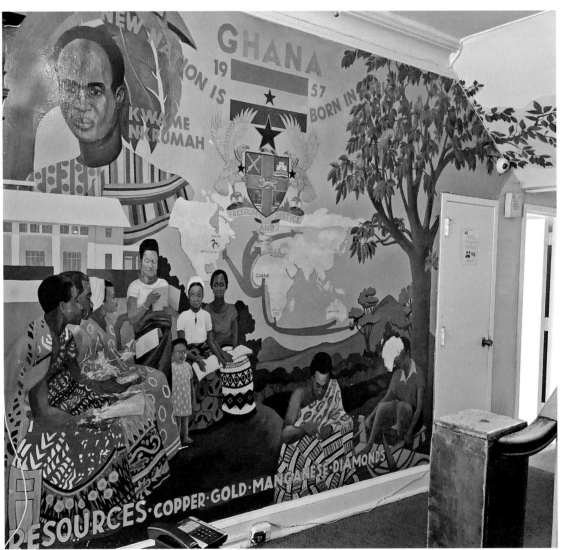

ENDURANCE."[70] The movement from past through present to future mimicked the journeys of the vacationing missionaries staying at the Retreat, whose descent from the upstairs bedrooms would have followed this path from the symbols of Africa's past, through the good work they were doing in the field, and, finally, ending with an image reminding them of their goal: to reach the waiting people of Africa who appear both to welcome the missionaries with open arms and to celebrate their own African past.

At the time Jones painted the *Spirit of Africa* mural, freedom from colonial rule was still only a dream for many African colonies. In an unpublished description of *Spirit of Africa*, Jones explained, "The standing woman [seen at the foot of the stairs] represents the peoples of South Africa as she pleads with outstretched arms for her freedom as she looks towards the map."[71] Her companion who stands behind her is "a typical Liberian man symbolic of his stalwart people and his independent country on the ivory coast." The child in front "symbolizes the Belgian Congo of Central Africa and in general 'all children' of Africa who must be free." She declared the mask "self-explanatory" and noted that the sculptural head "projects from the area of French West Africa," the region from which so many of the African objects she had encountered in Paris were stolen.

In the spring of 1958 Jones returned to the Retreat where she painted *A Birth of a New Nation* to commemorate the forthcoming visit of Ghanaian president Kwame Nkrumah (1902–1972) (fig. 62). This mural is located across the hall from *Spirit of Africa*. The theme of freedom links Jones's two murals together.

Nkrumah had risen to international acclaim as the first president of Ghana, the first sub-Saharan African nation to gain independence from its colonial status.[72] In July 1958, Nkrumah arrived in Washington, D.C., for an official visit that generated substantial public interest. An article in *Jet*, the American weekly magazine targeted to an African American audience, detailed the president's arrival and noted, "[Nkrumah] was prepared to shake some 50,000 hands, give about 25 speeches, and to be honored at upwards of 35 functions in four major cities."[73] In the months just prior to Nkrumah's voyage to the United States, Jones completed *A Birth of a New Nation*, this large mural in his honor. It was mentioned, without reference to its location, in the May 29 issue of *Jet*.[74]

With Jones's acts of selecting and synthesizing elements for the mural, she mirrored the acts of assembling and cutting that she used in her collage works of the early 1960s. *A Birth of a New Nation* is a montage of images on the large foyer wall that pays homage to the many hats the Ghanaian president wore. The left half of the wall includes a photorealist portrait of Nkrumah wearing a Kente cloth wrap; a mixed-gender, multigenerational group of Africans, seated with books in hand as if in the midst of a discussion; and, in the background, a white house. The Ghanaian flag and coat of arms dominate the top and middle of the composition. Beneath them, a world map accompanied by arrows indicates the export of Ghanaian cocoa to the Western world. Jones's map seems to strikingly replicate similar maps that illustrated the exportation of black bodies in the Atlantic slave trade. On the far right a mountainous and tree-filled landscape extends

into the background. Didactic in nature, the mural is further evidence of how Jones negotiated Africa—here through the lens of Ghanaian history—and synthesized these ideas visually for consumption on American soil. Though executed on a flat wall, the mural possesses a multilayered significance. Nkrumah is presented as the personified base on which the future of the younger generation of Ghanaians rests.

Jones's selection of images for the mural is telling: Ghana is a specific geographic locale, a home to educated black peoples, an exporter of goods, and a former colonial state now led by a black man. Having brought Ghana to colonial independence in 1957, Nkrumah advocated African nationalism and Pan-Africanism, which encouraged solidarity (political and otherwise) among peoples of African descent. In the 1950s Nkrumah emerged as the Pan-Africanist movement's most vocal spokesman in politics.

As the 1960s dawned, Jones's murals at the Retreat for Foreign Missionaries called for (in the case of *Spirit of Africa*) and celebrated (in the case of *A Birth of a New Nation*) the wave of colonial independence that was sweeping the African continent. In Washington, D.C., Jones rubbed elbows with members of the diasporic elite at independence parties held at various African embassies, including Gabon, Nigeria, Senegal, Ghana, and Burundi.[75] Jones's interest in Africa and the African diaspora drew diplomatic attention—in 1961, the American consulate in Kingston, Jamaica, gave her name to the U.S. State Department as a potential American specialist for the department's cultural exchange programs.[76] The State Department extended an initial invitation to the University College of the West Indies

but asked Jones to indicate other places she would be willing to visit. Other letters exchanged with the Office of Cultural Exchange Program suggests that Jones had previously applied for service in Africa.[77] Thus Jones's desire to set foot on the African continent remained strong.

Through her faculty position at Howard University, Jones served as a point of contact for African and Afrodiasporic artists traveling in the United States as well. In May 1960, Mary Beattie Brady of the Harmon Foundation wrote to Jones to inform her that Tanzanian painter Sam J. Nitro (1923–1993) from the department of art at Makerere College in Kampala, Uganda, was in Washington with his wife.[78] In the letter, Brady admits that Jones might not "have the time to chase up the Nitros" but suggests that making a connection with them could lead to an "interchange of ideas."[79] The following year, Brady sent Jones materials on contemporary African artists assembled by the foundation for her to use in the classroom.[80] It is unclear whether Jones had solicited the materials from Brady or if Brady knew of Jones's interest in the subject and passed along information accordingly. These instances are cases of people calling upon Jones to serve as a negotiator of ideas between African American, African, and Afrodiasporic peoples; she was recognized as an artistic interlocutor, able to translate and advance African art through her own artwork and her position as art instructor at Howard University. As Jones carried out her mediating role as diplomat of ideas and people, she turned to the collage form and its characteristic use of mixed media to represent diasporic encounters and communicate her sense of the multiplicity of black identities.

Embracing the Collage Aesthetic

In the early 1960s, Jones made a number of small scale collages on the theme of Haitian Vodou: two works sharing the title *Vèvè Vodou II* (1962 and 1963) and *Vèvè Vodou III* (1963).[81] Where Jones's use of newspaper elements in *Coq Fight* had harkened back to the cubists' initial experiments with the collage technique at the turn of the century, in these later works, which took the emblematic drawings known as vèvè as their principal subjects, Jones deployed collage to a different end more reflective of the diaspora.

Jones's knowledge of Vodou practices came from a variety of sources: firsthand experience witnessing rituals in Haiti, books in her library, and an assortment of popular imagery she encountered in Haiti and in the United States. The religion's vèvè drawings, which Jones referred to as "Vodou symbols," were particularly fascinating to the artist. Vodou priests draw vèvè during ceremonies to attract specific gods, in which the emblems function as the base for the multilayered rituals. Vèvès are regarded as diasporic transformations of the symbolic languages used in West African religious traditions.[82]

Typically drawn first around the *poto mitan*, the vertical pole found in the center of the Vodou temple, vèvè serve as "a magic 'support' on which the meaning of this or that ritual service rests."[83] Each vèvè corresponds to a specific deity and possesses unique stylistic elements. The vèvès are not consecrated until three-dimensional objects—beaded rattles, bottles and bowls filled with liquid, shells, or other materials—are placed atop them.[84] In this way, vèvès provide a structure for the ritual; ceremonies take place around and on top of the drawings (fig. 63).

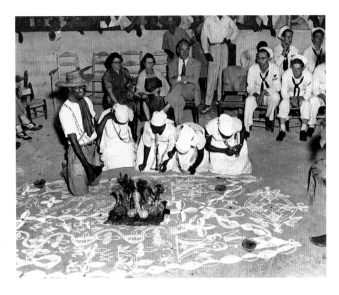

Fig. 63 Voodoo ceremony in Haiti. Photo: Bettmann via Getty Images.

Jones later described to the interviewer Charles Rowell her excitement in watching the vèvè emerge during the various ceremonies she witnessed and how she drew inspiration from the drawings, drumming, and music of the rituals.[85] Jones also owned both volumes of Philippe Sterlin's *Vèvès Vodou* (1953–54), which include full-page colorplates and descriptions of various vèvès (fig. 64). Texts such as Sterlin's became treasured study objects for Jones, and her annotations include two telephone numbers for Sterlin, suggesting they may have spoken directly.[86] Jones may have also seen Hale Woodruff's interpretation of vèvè in his 1950–51 mural suite *The Art of the Negro* at Clark Atlanta University.

During the 1950s and early 1960s, Jones and her husband spent months apart. She taught at Howard in Washington, D.C., while Pierre-Noël stayed in Port-au-Prince trying to secure a visa to enter the

Fig. 64 Loco Atissou. From Sterlin, *Vèvès vodou*, 1:33.

Fig. 65 Néhémy Jean, *Initiation du Houn'sih (Vodou)*, ca. 1968. Courtesy Moorland-Spingarn Research Center, Howard University Archives, Howard University, Washington, D.C.

United States. The pair corresponded frequently via letters, telegrams, and postcards. Dozens of saved postcards fill her archive. Pierre-Noël did not select the postcards he mailed his wife randomly; he noted, "Whenever I send you a Post Card it is because I want you to see some Haitian scenery that might interest you as an artist."[87] Pierre-Noël's cards were adorned with photographs of cockfights, market scenes, various landscapes that undoubtedly made an impression on Jones. Vodou imagery also appeared on postcards Jones saved, such as a color reproduction of Néhémy Jean's painting *Initiation du Houn'sih (Vodou)* (fig. 65). In the narrow, vertical composition, a woman wearing a white dress and red headscarf bends over at an uncomfortable angle while drawing a vèvè in white on the ground. Behind her stands a man holding a ceramic vessel and a gourd rattle enmeshed with beads known as an *ason* and used by priests to conduct Vodou rituals.

Jones's 1962 *Vèvè Vodou II* combines Roman lettering, images, and mixed media (fig. 66). The multilayered nature of the work and the visible glue bubbles convey the process of pasting so central to collage. In the middle of the left and right sides, two words—"Haiti" and "Vodou"—are written repeatedly in black ink on top of the earth-colored paper. Handwritten text also appears along the top and bottom of the composition. At the top, the diagonal script running off the paper names various lwa, the Vodou deities called to the ceremony by both visual and oral means. The lwa named in Jones's collage include, among others (from top to bottom), Azaca (god of agriculture), Agouassou Miroi (protector of Dahomean traditions), Kadja-Bossou (spirit of the Dahomean king Tegbessou), and Damballah-Ossangne (serpent god of wisdom combined with Ogoun Féraille, god of fire and war).[88]

Jones refers to the vèvè in both text and image. The word "veve" [*sic*] is interspersed with the lwa names on the bottom of the paper. The word is again visible in larger script in the middle of the bottom register, while two vèvè drawings appear on either side of the composition. On the right, Jones uses light yellow to execute the vèvè for Aïzan-Véléquété, the god of marketplaces and commerce; her choice of color is reminiscent of the cornmeal powder used to trace the vèvè in Vodou ceremonies.[89] Blue, gray, and brown trapezoidal shapes cover the bottom third of the Aïzan-Véléquété vèvè, perhaps mimicking the added offerings placed atop vèvè drawings during Vodou rituals. Due to the large assortment of geometric forms overlapping at the center of the composition, the viewer gets the sense that other drawings may be located underneath

them, unseen. On the left is the vèvè for Agaou, the widely feared god of thunder and earthquakes.[90] Jones placed the Agaou vèvè atop a cubic form that rises up from the composition's base. Complicating the multilayered nature of the piece is the way part of the Agaou vèvè extends atop the turquoise color field belonging to one of the painted, collaged shapes in the center. Jones bounds the lateral edges of her composition with text; the pairing of "Haiti" and "Vodou" links the country to the religious practice. The visual invocation of text may operate like a chant, causing the reader-viewers of the painting to internalize the names of the gods.

Of Jones's vèvè collages, her *Vèvè Vodou III* is the most didactic, in regard both to its references to Haitian Vodou and to the history of collage as a modernist medium (fig. 67). The horizontal composition is divided into three loose vertical registers and includes a mix of painted and collaged elements. Two vèvès occupy the left and middle, while the top of an African reliquary statue is visible on the right, obscured in part by an encircled gold and green leaf. Two rectangular strips of red with drawn forms bound the top and right side of the god Grand Bois d'Illet. These strips strongly resemble elements from the Marassa vèvè, the associated god of divine twins. As in her *Vèvè Vodou II* collage from 1962 (see fig. 66), Jones filled the composition's margins with text, here a mix of newspaper clippings and painted words. Moving down the left edge from the top, the dispersed clippings read: "Haiti Toujours," "Damballah," and a snippet of French that reads, "Le Mystèr[e] de la femme qui ne vieillit jamais" (The mystery of the woman who never grows old). Along the bottom another newsprint

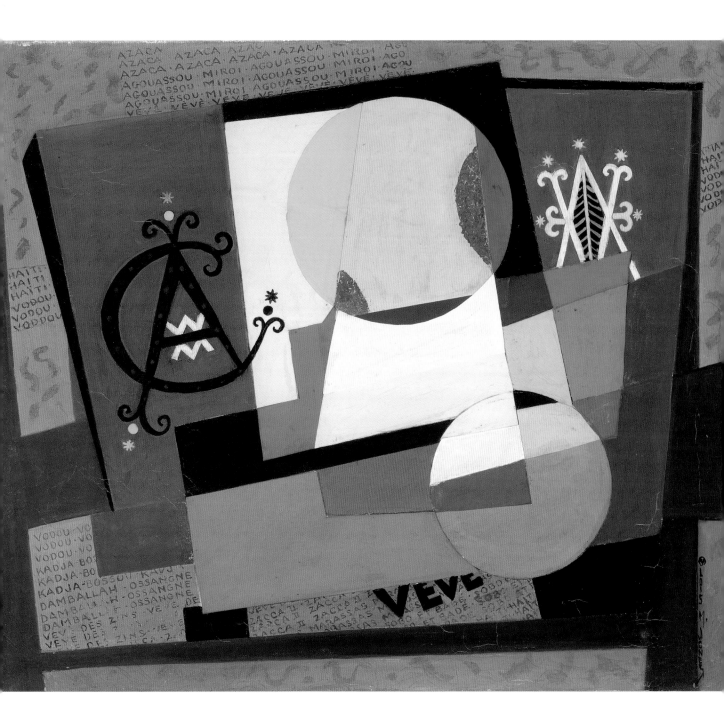

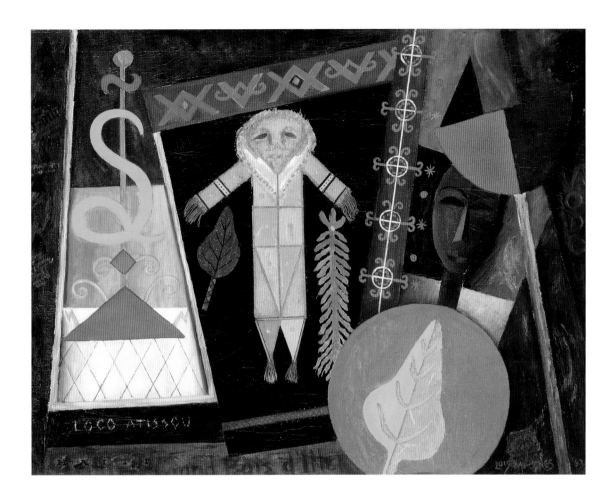

clipping that reads "Haiti" is pasted on top of the painted red base layer. The names of the two gods pictured as vèvès, Loco-Atissou and Grand Bois d'Illet, appear beneath the emblematic drawings at left and center. Last, on the right, emerging from the shadowy dark-blue background, the

Fig. 66 Loïs Mailou Jones, *Vèvè Vodou II*, 1962. Mixed media, 21 × 25 in. Courtesy Loïs Mailou Jones Pierre-Noël Trust.

Fig. 67 Loïs Mailou Jones, *Vèvè Vodou III*, 1963. Collage, 37 × 45 in. Courtesy Loïs Mailou Jones Pierre-Noël Trust.

word "Vodou" glows. Jones's textual inclusions identify the geographic location, reference the specific religion, and identify the vèvès for the viewer.

Jones's choice of vèvès is significant in that they demonstrate her knowledge of the hierarchy within the Vodou religion. On the left is Loco-Atissou, symbolized by a green serpent coiled around a stake (see fig. 64). Loco-Atissou, the patron lwa of all priests, is commonly thought of as the first Vodou priest, father of all initiates, and a god of healing. The anthropomorphic

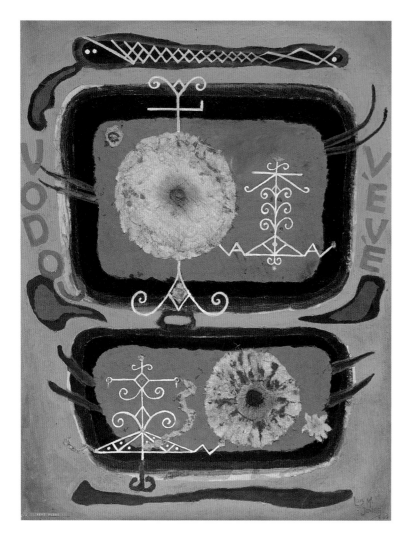

Fig. 68 Loïs Mailou Jones, *Vèvè Vodou II*, 1963. Oil and collage on canvas, 38 × 29 in. Museum of Fine Arts, Boston, Gift of the Loïs Mailou Jones Pierre-Noël Trust, 2006.1449. Courtesy Loïs Mailou Jones Pierre-Noël Trust. Photo © 2020 Museum of Fine Arts, Boston.

figure of Grand Bois d'Illet, or Great Tree, the god of the forest, dominates the center of the composition. Grand Bois is also connected to Damballah, whom Jones invokes on the left via a textural fragment cut from a newspaper that includes the word *Damballah*, thus naming the spirit. The serpent god resides in the branches of the Grand Bois. Like Loco Atissou and Grand Bois, Damballah is a major lwa, known as the Sky Father and the source of all life.[91] By naming Damballah and

including the vèvè of Loco Atissou and Grand Bois, Jones offers her viewer a Haitian Vodou primer of sorts, legible to those with extant knowledge.

For Vodouists participating in initiation rites, the learning and drawing of vèvès forms a critical part of the process. Though not an initiate, Jones articulated in her 1967 artist statement that she too engaged in a special study of vèvè, which had informed her artistic practice.[92] Jones sought not religious initiation but, rather, academic

mastery in order to convey the formal qualities of the Vodou ritual to her viewer. Jones titled these vèvè-themed works numerically—including the two paintings that share the same title, *Vèvè Vodou II*. Her choice to use numerical (and ostensibly nonsequential) titles suggests that she may have viewed them as practice pieces through which she could contemplate and master the creation of vèvès in the same way a Vodou initiate would. In fact, Jones frequently referred to these vèvè works as a series.

Vertical in orientation, Jones's 1963 *Vèvè Vodou II* (fig. 68) is executed in a muted color palette, with a mix of seemingly unidentifiable shapes and materials painted and pasted on a gray ground. Two oblong shapes outlined in thick bands of black, red, and white occupy the center. The words "Vodou" and "Vèvè" appear in the top half of the collage, extending vertically down the left and right edges of the composition, respectively. In the upper compartment, Jones painted two vèvès in white, with the one on the left partially obscured by a circular papier-mâché form. The legible vèvè on the right belongs to Ogoun Féraille, the lwa of iron and fire. In the lower compartment, a third white vèvè is paired with another circular papier-mâché form. The bottom vèvè represents Damballah-Ossangne, the assimilation of two lwa as described in Sterlin and noted above, who is also hailed as a healer of the sick. Notably, Jones rendered the serpent component of the vèvè using the additive process of papier-mâché rather than the typical drawing. Damballah-Ossangne is associated with Ogoun Féraille, which is why the two vèvès share similar visual characteristics.[93] Two brown rods appear at the top and bottom of the canvas; a green diamond design

suggesting a snake's scales adorns the upper rod. Where Jones's earlier version, *Vèvè Vodou II* (1962), was decidedly flat, her 1963 incarnation is emphatically three-dimensional, with ridges of papier-mâché rising off the gray ground. Her play with dimensionality signals another transition in her work facilitated by her adoption of collage.

Uninformed viewers might at first interpret these vèvè compositions solely as abstractions, but Jones is actually presenting a bird's eye perspective of a Vodou ritual. Jones utilizes this overhead perspective in all three of her Vodou-inspired collages. In her 1963 version, Jones abandoned the French textual referents to the lwa found in her 1962 version. Only the title words "Vodou" and "Vèvè" appear, reversed as if the work were a mirror image of the scene. As mentioned, priests draw the vèvès in the beginning stages of a ritual to invite the lwas. Heightening the connection between the religious rite and her artistic translation, Jones repeatedly and extensively reworked the composition, as if mimicking the layers of a Vodou ceremony, which frequently included several phases—the drawing of the vèvès, the layering of material objects on top of and around the vèvès, and the performance of additional elements once the material objects were in place. Here, Jones's use of collage and her deployment of diasporic grammar rooted in the actual practices of Haitian Vodou allow her to visualize multiple and, at times, disjointed perspectives. Moreover, these vèvè collages suggest a different, more participatory kind of diasporic imagery.

As discussed, when priests draw multiple vèvès for ceremonies honoring several lwas, the priests arrange the vèvès into a circular *milokan*

(ritual diagram) around the *poto mitan* (center pole of the peristyle or Vodou temple).[94] While all three of Jones's vèvè-inspired collages include multiple drawn vèvès, she does not arrange them in a circle but rather places the vèvès in distinct vertical or horizontal registers. More than just decorative or ceremonial elements, the vèvès form part of the *logic* of the ceremony in Haitian Vodou ceremonies. According to anthropologist Karen McCarthy Brown, vèvès are part of the metalanguage of Vodou and "are, in themselves, a coherent language system."[95] As such, vèvès require a specific literacy in order to be understood.[96] In using the language of abstraction and collage, Jones renders artworks legible to those who understand modern art. Yet one of the elements that marks these collages as diasporic is the additional layer of meaning for viewers familiar with the ritual practices of Vodou ceremonies.

Jones's vèvè collages call attention to underlying layers and the acts of separation and assembling inherent to the production of these works. I theorize that Jones's turn to collage is directly related to her acquisition of a new diasporic visual vocabulary (specifically, her knowledge of Vodou vèvè) in Haiti. This stylistic transformation culminates in the artist's adoption of a composite aesthetic that characterizes her art production after 1970. It also builds on a diasporic cultural knowledge first acquired through her interactions with the cosmopolitan artistic and intellectual circles at Howard University and in Paris during her 1937–38 sabbatical.[97] Jones's new use of mixed media highlights how an artist can connect collage to conceptions of diaspora and diasporic identity, artistic or otherwise.

The Cut and the Paste: Diasporic Connotations of Collage

Derived from the French verb *coller* (to glue, to paste, or to stick), collage has traditionally been defined as the formation of a composition via the pasting of materials to a flat surface.[98] Cubist collage, with which the European modernists Pablo Picasso and Georges Braque experimented in the first decade of the twentieth century, marked a radical shift in image making, as the papier collé technique insisted on the artist's ability to use "low" materials—newspapers, paper scraps, stenciled letters, and so forth—to make "high" art. Thus collage subverted artistic conventions in the service of creating a new visual language.[99] Often collage is considered strictly as an additive process. In other words, attention is paid to the acts of pasting together or production of the end product. Jones's diasporic *Vèvè Vodou* collages from the early 1960s beg us to question the entire process of production—the acts of selection, cutting, and assembling—in the hopes of finding resolution to diasporic disjuncture.

Jones's turn to collage has previously been seen as evidence of fellow African American artist Romare Bearden's influence. But Bearden and Jones need to be considered together in regard to the advancement of a black collage aesthetic, as Jones's adoption of collage was at the very least simultaneous with Bearden's. In the late summer of 1963, Bearden, along with fellow artists Charles Alston, Norman Lewis, Charles White, and Hale Woodruff, formed an artist collective called Spiral. The group, which eventually numbered fifteen, met regularly in Bearden's New York studio to discuss the role of art and the ongoing struggle for

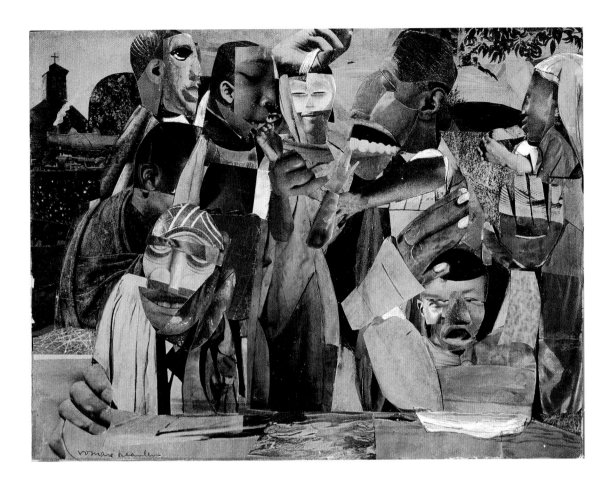

Fig. 69 Romare H. Bearden, *The Prevalence of Ritual: Baptism*, 1964. Photomechanical reproductions, paint, and graphite on board, 9 ⅛ × 12 in. (23.2 × 30.5 cm). Hirshhorn Museum and Sculpture Garden, Washington, D.C. Gift of Joseph H. Hirshhorn, 1966, 66.410. © Romare Bearden Foundation / Licensed by VAGA at Artists Rights Society (ARS), New York. Photo: Cathy Carver / Hirshhorn Museum and Sculpture Garden.

civil rights. Bearden suggested the group produce a collaborative piece using collage. The other members of Spiral were disinterested in the idea, so Bearden forged ahead on his own. The following year Bearden exhibited his Photostat-enlarged collages at his gallery, Cordier & Ekstrom.[100]

According to art historian Kobena Mercer, Bearden's pieced-together fragments of torn paper and photographs form figural groups within "post cubist pictorial space that evoke[d] the turbulent changes in African American life throughout the 20th century."[101] Reading Bearden's collages as "history paintings," Mercer posits that the pieces "disclose an understanding of African American identity as something that has itself been collaged by the vicissitudes of modern history."[102] In photomontages such as his 1964 *The Prevalence of Ritual: Baptism*, Bearden explored his Southern heritage and the fractured

existence of African Americans in the Civil Rights era (fig. 69).

Bearden garnered acclaim for his photomontages and is often credited with championing collage among African American modernists. This approbation comes in part because Bearden worked in New York, the center of the midcentury art world, and because he had regular gallery representation. The significance of Jones's use of the medium—which began on the diasporic periphery in Port-au-Prince—has been buried within the scholarly literature on African American collage.[103] If one believes that Jones's *Coq Fight* was made in 1957, as her annual reports suggest, then Jones's use of collage in fact predates Bearden's. Jones's decision to make collages in the late 1950s and early 1960s placed her on equal footing with members of the African American avant-garde.

The black experience interested both Bearden and Jones, and they both turned to collage in order to express it. Where Bearden mined the pages of *Ebony*, *Jet*, and other black media for source material, Jones's collages quoted Haitian religious symbols and ritual practices. In doing so, her collages make explicit reference to her diasporic position and experiences in Haiti. Moreover, works such as Jones's 1960s-era collages, which deploy diasporic grammar, respond to the combinatory nature of black culture and result in a distinctly modernist black art form.

Jones would also turn to the collage technique to address the black experience in the context of the United States. Jones, like so many of her fellow Americans, found herself preoccupied with the fight for civil rights in the early 1960s. The fractious nature of racism and the struggle for racial

equality inspired Jones's first American-themed collage, the 1964 *Challenge America*, which dealt with the past and present Civil Rights movement (fig. 70). Comprising a mélange of references to the historical and contemporary African American experience, *Challenge America* utilizes a variety of pictured forms (photographic portraits, textual fragments, and objects). One can divide the collage into three registers, the top of which is devoted to celebrating African American achievement, while the bottom two-thirds of the composition focus on the ongoing fight for civil rights. The word *America* appears in red and blue paint on a slight diagonal and marks the division of the top third of the composition. Throughout this top register, Jones pasted penny-sized circular photographs of prominent nineteenth- and twentieth-century African American figures. Among the notable figures are: the hair-care entrepreneur Madame C. J. Walker, the intellectual W. E. B. Du Bois, the abolitionist Sojourner Truth, the classical singer Marian Anderson, and the painter Henry Ossawa Tanner. She placed a newspaper clipping with the text "Blood, Toil, Sweat, and Tears" just above the red portion of America, signaling the perseverance demonstrated by those pictured in order to succeed in their given fields.

In the middle register below the "America" banner, Jones incorporates multiple references

Fig. 70 Loïs Maïlou Jones, *Challenge America*, 1968. Photomechanical reproduction, acrylic, and paper on canvas, 39 ⅛ × 30 ⅛ in. (99.2 × 76.6 cm). Hirshhorn Museum and Sculpture Garden, Washington, D.C. Museum Purchase, 1977. Courtesy Loïs Maïlou Jones Pierre-Noël Trust. Photo: Lee Stalsworth / Hirshhorn Museum and Sculpture Garden.

to those leaders (black and white) credited with advancing the fight for civil rights. For instance, the photo of Dr. Martin Luther King Jr. appears pasted beneath a cropped image of the marble statue of Abraham Lincoln—a reference not only to King's famous "I Have a Dream" speech delivered at the 1963 March on Washington but also to Lincoln's 1863 issuance of the Emancipation Proclamation. To the right of the King/Lincoln pairing in the center of the middle register, a portrait of Thurgood Marshall appears next to a black-and-white drawing of the late president John F. Kennedy, which is glued atop a fluttering American flag. Just above the flag Jones includes an image from Kennedy's 1960 presidential campaign alongside a selection of campaign rally photographs and a circular portrait of Kennedy's vice president and ultimate successor, Lyndon B. Johnson.

While the collage celebrates activists in the Civil Rights movement and advocates for their victories, Jones also includes references to the ongoing struggles. Along the left edge of the composition, a camera lens pasted next to black, red, and white magazine text reading "MISSISSIPPI MONSTERS" alludes to the Southern state's troubled race relations. Moving toward the center, Jones mixes clippings reading "Black Power" and "Civil Rights" with torn photographs of protest marches and activist Malcolm X. The right side of the composition speaks to the United States' advancements in space exploration, with pictures of spacecraft and textual elements referencing "NASA" and the space age. Jones returns to the Civil Rights movement along the bottom of the collage where she pasted three media clippings. On the right, "One Day's March Toward Freedom"

partially obscures the phrase below, which reads "All We Want Is Freedom." Jones binds the edge of the composition with yet another text clipping that includes the first words of the 1819 Declaration of Independence, "We hold these truths . . . to be self-evident."

With its varied formal and collaged elements, *Challenge America* is a medley of blackness in American life and history. While the collage celebrates achievement, it also pays homage to the historical and continuing inequality in the African American experience. The piece also illustrates Jones's engagement with contemporary trends in African American art and her continued preoccupation with the many faces of blackness.

Collage as Diasporic Literacy's Visual Counterpart

From its inception, collage calls into question a host of artistic conventions, including the supposed appropriateness of materials and the ability of art to signify.[104] Characterized by its engagement with and subversion of compositional conventions—the "high" and the "low"—cubist collage can be viewed as a "grammatical" challenge within the realm of Western post-Renaissance artistic traditions.[105] Artists at the start of the twentieth century used collage as a deliberate departure from the tenets of Western art by employing familiar elements in new ways to create new meanings. Discussing the invention of collage, poetry scholar Marjorie Perloff cautions against a reductive definition, stating that "the process of pasting is only the beginning of collage."[106] At its core, as literary scholar Rona Cran notes, "Collage is about encounters. It is

about bringing ideas into conversation with one another."[107] Arguably, pasting is an end phase of collage, which is preceded by the separate acts of selecting materials and cutting. Thus a crucial question emerges: what is the nature of the relationship between the cut and the paste? In other words, how do artists negotiate the temporal gaps and spaces found between the phases of collage—materials selection, cutting, and pasting? How do these phases combine?

Given the conceptual, spatial, and temporal moves implied by the medium, collage emerges as an appropriate means to express the diaspora or the development of a diasporic grammar—a system of composition and structure oriented around diasporic traditions of visual language. In its most basic distillation, grammar is a set of rules or guidelines by which words are arranged to form sentences, to convey meaning. In a similar manner, artists employ a visual grammar predicated upon specific artistic traditions, training, and ways of seeing. Diasporic grammar is not a grammar unto itself; rather it functions as a subversion of an extant grammar from which Western artists are expected to draw: the grammar of the canon of Western art from 1500 to the present. It utilizes a visual vocabulary inflected by the diaspora—which at times is distinctly connected to one region and at others is decidedly Pan-African or Afrodiasporic. In some of Jones's artworks, the diasporic grammar is linked to one region, in while other works, the grammar functions more as a blending of different region-based styles or aesthetics. Moreover, in some cases within a single work, her interaction with and subversion of certain "grammatical rules" of Western art can simultaneously form links to disparate regions and their aesthetics.

Several scholars, among them Brent Edwards, Kobena Mercer, James Snead, and Richard Powell, utilize the concept of the "cut" in relation to the dislocation and disjuncture of black diasporic culture.[108] In Edwards's treatise on the practice of diaspora, the idea of the cut is found in his notion of *décalage* (shift). He writes, "A *décalage* is either a difference or gap in time (advancing or delaying a schedule) or in space (shifting or displacing an object)."[109] It is through décalage, Edwards states, that "articulations of diaspora demand to be approached."[110] Edward's conceptualization of décalage necessitates consideration of composition and structure—in particular that of time and space. Since collage is about cutting and removing an image/object from its original context (historical, material, representational, and so forth), it can be thought of as sharing a conceptual relationship to décalage and hence to diaspora. Thus collage is a privileged language or strategy through which to express the diasporic condition. My notion of diasporic grammar is not married to collage as the only method for expression. Rather, Jones's exploration of Afrodiasporic vocabularies and grammars leads her to use collage as first a literal and later a painted method. Diasporic grammar is connected first to the acquisition of a diasporic visual vocabulary, which Jones accumulated in Paris and in Port-au-Prince. In Paris this diasporic visual vocabulary was comprised of both European, modernist aesthetic trends and African art she encountered in Parisian galleries. Years later while in Haiti, Jones learned a new visual vocabulary related to Haitian Vodou. The décalage she experienced—breaks in time, in space, and of objects—enabled her to formulate a new means of expression for her compositions.

Literary and film scholar James Snead is also taken with the idea of the cut as a formal and aesthetic trope within black culture. Writing about repetition as a distinguishing feature, Snead plays off of the musical definition of cut "as an abrupt, seemingly unmotivated break . . . with a series already in progress and a willed return to a prior series."[111] Following Snead, the cut in black culture is both a point of disjuncture or disruption and a return or a cut back to the beginning. Snead's theory of the cut, with its inherent connotations of temporality, dislocation, and disruption, contends that the cut is an appropriate term with which to think about Afrodiasporic culture.

Mercer's understanding of the cut and collage's relationship to black visual culture is most useful for thinking about Jones's use of collage, as he links the medium to the diaspora in more explicit terms. Writing about Bearden's turn to collage in the mid-1960s, Mercer suggests that it "was indicative of a historic shift in African American culture at large" and encourages us "to think of the formal dynamics of collage as especially relevant to the hyphenated-character of diaspora."[112] It is the very "formal dynamics of collage"—the cut and the paste—that speak to the acts of cultural dislocation and subsequent combination that occurs within diasporas, as peoples, objects, and ideas are removed, relocated, forced to join and at times rejoin new communities and cultures. Cutting and its associated decontextualizing of images contain critical potential—one that Picasso and Braque certainly exploited. Collage is also dialectical, in that the medium allows for the reinsertion of images or text into new statements. Thus collage possesses a formal similarity to the diasporic condition itself,

in which objects and people are inserted into new contexts and are able to produce new meanings.

Where Edwards, Mercer, and Snead concerned themselves with the cut, the art historian Patricia Hills focuses on collage's ability to bind via a discussion of how Romare Bearden's and Jacob Lawrence's adoption of cubist collage enabled them to connect to "cultural practices distinctive to themselves and to the larger diasporic community."[113] Collage afforded African American artists an opportunity to achieve several goals: forge a link with European modernism, draw inspiration from African ancestors, and "fuse . . . cubism . . . with cultural practices from their own African-American communities [for example, quilting and/or the use of pasted-together newspaper images as domestic wallpaper]."[114] Hills aptly proposes that collage "is a dialectical and syncretic process that gives them reasons to perpetuate the cubist collage aesthetic."[115] It is exactly collage's ability to be both dialectical and syncretic—in that the medium is both an investigation of compositional logic and often a synthesis or merging of ideas, objects, and visual languages—that, I posit, led Jones to adopt the technique while she was in Haiti in the 1950s and 1960s.

After her exposure to forms of diasporic visual production in France and Haiti, Jones turned to collage in an effort to work through these new visual languages. By attending to the ways in which collage as a medium and a technique relates to notions of diaspora and black cultural production, Jones's use of it in a Haitian context expands our understanding of African diasporic visual vocabularies and the use of collage in modernist African American art.

Collage offered Jones an opportunity to experiment, to try and make sense of an unfamiliar cultural practice and associated visual language, specifically the vèvè of Haitian Vodou. Her series of collages in the late 1950s and early 1960s is indicative of several changes within her artistic practice and cultural perspective. Jones's sustained engagement with and special focus on vèvè drawings is evidence of her understanding of Vodou ritual practices and the shedding of an outsider's ethnocentric lens—a development reflected in her turn to collage. While scholars like Pat Hills and Kobena Mercer discuss African American modernist collage in relation to African American domestic cultural traditions, West African weaving practices, and contemporary African American history, Jones's exploration of the technique appears to be based on the layering processes of Haitian Vodou ceremonies.[116] Significantly, Jones's use of collage does not signal resolution but, rather, a continued effort to work through ideas with a new visual language and perhaps to introduce not only "new vocabulary" but also the "grammar" derived from the order and function of these elements in their original contexts. Jones's Haitian collages correspond to a distinctly diasporic visual language and respond, through cutting and pasting, to the combinatory nature of black culture and the creation of a modernist form. Ultimately, collage (as an aesthetic *and* as a method) is a fitting visual language for addressing the fragmented nature of the black diaspora.

In November 1968, *Ebony* magazine published a feature story on Jones entitled "Artist of Sunlit Canvases," which included a frontispiece with four of Jones's recent works—two paintings, *The Blue Mask* (1968, location unknown) and *Vendeuses de Tissus* (1961), and two collages, *Challenge America* (1964) and *Vèvè Vodou III* (1963). Noting the diverse subjects of her paintings, the unnamed author remarked that it was Jones's style—her commitment to color, structure, and design—that unified her oeuvre. The fact that two of the four reproduced images were collages highlighted the recent direction in Jones's praxis. In the accompanying text, Jones foreshadowed her next career moves. She emphasized that her current "preoccupation with Haiti" was but one "phase of her interest in 'black art.'"[117] The text continued, "Next on her list is a study of Afro-American painters and a long-awaited trip to Africa."[118] As the 1960s drew to a close, Jones learned she would soon achieve her wish. Her trips to Africa in the 1970s furthered her use of diasporic grammar and its associated collage aesthetic while also enabling her to engage with the growing concerns surrounding definitions of black art and identity.

In and Out

Africa and the Academy

4

In its April 1970 issue, *Art Gallery* magazine posed a provocative question to Jones and a group of ten other black and white artists: "Black Art: What Is It?" The responses were varied. Painter Malcolm Bailey quipped, "There is no definition of black art. It is absurd to take a group of painters, whose various works and concepts differ, and categorizes this group as exponents of black art just because of their skin color." Light artist Tom Lloyd retorted, "What is white art?" Jones responded, "I consider 'black art' a name or a title given to works done by black artists in an effort to bring about an awareness that black artists exist. It establishes for them 'black identity.'"[1] For Jones, the label "black art" offered artists a way in to the exclusionary canon of Western art.

As the 1970s progressed Jones would elaborate further on the challenges she faced as an artist. In 1977, interviewer Theresa Danley asked her to recount an instance in her life where she encountered an obstacle that prevented her from "achieving some goal or desired state of affairs."[2]

Jones rejoined, "To be black and a woman has retarded my acceptance into the mainstream of American art. Only in my late years have I been recognized by the art establishment which should have paid honor to my work much earlier."[3] Then in her early seventies, Jones had spent her entire career working to overcome and to move around the obstacles society placed in her path.

During the 1970s, Jones entered a period of redefinition in which she navigated new geographies in Africa and the African diaspora and new professional situations as she transitioned from faculty member to retiree. Professionally, she found herself negotiating a rapidly changing art department at Howard University. Jones butted heads with the newly appointed department chair, Jeff Donaldson, who had his own ideas about black art and Howard's role in training future generations of black artists. In the increasingly progressive department, Jones acquired yet another label with which she struggled: conservative.

Despite Jones's engagement with the political evinced in *Challenge America* (see fig. 70), her students still considered her conservative, politically and artistically. As the decade progressed, the Howard University student body and the sociopolitical climate of the United States underwent radical shifts that affected Jones's position as both a faculty member and an artist. Her travels to Haiti and then to the African continent did not appear to shift her students' perceptions of her supposed conservatism. Renowned artist and art historian David Driskell, one of her former students recalls, "In the 1950s [Jones] was the entrenched professor. She was the target but she managed to stay above the antibourgeois rhetoric.

Gradually she was recognized for her historic links."[4] At Howard in the mid-1960s, she was seen as a symbol not only of authority on a volatile campus but also of the old guard of artists that stood in the way of younger black artists who were loudly calling for a new African American aesthetic.

The changes that took place at Howard and in the larger art world during the 1970s were not new to Jones. She had witnessed the contours of "black art" shift several times in her lifetime. She had been working as an artist and an art instructor in the mid-1920s when her then-colleague Locke began advocating for a "black aesthetic" rooted in notions of an African ancestral homeland and in the lived realities of the African American experience that promoted positive representations of the race. During the 1940s and 1950s, prejudice dominated the art world, and "black art" was not regularly viewed by the white mainstream. The struggle for civil rights in the 1960s drew new attention to the work of black artists from both those within the race and those outside. As discussed in the previous chapter, Jones followed along as artists like Bearden, Alston, and others sought to reconcile their beliefs concerning the Civil Rights movement and their artistic practice. At the same time, Jones's own understanding of "black art" changed, as her time in Haiti exposed her to new facets of Afrodiasporic identities. In the early 1970s, Jones again found herself weighing different definitions of black art as some more militant African American artists sought to link their work to black separatist politics. She, too, was expanding her definition as four trips to the African continent in 1970, 1972, 1976, and 1977 finally brought her into contact with traditional African

art objects and contemporary African artists on African soil.

True to form, Jones adapted and moved forward aesthetically. The works she produced between 1970 to 1989, the last phase of her lengthy career, illustrate her continued artistic experimentation with a composite aesthetic that involved the mixing of black bodies, black art objects, black geographic locations, and black cultural signifiers. Jones's understanding of Africa had changed since her representations of the black diaspora in the late 1930s, and her later works represent her resistance to a one-dimensional conception of Africa. Read against the larger cultural and political debates about the role of the African continent in conceptions and definitions of "black" identity in the 1970s and 1980s, Jones's use of pastiche as a formal technique during this final period takes on greater significance. The visual diasporic grammar she developed over the course of her career spoke to the presence of multifaceted black identities at the end of the twentieth century. It was also an acknowledgment that a black artist's engagement with Africa need not be unified but rather could be seen as series of breaks and moments of disjuncture.

Two years after her *Art Gallery* magazine response, Jones revised her definition of black art, this time for publication in a catalogue produced in conjunction with her career retrospective at the Howard University Art Gallery in 1972. Jones wrote, "As the movement develops—true black art concentrates almost entirely on The Black Experience."[5] Jones's statement articulated her desire to use art to document or evoke the variety of black life throughout the diaspora. She would elaborate

this move from identity to experience in a later, unpublished treatise she titled "The African Presence in America," in which she explained her view of the significance of Africa to African American artists:

> The Afro-American artist now goes to Africa—in lieu of going to Europe which was the vogue in the early period dating from the mid 1800s into the 20th century—to gain the recognition that this society was not willing to give. Edmonia Lewis, Robert Duncanson, Meta W. Fuller, and Henry O. Tanner. Because of their eagerness to be recognized as "artists" without regard to race, they, with few exceptions, avoided subjects relative to the Black experience. It was not until Afro-American artists began to reveal in their works an awareness to their great heritage: Zimbabwe, Nok, Ife, Benin, the Ashanti Empire—that they achieved the self-definition necessary to develop as an effective creative force.[6]

Jones here charted the occasionally fraught relationship between African American artists and racially themed artwork. She acknowledged that some artists eschewed a racial aesthetic as part of their efforts to be treated as artists, full stop, without ethnic or racial distinction.

Jones's continued refinement of her definition of black art during the 1970s must be considered against two influencing factors. The first is the growing Black Arts Movement (BAM) and Black Power Movement (BPM) of the late 1960s, both of which advocated an increase in African American political involvement, with some factions promoting forms of black nationalism. The second is the expansion of Jones's own understanding of the

black experience over the course of those two years, facilitated in part by her trips to the African continent. While the retrospective offered a look back at the arc of Jones's artistic career, she was looking forward and designing a new course of action.

Howard, the Black Arts Movement, and the Black Power Movement

As Jones gained recognition from the wider arts establishment, her ties to her longtime employer, Howard University, increasingly frayed. In 1977 Jones was unceremoniously forced into retirement. The changes in the department of art, which began with the student unrest of the late 1960s and influenced the faculty make-up in the 1970s, mirrored larger chasms in the art world and shed light on the issues with which Jones wrestled at the end of her Howard tenure: gender politics, growing self-awareness of her own aging, and the mounting tensions within and among African American intellectual and creative circles, parts of which were adopting a more nationalist orientation that sought to cultivate black-oriented cultural and institutional structures.

The Civil Rights movement of the 1950s and early 1960s paved the way for the BPM of the late 1960s and 1970s. The leader of the Student Non-Violent Coordinating Committee (SNCC), Stokely Carmichael, first used the phrase "Black Power" in a June 1966 speech, after his arrest during the final leg of the "March Against Fear."[7] Carmichael's slogan quickly became a call to arms for African Americans. Defined as "an alternative to the ineffectiveness of civil rights demands in critical areas of American life," the BPM

advocated for self-reliance and self-determination while questioning the efficacy of nonviolent approaches and the larger goal of integration.[8] Many Black Power activists aligned ideologically with the black nationalism preached by Malcolm X, who, for a period, called for racial separatism.[9] Black studies scholar and activist Ron Karenga (later Maulana Karenga) exclaimed in his 1968 essay "Black Cultural Nationalism" that black art "must respond positively to the reality of revolution. It must become and remain a part of the revolutionary machinery that moves us to change quickly and creatively. . . . For all art must reflect and support the Black Revolution."[10]

Echoing the language and ideas of the BPM, Larry Neal, de facto spokesman of the BAM, wrote in the movement's unofficial manifesto, "The political values inherent in the Black Power concept are now finding concrete expression in the aesthetics of Afro-American dramatists, poets, choreographers, musicians, and novelists. A main tenet of Black Power is the necessity for black people to define the world in their own terms. The black artist has made the same point in the context of aesthetics."[11] He would go on to call the BAM "the aesthetic and spiritual sister of the Black Power concept."[12] Thus the BAM and BPM were ideologically and aesthetically related and, as a result, saw incidences of overlap in terms of membership, activities, and objectives. The BAM took many forms, institutional and otherwise, across the United States. Beginning in the late 1960s, practitioners and adherents formed a slew of workshops, exhibitions, theater troupes, and other creative outlets, all working to advance the same causes.[13]

The story of the BPM and the BAM is told frequently through the narratives of their male

participants. Despite the domineering masculinity of the two movements, black women played pivotal roles in advancing their messages. Historian Ashley Farmer counters the claim that black men controlled the BPM and argues that black women worked within the movement in ways that were not always visible or legible.[14] Never one for overt political action, Jones contributed to the Black Arts Movement in her own way and, as always, on her own terms.

Jones's papers divulge that she kept abreast of developments in the increasingly politicized African American art world, both on and off Howard's campus.[15] Her archive reveals an interest in the institutional exclusion of African American artists and includes a dog-eared copy of a 1969 issue of the *Metropolitan Museum of Art Bulletin*, which included articles on "The Black Artist in America" and "The Metropolitan Museum of Art: Cultural Power in Time of Crisis."[16] Jones also hung onto the inaugural issue of *Black Shades*, a newsletter first published in October 1970. The preface to *Black Shades* echoed the questioning nature of the *Art Gallery* magazine issue in which Jones partook a few months earlier. "Black Shades is here to answer the question we are certain many Black artists have asked every time we pick up an art magazine—where are we? . . . WE KNOW WE HAVE BEEN EXCLUDED. . . . Our art from our homeland was and still is being physically removed from our mother country and along with this is removed our own natural standards of beauty and creativity. Our standards is what Black Shades is all about."[17] She also kept the program for the 1973 annual meeting of the ASNLH, where panels entitled "Afro-Americans and Africa," "Post-War Protests," "Black College Students,"

"Blacks and the Arts," and "African Nationalism and Black Americans" answered the growing calls for student-oriented activism.[18]

From her faculty position, Jones witnessed student activism first hand. In February and March 1968, students launched protests that nearly shut down Howard University. In an open letter to administrators, students laid out their demands, foremost "that the University begin to move towards becoming a black university."[19] The student body was adamant that Howard must adopt a more "Afro-American orientation" in all aspects: curriculum, racial makeup of faculty, and ideological stances.[20] In keeping with these calls, students affiliated with the department of art began to reject the Western art canon. The wife of department chair James Porter, Howard librarian Dorothy Porter, remembers that her husband was upset about the demand that Howard students only be taught about black art. He insisted that he would "give them African art, Afro-American art, but they will also have Rembrandt, they will also have Baroque art. They'll have it all!"[21] While Porter advocated the importance of the Western art canon, the students did not agree. Student-led protests caused destruction in the Howard Art Gallery. Three paintings were taken from its walls, and one of them—Porter's portrait of congressman Louis Cramton, the namesake of Howard's auditorium—was viciously slashed.[22]

Perhaps influenced by the events on campus that spring and sensing a lacuna of visual materials related to contemporary black art practices, Jones wrote to her dean Warner Lawson that summer: "With the current stress and focus of our leading colleges and museums on 'The Black Arts' I feel that Howard University should certainly

make [a] contribution."[23] On the subject of African art, she added, "There is available visual material on the Primitive Sculpture, and some Crafts and Textiles of Africa, but very limited visual material on contemporary African Sculpture and Painting."[24] She requested research funds to support a three-phase project she titled "The Black Visual Arts: Contemporary Afro-American and Contemporary African Art," which would document the work of contemporary black artists working in Haiti, Africa, and the United States. Ultimately, Jones aimed to compile a photographic archive that Howard students and faculty could use in their research and artistic production. She intended to spend the summer of 1968 completing the first phase of research in Haiti; her second phase of research on African American artists would be ongoing, and she planned to conduct her third phase in Africa during her 1970 sabbatical year.[25] Dean Lawson agreed and supported the proposed research with travel funds.

Jones's development of an art-historical research agenda differed from the work on black art produced by her colleagues Locke and Porter in the 1940s and 1950s—among them Porter's influential 1943 *Modern Negro Art*. Where her male counterparts had woven selected artists and artworks into larger cultural narratives using words and images, Jones sought to produce a strictly visual archive that documented black diasporic art practices. With the archive, Jones could meet the student demand for exposure to black artistic production and provide an alternative mode of learning about black art—one that privileged the act of looking, rather than reading.

With funding for "The Black Visual Arts" project secured, Jones escaped the campus turmoil

and spent the summer of 1968 in Haiti. Just before she left, her longtime colleague Wells retired. The following year, Porter died unexpectedly. Hired by Herring, who founded the department of art, Porter had been, along with Wells and Jones, the core faculty in the department since the 1930s. Jones was the only member of this old guard who continued in the department, where she would come to find herself to be the odd woman out.

Despite Jones's rank as longest-tenured member of the department, after Porter's untimely death there was no talk of her taking over as department chair.[26] Jones was sixty-five, and the administration most likely saw her heading toward retirement rather than assuming a leadership position. During the summer of 1970, while Jones was on a tour of eleven West African nations, the Howard administration installed AfriCOBRA founder Jeff R. Donaldson (1932–2004) as the new department of art chair. Donaldson came to Howard by way of Chicago, where he had cofounded the Organization for Black American Culture (OBAC) and its successor, AfriCOBRA.[27] The members of AfriCOBRA were concerned with creating a new black aesthetic in which African artistic traditions would be combined with more left-leaning sociopolitical ideologies and community engagement.

Donaldson's appointment came after a nationwide search. The committee member's decision was surely influenced by the department of art's statement for the *Howard University Annual Report* of 1969–1970. The blurb noted that "a mood of student discontent hung ominously over the department throughout most of the academic year."[28] Students in the department of art sought black art–themed courses as well as improved

studio space, regular class schedules, revised major requirements, and more readily available art materials. One of the students' major demands was for an art history curriculum that focused solely on black artistic production.[29]

When Donaldson took the helm of the department of art on August 1, 1970, he immediately set about making changes. In his initial correspondence with the faculty, a letter from the end of August delivered just prior to the start of the school year, Donaldson demanded, "Prior to our first meeting will you re-examine your syllabi, re-vaulate [sic] projected experiences, make adjustments, subtract, add to and make changes in the interest of relevance to the overall purpose of the University."[30] Donaldson included an excerpt of Howard president James A. Cheek's inaugural address, delivered in April 1970: "The business of education must be conducted not in the atmosphere of the museum where men are gathered to contemplate the past, but in the atmosphere of the true university where men are gathered to <u>create the future</u>."[31] Donaldson's underlining of the phrase "create the future" evinces his views on the department of art: the faculty and staff were molding the future generation of artists and therefore had to be aware of current trends and ideologies informing artistic practices. As Jones was considered a part of the old guard, she was very much seen as part of the institution's past.

The commitment to teaching students about the black experience was represented in the slew of new courses offered by the faculty. Classes included surveys of African, African American, West African, and Central and East African art, as well as "African American Art History I"

(pre-Columbian art to 1945) and "African American Art History II" (from World War I to the present). Additionally, students could enroll in research courses on African or African American art history. To achieve these pedagogical and ideological goals, Donaldson hired thirteen new faculty members during his chairmanship from 1970–76.[32]

Jones's ongoing research project on the black visual artist would appear to have been in line with Donaldson's new objectives. In the spring of 1971, she delivered a lecture at Howard's Founders Library entitled "Slides on Contemporary African Art."[33] Afterward, she deposited thousands of slides and boxes of materials from her African summer travels in 1970 into the Howard University archives. Despite the new Afrocentric direction of the art department's course offerings, however, the slides remain to this day almost untouched and sit in several uncatalogued boxes. The seeming lack of attention paid to Jones's research slides both in the years immediately following their archival deposition and today, is telling. While Jones was in the middle of the black intellectual scene, she remains on the periphery. While her work is documented archivally, it remains understudied. Jones is, on the one hand, "in" but, on the other, still "out."

In the spring of 1972, the Howard University Art Gallery mounted a major retrospective of Jones's art. The show, *Loïs Mailou Jones: Retrospective Exhibition "Forty Years of Painting," 1932–1972*, was on view from March 31 to April 21. A black-and-white reproduction of her mixed-media *Moon Masque* illustrated the exhibition catalogue's cover. The show included close to one hundred works of art and divided Jones's

career into four phases: 1932–39, 1940–49, 1950–59, and 1960–72. In this ostensibly self-curated selection of her work, paintings of African and Haitian themes represented 25 percent of all the work displayed. However, within Jones's post-1954 art, the percentage increased to almost 50 percent and highlighted the Afrodiasporic direction of her current practice. The catalogue included Jones's most recent artist statement, in which she wrote:

> I feel it is the duty of every black artist to participate in the current movement that aims to establish recognition of works by "Black Artists." I am and will continue to exhibit in "Black Art Shows" and others, the works that express my sincere-creative feelings. That these works portray the "Black experience" or "heritage" or are purely abstract is immaterial so long as they meet the highest standards of the modern art world. The major focus is to achieve for Black artists their just and rightful place as "American artists."[34]

Within the context of the changes occurring in the department of art at Howard University in the early 1970s, Jones clearly used the published statement as an opportunity to comment on the recent state of affairs concerning black artists and perhaps take a veiled jab at the current chairperson's ideological stance. Donaldson countered when he opened his published exhibition commentary by stating, "Lois Mailou Jones is an institution."[35] To Donaldson, Jones represented the establishment he sought to challenge.

Despite their institutional affiliation, Jones and Donaldson represented two distinct generations of African American artists. Unlike Jones, Porter, Wells, and Herring, whose formative young adulthoods occurred during the Harlem Renaissance, Donaldson's 1932 birth meant that his twenties and thirties were involved in percolating struggles that would lead to the Civil Rights and Black Power movements. Donaldson and Jones's interactions were emblematic of the increasingly factionalized debates among African American artists, activists, and intellectuals during the late 1960s, including disagreements over the merits and validity of Pan-Africanist thinking.[36]

Donaldson championed what he termed "TransAfrican art," an aesthetic that employed African elements common to all peoples of African descent. For Donaldson and other members of AfriCOBRA, "There [was] no difference, at least stylistically, in the interpretation and explication of Black art in the United States, the Caribbean and Africa."[37] In 1968 Donaldson published the group's manifesto, "Ten in Search of a Nation," in which he articulated their collective vision: "Our guidelines are our people—the whole family of African people, the African family tree. And in this spirit of familyhood, we have carefully examined our roots and searched our branches for those visual qualities that are more expressive of our people/art. . . . We strive for images inspired by African people."[38] While the sentiments of AfriCOBRA appear similar to those Jones expressed, the group's interest in creating an overtly political art represented a key difference. Jones alluded to how Africa—the continent and the concept—had been co-opted in service of the political at Howard: "With Jeff Donaldson there, Frank Smith, they were all leaning towards that direction and influencing the students, however . . . when I first went to Howard to teach, you'd

be surprised to see the African influence that I introduced. . . . Apparently it was part of me way back, it isn't something that came with the movement, the revolution, it happened way before."[39] Here Jones alludes to her own Pan-Africanist aesthetic, which, as discussed in previous chapters, developed *before* it became more broadly popular among African Americans in the 1960s. Jones's inclination to avoid creating art that was polemical would have exacerbated tensions between herself and Donaldson, who advocated the political potential of black art. The absence of an overt political ideology in Jones's work may be one reason why her African-inspired art from this period has not been given more critical attention. Yet as Jones pointed out, her own version of Pan-Africanism preceded the 1960s movements, thereby placing her work ahead of the curve when it came to thinking of a cohesive black diaspora.

As the 1970s progressed, Jones found her art increasingly recognized by the mainstream arts establishment. In 1970, Barry Edmund Gaither, director of the National Center of Afro-American Artists, selected two of Jones's paintings for his landmark 1970 exhibition *Afro-American Artists: New York and Boston*, at the MFA in Boston. Then sixty-five years old, Jones was the oldest artist included in the exhibition. Gaither noted, "I chose to include her not because of her seniority, but rather as a tribute to her vitality and continuing productivity."[40] In 1973 Jones made history by becoming the second African American woman to have a solo exhibition at a major American art museum when *Reflective Moments: Loïs Mailou Jones, 1930–1972* opened in March at the MFA. Gaither curated the exhibition, which he later told

Jones was "very successful and drew an excellent response."[41] The 1973 MFA retrospective brought Jones full circle: her work hung in the very galleries that she had walked as an art student almost fifty years before.

Despite her difficulties with Donaldson, Jones had supported his appointment in 1970, and in 1973 she nominated him to another three-year term as department chair.[42] But by the end of his second term, her patience with him was running thin. Evidently, this disenchantment was mutual: at a May 1976 departmental meeting, a unanimous vote determined "that Professor Pierre-Noël should not continue to be an active member of the faculty."[43] Understandably, Jones was upset that she had not been aware of the meeting and that the entire department had not been present. Although she attempted to protest the decision, citing her decades at the school and requesting a named chair, the 1976–77 academic year was Jones's last as a Howard professor. She retired that May, after forty-seven years of service, at age seventy-two.[44]

On African Soil: 1970, 1972, 1976, 1977

In the years prior to her retirement, Jones realized her lifelong dream of visiting the African continent. When Jones traveled to Africa in 1970, she became part of a middle wave of African American artists who traversed the continent. Aaron Douglas journeyed through West Africa (Dakar, Accra, and Lagos) in 1956. John Biggers (1924–2001) received a UNESCO grant in 1957 and traveled to Ghana and surrounding countries. Jacob Lawrence (1917–2000) and Raymond Saunders (b. 1934) went to Africa in 1963 and 1964.[45] In

total, Jones made four trips to the African continent: in 1970 she conducted solo research; in 1972 she led a multicountry tour for Howard alumni; in 1976 she joined a Howard delegation at an international symposium in Senegal to celebrate the birthday of poet and former president Léopold Sédar Senghor; and in 1977 Jones participated in FESTAC '77, held in Lagos, Nigeria. Much as her time in Haiti had influenced Jones's praxis in the 1950s and 1960s, her first two trips to Africa were, as Jones described, "a revelation."[46]

Jones departed for a four-month tour of Africa in April of 1970. The Africa trip was the final phase of her "Black Visual Arts" project, begun two years earlier in 1968. The project explored the contours of contemporary black artistic production in the United States, Haiti, and Africa. In light of the changing political climate of the era, Jones suspected her final phase of research in Africa "would be excellent for the Black Studies programs which we are featuring and promoting at Howard University."[47] Jones's trip to Africa came a decade after a wave of colonial independence swept the continent. In total, Jones visited eleven countries over the course of the summer: Congo, Dahomey (Benin), Ethiopia, Ghana, Ivory Coast, Kenya, Liberia, Nigeria, Senegal, Sierra Leone, and Sudan. Jones interviewed contemporary artists, photographed collections, and delivered the occasional lecture. Who or what determined her itinerary is unknown. Her letters reveal her regret over not including Uganda, as once in Africa she came to understand that the postcolonial Ugandan art movement was booming.[48]

While she found little time to paint during her first African tour, the trip, like her previous travels to France and Haiti, expanded her worldview

and understanding of diasporic black identities via encounters with black cultural producers and with a greater variety of black cultural objects. Further complicating the Afrodiasporic nexus within which she worked, a number of her paintings dealing with distinctly African motifs, including *Moon Masque*, *Dahomey*, and *The Magic of Nigeria*, were painted in the summer of 1971, when Jones was not in Africa but once more in her Haitian studio.

To prepare for her summer trip in 1970, Jones spent the spring semester conducting research on the artists with whom she hoped to liaise. She would have undoubtedly consulted materials that Mary Beattie Brady of the Harmon Foundation sent her in the 1960s. According to her research report, Jones found the following texts of particular use: Evelyn Brown's *Contemporary African Art and Artists* (1968), German art historian Ulli Beier's *African Contemporary Art* (1968); Marshall Mount's *Contemporary African Art—The Years Since 1920* (1973), and various issues of the journal *African Arts*.[49] With preliminary research executed stateside, once in Africa, Jones said, "The first thing I did when I entered a country was go to the United States Information Service Center [USIS] and ask them to let me see their file on contemporary African artists in order to compare their listing of artists with the research I had done in the States."[50] Jones visited studios, art schools, and art museums in each of her destinations, where she met with artists, faculty, and museum officials who let her photograph their work.

The trip also provided Jones an opportunity to promote her own work and art-historical knowledge. According to her reports, Jones

delivered lectures on contemporary African American art at USIS headquarters in Ethiopia, Kenya, Congo-Kinshasa, Nigeria, Ghana, Liberia, Sierra Leone, and Senegal.[51] In her final report for Howard University, Jones said the lectures were "beneficial in that the [local artists in attendance] were made aware of my presence and my mission, and as a result, contacts with them were made easier."[52] The lectures, which Jones presented in Nairobi, Kenya; Lagos, Nigeria; Kinshasa, Democratic Republic of Congo; and elsewhere, also afforded her the opportunity to speak about her experiences as an African American artist active for much of the twentieth century and to discuss trends in contemporary African American artistic production.[53] In addition to the public presentations, Jones gave several radio interviews for the "Voice of America" broadcast funded by the United States—first in Nairobi and then in Lagos. These radio shows, coupled with the local newspaper write-ups on her visits, spread the news of her presence to a wide audience.

Jones relayed tidbits concerning both her research agenda and happenings on the ground via letters to her husband and friends. For instance, during her first stop in Addis Ababa, Ethiopia, Jones expressed dismay that the renowned artist Afewerk Tekle (1932–2012) was out of town. She wrote, "This set me back somewhat as I had counted on him to make contacts for me."[54] Undeterred, Jones "looked in the phone book and got the address of the only art gallery and went to see an exhibit there."[55]

In Kinshasa, the capital of the Democratic Republic of the Congo, she gave a well-attended talk at the USIS center, after which she was invited to dinner at the home of Frenchman Maurice Alhadeff, a major collector of Congolese art.[56] Jones particularly enjoyed her time in the Congo, writing, "Travel is really enlightening. These people here speaking French make me feel like I am in Haiti. I like it very much."[57] Jones's facility in French served as another conduit for diasporic communication, albeit one with colonial complications. While Jones was in France, French was the native tongue; in Haiti and in the Francophone countries she visited in Africa, the dominance of the European language reflected the colonial oppression of the region.

As in Haiti, Jones encountered the African nations she visited from a position of political and economic privilege that surely impacted her understanding of the goings-on. While traveling the continent, Jones interacted frequently with the diplomatic set and wealthy expatriates. In Kenya, U.S. cultural attaché Sarale Owens helped Jones make contact with artists, while a Mr. and Mrs. Harold Snell hosted Jones for lunch in Nairobi.[58] In Nigeria another cultural attaché, Wilbert Petty, received Jones. Petty was a Howard graduate who had majored in art education and had taken a class with Jones.[59] Jones delighted in telling Pierre-Noël that a Nigerian chief, Mme. Sodiene, called on her while she was in Lagos.[60] When Jones visited Addis Ababa, William Hall, the American ambassador to Ethiopia, invited her to cocktails and allowed her to send five rolls of film to Washington, D.C., in his "special pouch."[61] Jones would make mention of her using diplomatic pouches in other letters as well. At the end of May, she found herself in Cotonu, Dahomey, where she utilized one such diplomatic pouch to send seven packages of materials back to the United States.[62] Her continued use of such

diplomatic services speaks to the privileges to which she had access.

Many of the newly independent African countries that Jones visited during her 1970 trip suffered from growing pains during their nascent statehood. On occasion in her letters, Jones commented on the political situations she encountered and on race relations. For example, she quickly realized the proper etiquette when referring to Africans was to call them "The Nationals / you don't dare to call them 'natives.'"[63] In Sudan, Jones wrote, "The porters come up to me to greet me and remarking 'You are black like us, we like you!'" The racial kinship Jones recounted differed from the experiences many other African Americans had in Africa, which often revealed that the connection African Americans hoped for in the "homeland" was unfulfilled. The novelist Richard Wright, for instance, commented frequently on the disjuncture between African Americans and West Africans in his 1954 travelogue *Black Power: A Record of Reactions in a Land of Pathos*.[64]

While touring, Jones enjoyed being wined and dined and seemed at times ill-informed about the political realities of the postcolonial period. Of Sudan, Jones said, "There was a war on here but it lasted only one day."[65] That Jones thought the war "lasted only one day" indicates a deep lack of political awareness. She was most likely referring to a conflict related to the First Sudanese Civil War, which lasted from 1955 to 1972 and in which cultural groups in southern Sudan fought against the Sudanese government.[66] While the skirmish affecting Jones's itinerary may have only been a day long, the conflict had plagued Sudan for decades. In fact, a *National Geographic*

photographer had warned Jones not to travel to Sudan when the two were at a dinner together in Ethiopia. He told Jones that "they had taken away his cameras but he got them back even tho [*sic*] he was unable to take any pictures."[67] Later in May, Jones told Pierre-Noël that she could not "go to Brazzaville [in the Congo] as there is trouble there and the frontier is closed."[68]

Six weeks into her tour, Jones explained to Pierre-Noël, "I've really been ON THE GO!! I have so much to tell you!"[69] She also had much to show him. Jones took thousands of photographs during her four-month journey. In Nigeria, she used her camera at the Lagos Museum; in Dahomey, she visited the Musée éthnographique de Porto-Novo and the Musée d'Abomey; and at the National Museum in Accra, Ghana, she was allowed to make slides of their entire collection of contemporary art.[70] Writing from Sudan, Jones explained to Pierre-Noël how she "had to have a permit from the Bureau of Tourisme to take photographs" and how the director of the museum there gave her "valuable art magazines for [her] collection."[71] In addition to photographing traditional works, Jones visited artists' studios and shot their most recent creations. In these images, the artists were often included in the frame. Sometimes Jones posed the artists in front of their art, and sometimes only the artist's hands are visible on the edges of the canvas they hold up for the camera. Unfortunately, the slides Jones produced are poorly labeled, making it impossible to identify the specific artists and works she pictured. Although Jones saw plenty of art during her travels, she had little time to paint on her own. She notes that she reveled in stealing away a few times to sketch in the marketplace in Lagos.[72]

During her travels, Jones visited a number of art schools and was deeply impressed by the artistic output of several students. According to her biographer Tritobia Benjamin, Jones "was responsible for recruiting many of the African artists who subsequently came to the United States to study at Howard University."[73] For instance, in October 1970, shortly after Jones's return to Howard, an Ethiopian student appealed to Jones for assistance in obtaining a scholarship for study in the States. The student, Tadessa Ghila, noted that she was writing to Jones on the advice of the American embassy's cultural officer in Addis Abba.[74]

Armed with her photographs and memories, Jones spent the summer of 1971 in Port-au-Prince, where she completed a series of paintings with overtly African themes. Significantly, these works demonstrated Jones's attentiveness to the differences among the aesthetics and styles of various peoples across the African continent. While her African-themed art from the 1930s relied on a monolithic conception of a singular Africa (e.g., her 1932 *The Ascent of Ethiopia*; see fig. 26), by the 1970s Jones was more cognizant of Africa's political history and of many distinct ethnic and cultural groups that populated the continent. Yet many Americans—of all races and ethnicities— had difficulty comprehending postcolonial Africa. As James Meriwether writes, "Twentieth-century African Americans generally did not disaggregate areas of Africa. . . . The 'imagined' Africa was just that: Africa as a whole."[75] Despite Jones's occasional ignorance of political situations in African nations (such as her quip about Sudan's one-day civil war), she was fully aware that Africa is a continent of individual countries, each with its own aesthetic traditions.

Her 1971 mixed-media work *Moon Masque* addressed the growing Afrodiasporic sensibility of the era by effectively juxtaposing elements of African traditional arts with contemporary African American aesthetics (fig. 71). As Jones confirmed to interviewer Theresa Danley in 1977, with *Moon Masque* she was differentiating between the Nigerian studies she had done and Ethiopian textiles, from which she drew inspiration.[76]

Two trios of horizontal lines divide the rectangular canvas into three registers, with abstract graphic designs inspired by Ethiopian textiles filling the top and bottom thirds. At the heart of *Moon Masque* is a replica of a mask made by the Bantu-speaking Kwele people, who reside in the West African region known now the Republic of the Congo. Due to its white pigmentation and round shape, Jones called the form a "moon" mask. The mask would have been used in initiation and other social rituals administered by the Beete cult, a social association within the Kwele. The Beete cult is responsible for regulations of social behavior. Notably, although the use of these masks for ritual purposes had declined by the 1920s, carvers continued to produce them for the European market.[77] Therefore, while Jones's cultural specificity might be read as a sign of "insiderness," she was still accessing Africa through a proxy—here the European market for which such masks were produced.

Traditionally, Kwele face masks are heart-shaped and perforated with dark holes to demarcate dramatically arched eyebrows, with a trio of vertical lines that emanate from each eye. In *Moon Masque*, Jones rounded the shape of the mask and, in lieu of the pierced lines, pasted three silver

foil pieces atop the canvas to give the appearance of tears streaming down the mask's visage. The mask's three-dimensionality contrasts with the flat, painted surface of the canvas. Three concentric circles that alternate in hue between light and dark surround the central form. Flanking the Kwele mask are two black faces shown in profile.[78] Although these silhouetted faces appear similar, under scrutiny, it becomes clear that the two countenances are distinct. The head on the left has a subtly curved forehead, smallish red eyes, an angular nose, petite pointy lips, and a slightly receding chin, whereas the face on the right has a sloping forehead and nose, wide green eyes, extended lips, and a long chin.

Benjamin interpreted *Moon Masque* as an example of Jones's effort to "combine the motifs from various regions of Africa in one composition."[79] The work is an instantiation of Jones's blackness-in-triplicate trope. The Kwele mask at the center of the composition signifies the Motherland, as the concentric circles emanating from the center suggest the ocean waves that separate North America and the Afro-Caribbean. Twenty years earlier, in her *Héritage Egyptien* (see fig. 49), Jones placed black America and the Caribbean at the center of her imagining of the faces of the African diaspora, or black world; three decades later, Africa reclaims center stage in *Moon Masque*.

In the summer of 1972, Jones returned to Africa. But instead of conducting independent research, on this visit she served as a tour guide on a five-week trip that brought twenty individuals to ten African countries—Sudan, Ethiopia, Kenya, Tanzania, Uganda, the Republic of Zaire, Nigeria, Dahomey, Ghana, and Senegal.[80] The trip was billed as an "Art Tour of Africa," and promotional materials promised that participants would "see Africa and its outstanding art and history through the eyes of Loïs Pierre-Noël . . . who has visited Africa numerous times and has intimate first-hand knowledge of the areas you will visit and the places and things you will see. . . . But art is not all you will experience on this great holiday. You shall see the people—proud black people— running their own governments and shaping their own destinies."[81] The tour organizers exaggerated Jones's on-the-ground experience in Africa (she had only been to the continent once before). Yet Jones's ongoing research on contemporary and traditional African art made her an excellent resource on the subject.

Jones's 1972 *Ubi Girl from the Tai Region* illustrates how her trips to Africa transformed her work (fig. 72). The painting is a mélange of African design motifs, objects, and countenances. Painted back in the United States, *Ubi Girl* offers a virtual tour of Africa—a trip that, just as the tour organizers advertised, includes African art and peoples. Similar to her 1938 *La Tête d'un nègre* (see fig. 40), Jones's title for *Ubi Girl* reads like an ethnographic museum label. Yet the painting transcends categorization as a quintessential portrait of a young girl from the southwestern corner of the Ivory Coast.

Jones divides the composition among a quartet of faces. Left of center, a large Baule or Dan portrait mask is shown in profile. Next to this mask, at the top of the canvas, is the

Fig. 71 Loïs Mailou Jones, *Moon Masque*, 1971. Oil and collage on canvas, 41 × 30 ⅛ in. Smithsonian American Art Museum, Washington, D.C., 2006.24.5. Bequest of the artist. Courtesy Loïs Mailou Jones Pierre-Noël Trust.

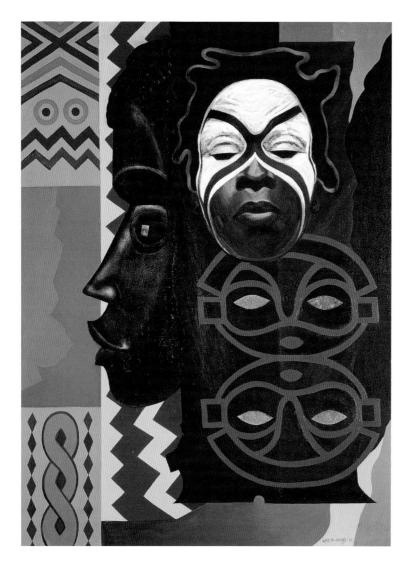

Fig. 72 Loïs Maïlou Jones, *Ubi Girl from the Tai Region*, 1972. Acrylic on canvas, 43 ¾ × 60 in. (111.1 × 152.4 cm). Museum of Fine Arts, Boston. The Hayden Collection—Charles Henry Hayden Fund, 1974.410. Courtesy Loïs Maïlou Jones Pierre-Noël Trust. Photo © 2020 Museum of Fine Arts, Boston.

photorealistically painted face of a young woman. The woman sports dramatic white and red face paint that covers her forehead, eyes, and cheeks, leaving her nostrils, lips, and chin bare. A pair of abstracted Pende masks, rendered in orange outlines and positioned chin to chin, are superimposed beneath the young girl's face. Under the Pende mask outlines and the realistic human head, Jones painted a two-toned maroon heddle pulley employed in West African weaving practices. Weavers use heddle pulleys to operate small looms to produce long, narrow fabric strips later sewn together to create larger textiles. Jones alludes to these strips with the vertical bands of pattern and solid color that make up the rest of the composition's background.

164 Designing a New Tradition

The way that Jones overlaps the central elements in *Ubi Girl* creates a layered, collaged effect using paint rather than mixed media. This overlapping method allows Jones to engage a collage-like weaving practice that stitches together humans, art forms, cultural practices, and graphics. With the trio of face shapes comprising the composition, *Ubi Girl* invokes blackness in triplicate. Of the painting's multiple elements, Jones said, "There was something about the deep look in [the girl's] eyes that impressed me as being symbolic of Africa—so much so that I combined in that painting two masks from the Congo and also the profile of a huge fetish from Ivory Coast, which seemed to me to give an overall feeling of what I consider Africa."[82] Although Jones described her endeavors as "bringing together through my paintings a sort of union of Africa," she found it "very challenging . . . to do these creative works."[83] The number of African-themed paintings Jones created in the period following her trips to the continent indicate that she did not shy away from such artistic challenges. Her use of collage, which, as discussed in the previous chapter, functioned as both an aesthetic choice and a cultural statement, reflects that blackness is itself a mix of objects, faces, and motifs. Jones did not rest on her laurels; she actively sought out new artistic puzzles with which to grapple.

In February 1973, Mary Butler working for the news agency Inter Press Service Africa Branch (part of the USIS) wrote an article on the role of Africa in Jones's new work. Butler quoted Jones: "Each time I made a study of African design, I found the imagery and motifs so inspiring that I've had to utilize them in a sort of combination.

. . . This overlapping and bringing together of ideas is very successful in creative work."[84] We will remember from the previous chapter that Jones first experimented with collage in Haiti during the 1960s in such works as *Vèvè Vodou II* (1963; see fig. 68) and *Challenge America* (1964; see fig. 70). In these 1960s works, Jones literally pasted the elements together; in *Ubi Girl*, Jones uses paint to achieve the collaborative effect. Jones would revisit the compositional layout of *Ubi Girl* in her later *Petite ballerina du Senegal* from 1982 (fig. 73). In the latter, Jones retains the heddle pulley, adding a physical marker for her concern with the weaving together of histories, cultures, and identities. The continued juxtaposition of African art objects with black bodies foreshadows Jones's other paintings from the 1980s, almost all of which include such a combination.

Jones returned to Africa again in 1976, this time to Senegal, where she served on a Howard University delegation participating in the International Colloquium on Culture and Development held in honor of President Senghor's seventieth birthday.[85] At the colloquium, Jones gave a lecture titled "The African Influence of Afro-American Art" and presented President Senghor with a portrait (figs. 74 and 75). Demonstrating forethought of the portrait's importance to her oeuvre, Jones had a plate of the painting made so it could be reproduced after the original entered the presidential collection. *Hommage au président Léopold Sédar Senghor*, in subject and style, extends some of the ideas and motifs found in Jones's 1958 portrait mural of Ghanaian president Kwame Nkrumah (see fig. 62) and her more recent *Ubi Girl* (see fig. 72). In her 1958 mural *A Birth of a New Nation*, Jones deployed a collage aesthetic to piece

Fig. 73 Loïs Mailou Jones, *Petite ballerina du Senegal*, 1982. Acrylic on canvas. Location unknown. From Benjamin, *Life and Art of Loïs Mailou Jones*, 108. Courtesy Loïs Mailou Jones Pierre-Noël Trust. Photo: Marvin T. Jones.

together the elements (material and ideological) that visualized Nkrumah's importance as the first black president of Ghana and leading promoter of Pan-Africanism. As in her Nkrumah mural, in *Hommage au président*, only Senghor's head and part of his shoulder are visible at the bottom right of the canvas. *Hommage au président* is a montage of referents to modern-day Senegal in which the likeness of Senghor forms only one part.

Hommage au président Léopold Sédar Senghor brings the viewer through a nonlinear history that includes the Atlantic slave trade, the classical Ife and Benin kingdoms, the contemporary moment in which a black man returns to the seat of power in Senegal, and the ancient times of Great Zimbabwe. Several African cultures (top to bottom: Senegal, Benin, Nigeria, and Zimbabwe) are referenced via symbols. In particular, Jones's inclusion of an Ife terracotta and a Zimbabwe bird are direct references to ancient African art and culture in South and West Africa. At the bottom left, a soapstone Zimbabwe bird (an iconic

Fig. 74 Loïs Mailou Jones, *Hommage au président Léopold Sédar Senghor*, 1996. Publisher: Limited Editions Club. Color screenprint: Minneapolis Institute of Art, Ethel Morrison Van Derlip Fund P.98.1.3.3. Courtesy Loïs Mailou Jones Pierre-Noël Trust. Photo: Minneapolis Institute of Art.

Fig. 75 Loïs Mailou Jones presenting President Senghor with portrait, 1976. Courtesy Moorland-Spingarn Research Center, Manuscript Division, Howard University, Washington, D.C.

emblem of the ancient city of Great Zimbabwe) stands against a brick backdrop. Construction of Great Zimbabwe began in the eleventh century and continued for more than three hundred years. The city was known for its stone walls, which rose more than thirty-five feet. The nineteenth-century excavations of the city saw the discovery of eight soapstone Zimbabwe birds.[86] Above Senghor, Jones placed an Ife terracotta head with facial striations and an elaborate beaded crown positioned so that its gaze mimics that of Senghor. Produced between 1000 and 1400, terracotta heads of the type pictured in Jones's portrait played a large role in the symbolic representations of prominent Ife rulers.[87] Jones's replication of the head suggests her familiarity with Ife terracottas in Western collections, and her choice to depict only Senghor's head in *Hommage* sought to capitalize upon the representational tradition. Here Jones riffed off of traditional Senegalese forms for representing political power but in a modern way. She created a further bond between ancient and contemporary black leaders by superimposing Senghor's likeness on the Ife head.

To the left of the Ife terracotta, Jones inserted a mixed-gender group of African figures. The young woman who stands at the center of the group holds a child in her arms; muscular men engaged in agricultural labor surround them. The group's traditional white robes suggest that this is a historical tableau. Above the group are shapes rendered in black, yellow, and orange that at first appear to be some of Jones's geometric designs; however, they represent the windows and horseshoe staircase to the House of Slaves on Gorée Island. The House of Slaves and Gorée Island are key sites in the collective memory of peoples of African descent. Located just off the coast of Senegal, the Portuguese used Gorée Island as a final holding cell before the voyage across the Atlantic during the Atlantic slave trade.[88] At the bottom of the canvas, two lines of yellow text float between the plinth of the Zimbabwe bird and the blue edge of Senghor's blazer lapel. The text, "Dessous l'arc en ciel de ta paix" (Below the arc in the sky of your peace), is the final line of Senghor's poem "Prière de paix" from his 1948 volume, *Hosties noires*.[89] The combination of text and image represents yet another way in which Jones continues the collage aesthetic within painting.

Yet the picture is more than just a portrait of Senghor or a history painting. Jones's content choices—the horseshoe staircase of the House of Slaves, the Ife terracotta head, and the photorealist portrait of Senghor—work to expand the concept of blackness in triplicate. In depicting a range of experiences, locations, eras, objects, and peoples that come into contact or collide with one another in a variety of ways, the painting speaks to both the collapsing of historical moments and the inherent pastiche quality of blackness.

Chapter 3 linked Jones's conception of blackness to three locales: Africa, the Caribbean, and the United States. The painting *Hommage au president* offers a more multifaceted vision of blackness. First, blackness is both a physical location and a shared experience, embodied by references to the Atlantic slave trade via Gorée Island. Second, the references to blackness, both physical and aesthetic, are ancient and classical, signified by the Ife terracotta head and the Zimbabwe bird. Third, blackness is human and modern, as indicated by Jones's inclusion of Senghor's portrait and his twentieth-century words. The three

facets represent a conceptual actualization of the triplicate trope. Jones's arrangement of these compositional elements, manipulated so that they cascade and overlap, highlights the painting's movement through art and cultural histories, articulating blackness in triplicate with a diasporic grammar.

Jones declared that the portrait "dealt with the theme of African influence . . . and a tribute which I paid to . . . Papa Ibra Tall [b. 1935], who is the outstanding Senegalese artist."[90] An artist and art teacher, Tall returned to Senegal in 1960 after several years in France, where he was involved with the Négritude circle. Upon his homecoming, he founded the Section de recherches en arts plastiques nègres. Skeptical of Western education, Tall advocated the use of "'identifiable' African subject matter."[91] In describing his aesthetic, he explained, "It was a question of creating, for myself, an artistic language which seemed to me to belong to Africa and to Senegal. . . . What interested me in finding a kind of authenticity was not to create pure decoration but to create a language of visual forms which defined me for myself."[92] Arguably, Jones was involved in a similar exercise and over the course of her career created a visual grammar to express her experiences in Africa, the Caribbean, and the United States.

Her interest in understanding black art also took verbal form. In the opening remarks of her 1976 lecture "The African Influence of Afro-American Art," Jones described the interwoven nature of contemporary African American art, African art, and black identity: "The art of our ancestral homeland so permeates contemporary Afro-American art that it is presently impossible to speak of Afro-American art without speaking of African art, without expressing our indebtedness to Mother Africa who has nurtured us spiritually and aesthetically, who has given form to the Black Art Movement, which aspires to reflect the black experience and heritage as a means of establishing black identity."[93] In the lecture, Jones mentioned her own use of African art and discussed two contemporary African American artist collectives, AfriCOBRA and the Harlem-based Weusi-Nyumba Ya Sanna, as examples of contemporary African American engagements with African motifs and aesthetics.[94] At the time of the 1976 lecture, Jones's professional relationship with AfriCOBRA cofounder and current Howard department of art chair, Jeff Donaldson, was becoming increasingly strained. In the following months Donaldson would oversee the departmental vote resulting in Jones's unceremonious retirement.

Just prior to her retirement, Jones had the opportunity to travel to Africa once again, as a participant in the U.S. delegation to FESTAC in the winter of 1977. FESTAC '77 was the much-anticipated follow-up to the First World Festival of Black and African Arts and Culture that had been held in Dakar, Senegal, in 1966. The second incarnation of FESTAC had been originally scheduled for 1975, but those plans were abandoned, in part because of a military coup in Nigeria. The delegation from the North American Zone (NAZ) also had difficulties with fundraising and its own administration.

In October 1976, writing on official letterhead for the FESTAC United States Zonal Committee, Donaldson invited Jones to attend the upcoming FESTAC planned for January of 1977 in Lagos.[95] Ironically, shortly after the May 1976 meeting

that saw Jones forced out of Howard, Donaldson relinquished his chairmanship to devote his full attention to FESTAC '77. Despite the tensions between Donaldson and Jones, he does not appear to have hesitated to invite her to participate. Jones submitted two pieces to the planning committee for consideration: *Moon Masque* and *Philome and Robert in Haiti*, also painted in 1971.[96] Ultimately, only *Moon Masque* was exhibited at the United States exhibition pavilion in 1977.

As chair of the NAZ, Donaldson was responsible for assembling the 444 African Americans—a mix of artists, musicians, performers, and celebrities—who would fly to Nigeria to attend the festival.[97] For those twenty-nine days, Lagos served as the capital of the black world. The festival brought more than seventeen thousand individuals to the sprawling festival site, much of it new construction funded by the Nigerian oil boom.[98] These artists joined in a celebration of Pan-Africanism linked inextricably to the arts of Africa. The May 1977 cover of *Ebony* declared, "Festival in Nigeria Strengthens Bond between Black America and Africa."[99] While the festival's theme, the traditional arts of Africa, honored longstanding artistic traditions, the event showcased classical African art, contemporary black art, and work by artists of from all parts of the African diaspora, thereby illuminating past and future directions of black art.

FESTAC '77 embodied a blurring of cultural and national boundaries, an institutional point of contact for black art and culture on a global scale, and the mingling of black objects and black bodies from widespread geographic locations. Jones's participation in the festival placed her within this nexus. Yet while Jones's inclusion in FESTAC '77 brought her to the center of the black art world of the late 1970s, she was at the same time being marginalized and pushed out of the Howard University department of art for her supposed old-guard stances.

Gaining Traction

Perhaps due to increased travel and workplace concerns, between 1972 and 1979, Jones's artistic output slowed somewhat as she turned her attention to her research projects, growing involvement with the burgeoning feminist movement, and her traction and recognition in the larger art world. While in the 1930s and 1940s Jones had participated in a number of black group shows, in the 1970s she exhibited with increasing frequency in shows that celebrated the work of women artists. She also began to address issues concerning gender and shared her own story.

In the spring of 1972, Jones spoke to the crowd at the Corcoran Gallery of Art's two-day Conference on Women in the Visual Arts. The Corcoran, which in the 1940s had denied Jones entry into its painting competitions on racial grounds, had more recently drawn criticism for its exclusion of women artists in its 1971 biennale. Jones's participation in the Corcoran conference placed her in the middle of yet another critical cultural issue. The year prior, *ARTnews* published art historian Linda Nochlin's influential essay, "Why Have There Been No Great Women Artists?," which condemned the Eurocentricity and male domination of the Western art canon.[100] The publication of Nochlin's essay and the convening of the Corcoran symposium were but two of many events that focused attention on women artists during the

early 1970s. For instance, Judy Chicago, one of the most important feminist artists to emerge in that decade, began to offer women's-only art classes at Fresno State College in 1970. The resulting Feminist Art Program was the first of its kind.[101] That same year, Lucy Lippard created a slide bank of women's art, the New York Women's Art Registry.[102] In 1972, the Women's Caucus for Art (WCA) was founded at the annual College Art Association meeting in San Francisco to fight the discrimination that female artists and art historians faced in their professional endeavors.[103]

Inspired by the success of her earlier "Black Visual Arts" project and her involvement with the nascent feminist movement, Jones applied to Howard University in 1973 to fund a new project entitled "The Black Woman Artist: Her Vision and Stature," later renamed "Women Artists of the Caribbean and Afro-American Artists."[104] Whereas her previous research examined African and Afrodiasporic contemporary art practices from a wide-angle view, this project focused primarily on gender and race. In a draft letter to Vice President of Academic Affairs Andrew Billingsley, Jones explained the pressing need "to research and document . . . the accomplishments of twenty-five leading Black Women artists selected from the U.S.A. and the Caribbean. . . . To date there is no single publication on this theme. However, there is a definite need for such documentation which I intend to publish."[105] Jones's art and travel patterns of the 1970s reflect her ongoing exploration of facets of Afrodiasporic identity particularly in African, Caribbean, and European contexts. Her research led to the 1974 exhibition *Caribbean and Black Women Artists* at the Acts of Art Gallery in New York City. In the gallery guide, Jones wrote, "The works on view are but a sampling of the vast field yet to be explored."[106]

In addition to curating exhibitions featuring women's art, Jones participated in them. In 1975, fellow artist Faith Ringgold included Jones's work in the *11 in New York* exhibition held at the Women's Interart Center.[107] Writing about the show for the feminist publication *Majority Report*, Ringgold's daughter Michelle Wallace stated, "This show . . . though not reviewed and though completely ignored by the art establishment of New York made the existence and the greatness of the black woman artist and the importance of her contribution to the life of American art a fact impossible to deny any longer."[108]

Now well into her seventies, Jones's contribution to the canons of American and African American art were finally gaining recognition. In 1976, her work was included in the exhibition *Two Centuries of Black American Art* at the Los Angeles County Museum of Art (LACMA). She also took part in the programming for the *Six Distinguished Women Artists* exhibition at the Brooklyn Museum of Art. For the latter, as Jones describes, she joined in a panel conversation with fellow women artists Isabel Bishop, Alice Neel, Louise Nevelson, "and other celebrated white artists who were impressed by my review of achievement but who regretted that we had never met."[109] That the white feminist artists were not aware of Jones's artistic contributions echoed the broader exclusion of women of color from the feminist movement.

The same year that the Brooklyn Museum mounted *Six Distinguished Women Artists*, LACMA hosted *Women Artists: 1550–1950*. The exhibition, organized by Linda Nochlin and former WCA president Anne Sutherland Harris,

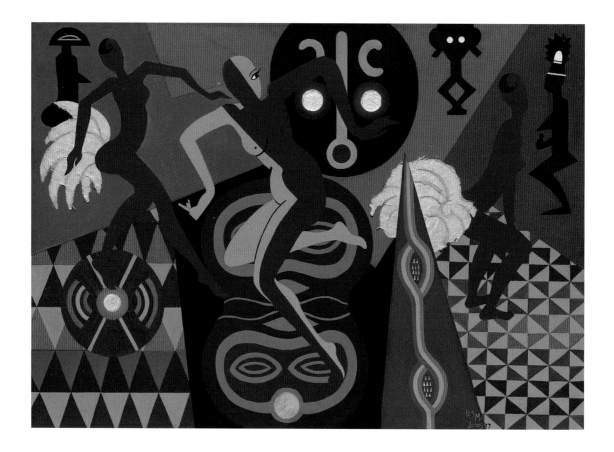

Fig. 76 Loïs Mailou Jones, *La Baker*, 1977. Acrylic and collage on canvas, 40 ½ × 56 ½ in. Museum of Fine Arts, Boston. Gift of the Loïs Mailou Jones Pierre-Noël Trust, 2006.1450. Courtesy Loïs Mailou Jones Pierre-Noël Trust. Photo © 2020 Museum of Fine Arts, Boston.

sought to expose the previously obscured history of women artists active from the Renaissance through 1950 in a major mainstream art museum.[110] *Women Artists* presented eighty-three women artists from twelve different countries. Despite its broad chronological and geographic scope, only one woman of color—the Mexican painter Frida Kahlo—was included in the exhibition and its accompanying catalogue. No black women were incorporated, an omission indicative of the way many artists of color were treated by the mainstream, mostly white feminist art movement.[111]

On September 30, 1976, *Two Centuries of African American Art* opened at LACMA, with Jones's beloved former student, artist and art historian Driskell, as guest curator. Highlighting African American art produced from 1750 through the mid-twentieth century, the landmark exhibition included more than two hundred works by sixty-three artists and is considered the first "historically comprehensive" survey of

African American art.[112] Jones was one of nine women artists showcased in the exhibition. In the galleries, her art hung alongside that of Margaret Burroughs, Selma Burke, Elizabeth Catlett, Minnie Evans, Clementine Hunter, Edmonia Lewis, Alma Thomas, and Laura Wheeler Waring. Driskell selected four of Jones's paintings: *Notre Dame de Paris* (1938), *Mob Victim* (1944), *Dahomey* (1971), and *Ubi Girl from the Tai Region* (1972). The paintings came from three phases of Jones's career: her 1937–38 sabbatical in Paris, her interest in social realism of the 1940s, and her post-1970 explorations of African themes. Notably, examples of Jones's praxis in the 1920s and the 1950s–60s are absent, a trend that would continue in art-historical treatments of her work.

Motivated by the growing traction her fellow women artists were gaining, Jones's own feminist activism intensified. In the fall of 1978, she penned an angry letter to the Brooklyn Museum of Art on the occasion of its exhibit *Haitian Art*. While calling the show "one of the finest yet to be presented to the American public," Jones took the curators to task for omitting the work of Haitian women artists in an exhibition that aimed to "relate to . . . major aspects of Haitian life."[113] She continued, "It is time that the achievements of the black woman artist be made known to the world. The Afro-American woman artist has suffered this oversight too long and today through 'Black Art Exhibitions' is establishing her identity."[114]

Jones's art from the late 1970s and early 1980s exhibits a continual return to the black female figure, speaking to the artist's ongoing desire to render the black woman and, in particular, the black woman artist visible. One of the few pieces Jones painted during the late 1970s was her 1977 tribute to famed African American performer Josephine Baker, entitled *La Baker* (fig. 76). While Baker found fame in Paris during the 1920s and 1930s, during the 1950s and 1960s she returned frequently to the United States and was active in the Civil Rights movement. In 1973 Baker performed at New York City's Carnegie Hall and mounted a return to the stage. Two years later, she died in her sleep of a cerebral hemorrhage in Paris.

Jones's posthumous homage, *La Baker* measured 40 ½ by 56 ½ inches and is one of Jones's largest compositions. Her use of high-key color, flatness, and pattern in the composition make reference to her ongoing conversation with high modernism. In *La Baker*, Jones offers up a trio of brown female dancers who perform steps from the Charleston, one of Baker's signature dances, on a brightly colored and busy stage.[115] The dancing women are joined by a variety of African sculptural forms. The painting foregrounds the importance of black women while also capturing both the Charleston's polyrhythmic moves and its African origins.

The central dancing figure, ostensibly the star herself, captures Baker's coquettish spirit with the curl of the dancer's elongated eyelashes and flirtatious sideways glance. Baker's figure wears a two-toned costume that splits her body in half. Her nipples are visible, making it difficult to discern if Jones depicted Baker nude or in a sheer costume. Two faceless dancers flank the central figure, both sporting Baker's signature forehead curl. The curl, however, functions as an accessory rather than a humanizing element. Whereas the central figure may be wearing a full-body costume, the other dancers perform nude except for pink feather plumes that adorn their backsides. Torn

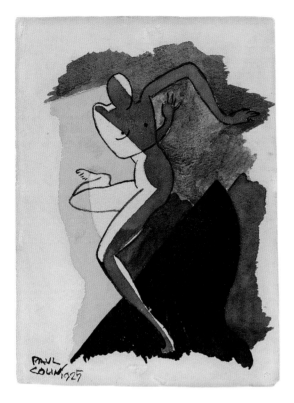

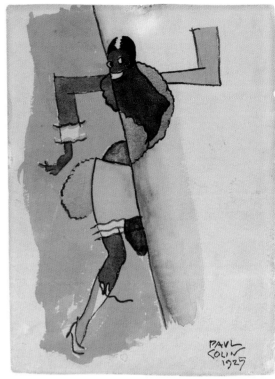

Fig. 77 Paul Colin, *Josephine Baker*, 1925. Ink and watercolor on paper, 8 1/16 × 6 in. National Portrait Gallery, Smithsonian Institution, Washington, D.C. © 2018 Artists Rights Society (ARS), New York / ADAGP, Paris.

Fig. 78 Paul Colin, *Josephine Baker*, 1925. Ink and watercolor on paper, 8 1/16 × 6 in. National Portrait Gallery, Smithsonian Institution, Washington, D.C. © 2018 Artists Rights Society (ARS), New York / ADAGP, Paris.

from pink tissue paper, the textured paper feathers stand in contrast to the flatness of the acrylic paint. Notably, Jones's choice of the chocolate brown and pink colors has racial implications. They not only speak to racial distinctions but perhaps also serve as a commentary on Baker's appeal to both white and black audiences. Baker had left the United States for Paris in 1925; there, with her exotic dancing in *La Revue Nègre*, she became an overnight sensation.[116]

The dancers are not the only elements in the painting. A mask shape and Gabon reliquary figure occupy the orange field at the center of the composition located behind Baker. Two African figurines (perhaps Luba or Hemba) bookend the composition. The poses of the human backup dancers mirror the poses of these African statuary figurines. Like their human counterparts, the statuettes are also faceless and nude. The dancer on the left arches her back with her arms outstretched, a stance that accentuates the roundness of her buttocks. Although the plumes of her costume obscure part of the African figurine, the

feathers separate in a way that exposes the similarly curved backside of the African statue behind her. The dancer on the right bends forward with her hands on her knees in a step from the Charleston. Her position is also echoed in the sharp angles of the African figurine placed facing her.

With the repetition of poses (in African and African American form), Jones suggested a link not only between the black body and the African figurine but also between African American cultural traditions—here represented by the Charleston dance—and African cultures. Rather than accentuate the differences between the human dancers and the material objects, Jones strives to connect them and to illustrate their similarities. The collective nudity, facelessness, and bodily parallels ascribe human characteristics to the objects and objectify the human figures. Jones's title, *La Baker* (the nickname given to Baker by the French press), also plays with the human-object distinction.

Further complicating this conflation is the way in which Jones based *La Baker* on a set of extant art objects. The central dancer in *La Baker* is a quotation of a 1925 watercolor of Baker by French poster artist Paul Colin (1892–1985), who published a portfolio of Baker inspired lithographs titled *Le Tumulte Noir* in 1927 (fig. 77). The African figurines in *La Baker* appear on plate 11 of the portfolio, and the pink-feathered dancers on plate 35 (fig. 78). Whereas Colin's dancers perform in empty spaces, Jones places Baker into a context that includes references to modernist art practices, African and African American visual culture, and conceptions of black performativity. *La Baker* evinces Jones's practice of building bridges between black cultural traditions from

across the Atlantic. The combinatory effect of her pulling from the different facets of blackness and black cultural forms elucidates the composite aesthetics of blackness and the effectiveness of using the collage aesthetic to visualize the multifaceted nature of black identity.

From Pairs to Pastiche: Jones's Composite Aesthetics in the 1980s

Jones's negotiation of traditions was her artistic hallmark, and as she moved into the 1980s—the last markedly productive decade of her career—one finds her continually revisiting the themes present in her earlier art. Conceptually, layering and collage were Jones's visual techniques for giving visual form to the contradictions of twentieth-century black identity and black art. Her works from the 1970s and 1980s indicate that creating a seamless representation of blackness is impossible: blackness is inherently composed of breaks and disjuncture. Her 1980 painting Damballah exemplifies this continued negotiating, mixing, and layering (fig. 79).

Her 1980 painting *Damballah* exemplifies this continued negotiating, mixing, and layering (fig. 79). As in her 1976 *Hommage au président* (see fig. 74), here Jones combined word and image to convey a symbolic message that spans the Black Atlantic. Her choice of title refers to a religious spirit whose roots trace back to the Dahomey in West Africa and who is also the deity of creation in Haitian Vodou.[117] On the far left, Jones painted a green, blue, and orange snake, one of the symbols associated with Damballah.[118] To the snake's right, an Afikpo Igbo mask spans the width of the canvas.[119] Painted braids of raffia encircle the

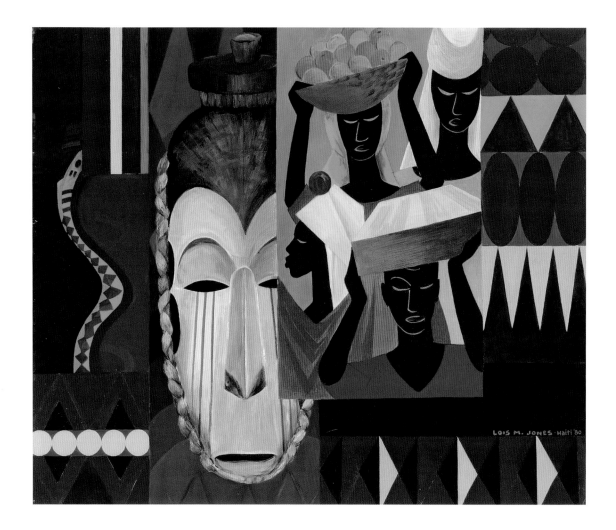

Fig. 79 Loïs Mailou Jones, *Damballah*, 1980. Acrylic on canvas, 30 × 35 ½ in. Courtesy Loïs Mailou Jones Pierre-Noël Trust.

edges of this monkey-like mask; its right side is covered by a rectangle that contains the faces and shoulders of four black vendors. These merchants, with their vibrant clothing, minimalist features, and ebony skin, are reminiscent of the figures in the many market scenes Jones painted in Haiti during the mid- to late 1960s.

Jones once described herself as prone to combining "motifs from various regions in Africa, which result in a composition that tends to unify Africa."[120] However, rather than smoothly blending her references to Haitian Vodou, Africa, and contemporary Haiti in *Damballah*, Jones elects to render the seams visible by placing each referent in its own contained segment. The painting's sections appear pasted together, at times overlapping and obscuring one another. With its mix of patterns, objects, animals, and peoples, it is

unclear which element, if any, is meant to occupy center stage.

In a trio of paintings from 1982—*Les Jumeaux* (the twins), *Petite ballerina du Senegal* (small ballerina from Senegal), and *Deux coiffures d'Afrique* (two African hairstyles)—Jones repeatedly juxtaposes black bodies and black sculptures. In *Les Jumeaux*, Jones depicts a pair of carved wooden figurines in front of an abstract Akan stool from Ghana (fig. 80). Made of wood and typically decorated with intricate geometric designs, such stools were the prized possessions and symbols of Akan rulers.[121] By rendering the stool's outline in brown, Jones suggests its wooden material. She also references its traditional decoration by demarcating its curved seat with a running blue-and-brown chevron design. The manner in which Jones animates the wooden twin figures is noteworthy. Each one has one arm wrapped around the other's waist, and each has the other arm raised as if to wave, with palms facing outward. These figurines are used as material conduits between the human realm and the ancestral spirit world.[122] With the placement of the arms, Jones forges a physical connection—not just between the two African figurines but also with the viewer who stands outside the canvas. The figurines, who physically embody ancestral spirits, represent the past and hail the viewer in the contemporary moment. *Les Jumeaux* perpetuates Jones's pattern of pairing black objects with black bodies (here the unseen bodies of the black artist and the bodies of the spirits materialized by the figurines) and animated African art objects that serve as links between past and present.

In *Petite ballerina du Senegal*, Jones retained the compositional layout of her earlier *Ubi Girl from the Tai Region* (1972) and simply swapped

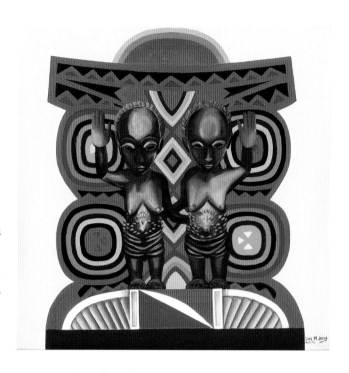

Fig. 80 Loïs Mailou Jones, *Les Jumeaux*, 1982. Acrylic on canvas, 36 × 36 in. Courtesy Loïs Mailou Jones Pierre-Noël Trust.

out the major elements (see figs. 72–73). In both works, the head of a young African girl floats in the center on top of a two-tone maroon heddle pulley. In *Ubi Girl*, the young girl's face wore face paint; in *Petite ballerina*, her face is bare, and she wears an elaborate headdress fashioned from cowry shells and white feathers. In place of the orange Pende masks, Jones added a pair of red abstract designs that echo the form of the Pende masks. Along the edge of the heddle pulley, Jones replaced the portrait mask from *Ubi Girl* with a seated carved figurine (perhaps another Baule figure). Here one finds the layering of three elements—the seated sculpture, the photorealistic head, and the abstracted mask

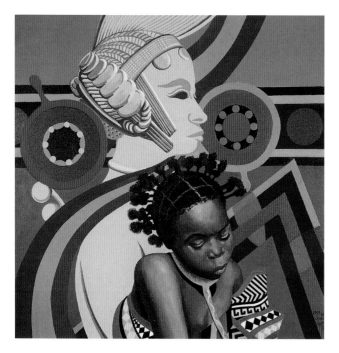

Fig. 81 Loïs Mailou Jones, *Deux coiffures d'Afrique*, 1982. Acrylic on canvas, 36 × 36 in. From Benjamin, *Life and Art of Loïs Mailou Jones*, 106. Courtesy Loïs Mailou Jones Pierre-Noël Trust. Photo: Marvin T. Jones.

Fig. 82 (opposite) Loïs Mailou Jones, *Initiation Liberia*, 1983. Acrylic on canvas, 35 ¼ × 23 ¼ in. Smithsonian American Art Museum, Washington, D.C., 2006.24.7. Bequest of the artist. Courtesy Loïs Mailou Jones Pierre-Noël Trust.

forms—functioning as tripled references to blackness. Produced toward the end of Jones's career, *Petit ballerina* and *Les Jumeaux* may both be considered simultaneously forward- and backward-looking, reflecting the artist's own reconsiderations of her career.

The face of the young dancer from *Petite ballerina* also appears in *Deux coiffures d'Afrique*, in which the girl sits at the bottom of the composition, gazing downward and to the left (fig. 81). She leans forward as her shoulders and torso,

wrapped in printed cloth, pull away from the flatness of the background. Jones swapped the feathered headdress from *Petite ballerina* with an elaborate hairdo. A large grayscale female figure stands behind the young girl. Rendered in light gray blue with minimal modeling, the figure's hair is styled in an equally complicated design, perhaps of Fulani origin. In *Deux coiffures*, Jones comments on the past—via the background figure whose coloring and hollow eyes render her more sculptural than human—and the present—as embodied by the naturalistically executed young girl in the foreground. By placing the figures' two heads and torsos in line with one another along the vertical central axis, Jones also alludes to the continuity of cultural traditions. The artist may have also been thinking of familial lineage. Her beloved husband Louis Vergniaud Pierre-Noël died in April 1982, and the pair were childless.

In *Initiation Liberia* from 1983, Jones's young girl has transformed into a young woman who fills the center of the canvas (fig. 82). Her hair is done in a complicated braid, a band of white cloth covers her eyes, and four rings encircle her neck. At the left of the composition, her profile is replicated twice, making the painting another example of Jones's use of the blackness-in-triplicate motif. In the first profile, outlined in white, her features are simplified and schematized. In the second profile, which appears in the background, only her contours are discernible in a solid gray silhouette. The multilayered background contains a mix of patterned segments and blocks of solid color superimposed atop one another. The curved dark-brown outline of a heddle pulley, which also appears in *Ubi Girl* and *Petite ballerina*—is visible along the right side of the canvas.

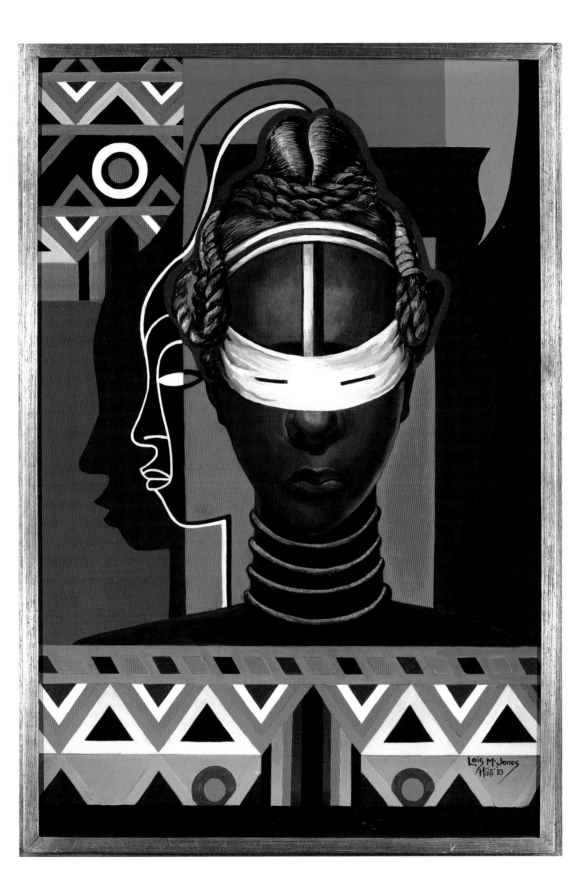

Aside from the heddle pulley, which would probably be indistinguishable to those unfamiliar with Jones's earlier works, *Initiation Liberia* does not contain overtly African objects. However, the stylization of the young woman bears an affinity to the Mende Sowei helmet mask from Liberia.[123] Female masqueraders sport such masks, which represent idealized feminine beauty, during rituals associated with Sande, the female secret society. Neck rings and elaborately braided hairstyles characterize the masks. The white band over the girl's eyes replicates the white scarves that are often tied around the mask to symbolize the initiate's face paint.[124] By humanizing the mask in *Initiation Liberia*, Jones successfully blurs the line between human and object. Taken together, these female-centered paintings—*Ubi Girl*, *Petit ballerina*, *Deux coiffures*, and *Initiation Liberia*—indicate that, for Jones, the black female body served as a conduit and a medium for exploring Afrodiasporic identities.

Jones's probing of the relationship between African art and contemporary modern art mirrored mainstream curatorial investigations. In the fall of 1984, the Museum of Modern Art's blockbuster exhibition *"Primitivism" in 20th Century Art: Affinity of the Tribal and the Modern* opened to the public.[125] The museum ran a quarter-page ad in the *New York Times* that juxtaposed a face from Pablo Picasso's 1907 cubist masterpiece, *Les Demoiselles d'Avignon*, with a visually similar *mbuya* [sickness] mask from the Pende group in Zaire.[126] In large font beneath the two images were two questions: "Which is 'primitive'? Which is 'modern'?" These queries were intended to problematize viewers' distinctions between the two categorizations.[127] In the physical

exhibition, Western "modern" paintings and sculptures were shown alongside complementary "tribal" objects from Africa, Oceania, and North and South America. According to the exhibit's press release, the show was designed to illustrate how African and Oceanic art objects were "external influences on the modern painters and sculptors."[128] Despite the presence of quotation marks, which ostensibly critiqued the dichotomy of the terms, objects could only be modern or primitive;[129] according to MoMA, it was not possible for a single object to be both.[130] This problematic and intransigent position drew significant criticism from the art world. Commentators took particular issue with the exhibition's obfuscation of modern African art, which was not presented as a viable category.[131] But by and large, African American artists were also excluded.

Jones visited the *"Primitivism"* show in the fall of 1984, while her own painting *Les Fétiches*, which was inspired both by African masks and cubism, was on view at the Emily Lowe Gallery at nearby Hofstra University on Long Island (see fig. 33). Jones expressed dismay that her work had not been included in the MoMA exhibition: "Perhaps it should be in the exhibit at the Modern," she said, "but there is a case of they don't know me. I should be in that show."[132] That year her work could be seen at several other venues: the Emily Lowe Gallery (Hempstead, N.Y.), Jamaica Arts Center (N.Y.), and the Museum of African Art (Los Angeles).[133] As Romare Bearden and Martin Puryear were the only two African American artists who appeared in the MoMA *"Primitivism"* exhibit, one of the many critiques of the show was the fact that it eschewed a discussion of how African art may have influenced modern African American

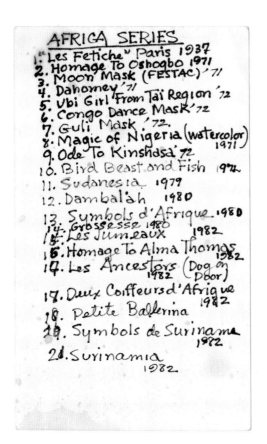

Fig. 83 Loïs Mailou Jones, "Africa Series," undated. Courtesy Moorland-Spingarn Research Center, Manuscript Division, Howard University, Washington, D.C.

Fig. 84 Loïs Mailou Jones, *Suriname*, 1982. Acrylic on canvas, 36 × 24 in. Smithsonian American Art Museum, Washington, D.C., 2006.24.6. Bequest of the artist. Courtesy Loïs Mailou Jones Pierre-Noël Trust.

artistic production.[134] Jones was undoubtedly aware of the problematics of naming an artist—especially an artist of color—"primitive," but the allure of showing work at MoMA, the bastion of modern art, undoubtedly still held appeal. Jones held tight to her desire to be seen on equal footing as the other Western artists who explored the potential of African art.[135]

It was around this time that Jones drafted the "Africa Series" list (fig. 83). The handwritten document outlines twenty-one of Jones's African-themed works, beginning with *Les Fétiches* from 1937 and continuing through to her 1982 abstract *Suriname* (fig. 84). Given her feelings about the *"Primitivism"* show, the "Africa Series" list might be read as Jones's personal exhibition checklist (that is, works she would have submitted to MoMA curators for consideration). *Ubi Girl* is fifth on the list, sandwiched between Jones's 1971 *Dahomey*, her brightly colored interpretation

Fig. 85 Loïs Mailou Jones, *Suda-nesia*, 1979. Location unknown. From Benjamin, *Life and Art of Loïs Mailou Jones*, 102. Courtesy Loïs Mailou Jones Pierre-Noël Trust. Photo: Marvin T. Jones.

of a Dahomean appliqué wall-hanging, and two mask-themed compositions from 1972, *Congo Dance Mask* and *Guli Mask*. Three other paintings completed in 1971 and 1972 round out the top ten. Jones's 1979 *Sudanesia* occupies the eleventh spot (fig. 85). One finds a stylistic shift in Jones's African-themed paintings of the 1970s, many of which she painted on canvases larger than those she previously employed. Bright colors, flat planes of color, decorative patterns, and an over-arching clarity characterize these works.[136]

Jones's titular use of the Greek suffix *-nesia*, perhaps shortened from *-mnesia* (the suffix for memory), implies that the work *Sudanesia* operates as a memory of Sudan. The composition does not appear to be based upon that country, however. It is instead filled with abstract allusions to the masquerade traditions of Burkina Faso, Mali, and other regions of French West Africa. In any case, *Sudanesia* is more than a pastiche of African masquerade motifs. The abstracted lizard at the top right is composed of thick white lines and black cubes, reminiscent of Dutch modernist Piet Mondrian's style. It appears to the uninformed viewer as a separate compositional element, positioned above a horned mask. Yet in fact Jones again riffs off an African tradition, not a European one. The compositional elements found on the right side of the canvas reference a kanaga mask with its characteristic wooden substructure produced by the Dogon peoples of Mali.[137] Regardless of the specific sources of her inspiration, Jones's poetic reference to Sudanese culture and reliance on what may at first be perceived as abstract rather than representational forms speaks to her ongoing artistic conversation with Africa, the diaspora, and modernism, which would continue for the remainder of her career.

Jones's 1982 *Suriname*, the last work of her "Africa Series" list, under the name "Surinamia," offers the viewer a return to Jones's roots as a textile designer, with its repetitive design elements. With its titular reference to the South American country of Suriname, the acrylic

painting charts yet another Afrodiasporic route. A complex, quilt-like pattern of red, orange, gray, black, white, and chartreuse fills the vertical composition. The pictorial plane possesses a distinct flatness; diamond and triangle shapes filled with horizontal and vertical rectangular fields of color appear overlaid on horizontal rows of intricately patterned bands.

Suriname deploys a diasporic grammar legible on several diasporic, political, and aesthetic levels. With its abstract geometric composition, flat pictorial plane, and bright colors, *Suriname* seems in line with trends in post-1960 American art, including the hard-edged abstraction of fellow African American artists like William T. Williams. *Suriname* also draws inspiration from textiles sewn by Saramaka women in Suriname. Saramaka Maroon women used scraps of fabric to fashion shoulder capes worn by men. According to anthropologists Richard and Sally Price, the women would lay out the narrow strips and determine a suitable pattern before sewing them together into the cape.[138] Art historian Robert Farris Thompson argues that the narrow-strip weaving practice of the Samaraka comes from the Mande weaving tradition in West Africa.[139] Elsewhere I have noted the ways in which Jones's paintings of African themes possess obvious referents to West African weaving practices—including her incorporation of the heddle pulley in her 1972 *Ubi Girl from the Tai Region* and her 1982 *Petite ballerina du Senegal*, completed the same year as *Suriname*.

One of six black cultural groups in Suriname, the Saramaka (known as Maroons) descended from enslaved Africans brought to the Dutch colony of Suriname in the seventeenth and eighteenth centuries.[140] The ancestors of this group escaped bondage and settled in the interior of Suriname. After much warfare, a peace treaty signed with the Dutch in the 1760s granted their independence. As a result, the Saramaka Maroons enjoyed unprecedented levels of freedom and isolation. Anthropologists and art historians note the significant number of West African cultural and artistic retentions found within these Surinamese groups.[141] At the time Jones painted *Suriname*, the country had recently gained independence from the Netherlands in 1975. The newly independent nation made national headlines in the early 1980s after a coup d'état led to a military regime gaining control.

The titles of the paintings on the "Africa Series" list map Jones's Afrodiasporic travels and experiences—spanning Paris, Haiti, Washington, D.C, West Africa, and South America. Jones's self-charting of the African influence in her praxis, which begins in Paris with *Les Fétiches* and ends with her 1982 *Suriname*, painted in Haiti after a trip to the South American country, highlights the movement and cultural encounters she experienced over the course of her career. The fact that the painting resonates aesthetically with both an Afrodiasporic artistic tradition and a Western modernist style speaks to the ways in which Jones continually designed a new tradition all her own.

Soon after visiting the MoMA show, Jones painted *The Beginning*, a stark work that operates as an Afrodiasporic creation story (fig. 86). The painting makes reference to both Judeo-Christian and Vodou creation myths. As in many of her works, Jones divided the canvas of *The Beginning* into vertical segments. At the left, a nude black couple stands silhouetted on a swath of yellow

sand. Above them, two bands of blue in different shades signify the ocean. The coral rectangle that fills the area above these bands represents the sky. Standing face to face, the male and female clasp hands around a green object––Jones's take on the infamous apple of the Hebrew Bible's book of Genesis. Beneath this black Adam and Eve, a multicolored serpent glides upward, flicking its tongue. The snake possesses symbolic significance in both Western and Afrodiasporic religious traditions. The snake betrayed Adam and Eve in the Garden of Eden, while in Vodou the snake is the symbol associated with Damballah, the god of creation.[142]

At the center of the canvas in a black rectangle is an elaborately rendered Senufo kpeliye'e mask, its outline executed in light brown. Balancing the entire composition is the ocean, which appears in two iterations on both sides of the mask's field. The way the ocean flanks the African mask speaks to the African diaspora and the transport of African bodies across the

Atlantic. In the composition, the mask serves as a metonym for the African continent. On the far right, a white sphere (sun or moon) is depicted close to the horizon line. A serpentine green plant at the right mirrors the snake on the left.

The Beginning might be read as a bookend to Jones's 1932 *The Ascent of Ethiopia*, painted more than fifty years earlier (see fig. 26). In *The Ascent of Ethiopia*, Jones commented on the role of Africa in the developing African American identity. She documented the incorporation of blacks into urban American society during the Harlem Renaissance. However, in *The Beginning* Jones posits a black origin to all humanity. The 1985 painting can be seen as a culmination of her decades-long engagement with the *idea* of Africa and epitomizes her deployment of a collaged, composite aesthetic to visualize blackness.

Three years after *The Beginning*, the *Washington Post* commissioned a watercolor from Jones. The resulting work, *We Shall Overcome*, is a pastiche that speaks to black humanity and survival (fig. 87). The title refers to the anthem of the Civil Rights movement. Like *The Beginning*, *We Shall Overcome* is a commentary on black humanity and survival but expressed through representational rather than abstract forms. The composition is crowded by a mix of black bodies, black faces, emblems, and assorted words. Whereas Jones's earlier collaged pieces used cuttings from popular media, like her 1964 *Challenge America* (see fig. 70), in *We Shall Overcome* she uses watercolor to achieve the same affect. This medium is both a nod to Jones's artistic roots and a demonstration of her artistic dexterity.

The large heads of two prominent African American clergymen-turned-activists are immediately visible. The Rev. Dr. Martin Luther King Jr. appears at the top left, in front of the Lincoln Memorial Reflecting Pool and Capitol. Rosa Parks's name is visible beneath his chin. Rev. Jesse Jackson, a 1988 presidential candidate, looks across the composition from the right. Between these iconic figures, superstar black entertainer Michael Jackson peers out. The smiling faces of actor-comedian Bill Cosby and actress Phylicia Rashad, of the groundbreaking television series *The Cosby Show*, fill the top right corner. A cascade of African American athletes—outfielder Reggie Jackson, who played for the New York Yankees and Oakland Athletics; Philadelphia 76ers forward-guard Julius Erving; figure skater and 1988 Olympic bronze medalist Debi Thomas; and Washington Redskins quarterback Doug Williams—divide the composition in half. To the left of the athletes, one finds an election campaign pin bearing the name of former D.C. mayor Marion Barry next to a black soldier in combat gear.

Beneath Thomas's skates, the words "November 28, Wappinger Falls" appear—the date and location of the alleged beating and humiliation of African American teenager Tawana Brawley in 1987. Cosby and Rev. Al Sharpton were among numerous prominent black public figures who came to her aid.[143] The textual reference to this incident appears above a trio of Klansmen in white robes. To the right of the athletes, South African archbishop and civil rights activist Desmond Tutu (b. 1931) stands in front of a pair of microphones. The arms of a group of African dancers, who appear behind Tutu circling red-orange flames, mirror his outstretched arms. Beneath Tutu, a multiracial crowd carries a white

Fig. 87 Loïs Mailou Jones, *We Shall Overcome*, 1989. Watercolor on paper, 23 × 17 in. Smithsonian American Art Museum, Washington, D.C., 2006.24.8. Bequest of the artist. Courtesy Loïs Mailou Jones Pierre-Noël Trust.

banner that reads "Apartheid Kills;" beneath the *K* appears a white skull and the word "Drugs." In front of the skull stands a young black man sporting a black cap and round, white-framed sunglasses with dollar signs over the lenses. To his left, another young black man in a tank top and do-rag turns toward the marching crowd, the word "cocaine" falling in white letters from his mouth.

The composition is multilayered, both in its painted collage elements, which overlap and build upon one another, and in its meaning. Its focus is also entirely contemporary, and its execution is representational, with none of Jones's signature abstractions or color blocking. The title, coupled with Jones's inclusion of numerous African American heroes in pop

culture and concrete references to the chal-
lenges facing blacks at the end of the 1980s (e.g.,
racism, crime, police brutality, politics, and the
war on drugs that meted out racially disparate
sentences), combine to convey a message of
strength in the face of difficulty and coexistence.

In *We Shall Overcome*, Jones does not quote
artistic sources but rather assembles a powerful
mix of black people, personalities, locales, and
historical events. The collage-like painting is a
time capsule, a commentary not only on the 1980s
but also on the complexity of black history that
had brought African Americans to that moment.
We Shall Overcome seems unexpected in Jones's
oeuvre. While it represents a retreat from overtly
African themes, it remains both a critique and
a celebration of blackness. Yet the stylistic and
rhetorical shifts found in *We Shall Overcome* reso-
nate with the late stages of Jones's career, when
she herself reflected on all she had overcome.

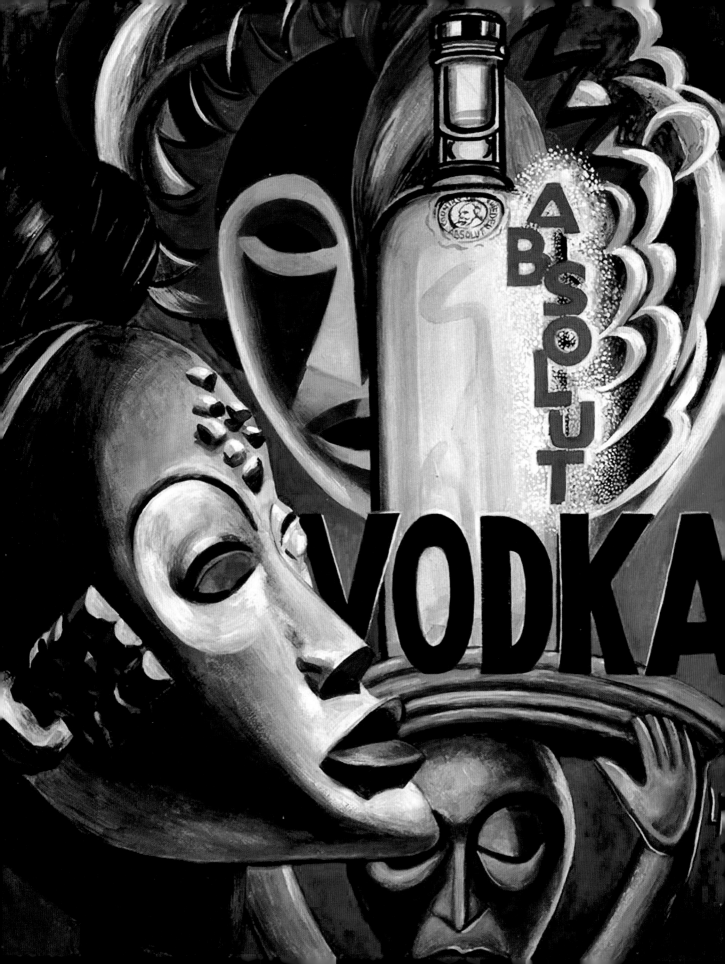

Conclusion

Composite Naming Practices and Art Histories

Will the Negro's art be African or

American, primitive or modern?

Or will it be a composite of all of these?

—ALAIN LOCKE, 1936

In 1991, the Swedish vodka company Absolut along with the publishers of *Black Enterprise* magazine awarded Jones a commission for their forthcoming "Heritage" advertising campaign (fig. 88).[1] Jones's contribution returned to her collage aesthetic, here mixing fine art and advertising. Jones inserted the commercial product within the context of Africa and the diaspora. A Punu mask from Gabon, with a stylized hairstyle and keloid scarification marks, dominates the left-hand side of the vertical composition. Shown in profile, this mask's gaze rests on a clear glass bottle elevated in space by a Congolese prestige stool with a caryatid figure. The word "VODKA" appears in capitalized black text atop the stool's seat. The word "ABSO-LUT" is suspended vertically along the right side of the bottle. Rendered in bright orange and surrounded by what appears as a white aura, the brand-name seemingly levitates in space. In the background, peeking out from behind the bottle, is a culturally nonspecific African mask with an elaborate headdress. This mask bears an uncanny

affinity to one found in Jones's painting *Les Fétiches*, completed during her Parisian sabbatical in 1938 (see fig. 33). As discussed in chapter 2, this painting marks an early appearance of her collage aesthetic in which she combined African art objects and employed a mélange of modernist styles: cubism, impressionism, and surrealism. In doing so, Jones foreshadowed the composite aesthetic she later developed as a metaphor for the African diaspora. Similarly, in her Absolut commission, Jones literally combined media, advertising, objects (African and modern), and styles (realistic and abstract), as well as word and image, in her artwork.

In the early 1990s, Absolut Vodka's marketing program became a global phenomenon. Predicated upon the clever pairing of word and image, the widely collected advertisements include a creative manipulation of the company's liquor bottle, beneath which the word "ABSOLUT" is paired with a second noun or an adjective that results in wordplay. For the brand's artist-themed campaigns, which began in 1985 with Andy Warhol, fine artists were tasked with applying their signature styles or techniques to images of the product. In these images, the artists' last names typically follow the word "ABSOLUT," which not only signifies the brand item but also testifies to the veracity of the image as being a genuine product of the identified creator's hand. The advertisements thus sell not only the vodka but also the artist and his or her identifiable aesthetic.

The "Heritage" series celebrated a host of twentieth-century African American artists such as Alonzo Adams (b. 1961), Tina Allen (1948–2008), Phoebe Beasley (b. 1943), Camille Billops (b. 1933), Moe A. Brooker (b. 1940), Gale Fulton Ross (b. 1947), Verna Hart (b. 1961–2019), Margo Humphrey (b. 1942), Mr. Imagination a.k.a. Gregory Warmack (b. 1948–2012), JoeSam (b. 1939), Donald Locke (1930–2010), Joe Overstreet (b. 1943–2019), David Philpot (b. 1940–2018), John T. Riddle, Jr. (1933–2002), and Sidney Schenck (b. 1951). While the selected artists were balanced vis-à-vis gender, Jones diverged from the rest due to her age; she was on average at least twenty-five years older than her fellow participants.

All of the advertisements in the "Heritage" series followed Absolut's standard titling practice with one notable exception: Jones's work is called *Absolut Heritage* rather than *Absolut Jones*, the latter of which would have followed the norm. As a noun, *heritage* refers to notions of inheritance, material property, or cultural traditions that are passed down from generation to generation. Her advanced age and the unique title of her composition position Jones and her artwork as part of the legacy of twentieth-century African American art. With the title *Absolut Heritage*, Jones was afforded a revered position of prominence reserved for patriarchs and matriarchs, suggesting an honor she achieved through decades of hard work. The honorific titling, however, placed Jones firmly in the past and simultaneously erased her surname, in effect removing her from the venerated artists and obscuring her crucial position. In the Absolut campaign, as in American and modernist art histories (African American and otherwise), Jones was both part of a select group and relegated to the margins. The erasure of Jones's name in the Absolut advertising campaign mirrored the art world's (mis)understanding of her artistic contributions and career achievements, an ongoing slight that this monograph seeks to remedy.

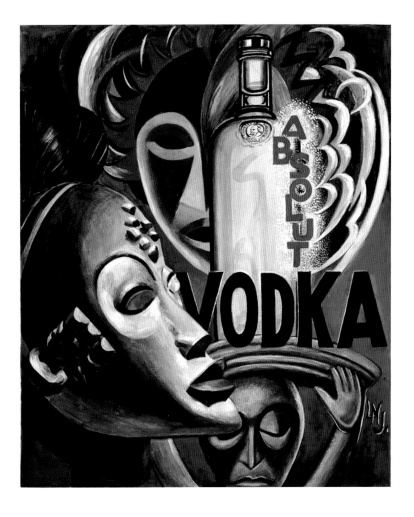

Fig. 88 Loïs Mailou Jones, *Absolut Heritage*, 1991. Artwork © Lois Mailou Jones, 1991. Courtesy Loïs Mailou Jones Pierre-Noël Trust.

While Jones's last name may not have appeared in bold font along the bottom edge of the advertisement, scanning the margins of *Absolut Heritage* reveals that her initials, L. M. J., appear next to the caryatid's left hand. Over the course of her nearly seventy-five-year career, Jones utilized a number of different autographs in her works: L. M. J., Lois Mailou Jones, Loïs Mailou Jones, Loïs Maïlou Jones, Lois M. Jones, and Loïs Pierre-Noël. Jones first began to experiment with the spelling of her name during the 1930s, at times adding a French tréma accent to her first name, which transformed it from Lois to Loïs. The insertion of this diacritical mark appears on the canvases Jones completed during her Parisian sabbatical from 1937 to 1938. Her continued use of the tréma upon her return from Paris indicated her desire to be viewed as a Francophile. After her 1953 marriage to Louis Verginaud Pierre-Noël, she took her husband's name. When signing her name as Loïs M. Pierre-Noël, Jones signaled not only her change in marital status but also her new association with her husband's Haitian homeland. The

visual symmetry of the accent in her first name mirroring the one in her married last name must have appealed to Jones's design sensibility and drew visual attention to the beginning of her name. Frequently, as in Jones's Absolut commission, she signed her work with only her initials—L. M. J.—a neutered name with no obvious gendered, national, or racial associations. In doing so, Jones followed in the footsteps of Lee Krasner, the female abstract expressionist who used the signature L. K. as a strategy to avoid her art "being identified" as the product of a woman.[2] L. M. J. and L. K. were artists, full stop. The varied signatures Jones employed mark her awareness of the different naming practices to which she and her art work could be subjected and reflect her ongoing negotiation of a composite of identities related to racial, gendered, and geographic positions.[3]

The role of the tréma accent within this context itself marks the genesis of a composite by both uniting and separating the vowels. Jones's life, like her signatures and her artwork, combined her varied lived experiences—her Boston upbringing, her traditional training at the SMFA, her long teaching career at Howard University, and her travels to France, Haiti, and Africa. Her art styles, which frequently feature the mixing of African and Afrodiasporic subject matter with modernist painting techniques, manifest another composite. Jones's collage aesthetic, evident in her true collages of the late 1950s and the majority of her paintings post-1970, serves as a metaphor both for the diasporic condition and for her negotiation of the composite aesthetics of blackness, itself an amalgamation of peoples, cultures, geographies, and objects.

In 1993, shortly after the Absolut commission, Jones appeared on an episode of the Public Broadcasting Network's *MacNeil/Lehrer NewsHour*. Correspondent Charlayne Hunter-Gault interviewed the artist, then eighty-eight years old, and asked how she would history to remember her. Jones responded by referring both to her long tenure as an art instructor at Howard University and to her contributions to American art. Her pedagogy, the artist explained, indicated her dedication to "helping the younger generation of blacks . . . to guide them . . . to lead them."[4] She expressed the desire to be inserted into the history of art: "The paintings that I leave behind I hope will find their place as a contribution to American art in the broadest vein of it, and to really go down in history as an American artist who has made a mark in life, who has achieved."[5] This quote indicates the artist's self-awareness of her significance in the field and underscores my own argument that Jones consistently deployed African and Afrodiasporic motifs to negotiate a myriad of aesthetic, institutional, and cultural contexts. She developed a composite aesthetic that often employed the blackness-in-triplicate motif and the notion of diasporic grammar, while demanding recognition for her many artistic and educational contributions.

Jones's yearning to be named within the art-historical canon brings us back to the watercolor illustration with which this book began: *Under the Influence of the Masters* (see fig. 1). While my initial analysis of this image in the book's introduction focused on the identification of the androgynous central figure as a self-portrait of Jones, I now want to focus on the naming

practices at play within the watercolor. We know Jones went to great lengths to insert herself into the annals of African American and Western art history at large, as evinced in the quote above. In the main section of the composition, she included her androgynous self-portrait, and her name (L. Jones) appears in the list of selected African American artists split among the four frieze panels that flank the central panel. As discussed previously, the names and faces of fourteen Western masters float above Jones's figure. Notably, the surnames of John Singleton Copley, Mary Cassatt, and Henry Ossawa Tanner follow the curve of her palette. Renowned portraitist Copley, like Jones, was Boston-born. By associating herself with him, Jones highlighted her New England roots, her portrait practice, and her lineage to this renowned colonial painter. Cassatt, the single woman named among the masters, found freedom (from gender norms and stifling aesthetic academicism) in the Parisian art scene, thereby becoming a model and precedent for Jones herself. Tanner, the African American painter who also sought refuge in Paris, achieved international acclaim, becoming in many ways the grandfather of African American art. Undoubtedly Jones sought to forge a link to his legacy as well.

Naming herself among the African American artists listed in the side panels enabled Jones to establish a connection between herself and African American art history. She also took the opportunity to establish her own *middle*-ness. Her name is in the middle of a list of black artists; her body is in sandwiched between the names and occupies the physical middle of the composition. She literally stands in the middle of several artistic traditions. Among the twenty-nine notable African American artists of the late nineteenth and early twentieth centuries, only one other African American woman is included: portraitist Laura Wheeler Waring. The illustration thus stresses the status of women, but especially African American women, as minorities within the canons of Western and American art history. Jones seemingly arranged the African American artist's names chronologically, according to their active years in the art world. She expressly paired her own name with that of her Howard University colleague James A. Porter. In 1943, several years later after Jones's illustration appeared, Porter published his seminal survey of African American art from the slavery era to the 1940s, *Modern Negro Art*. His book included Jones, suggesting that he agreed with her self-assessment in this illustration that she fit into the history of African American art as a significant figure.

Two months before *Under the Influence of the Masters* appeared on the cover of the April 1939 issue of the *Negro History Bulletin*, Anthony Philpott of the *Daily Boston Globe* proclaimed: "There is little doubt in the minds of those who have seen her work that Lois M. Jones is the outstanding Negro artist in the United States."[6] Following suit, Jones inserted herself literally into the trajectory of remarkable American and African American artists when she claimed the middle of the illustration. More than forty years later, in 1983, the *Washington Post* published an article entitled, "Loïs Mailou Jones: An Indefatigable Black Woman Artist."[7] In this interview given in the twilight of her career, Jones reiterates what she had self-consciously illustrated in *Under the Influence of the Masters*. Although separated in time by nearly half a century, a period that

saw Jones's accomplishments steadily mount—success in the classroom at Howard University where she trained numerous black artists; travels throughout Africa, the Caribbean, South America, and Europe; the receipt of frequent accolades for her paintings displayed at home and abroad, including the distinction in 1973 of being the first African American woman to be given a solo retrospective at the Museum of Fine Arts Boston; to name just a few—nevertheless, the burden lay on her to ensure that she was remembered in the annals of art history. Just as in her art, via her use of the collage aesthetic, Jones rendered visible the fissures and seams of blackness. This effort continued into her later life, when in interviews Jones once again asserted her legacy and involvement in visualizing the myriad of black identities present in the twentieth century.[8] Jones's interest in the composite aesthetics of blackness highlights the course of her biography, the evolution of her stylistic and compositional choices, and her varied diasporic experiences and influences.

To some art historians, the single-artist monograph might feel outdated. Others place unreasonable demands on such studies to provide the complete, unfettered, and omniscient narrative of a historical life. Given the categorical ways in which black visual expression has been stifled, repressed, overlooked, and understudied in the field of art history, I contend that there can never be too many books on black artists. This study claims space for Loïs Mailou Jones and offers a methodology for others interested in moving twentieth-century minority artists from the margins to the middle. Leveraging Jones's artistic output and personal biography, *Designing a New Tradition* strives to alter the ways we understand African American artistic production in relation to the influence of Africa as well as to the roles of class, gender, and politics. Such a study is possible because Jones kept meticulous records and was cognizant of the fact that American art history might not remember her. By privileging her objects and her archive, I tell one story about Jones's life and career that I hope serves as an invitation to future scholars to continue the conversation. While Jones may have found her niche within the art-historical canon, there are others who have gone unnamed, whose art histories remain untold. The single-artist monograph, particularly in the field of African American art history, continues to be critically important.

Notes

Introduction

1. "Distinguished Painters Inspire Those of African Blood," *Negro History Bulletin* 11, no. 7 (Apr. 1939): 58.
2. I am not the first to deploy the roots and routes metaphor in relation to African American cultural production. See, for example, Gilroy, *Black Atlantic*; Clifford, *Routes*; Collins, *Art of History*; Mercer, *Exiles and Strangers*.
3. Betty Perry, "Lois Mailou Jones: An Indefatigable Black Woman Artist," *Washington Post*, Feb. 23, 1983. Note that throughout Jones's life, she used different articulations of her name, often adding diacritical marks and moving between her maiden and married names. Accordingly, various spellings of her name can be found in scholarship and writing about her work and life.
4. Fern Gillespie, "The Life and Legacy of Lois Mailou Jones," *Howard Magazine* 8, no. 2 (Winter 1999): 8.
5. Holland Cotter, "Lois Mailou Jones, 92, Painter and Teacher," *New York Times*, June 13, 1998.
6. Ibid.
7. Jones, interview with Theresa Danley, in Hill, *Black Women Oral History Project*, 6:272–73.
8. Benjamin, *Life and Art of Loïs Mailou Jones*, 4.
9. Benjamin, "Color, Structure, Design," 33.
10. The other artists were: Elizabeth Catlett, Pat Davis, Carol Lee, Dinga McCannon, Howardena Pindell, Adrian Piper, Barbara Chase Riboud, Faith Ringgold, Betye Saar, and Alma Thomas. According to letters exchanged between Ringgold and Jones, the exhibit was originally intended to include eight artists and was titled *Eight Black Women Artists* (Jones to Faith Ringgold, Feb. 25, 1975, box 215-11, folder 28, Loïs Mailou Jones Papers. Moorland-Spingarn Research Center, Howard University, Washington, D.C., hereafter "Jones Papers.").
11. Paul T. Heffron of the Library of Congress Manuscript Division to Loïs Mailou Jones, Oct. 1, 1980, box 215-8, folder 4, Jones Papers, and email to author from Barbara Bair, manuscript specialist in literature, culture, and the arts, Sept. 6, 2017.
12. Jimmy Carter, "National Conference of Artists Remarks at a White House Reception," Apr. 2, 1980, East Room, White House, American Presidency Project, https://www.presidency.ucsb.edu/documents/national-conference-artists-remarks-white-house-reception.
13. Ibid.
14. Jones traveled to seventeen venues in total (Hanzal, *Loïs Mailou Jones*, 140).
15. Ibid., 134–40.
16. Smalls, "Ghost of a Chance;" Powell, "Rechercher et imaginer."
17. For the challenges of the single-artist study, see Frederickson and Webb, *Singular Women*, and Salas, *Life and the Work*.
18. Benjamin, *Life and Art of Loïs Mailou Jones*. Benjamin studied with Jones at Howard in the late 1960s and early 1970s. Other publications on Jones include: Chapman, *Loïs Mailou Jones*; LaDuke, *Africa Through the Eyes of Women Artists*; LaDuke, "Loïs Mailou Jones." Jones's work is discussed in Farrington, *Creating Their Own Image*. The catalogue for Jones's 2009 retrospective organized by the Mint Museum of Art in Charlotte, North Carolina, brought together a series of essays on Jones by Cheryl Finley, Edmund Barry Gaither, Lowery Stokes Sims, and Tritobia Benjamin (Hanzal, *Loïs Mailou Jones*). Most recently Cheryl Finley has written on Jones's time in the South ("Loïs Mailou Jones"), and Susan Earle discussed Jones's importance in her essay "Wide-Ranging Significance of Loïs Mailou Jones."
19. The exhibit traveled to the Polk Museum of Art, Lakeland, Florida; the National Museum of Women in the

Arts, Washington, D.C.; and the Hunter Museum of American Art, Chattanooga, Tennessee.

20. Scholarship on the African retention in African American cultural forms abounds. See Herskovits, *Myth of the Negro Past*, and Thompson, *Flash of the Spirit*. Notable examinations of the African influence in African American art include: Locke, *New Negro*; Porter, *Modern Negro Art*; Ford, "Influence of African Art"; Gaither, "African and African American Art"; Powell, *African and Afro-American Art*; Rozelle, Wardlaw, and McKenna, *Black Art*; Wofford, "Africa as Muse;" Miller, "Primitivist Encounters."

21. Bowles, "African American Artists as Agents."

22. Mudimbe, *Idea of Africa*.

23. Powell, *Black Art*, 22.

24. Gilroy, *Black Atlantic*.

25. Ibid., 102.

26. Edwards, *Practice of Diaspora*.

27. For a genealogy of the term "diaspora," see Palmer, "Defining and Studying the Modern African Diaspora," 27–28; Edwards, "Uses of Diaspora"; and Clifford, *Routes*, 244–78. For discussions of the African diaspora within art history, see Thompson "Sidelong Glance"; Thompson, *Flash of the Spirit*; Powell, *Black Art*. Additionally, a number of anthologies edited by Kobena Mercer have augmented the discourse: *Cosmopolitan Modernisms*; *Pop Art and Vernacular Cultures*; *Exiles and Strangers*; and *Travel and See*.

28. This division derives from the broad history of Romance languages predominating in Central and South America, as opposed to North America, where English has been dominant.

29. Farebrother, *Collage Aesthetic in the Harlem Renaissance*, 3.

30. Mirezoff, *Diaspora and Visual Culture*, 2.

31. Ibid., 6.

32. Historian John Hope Franklin coined the term "Harlem Renaissance" to capture the essence of renewal and rebirth in African American culture in the 1920s and 1930s (Franklin, "Harlem Renaissance"). See also Baldwin, *Chicago's New Negroes*; Ogbar, *Harlem Renaissance Revisited*; Nadell, *Enter the New Negroes*; Huggins, *Harlem Renaissance*; Lewis, *When Harlem Was in Vogue*; Hutchinson, *Harlem Renaissance in Black and White*.

33. Jones, artist statement, Jan. 27, 1967, box 215-1, folder 14, Jones Papers.

Chapter 1

1. Newspaper clipping [title removed], n.d., Lois Mailou Jones scrapbooks, 1922–92, frame #14 of reel 4371, Smithsonian Archives of American Art. The scholarship enabled Jones to take afternoon vocational drawing classes at the museum (Rowell, "Interview with Loïs Mailou Jones," 357).

2. Newspaper clipping [title removed], *Boston Herald*, Aug. 4, 1929, Lois Mailou Jones scrapbooks, 1922–92, Smithsonian Archives of American Art.

3. Earle, "Wide-Ranging Significance of Loïs Mailou Jones," 185–86.

4. Gaither, "Loïs Mailou Jones," 17.

5. Jones, interview with Danley, in Hill, *Black Women Oral History Project*, 6:275.

6. Gaither, "Loïs Mailou Jones," 17.

7. All data in this paragraph from Schneider, *Boston Confronts Jim Crow*, 4.

8. Ibid., 5.

9. Benjamin, *Life and Art of Loïs Mailou Jones*, 4.

10. While a black middle class (occupied by those with white-collar jobs and some college education) emerges at the end of the nineteenth century, the modern black middle class does not become visible until the 1950s and 1960s (Frazier, *Black Bourgeoisie*).

11. Jones, interview with Danley, in Hill, *Black Women Oral History Project*, 6:274.

12. Schneider suggests that the influx of Jewish residents to the West End area was one reason why African Americans began to settle in the South End (*Boston Confronts Jim Crow*, 4).

13. Ibid.

14. Mitchell and Davis, *Literary Sisters*, 69.

15. "New England Sees 9,000 Women March," *New York Times*, May 3, 1914, 12. The black press also covered the women's suffrage movement with great interest.

16. Jones, interview with Danley, in Hill, *Black Women Oral History Project*, 6:273.

17. Ibid.

18. Higginbotham, *Righteous Discontent*, 185–229.

19. Mjagki, *Organizing Black America*.

20. Jones, interview with Danley, in Hill, *Black Women Oral History Project*, 6:278.

21. Earle, "Wide-Ranging Significance of Loïs Mailou Jones," 185.

22. Schneider, "League of Women for Community Service," 264.

23. Jones, interview with Danley, in Hill, *Black Women Oral History Project*, 6:275.

24. Schneider, *Boston Confronts Jim Crow*, 4.

25. Jones, "Career of an African American Artist," 45.

26. According to Jones's SFMA entrance forms, the Joneses lived at 25 Hammend Street in Roxbury, SMFA Records, Tufts University Digital Collections and Archives.

27. United States Office of Education, *Report of the Federal Security Agency: Office of Education* (U.S. Printing Office, 1910), 1:109.

28. Ibid.

29. Jones, interview with Danley, in Hill, *Black Women Oral History Project*, 6:275.

30. Ibid.

31. Jones, "Career of an African American Artist," 46.

32. Jones, interview with Danley, in Hill, *Black Women Oral History Project*, 6:278.

33. It is most likely that Ripley Studios assisted the company with their 1920 program, which included Ancient Greek, Japanese, East Indian, Persian, Siamese, Chinese, and Egyptian dances (Schlundt, *Chronology of the Professional Appearances*, 120).

34. Ibid., 20, 22, 25, 27.

35. Rowell, "Interview with Loïs Mailou Jones," 358.

36. The exhibition was thought to have been put on by a local school teacher. Alex Floyd, "Honoring Loïs Mailou Jones, an Artist and a Trailblazer," *Vineyard Gazette*, June 5, 2015.

37. Benjamin, *Life and Art of Loïs Mailou Jones*, 27.

38. Ater, *Remaking Race and History*.

39. Brown, *Inventing New England*, 84.

40. Benjamin, *Life and Art of Loïs Mailou Jones*, 5.

41. Graham, *Our Kind of People*, 154.

42. Karla Arajou, "Against All Odds," *Martha's Vineyard Magazine*, Nov. 14, 2014.

43. Mitchell and Davis, *Literary Sisters*, 83.

44. Ibid.

45. Rudnick, "Modernizing Women," 161.

46. Jones, interview with Danley, in Hill, *Black Women Oral History Project*, 6:274.

47. Ibid.

48. Denenberg, *Call of the Coast*.

49. Jones, interview with Danley, in Hill, *Black Women Oral History Project*, 6:279.

50. Floyd, "Honoring Loïs Mailou Jones, an Artist and a Trailblazer."

51. Arthur Fairbanks, "Report of the Committee on the School," *Annual Report for the Year, Museum of Fine Arts, Boston* 48 (1923): 123.

52. Hirshler, *Studio of Her Own*, 135.

53. Winners and the occupations of their families were listed in the SFMA annual reports for 1926–1927 and 1927–1928, SMFA Records, Tufts University Digital Collections and Archives.

54. Jones, interview with Danley, in Hill, *Black Women Oral History Project*, 6:278.

55. Ibid.

56. Jones's student registration card index, SMFA Records, Tufts University Digital Collections and Archives.

57. Fahlman, "Art Spirit in the Classroom," 103. For more on the history of the SMFA, see Hayes, *Art in Transition*, and Fleming, "Instructors and Courses in the Museum School," 233–35.

58. Hirshler, *Studio of Her Own*, 13.

59. A list of special exhibits can be found in the pages of the MFA's *Annual Report*.

60. A search of the MFA collections does not reveal potential sources for these two drawings. It is possible that Jones saw them during a traveling exhibition of Rodin's work.

61. Jones, "Loïs Mailou Jones," biographical sketch, Oct. 22, 1972, box 214-14, folder 41, Jones Papers.

62. Jones, "Career of an African American Artist," 46.

63. Lowery Stokes Sims has a similar conjecture ("Loïs Mailou Jones," 43).

64. On the designations for the movement, see Gates, "Trope of a New Negro," and Powell, *Black Art*, 41–54.

65. Corbould, *Becoming African Americans*, 19.

66. In 1923, another seventy-eight cases arrived from Egypt. The notable acquisitions included a twelve-foot granite statue of "Tanutamon" and the massive sarcophagus of Aspalta. See Morris Gray, "Report of the President," *Annual Report for the Year, Museum of Fine Arts, Boston* 48 (1923): 17–18.

67. Press coverage of the Egyptian discoveries was frequent in mainstream and African American publications. See, for example, "Ancient People Believed Soul Stayed in Tomb," *Chicago Defender*, Feb. 23, 1924, A1;

"Civilization in Africa at One Time Superior to Ours," *Chicago Defender*, Oct. 11, 1924, A9; "Princesses' Tombs Found Near Thebes," *New York Times*, Dec. 23, 1924, 18; "Howard Carter in Cairo," *New York Times*, Dec. 17, 1924, 44. Haberland, *Leo Frobenius*. For an example of a heavily illustrated text, see Frobenius, *Voice of Africa*.

68. Ater, "Making History," 17–20.

69. Ater, *Remaking Race and History*, 25.

70. Ater suggests that Fuller may have been inspired by the MFA's statues of King Menkaure and his queen ("Meta Warrick Fuller's *Ethiopia*," 18).

71. "Americans of Negro Descent," in *The Book of America's Making Exposition, 71st Regiment Armory New York, October 29–November 12, 1921* (New York: City and State Departments of Education, 1921), n.p. (Ater, "Meta Warrick Fuller's *Ethiopia*," 53).

72. *Bulletin of the Public Library of the City of Boston* 3–4, no. 32; *New York Tribune*, October 29, 1922, D6.

73. Ater, *Remaking Race and History*, 103, 109–15.

74. Ibid., 109–15.

75. Archer-Straw, *Negrophilia*; Blake, *Tumulte Noir*; Harris and Molesworth, *Alain Locke*.

76. Lemke, *Primitivist Modernism*; Miller, "Primitivist Encounters?"

77. The 110 attendees included W. E. B. Du Bois, Alain Locke (master of ceremonies), playwright Eugene O'Neill, journalist/satirist H. L. Mencken, writer/photographer Carl Van Vechten, and NAACP Board member Joel Spingarn. The program included a lecture on African art by Albert Barnes and poetry readings from Countee Cullen and Gwendolyn Bennett. Wintz and Finkelman, *Encyclopedia of the Harlem Renaissance*, 2:933.

78. The special issue of *Survey Graphic* proved to be particularly popular; according to the 1992 reprint of *The New Negro* (New York: Simon & Schuster, x), it sold through two printing runs—an estimated 42,000 copies. Watson, *Harlem Renaissance*, 28.

79. Cullen, "Heritage"; the other three articles on art were: Barnes, "Negro Art and America," 668–69; Schomburg, "Negro Digs Up His Past"; and Locke, "Art of the Ancestors," 673.

80. Locke, *New Negro*.

81. Gates and Jarret, *New Negro*, 1.

82. Locke, "New Negro," and Barnes, "Negro Art and America."

83. Locke, "Legacy of the Ancestral Arts," esp. 255–56.

84. Jones is most likely referring to an informal lecture series held at the Women's Service Club at 464 Massachusetts Avenue. Jones, interview with Danley in Hill, *Black Women Oral History Project*, 6:281.

85. J. Edmond Moses, poem in Jones's SMFA notebook, 1925–26, box 215-1, folder 41, Jones Papers.

86. Locke, "Legacy of the Ancestral Arts," 256.

87. *Vanity Fair*, an American society magazine, began publication in 1913; in 1936, it merged with *Vogue*. Williams, *Covarrubias*, and Cox and Anderson, *Miguel Covarrubias Caricatures*.

88. Shakespeare, *Hamlet*, 3.2.17–24.

89. Pratt, *Imperial Eyes*, 6–7, and Clifford, "Museums as Contact Zones," 192.

90. Clifford, "Museums as Contact Zones," 204.

91. The exception is the unpublished yet widely cited Columbia dissertation by Helen Shannon, which explores early displays of African art and their relationship to African American modernism ("From 'African Savages' to 'Ancestral Legacy'"). Bridget R. Cooks's recent work on African Americans and the American art museum hones in only on the art-museum space (*Exhibiting Blackness*).

92. Its original name was Hampton Normal and Agricultural Institute. Puryear, *Hampton Institute*, and Engs, *Educating the Disenfranchised and Disinherited*.

93. Zeidler, "Hampton University Museum," 22.

94. Hultgren, "Roots and Limbs," 44. See also Hultgren and Zeidler, *Taste for the Beautiful*.

95. Chapman's mother was originally responsible for housing this collection of non-Western objects. Zeidler, "Hampton University Museum," 22, and Hultgren, "Roots and Limbs," 45.

96. The show was on view from November 3 to December 8, 1914. Zayas, "Statuary in Wood by African Savages," 70–72.

97. The gallery 291, run by photographer Alfred Stieglitz, played a pivotal role in introducing American audiences to art photography and work by members of the European avant-garde. Greenough, *Modern Art in America*.

98. Berzock and Clarke, *Representing Africa in American Art Museums*, 14–15.

99. Shannon, "From 'African Savages' to 'Ancestral Legacy,'" 366.

100. "Brooklyn Jottings," *Chicago Defender*, May 19, 1923: 9.

101. Seligmann, "Primitive Negro Sculpture on View in Brooklyn, N.Y. Museum," *Amsterdam News*, May 16, 1923. Seligmann, an author and advocate for civil rights, was publicity director for the NAACP from 1919 until 1932 and had a special interest in the visual arts. Other African American press mentions include: "African Negro Art," *New York Amsterdam News*, April 18, 1923, 5; and "Congo Art Proves High Culture: Examples from Central Africa at Vriikyn Museum Show That Africans Had Developed High Culture," *New York Amsterdam News*, May 30, 1923, 9. The mainstream news media also covered the exhibit; for instance: "Wide Vogue Gained by Art of Africa," *New York Times*, Sept. 2, 1923; "The World of Art: Two Museum Exhibitions," *New York Times*, Apr. 15, 1923.

102. Barnes used the services of famed Parisian dealer Paul Guillaume (1891–1934) to build his collection. See Clarke, *African Art in the Barnes Foundation*, and Berzock and Clarke, *Representing Africa in American Art Museums*, 7.

103. The print run was limited to about 250 copies. See Davis and Mitchell, "Eugene Gordon, Dorothy West," 389.

104. The male contingent of the Quill Club included Ralf Meshack Coleman, who would go on to direct the Federal Theatre Project's Boston Negro Unit, law graduate Marion G. Conovor, poet Waring Cuney, poet George Reginald Margetson, theology student Clifford L. Miller, law student Joseph S. Mitchell, MIT graduate Ferdinand L. Rousseve, and artist Roscoe Wright, who was responsible for the annual cover design. See Davis and Mitchell, "Saturday Evening Quill Club," 393, 396–402.

105. Sherrard-Johnson, *Dorothy West's Paradise*, 64.

106. Ibid., 69.

107. Edward Jackson Holmes, "School of the Museum of Fine Arts," *Annual Report for the Year, Museum of Fine Arts, Boston* 51 (1926), 100–3.

108. Earle, "Wide-Ranging Significance of Loïs Mailou Jones," 178 n. 9, 180.

109. My investigation of the holdings of the SMFA, the Boston MFA, and the Peabody Museum at Howard revealed that none of the museums had a Ci Wara mask during this time; therefore, it is most likely that Jones saw a photograph of the mask in a book. Neither the Boston Public Library nor the library at the SMFA were able to discern when texts on African art were added their collections. Perhaps Jones saw a photograph containing a Ci Wara mask among Paul Guillame's photographs of African art (*Sculptures Nègres*).

110. Christaud Geary to author, Feb. 7, 2011.

111. Sims, "Loïs Mailou Jones," 38.

112. Poiret ran a studio called La Maison Martine, in which he employed young working-class girls whose drawings he exploited for his own work. See Goss, "Paul Poiret and the Decorative Arts," 43–44.

113. Kirkham and Stallworth, "African American Women Designers," 126.

114. Benjamin, *Life and Art of Loïs Mailou Jones*, 7.

115. Reports also mention that another attendee is Lillian Moseley, perhaps Loïs's cousin. "New York Society," *Afro-American*, June 30, 1928; "Club Chats," *New York Amsterdam News*, July 4, 1928; "New York Society," *Afro-American*, July 7, 1928.

116. Jones, interview with Danley, in Hill, *Black Women Oral History Project*, 6:281.

117. "Display Art Works," *Afro-American*, June 30, 1928. See also Wintz and Finkelman, *Encyclopedia of the Harlem Renaissance*, 1:567.

118. For more on the importance of the *Crisis* and African American identity, see Kirschke, *Art in Crisis*.

119. Sherrard-Johnson, *Dorothy West's Paradise*, 60.

120. Wall, *Women of the Harlem Renaissance*, xiv, 4, and Bracks, *Black Women of the Harlem Renaissance Era*.

121. Rowell, "Interview with Loïs Mailou Jones," 359.

122. Benjamin, "Color, Structure, Design," 33.

123. Jones, interview with Tritobia Benjamin, Washington, D.C., Oct. 29, 1986, quoted in Benjamin, "Color, Structure, Design," 40 n. 9.

124. Rowell, "Interview with Loïs Mailou Jones," 359.

125. Ibid.

126. McCluskey, "'We Specialize in the Wholly Impossible," 403–26.

127. Higginbotham, *Righteous Discontent*, 21.

128. Graham, *Our Kind of People*, 54–57.

129. Wadelington and Knapp, *Charlotte Hawkins Brown*, and Hunter, "Correct Thing."

130. PMI 1928–29 teacher list, Charlotte Hawkins Brown Museum Archives.

131. Rowell, "Interview with Loïs Mailou Jones," 360.

132. Daniels, *Women Builders*, 160. Little is known about the objects in this collection.
133. Finley, "Loïs Mailou Jones," 84.
134. Mooney, "Comfortable Tasty Framed Cottage," 60.
135. Sherry Howard, "Lois Mailou Jones Art Exhibit in DC," *Auction Finds*, Nov. 14, 2010, http://myauctionfinds .com/2010/11/14/lois-mailou-jones-art-exhibit-in-dc.
136. Harmon Foundation and the Commission on Race Relations Federal Council of Churches, "Exhibit of Fine Arts by American Negro Artists," Jan. 7 to 19, 1930. Meta Warrick Fuller was on the judging committee. Catalogue foreword mentions that the "present arrangement was adopted at the recommendation of one of the judges," suggesting that the order in which they are listed was the order in which they were hung. Jones's submission was number fifty-four and hung between Sargent Johnson's *The Parade* and Palmer Hayden's *Flotte de Peche*. For more on the Harmon Foundation's support of African American artists, see the collected essays in Reynolds and Wright, *Against the Odds*.
137. Gaither, "Loïs Mailou Jones," 19.
138. Charlotte Hawkins Brown to Dr. George Haynes, Mar. 17, 1930, Charlotte Hawkins Brown Museum Archive.

Chapter 2

1. Driskell, "Introduction," 5.
2. Dyson, *Howard University*, and VanDiver, "Art Matters."
3. Dyson, *Howard University*, 126, and Baker, "From Freedmen to Fine Artists," 5.
4. Kendrick, "Art at Howard University," 348.
5. Herring, "American Negro as Craftsman and Artist," 117.
6. Summerford, "Phillips Collection and Art in Washington," 207.
7. For example, renowned sculptor Meta Warrick Fuller and painter Henry Ossawa Tanner were both graduates of the Pennsylvania Academy of the Fine Arts.
8. Reynolds and Wright, *Against the Odds*, 35.
9. Jackson taught a sculpture course between 1922 and 1924. Bennett joined the faculty for one year in 1924 before leaving for Paris. She returned to Howard in 1927 and then moved to New York City, where she became affiliated with the Works Progress Administration (WPA) Federal Arts Project in the 1930s (Baker, "From Freedmen to Fine Artists," 5).
10. Ibid, 5–6.
11. Best Magard, "New Method for Developing Creative Imagination."
12. Herzog, *Elizabeth Catlett*, 16.
13. Jones, interview with Danley, in Hill, *Black Women Oral History Project*, 6:283.
14. Jones to Dean St. Clair Price, Dean of the College of Liberal Arts, Apr. 12, 1950, box 215-11, folder 27, Jones Papers; Jones to President Mordecai W. Johnson, Feb. 10, 1960, box 215-11, folder 27, Jones Papers; Jones to James Porter, Head of Department of Art, July 26, 1961, box 215-11, folder 27, Jones Papers.
15. Locke's name appears in Jones's signature book in between entries from Jan. 16 and Jan. 17, 1934, box 215-2, folder 10, Jones Papers.
16. Graham, *Our Kind of People*, 86.
17. This organization is now known as the Association for the Study of African American Life and History (ASALH).
18. Woodson cofounded the ASNLH with Jesse Moorland. The organization was renamed the Association for the Study of African American Life and History in 1973. See Dagbovie, *Early Black History Movement*.
19. VanDiver, "Association for the Study of African American Life," 302–3, and Chapman, *Loïs Mailou Jones*, 17.
20. The profiled women leaders included: Lucy Craft Laney, Maggie Lena Walker, Jane Porter Barrett, Nannie Helen Burroughs, Charlotte Hawkins Brown, Jane Edna Hunter, and Mary McLeod Bethune.
21. Goeser, *Picturing the New Negro*, 17.
22. For Locke's writings on African art and African American art in the 1920s, see Locke, "Note on African Art"; Locke, "Collection of Congo Art"; Locke, "African Art Classic Style"; Locke, *Negro in Art*. On the importance of Locke's writings and institutions such as the Harmon Foundation to framing the discourse surrounding African American art in the interwar period, see Calo, *Distinction and Denial*.
23. Ater suggests that Fuller may have been inspired by the MFA's statues of King Menkaure and his queen ("Meta Warrick Fuller's *Ethiopia*," 60).
24. Jones's deliberate retelling of how *The Ascent of Ethiopia* came into being is scattered throughout her interviews. She also included the vignette in a 1976

lecture "The African Influence of Afro-American Art" given for the Léopold Sédar Senghor Foundation, International Scientific Committee for President Léopold Sédar Senghor's 70th Anniversary, "Colloquium: Culture and Development," Dakar, Senegal, October 1976, box 215-18, folder 3, Jones Papers.

25. Ibid.

26. Paul Gilroy to Jones, June 6, 1992, box 215-8, folder 1, Jones Papers.

27. Gaither, "Loïs Mailou Jones," 24.

28. For a biblical reference to people climbing a stairway to a celestial city, see Genesis 20:10–19.

29. For Garvey and the Black Star Line, see Bandele, *Black Star*, esp. 100–23, 132–62.

30. Burin, *Slavery and the Peculiar Solution*.

31. Jones contributed works to four Harmon Foundation exhibits: 1930, 1931, 1933, 1935.

32. Francis, *Making Race*, 7, 20, 118, and Calo, *Distinction and Denial*.

33. Quotation from Francis, *Making Race*, 20. See also Calo, *Distinction and Denial*, 75–77.

34. The itinerary for the traveling exhibitions varied slightly from year to year. Sites included Atlanta, Baltimore, Boston, Charleston, Nashville, Oakland, and Washington, D.C. (Reynolds and Wright, *Against the Odds*, 42 nn. 19, 21, and 28).

35. *Fétiches et Fleurs* is sometimes dated to 1926; however, Alain Locke and Theresa Leininger-Miller both date the painting to 1931–33 (Locke, *Negro in Art*, 41; Leininger-Miller, *New Negro Artists in Paris*, 102).

36. Reynolds and Wright, *Against the Odds*, 30.

37. Ott, "Labored Stereotypes," 102–15.

38. For more on the fad for blackness in Europe during the interwar period, see Archer-Straw, *Negrophilia*, and Blake, *Tumulte Noir*.

39. Francis, *Making Race*, 18–19.

40. Smalls, "African American Self-Portraiture," 55.

41. Columbia course records, box 215-1, folder 42, Jones Papers.

42. Jones listed Macgowan and Rosse's *Masks and Demons* as source material for the masks (box 215-18, folder 58, Jones Papers).

43. For the reception of *Kykunkor* as an authentic African form, see Corbold, *Becoming African-Americans*, 191–93.

44. Earle, "Wide Ranging Significance of Loïs Mailou Jones," 191–92.

45. Benjamin, *World of Loïs Mailou Jones*, 4; Finley, "Mask as Muse," 57–58; Earle, "Wide-Ranging Significance of Loïs Mailou Jones," 190. There is no mention of Jones in Maureen Needham's description of the musical's plot and staging in "*Kykunkor, or the Witch Woman*," 233–66.

46. Webb, *Perfect Documents*, 104. Despite diligent efforts, Howard's copy of the portfolio has not been located. However, numerous sources affiliated with the department attest to its continued presence in the department of art through the 1950s.

47. "African Negro Art," https://www.moma.org/calendar /exhibitions/2937?locale=en. The exhibition was on view from March 18 to May 19. More than seven hundred students from Manhattan and the Bronx reportedly visited the exhibit ("African Art Show Viewed by Pupils," *New York Times*, Apr. 14, 1935).

48. "Circulating Exhibitions 1935–36," *Bulletin of the Museum of Modern Art* 6–7, no. 2 (Mar.–Apr. 1935), 4. A total of 30,330 visitors (black and white) visited the exhibit during its first month.

49. Webb, *Perfect Documents*, 40.

50. Driskell, interview with author, Aug. 11, 2010.

51. Grossman, *Man Ray, African Art, and the Modernist Lens*, 46–47.

52. Fosdick, *Adventure in Giving*, 303.

53. Ibid.

54. Barnard, *Directory of Fellowship Awards*, 271–73, and Fosdick, *Adventures in Giving*, 305.

55. Benjamin, *Life and Art of Loïs Mailou Jones*, 27.

56. Stovall, *Paris Noir*, 63.

57. Fabre, *From Harlem to Paris*, and Stovall, *Paris Noir*. On African American visual artists in Paris, see Leininger-Miller, *New Negro Artists in Paris*.

58. Stovall, *Paris Noir*, 26.

59. Jones, report for foreign fellowship, 1937–39, box 215-16, folder 27, Jones Papers.

60. Leininger-Miller, *New Negro Artists in Paris*, and Sharpley-Whiting, *Bricktop's Paris*. The debates concerning modernist primitivism or twentieth-century artistic appropriations of non-Western art are lengthy and complex. See, to name just a few examples, Flam and Deutch, *Primitivism and Twentieth-Century Art*; Grossman, *Man Ray*,

African Art, and the Modernist Lens; Lemke, *Primitivist Modernism*; Rhodes, *Primitivism and Modern Art*; Torgovinick, *Gone Primitive*.

61. Edwards, *Practice of Diaspora*, 3.
62. The exposition, which had the theme "Art and Technology as Applied to Modern Life," ran from May 25 to November 25. During this time, approximately 31 million visitors viewed installations by more than eleven thousand exhibitors. See Herbert, *Paris, 1937*.
63. In her final report to the GEB, Jones mentions visiting the exposition and the contemporary art exhibits in the national pavilions. See Herbert, *Paris 1937*, 53–61.
64. Jones to Caroline Jones, n.d, box 215-8, folder 7, Jones Papers. In another letter she described being accosted by four men on her return from the Exposition (Jones to Caroline Jones, Oct. 5, 1937, box 215-8, folder 7, Jones Papers).
65. Leninger-Miller, *New Negro Artists in Paris*, 202–40.
66. Benjamin, *Life and Art of Loïs Mailou Jones*, 30.
67. Rowell, "Interview with Loïs Mailou Jones," 361.
68. Marley, *Henry Ossawa Tanner*, 21.
69. Leininger-Miller, *New Negro Artists in Paris*, 7, 12.
70. Fehrer, introduction to *Overcoming All Obstacles*, 3.
71. Jones to Carolyn Jones, Oct. 5, 1937, box 215-5, folder 8, Jones Papers.
72. Jones, "Incidents of Prejudice," n.d., Jones Papers.
73. Rowell, "Interview with Loïs Mailou Jones," 361.
74. Grossman, *Man Ray, African Art, and the Modernist Lens*, 47.
75. Archer-Straw, *Negrophilia*, 51–52.
76. Jones, interview by Catherine Bernard, 1995, quoted in Bernard, "Confluence," 25.
77. Ibid., 26.
78. Jones, cited in Bernard, "Patterns of Change," https://static1.squarespace.com/static/533b9964e4b098 d084a9331e/t/544d27d5e4b06eca91c0756d /1414342613095/Bernard_on_Mailou_Jones.pdf.
79. See "Chronology" in Hanzal, *Loïs Mailou Jones*, 136, and Brauer, *Rivals and Conspirators*.
80. Locke, "Legacy of the Ancestral Arts."
81. Jones to Carolyn Jones, Feb. 27, 1938, box 215–5, folder 8, Jones Papers.
82. Ibid.
83. Ibid.

84. For bathing in French art, see Werth, *Joy of Life*, esp. 157–63, 202–8.
85. Vlaminck, "Discovery of African Art," 27–28.
86. Rowell, "Interview with Loïs Mailou Jones," 363.
87. The travelogue originally appeared in serial form; the book was published in Paris by Les Inédits de Modern-Bibliothèque in 1910. An unbound copy of the text is in box 215-1, folder 35, Jones Papers.
88. Woodson, preface to *African Heroes and Heroines*.
89. Ibid.
90. Albéca, *France au Dahomey*, pl. 31. According to Chris Chapman, longtime friend of Jones and trustee of the Loïs Mailou Jones Pierre-Noel Trust, Woodson gave Jones a copy of James Young Gibson's *The Story of the Zulus* (1911) for her to base her illustrations on (*Loïs Mailou Jones*, 46).
91. Wilder, *French Imperial Nation-State*, and Diagne, *African Art as Philosophy*.
92. Benjamin, *Life and Art of Loïs Mailou Jones*, 27.
93. Edwards, *Practice of Diaspora*, 4.
94. Historian Celeste Day-Moore devotes a chapter to Achille's time in France her dissertation, "Race in Translation."
95. Maxwell, *Colonial Photography and Exhibitions*, esp. 38–72, and Stevens, *Orientalists*, 145.
96. See Tinterow and Miller, "Bashi-Bazouk," 390–92.
97. Jones to Caroline Jones, n.d., box 215-8, folder 7, Jones Papers.
98. "Jo Baker to Retire: Famed Dancer, Paris Broker Wed in France," *New York Amsterdam News*, Dec. 4, 1937.
99. Anderson performed at l'Opéra de Paris on December 14, 1937; Jones may have seen an earlier performance, or her dates may have been off by a week or two.
100. Jones to Caroline Jones, n.d., box 215-8, folder 7, Jones Papers.
101. Jane returned to Guadeloupe, where she lived with her doctor husband and taught Latin in a high school (Edwards, *Practice of Diaspora*, 154).
102. There were four Nardal sisters: Jane, Alice, Lucie, and Paulette. See Sharpley-Whiting, *Négritude Women*, 52–68. Only six issues of *La Revue du monde noir* appeared. See Boittin, "In Black and White," 121.
103. Edwards, *Practice of Diaspora*, 119–20.
104. Jane Nardal, "L'Internationalisme noir," *La Dépêche africaine*, Feb. 15, 1928, 5; Edwards, *Practice of Diaspora*, 126–29; Sharpley-Whiting, "Femme négritude," 10–11.

105. Rowell, "Interview with Loïs Mailou Jones," 363.
106. Rowell, "Interview with Chris Chapman," 1039.
107. Stewart, *New Negro*, 763.
108. Ibid., 773–74.
109. Locke, *Contemporary Negro Art*.
110. Executors of her estate have identified the works; however, their acquisition dates remain unknown. The location of her collected African objects is unclear.
111. Beginning from the left, the artists named are, on panel 1: Edward M. Bannister, Robert Duncanson, Henry O. Tanner, Laura Wheeler Waring, Edwin Harleston, John W. Hardrick, and Aaron Douglas; on panel 2: Palmer Hayden, Archibald Motley, William Edouard Scott Albert Alexander Smith, Hale Woodruff, Allan Freelon, and Malvin Gray Johnson; on panel 3: William H. Johnson, James L. Wells, James Porter, Loïs Mailou Jones, Richard Lonsdale Brown, Henry B. Jones, Elton Fax, and Arthur Diggs; and on panel 4: Charles Alston, Allan Crite, Robert Pious, William Cooper, R. Reid, Dan Terry Reid, William Farrow, and Charles Dawson.
112. Leininger-Miller, "Constant Stimulus and Inspiration."
113. Driskell and Fleming, *Breaking Racial Barriers*.
114. "Laura Wheeler Waring," 386.
115. First stationed in France during World War I, Smith had returned to the United States to complete his studies at the National Academy of Design, where he was the school's first African American student. Smith settled permanently in Paris in 1922, where he resided in the Montmartre neighborhood popular with African American expatriates. Leininger-Miller, *New Negro Artists in Paris*, 202–44.
116. Albert Alexander Smith to Jones, Dec. 25, 1938, Loïs Mailou Jones scrapbooks, 1922–1967, Smithsonian Archives of American Art.
117. Ibid.
118. Stewart, *New Negro*, 763.
119. Leigh Whipper to Lois Mailou Jones, Feb. 20, 1939, reprinted in Chapman, *Loïs Mailou Jones*, 53.
120. Verner and Mitchell, *Literary Sisters*, 118.
121. Benjamin, *Life and Art of Loïs Mailou Jones*, 50.
122. Ibid.
123. Rowell, "Interview with Loïs Mailou Jones," 362.
124. "Howard University Students Picket with Ropes Around Necks," *Afro-American* (Baltimore), Dec. 22, 1934, 17.
125. Rowell, "Lois Mailou Jones," 1025.
126. Rowell, "Interview with Loïs Mailou Jones," 365–66.
127. Jones to Professor Serge Chermayeff, chair of the department of design, Brooklyn College, Nov. 14, 1945, box 215–11, folder 14, Jones Papers.
128. Jones, application proposal, 1945, box 495, folder 20, Julius Rosenwald Papers, Fisk University Archives.
129. On the Rosenwald Fund, which donated more than $70 million to a variety of causes before becoming bankrupt in 1948, see Schulman, *Force for Change*, 13–23.
130. Logan, "Liberia in the Family of Nations," and Greer, "Selling Liberia."
131. Liberian Centennial Commission, *Centennial and Victory Exposition*, n.p.
132. In the 1952 portfolio, the original edition of which was unbound, the piece is titled *La Primus*. However, the slide of the painting in Jones's papers at Howard is titled *African Rhythms*.
133. How Jones became aware of Primus and her work is unclear. She may have seen one of Primus's performances in New York in the early 1940s (e.g., during her guest-artist appearance in Asadata Dafora's 1943 African Dance Festival) or one of Primus's college-tour performances. The photos of Primus in Jones's collected papers at Howard are undated (box 215-49, folder 38, Jones Papers). See Schwartz and Schwartz, *Dance Claimed Me*, 3, 47, 50, 77.
134. Schwartz and Schwartz, 47–48, 95, 262.
135. Benjamin, "Loïs Mailou Jones' Approaches to Africa and its Arts," n.d., box 215-20, folder 27, Jones Papers.
136. Jones, "The African Influence of Afro-American Art" (paper presented at the International Colloquium on Culture and Development in honor of President Léopold Sédar Senghor's 70th birthday, Dakar, Senegal, Oct. 1976), p. 14, box 215-18, folder 3, Jones Papers.

Chapter 3

1. Jones, artist statement, Jan. 27, 1967, box 215-1, folder 14, Jones Papers.
2. Ibid. When dealing with the subject of Haitian Vodou, Jones's spelling and diacritics vary, as has usage by other artists and scholars over the last several decades. This book uses the current Haitian Kweyol spellings and diacritics for "Vodou" and "vèvè," with the exception of such alternative versions that appear in

quotations and titles of artworks, including "Voudou," "Voodoo," and "vodoun." Parts of this chapter previously appeared in VanDiver, "Diasporic Connotations of Collage."

3. Jones traveled to Haiti each summer between 1954 and 1962 and again between 1964 and 1969, before political unrest made visiting the country difficult. Following her 1977 retirement from Howard University, she returned regularly to Port-au-Prince for months at a time. Rowell, "Interview with Loïs Mailou Jones," 367; Benjamin, *Life and Art of Loïs Mailou Jones*, 77; and Jones, draft of memo to Mary Campbell, ca. 1986–87, box 15-1, folder 14, Jones Papers.

4. Eric Brace, "Painting That Blurs the Boundaries," *Washington Post*, May 1, 1995, D7.

5. Jones to General Paul Magloire, Sept. 8, 1954, box 215-10, folder 27, Jones Papers.

6. Polyné, *From Douglass to Duvalier*, 131–53.

7. See Benjamin, *Life and Art of Loïs Mailou Jones*, 53; Rowell, "An Interview with Loïs Mailou Jones," 366; Jones, interview with Danley, in Hill, *Black Women Oral History Project*, 6:296, 298.

8. Twa, *Visualizing Haiti in U.S. Culture*, 101–56.

9. Jones, artist statement, Jan. 27, 1967, box 215-1, folder 14, Jones Papers.

10. Clark, "Developing Diaspora Literacy," 10–11.

11. Ibid.

12. Edwards, *Practice of Diaspora*, 11.

13. Kraut, "Between Primitivism and Diaspora," 434.

14. Ibid, 435.

15. Jones, interview with Tritobia Benjamin, Nov. 1, 1986, quoted in Benjamin, *World of Loïs Mailou Jones*, 8.

16. Schmidt, *United States Occupation of Haiti*.

17. For more on the relationship between African Americans and Haiti, see Dash, *Haiti and the United States*, 45–72; Polyné, *From Douglass to Duvalier*, esp. 131–53; Byrd, *Black Republic*, 1–12; and for visual representations, Twa, *Visualizing Haiti in U.S. Culture*.

18. Pauline E. Hopkins, "Toussaint L'Overture: His Life and Times," *Colored American Magazine* 2 (Nov. 1900), 9.

19. Locke, review of *The Magic Island*.

20. Hurston, *Tell My Horse*, 93.

21. Thompson, "Preoccupied with Haiti," 75.

22. Ibid., 80.

23. Ibid., 95.

24. The literature on the picturesque in art is vast. For my study, see Bermingham, *Landscape and Ideology*; Casid, *Sowing Empire*; Thompson, *Eye for the Tropics*.

25. Thompson, *Eye for the Tropics*, 35, 20.

26. Porter, "Picturesque Haiti," 178.

27. Ibid. For a discussion of the paintings Porter included in his article, see Twa, *Visualizing Haiti in U.S. Culture*, 214–16.

28. Aaron Douglas, "Plan of Work," Mar. 1, 1938, box 408, folder 13, Julius Rosenwald Papers, Fisk University Archives.

29. Twa, *Visualizing Haiti in U.S. Culture*, 132.

30. Twa, "Black Magic Island," 155.

31. Locke, "Advances on the Art Front," 134–35.

32. Twa, *Visualizing Haiti in U.S. Culture*, and Twa, "Black Magic Island."

33. Walter White to Joseph D. Charles, Sept. 20, 1947, part 14, reel 7, NAACP Papers, quoted in Polyné, *From Douglass to Duvalier*, 133.

34. Twa, *Visualizing Haiti in U.S. Culture*, 202–46, esp. 202–5.

35. "Caribbean Carnival," *Life*, Mar. 13, 1950, 98.

36. Keller, *Maya Deren*, 145.

37. President Dumarsais Estimé commissioned two monumental sculptures from Barthé, one of Toussaint L'Ouverture and the other of Jean-Jacques Dessalines (Twa, *Visualizing Haiti in U.S. Culture*, xxi, 221–22).

38. "GSA Artist Awarded Free Haitian Trip to Paint What He Sees," *Evening Star*, May 28, 1951, B-10, and Twa, *Visualizing Haiti in U.S. Culture*, 223.

39. Untitled clipping, *Haiti Sun: The Haitian-English Newspaper*, July 8, 1951, reel 4366, Richard Dempsey Papers, Smithsonian Archives of American Art.

40. Writing in French, Jones described her task as "un missionnaire due propaganda touristique en faveur d'Haiti" (Jones to Paul E. Magloire, Sept. 8, 1954, box 215-10, folder 27, Jones Papers).

41. Twa, *Visualizing Haiti in U.S. Culture*, 224.

42. Gaither, introduction to *Reflective Moments*, and Benjamin, *Life and Art of Loïs Mailou Jones*, 77.

43. "This Week's Census," *Jet*, Mar. 27, 1958, and Jones, interview with Danley, in Hill, *Black Women Oral History Project*, 6:298, 300.

44. Twa, *Visualizing Haiti in U.S. Culture*, 226.

45. See various letters between Verginaud Pierre-Noël and Jones, box 215-5, folder 56, Jones Papers.

46. Jones to Jacques N. Léger, Haitian ambassador to Washington, D.C., n.d., box 215-10, folder 27, Jones Papers.

47. It is unclear whether or not Jones's teaching at the Centre d'Art constituted part of her formal commission to work in Haiti. See Benjamin, *Life and Art of Loïs Mailou Jones*, 77; Louis Verginaud Pierre-Noël to DeWitt Peters, May 27, 1954, box 215-6, folder 2, Jones Papers; and Jones, "Haiti Lecture Notes," box 215-15, folder 15, Jones Papers.

48. Asquith, "Beyond Immobilised Identities," 40–43, and Rodman, *Where Art Is Joy*, 187.

49. Benjamin, *Life and Art of Loïs Mailou Jones*, 77.

50. Twa, "Diaspora en dialogue," 60.

51. A Haitian newspaper reported that the show was going to be remounted in January at the Shermann Art Gallery on 57th Street in New York City ("Depart d'artiste Lois Jones Pierre-Noël," ostensibly from *La Phalange*, n.d., box 215-15, Jones Papers).

52. The author described the exhibit as "un franc success" and that it "peut-etre considérée comme l'une des plus belles organisées par le Centre d'Art" ("Oeuvres de Loïs Mailou Jones Pierre-Noel au Centre d'Art du 7 au 15 Septembre," *La Phalange*, n.d., box 215-75, Jones Papers). For an example of an American review, see Ruth Schmaker, "Found Inspiration in Haiti," *Washington Post*, Nov. 27, 1954, 25.

53. Wanda Wiener, "Lois Mailou Pierre-Noel triomphe au Centre d'Art," undated clipping, box 215-75, Jones Papers. Weiner used the title *Resignation* for *Mob Victim*, a titular change that appears elsewhere as well, suggesting Jones exhibited the painting under the two titles.

54. Wiener refers to a painting of a young girl titled *Fleurs de la découverte*, which could potentially be the same work (ibid.).

55. For example, see "Une artiste nègre parmi nous," *Le Matin*, July 23, 1954, and "Les oeuvres de Lois Mailou Pierre-Noel," *Le Nouvelliste*, n.d., box 215-15, Jones Papers.

56. Vendryes, "Brothers Under the Skin," 225.

57. "Haiti President Arrives Jan. 29," *New York Amsterdam News*, Jan. 15, 1955, 22, and Marie McNair, "Magloire [*sic*] has 12-Hour Day," *Washington Post*, Jan. 29, 1955, 19.

58. "U.S. to Send Seeds in Haiti Storm Aid," *New York Times*, Oct. 29, 1954, 6.

59. At the time, Jones was pursuing a Howard-funded research project on Caribbean women artists (Jones, "Women Artists of the Caribbean and Afro-American Artists," Howard University Research Project SRP 646, 1973–74, box 215-3, folder 4, Jones Papers).

60. Donald Cosentino provides an excellent overview of Haitian Vodou practices in *Sacred Arts of Haitian Vodou*; see also Dayan, *Haiti, History, and the Gods*.

61. Mintz and Trouillot, "Social History of Haitian Voudou," 142–43.

62. Twa, *Visualizing Haiti in U.S. Culture*, 218.

63. André Pierre, in particular, painted a number of Vodou ceremony scenes that included vèvè drawings in the 1950s and 1960s (Smith, "Haitian Art and Voudou Imagery," 36–39). In her 1968 research report, Jones noted that she photographed work by Philome Obin, Hector Hyppolite, Castera Bazile, Wilson Bigaud, and Rigaud Benoit, among others (Jones, "Art in Haiti," box 215-18, folder 11, Jones Papers).

64. Asquith, "Beyond Immobilised Identities," 41.

65. Bernard has elsewhere suggested that Jones's interest in Haitian Vodou may also be linked to the Caribbean indigenist movement popular at midcentury ("Patterns of Change").

66. Golding, *Cubism*, 115–17.

67. Jones, annual report for 1956–57, Howard University, box 214-14, folder 38, Jones Papers.

68. Jones, annual report for 1957–58, Howard University, box 215-14, folder 38, Jones Papers.

69. "Baptist Women Maintain D.C. Missionary Retreat," *Ebony*, Dec. 1964, 82.

70. "The Significance of the Retreat," pamphlet included in Loïs Mailou Jones scrapbooks, #12, Smithsonian Archives of American Art.

71. All citations in the paragraph from Jones, "Spirit of Africa," unpublished description, n.d., Jones Papers.

72. Ahlman, *Living with Nkrumahism*.

73. "Nkrumah to Shake 50,000," *Jet*, July 21, 1958.

74. "Ticker Tape, U.S.A." *Jet*, May 29, 1958, 15.

75. Jones saved the paper invitations to many of these events, including: "Reception in Honor of the First Anniversary of the Independence of Nigeria," Oct. 1, 1960; "Invitation to the First Anniversary of the Independence of Mauritius," Nov. 6, 1961; "Celebration in Honor of the Independence of Sierra Leone," April 27, n.d.; invitation from the ambassador of Ghana to

celebrate Ghana National Day, July 1, 1961, box 215-11, folder 10, Jones Papers.

76. Denise Abbey to Jones, July 25, 1961, Loïs Mailou Jones scrapbooks, 1922–1967, reel 4577, Smithsonian Archives of American Art. A few months after the State Department solicited Jones for its cultural exchange programs, President John F. Kennedy signed the Fulbright-Hays Act, officially known as the Mutual Educational and Cultural Exchange Act, which formalized the State Department's efforts.

77. Jones to Denise Abbey, Aug. 5, 1961, box 215-11, folder 13, Jones Papers.

78. The Makerere Art School was the first such institution in East Africa, founded by British expatriate Margaret Trowell in 1937.

79. Mary Beattie Brady to Jones, May 27, 1960, box 215-7, folder 9, Jones Papers.

80. Mary Beattie Brady to Jones, Mar. 9, 1961, box 215-7, folder 9, Jones Papers. The materials to which Brady refers are probably related to a 1966 Harmon Foundation publication on modern and contemporary African art (Brown, *Africa's Contemporary Art and Artists*).

81. These works have been published previously using "Vévé Voudou" in the title (e.g., Hanzal, *Loïs Mailou Jones*, and Benjamin, *Life and Art of Loïs Mailou Jones*). In the works themselves, however, Jones uses "Vèvè Vodou." As such, I have used Jones's own spellings.

82. Thompson, "From the Isle Beneath the Sea," 102–3.

83. Rigaud, *Vè-vè*, 79.

84. Metraux, *Voodoo in Haiti*, 77, 163, 165.

85. Rowell, "Interview with Loïs Mailou Jones," 367. It is unclear whether or not Jones witnessed the staged Vodou performances popular at upscale Port-au-Prince hotels or if she sought out true practitioners outside the tourist market.

86. Philippe Sterlin's book *Vèvès vodou* includes text and a series of plates detailing the traits of specific vèvès. Jones possessed a copy of Sterlin's text, preserved in box 215-40, Jones Papers.

87. Verginaud Pierre-Noël to Jones, Mar. 5, [1954], box 215-6, folder 5, Jones Papers. Emphasis original.

88. Sterlin, *Vèvès vodou*, 1:59, 27, 47, 51.

89. On the use of cornmeal in rituals, see ibid., 1:35, 59; 2:8–16; Metraux, *Voodoo in Haiti*, 107; and Desmangles, *Faces of the Gods*, 118. Jones described seeing a

priest draw the vèvès with cornmeal in Rowell, "Interview with Loïs Mailou Jones," 367.

90. Ayizan is also known as Aizan or Aizan-Velequéte (Sterlin, *Vèvès vodou*, 1:35).

91. Cosentino, *Sacred Arts of Haitian Vodou*, 178–79.

92. Jones, artist statement, Jan. 27, 1967, box 215-1, folder 14, Jones Papers.

93. Rigaud, *Vè-vè*, 255; and Sterlin, *Vèvès vodou*, 1:47.

94. Desmangles, *Faces of the Gods*, 105.

95. Brown, "Vèvè of Haitian Vodou," xix.

96. Dayan, *Haiti, History, and the Gods*, 63, and Thompson, "Translating the World into Generousness," 22.

97. During Jones's tenure at Howard from 1930 to 1977, the university was a hotbed of black intellectualism. See Williams, *In Search of the Talented Tenth*, 90–92.

98. Perloff, "Invention of Collage," 6.

99. On cubist collage and its significance to modernism, see Krauss, *Picasso Papers*; Taylor, *Collage*; Poggi, *In Defiance of Painting*; Leighten, "Picasso's Collages"; Hoffman, *Collage*; Waldman, *Collage, Assemblage, and the Found Object*.

100. Martin, "From the Center," and Fine and Francis, *Romare Bearden*.

101. Mercer, "Romare Bearden," 125, and Finley, "Mask as Muse," 69.

102. Mercer, "Romare Bearden," 124.

103. Bearden spent time in the Caribbean in the late 1960s. Yet there is no evidence that his Caribbean exposure influenced his photomontage paintings. Sally Price and Richard Price have argued for a reconsideration of Bearden's Caribbean-inspired watercolors from the 1970s (*Romare Bearden*, 15, 22).

104. Poggi, "'Pasted-Paper Revolution,'" 387.

105. Scholars have elsewhere discussed the influence of writing and practices of writing to the visual innovations found in cubist art. See, for example, the various essays in Fisher, *Picasso and the Allure of Language*.

106. Perloff, "Invention of Collage," 6.

107. Cran, *Collage in Twentieth-Century Art, Literature, and Culture*, 4.

108. In his study on black portraiture, Powell employs the cut to play with the "nuanced sense of *sharpness*—a Black American–informed artistic strategy of modern style," encouraging an acknowledgment of the fluidity between "figural, literal, colloquial, and conceptual definitions of the terms [sharp and to cut]" (*Cutting a

Figure, 7). For different interpretations of the cut in black culture, see Moten, *In the Break*, and Edwards, *Practice of Diaspora*, 13.

109. Edwards, *Practice of Diaspora*, 13. Emphasis original.
110. Ibid., 15.
111. Snead, "On Repetition in Black Culture," 150.
112. Mercer, "Romare Bearden," 125.
113. Hills, "Cultural Legacies," 227.
114. Ibid., 227 and 229.
115. Ibid., 227, 229, quotes on 243.
116. Ibid., and Mercer, "Romare Bearden, 1964."
117. "Artist of Sunlit Canvases," *Ebony*, Nov. 1968, 136.
118. Ibid., 137.

Chapter 4

1. "Black Art: What Is It?," *Art Gallery*, Apr. 1970, 33.
2. The Black Women Oral History Project contains the interviews of seventy-two women, and the transcripts were published in a six-volume set edited by Ruth Edmonds Hill. The quote is found in supplementary interview questions from Jones's interview with Theresa Danley located in box 215-8, folder 7, Jones Papers.
3. Ibid.
4. Jacqueline Trescott, "Loïs Jones @ 72: An Artist's Slow Climb to Acclaim," *Washington Post*, Mar. 1, 1978.
5. Jones, "Loïs Mailou Jones," biographical sketch, Oct. 22, 1972, box 215-11, folder 41, Jones Papers.
6. Jones, "The African Cultural Presence in America," n.d., pp. 3–4, box 215-18, folder 2, Jones Papers.
7. Ongiri, *Spectacular Blackness*, 2. The march began as a solo effort undertaken by James Meredith to embolden his fellow black Mississippians. On just the second day, Meredith was shot and wounded by a sniper; the march was completed by a group of prominent civil rights leaders that included Carmichael and Martin Luther King Jr. (Carmichael and Hamilton, *Black Power and the Politics of Liberation*).
8. Collins and Crawford, *New Thoughts on the Black Arts Movement*, 4.
9. Ibid., 5.
10. Karenga, "Black Cultural Nationalism," 31.
11. Neal, "Black Arts Movement," 29.
12. Ibid.

13. Collins and Crawford provide an excellent list of BAM-related events: (*New Thoughts on the Black Arts Movement*, 9).
14. Farmer, *Remaking Black Power*, 5, 10.
15. For a variety of materials, see box 215-6, Jones Papers.
16. These and other examples are found in box 215-35, Jones Papers.
17. *Black Shades*, Oct., 1970, box 215-28, folder 39, Jones Papers.
18. Program from annual meeting of the ASNLH, 1973, box 215-28, folder 14, Jones Papers.
19. Adrienne Manns, "Curriculum Changes Are Imminent for Next Year," *Hilltop*, Apr. 26, 1968.
20. Ibid.
21. Bearden and Henderson, *History of African-American Artists*, 379.
22. Ibid.
23. Jones to Dean Warner Larson, proposal for Black Visual Arts Project, July 1, 1968, box 215-16, folder 19, Jones Papers.
24. Ibid.
25. Ibid.
26. Baker, "From Freedmen to Fine Artists," 18.
27. Founded in 1968 as COBRA (Coalition of Black Revolutionary Artists), the group added the prefix "Afri" in 1969 to reflect its commitment to Blackness on a global scale (Hogu, "Inaugurating AfriCOBRA").
28. Warner Lawson, *Annual Report for Howard University, 1969–1970, College of the Fine Arts*, June 30, 1970, 23.
29. Joanne Mcknight, "Hilltop Investigates: Art Students Speak Out on Course Inadequacies," *Hilltop*, Oct. 26, 1967.
30. Jeff Donaldson, letter to art department staff, Aug. 31,1970, box 215-7, folder 18, Jones Papers.
31. Cheek gave his address on April 25, 1970. Ibid. Emphasis original.
32. Tritobia Benjamin, Kojo Fosu, and Frank Smith joined in 1970; Alexander Skunder Boghassian, Wadsworth A. Jarrell, and Winston Kennedy came on board in 1972; James Phillips and Alfred J. Smith Jr. joined in 1973; Chi Chong Lee-Lau and Valerie Maynard were hired in 1974; and Gail M. Grant, Raymond Dobard, and Edward Spriggs arrived in 1975 (Edward S. Spriggs, "6th Annual Faculty Exhibition Howard University," 1976, p. 3, Jones Papers).

33. Jones, "Slides on Contemporary African Art," lecture notes, box 214-14, folder 33, Jones Papers.

34. Jones, "Statement by the Artist," n.p.

35. Donaldson, "Commentary," n.p.

36. For more on Pan-Africanism, see Walters, *Pan Africanism in the African Diaspora*, and Ackah, *Pan-Africanism*.

37. Kai, *AfriCOBRA*, 6.

38. Donaldson, "Ten In Search of a Nation."

39. Jones, interview with Evangeline J. Montgomery, Mar. 1984, p. 30, box 215-19, folder 15, Jones Papers.

40. Gaither, "Loïs Mailou Jones," 14.

41. The exhibition was on view from March 11 to April 15, 1973. Barry Edmund Gaither to Jones, May 9, 1973, box 215-8, folder 2, Jones Papers.

42. Jones to Dr. Vada E. Butcher, dean of College of Fine Arts, Howard University, Feb. 8, 1973, box 215-11, folder 14, Jones Papers.

43. Frank Smith, memo on the topic of appointments and promotions for the 1976–77 academic year, May 26, 1976, quoted in Jones to Jeff Donaldson, June 21, 1976, box 215-7, folder 18, Jones Papers.

44. Jones continued to lecture and teach throughout the United States after her retirement and, according to former Howard students, visited the Howard campus frequently.

45. See Gaither, "Heritage Reclaimed," 24, and Knappe, "Chronology," 221. The author of "His Dreams Come True: Sculptor Barthé Is on His Way" (*Afro-American*, Nov. 6, 1937) noted that Barthé was scheduled to go to Africa to study the people of West Africa. The front cover of the November 1963 newsletter of the American Society of African Culture included a photograph of Jacob Lawrence and Kofi Antubam in Lagos, Nigeria, where Lawrence was exhibiting his *Migration Series* paintings (Cedric Dover Papers, Manuscript and Rare Book Library, Emory University).

46. Jones, "Loïs Mailou Jones," biographical sketch, Oct. 22, 1972, box 215-11, folder 41, Jones Papers.

47. Jones, interview with Danley, in Hill, *Black Women Oral History Project*, 6:305.

48. Jones to Pierre-Noël, Apr. 27, 1970, box 215-6, folder 11, Jones Papers.

49. This list of secondary sources is included in Jones, draft of final report on African artists interviews, May 1975, box 215-18, folder 2, Jones Papers.

50. Jones, interview with Danley, in Hill, *Black Women Oral History Project*, 6:305.

51. Benjamin, *World of Loïs Mailou Jones*, 29. Jones's scrapbooks at the Smithsonian Archives of American Art include flyers circulated by the USIS advertising her talks. Jones cited excerpts from her research trip in an undated talk outline titled "The African Cultural Presence in America." The lecture, which included slides, appears to have been for the Howard University Institute for the Arts and Humanities (box 215-18, folder 2, Jones Papers).

52. Jones, "The Black Visual Arts: Contemporary Afro-American and Contemporary African Art," Howard University Research Project SRP 251, findings and data, 1968–70, box 215–16, folder 15, Jones Papers.

53. Jones, "Final Report," box 215-6, folder 11, Jones Papers.

54. Jones to Pierre-Noël, Apr. 11, 1970. Tekle was a leading figure on the Ethiopian art scene. He attended art school in London at the Slade School of Art and returned to Ethiopia in the 1950s. By the 1970s, Tekle had established a sterling reputation in Ethiopia and abroad.

55. Jones to Pierre-Noël, Apr. 11, 1970, box 215-6, folder 11, Jones Papers.

56. In 1950 Alhadeff opened an art school/workshop in Léopoldville (now Kinshasa). Throughout the 1950s and 1960s, he was a major arts patron. Albion Ross, "Congo Native Art Has U.S. Advocate," *New York Times*, Aug. 22, 1953, 5, and Van Beurden, *Authentically African*, 78, 93–96.

57. Jones to Pierre-Noël, Apr. 27, 1970, box 215-6, folder 11, Jones Papers.

58. Ibid.

59. Jones, final report for "The Black Visual Arts: Contemporary Afro-American and Contemporary African Art," Howard University Research Project SRP 251, findings and data, 1968–70, box 215–16, folder 15, Jones Papers.

60. Jones to Pierre-Noël, May 10, 1970, box 215-6, folder 11, Jones Papers.

61. Hall served as U.S. Ambassador to Ethiopia between 1967 and 1971. Jones to Pierre-Noël, Apr. 16, 1970, box 215-6, folder 11, Jones Papers.

62. Jones to Pierre-Noël, May 22, 1970, box 215-6, folder 11, Jones Papers.

63. Jones to Pierre-Noël, Apr. 27, 1970, box 215-6, folder 11, Jones Papers.

64. Wright, *Black Power*.

65. Jones to Pierre-Noël, Apr. 16, 1970, box 215-5, folder 11, Jones Papers.

66. Poggo, *First Sudanese Civil War*.

67. Jones to Pierre-Noël, Apr. 16, 1970, box 215-6, folder 11, Jones Papers.

68. Jones to Pierre-Noël, Apr. 27, 1970, box 215-6, folder 11, Jones Papers.

69. Jones to Pierre-Noël, Friday, May 22, 1970, box 215-6, folder 11, Jones Papers.

70. Jones, final report for "The Black Visual Arts: Contemporary Afro-American and Contemporary African Art," Howard University Research Project SRP 251, 1968–70, pp. 9–11, box 215-16, folder 15, Jones Papers.

71. Jones to Pierre-Noël, Apr. 16, 1970, box 215-6, folder 11, Jones Papers.

72. Jones to Pierre-Noël, Apr. 27, 1970, box 215-6, folder 11, Jones Papers.

73. Benjamin, *World of Loïs Mailou Jones*, 8.

74. Tadessa Ghila to Jones, Oct. 23, 1970, box 215-8, folder 1, Jones Papers.

75. Meriwether, *Proudly We Can Be Africans*, 4.

76. Jones, interview with Danley, in Hill, *Black Women Oral History Project*, 6:292.

77. Rodolitz and Bourgeois, *Remnants of Ritual*, 31.

78. Benjamin, *Life and Art of Loïs Mailou Jones*, 97.

79. Ibid., 98.

80. "Final Mailing for Trans Africa Art Tour," box 215-14, folder 53, Jones Papers.

81. Ibid.

82. Jones, quoted in Mary C. Butler, "American Artist Develops New Technique Using African Designs," IPS Africa Branch, Feb. 1973, 2. Copy of essay located in box 215-19, folder 2, Jones Papers.

83. Jones, interview with Danley in Hill, *Black Women Oral History Project*, 6:291.

84. Jones, quoted in Butler, "American Artist Develops New Technique Using African Designs."

85. Other members of the Howard delegation included Dean Jerome Lindsay, Vice President Lorraine Williams, and lecturer Irene Petty (E. Fannie Granton, "The Washington Scene," *Jet*, Oct. 7, 1976, 40).

86. Visona et al., *History of Art in Africa*, 471–76.

87. Located in present-day Nigeria, Ile-Ife was one of the largest Yoruba city-states. See LaGamma, *Heroic Africans*, 37–71.

88. A museum commemorating the history of Gorée Island opened in 1962; the island was named a UNESCO World Heritage Site in 1978. See Atwood, "Senegal's Forgotten Slaves."

89. The poem was dedicated to Georges and Claude Jacqueline Pompidou and appeared as the last poem in Senghor's 1948 *Hosties noire* (Irele, *Selected Poems of Léopold Sédar Senghor*, 68–71).

90. Jones, interview with Danley, in Hill, *Black Women Oral History Project*, 6:292.

91. Harney, *In Senghor's Shadow*, 56.

92. Tall, quoted in ibid, 59.

93. Jones, "The African Influence on Afro-American Art," n.d., p. 1, box 215-18, folder 3, Jones Papers. She originally gave this lecture in 1970 to a USIA audience during her African tour and repeated it in 1976 at the Senghor Colloquium.

94. Ibid., 3. The Weusi group (the name is a Swahili term meaning "blackness") was founded in Harlem in 1965. Like AfriCOBRA, Weusi sought to promote black art through a connection to Africa (Brown, "Weusi Artists").

95. Hollie I. West, "Getting an African Festival Together: The Problems of the African Festival of Arts and Culture," *Washington Post*, Apr. 26, 1975, and Jacqueline Trescott, "Festival's Beneficial Pushback," *Washington Post*, Aug. 8, 1976.

96. Jones, FESTAC entry form, n.d., box 215-29, folder 29, Jones Papers.

97. Howard University was well represented among NAZ delegates, with Donaldson's art department colleagues Jones and Ed Love, as well as professor of communications Basil Matthews; head of the Social Science Research Center, Ronald Waters; former head of African Studies P. Chike Onwauchi; the Howard University Players; and former art students Akili Ron Anderson, Winifred Owens, and Alma Thomas.

98. For more on the funding specifics and problematics of FESTAC '77, see Apter, *Pan-African Nation*, esp. 2–9, 54–65, 88–89, 201–9.

99. Cover, *Ebony*, May 1977.

100. Nochlin, "Why Have There Been No Great Women Artists?"

101. For more see, Wilding, "Feminist Art Programs at Fresno and CalArts."

102. Lippard, *Pink Glass Swan*, 55.

103. Anne Sutherland Harris was the WCA's first president. The organization was originally called the Women's Caucus of the College Art Association. See Garrard, "Feminist Politics," esp. 92–93, 94.

104. Jones, "The Black Women Artist: Her Vision and Stature," box 215-16, folder 13, Jones Papers.

105. Jones to Andrew Billingsley, Apr. 5, 1973, box 215-16, folder 13, Jones Papers.

106. Jones, gallery guide, artists' files, Smithsonian Archives of American Art.

107. The other artists were Elizabeth Catlett, Pat Davis, Carol Lee, Dinga McCannon, Howardena Pindell, Adrian Piper, Barbara Chase Riboud, Faith Ringgold, Betye Saar, and Alma Thomas. According to letters exchanged between Ringgold and Jones, the exhibit was originally intended to include eight artists and be titled "Eight Black Women Artists" (Jones to Faith Ringgold, Feb. 25, 1975, box 215-11, folder 28, Jones Papers).

108. Michelle Wallace, "Black and Fine—Women's Art," *Majority Report*, July 12, 1975, 9.

109. Jones's responses to letter from Ruth Edmonds Hill, Nov, 21, 1980, box 215-8, folder 7, correspondence HI, Jones Papers.

110. Garrard, "'Women Artists' in Los Angeles."

111. VanDiver, "Off the Wall," 33.

112. Cooks, *Exhibiting Blackness*, 87.

113. Undated statement signed Loïs Pierre-Noël, Ph.D., box 214-14, folder 43, Jones Papers.

114. Ibid.

115. The Charleston was popular dance during the 1920s that is thought to have roots in African dance traditions. It was one of the dances Baker performed during her run at the Folie Bergere in 1926. For more on Baker and the Charleston, see Kraut, "Between Primitivism and Diaspora," and Knowles, *Wicked Waltz*, 135–76.

116. For more on Baker, see Jules-Rosette, *Josephine Baker*.

117. Desmangles, *Faces of the God*, 128–30.

118. Some art historians have referred to the snake form as kakilamba snake (Finley, "Mask as Muse," 55). However, the form could also be a reference to a Baga Bansonyi snake mask from Guinea. For more on Baga masquerade traditions, see Visona et al., *History of Art in Africa*, 176–79, and Barley, "Sculpture in the Form of a Stylized Serpent," 476.

119. Traditionally, Afikpo masks are vertically oriented. Because the mask forms are often narrower than the human head, bands of raffia are used to hold them in place (Ottenberg, *Masked Rituals of Afikpo*).

120. Jones, notecards, n.d., box 215-18, folder 52, Jones Papers.

121. Bocola and Bassani, *African Seats*.

122. For more on twins in Africa, see Peek, *Twins in African and Diaspora Cultures*.

123. Phillips, "Masking in Mende Sande Society Initiation Rituals."

124. A collection search of the National Museum of African Art reveals that a Sowei mask (object no. 77-22-1) was acquired in 1977; this may be the mask that inspired this image (https://africa.si.edu/collections/view/objects/asitem/search@/0?t:state:flow=7d4e1815-5489-4979-99f6-166e2ad3977b).

125. MoMA published a large exhibition catalogue to accompany the exhibit: Rubin, *"Primitivism" in Twentieth Century Art*. The exhibition, which was on view at MoMA from Sept. 27, 1984, to Jan. 15, 1985, included 150 modern works and 200 "tribal" objects.

126. Advertisement for MoMA's *Primitivism* exhibit, *New York Times*, Dec. 14, 1984. Picasso's *Les Demoiselles d'Avignon* is in the permanent collection of MoMA. The *mbuya* mask was borrowed from a Belgian collection.

127. Manuela Hoelterhoff, "The Call of the Wild: 'Primitivism' in 20th-Century Art," *Wall Street Journal*, Oct. 9, 1984, and Foster, "'Primitive' Unconscious of Modern Art."

128. "New Exhibition Opening September 27 at Museum of Modern Art Examines 'Primitivism' in 20th Century Art," Aug. 1984, https://www.moma.org/momaorg/shared/pdfs/docs/press_archives/6081/releases/MOMA_1984_0017_17.pdf.

129. Hilton Kramer addressed the problematic use of quotation marks in the MoMA exhibition in his December 1984 review, "'Primitivism' Conundrum."

130. Garber, *Quotation Marks*. Jennifer Brody has also addressed the problematics of punctuation in regards to art (*Punctuation Marks*, 108–32).

131. The 1984 *"Primitivism"* exhibition generated several curatorial responses, among them the 1989 *Magiciens de la terre* held at the Pompidou Center in Paris (Martin, *Magiciens de la terre*).

132. Jones, quoted in Janet Levin, "Profiles in Visibility: Loïs Mailou Jones Today," unpublished term paper, Nov. 7, 1984, completed for David Driskell's course Art History 474, David C. Driskell Archives, Hyattsville, Md.

133. Benjamin, *World of Loïs Mailou Jones*, 31.

134. A small reproduction of Bearden's 1964 *The Prevalence of Ritual: Baptism* appears in Kirk Varnedoe's essay in the exhibition catalogue ("Contemporary Explorations," 679).

135. For more on the legacy of primitivism in art, see Rhodes, *Primitivism and Modern Art*; Antliff and Leighten, "Primitive," 217; Connelly, *Sleep of Reason*; Goldwater, *Primitivism in Modern Art*; Foster, "'Primitive' Unconscious of Modern Art"; Hiller, *Myth of Primitivism*; Kramer, "'Primitivism' Conundrum"; Lloyd, *German Expressionism*; Lemke, *Primitivist Modernism*; Perry, "Primitivism and the Modern"; Rubin, *"Primitivism" in 20th Century Art*; Sherman, *French Primitivism and the Ends of Empire*. See also n. 60 in chapter 2.

136. Gaither, "Loïs Mailou Jones," 26.

137. A popular mask form, kanaga masks are used primarily during funerary ceremonies and rituals called *dama* (Beckwith, "Spirits and Ancestors," 282–86).

138. Price and Price, *Maroon Arts*, 85–88.

139. Thompson, *Flash of the Spirit*, 208, 215–17.

140. Earlier scholars use *Samaaka*, yet current scholarship employs *Saramaka* as the name of the cultural group.

141. See Price and Price, *Maroon Arts*, and Thompson, *Flash of the Spirit*, 215–18.

142. According to Vodou mythology, the earth was created by the movement of the Damballah serpent. When he shed his skin, he released all the water that created the oceans, lakes, and rivers. The reflection of the water and the sun created a rainbow with which Damballah fell in love. The sky represents his wife, Aida-Wedo.

143. Brawley made national headlines when she accused six white men, including three police officers, of rape. It was later determined that Brawley had falsified her story (McFadden, *Outrage*).

Conclusion

Epigraph: Locke, *Negro Art*, 6.

1. "Fun, Fun For Everyone," *Black Enterprise Magazine*, Feb. 1998, 157. It is unclear if these advertisements ran only in *Black Enterprise* or if they appeared in other printed publications. To date, Absolut Vodka has commissioned more than eight hundred art-themed advertisements (see Lewis, *Absolut Book*).

2. Wagner, "Lee Krasner as L.K," 48.

3. The topic of naming practices in regards to African American art history has been taken up by a number of scholars. See Buick, "Confessions of an Unintended Reader"; Chambers, "Difficulties in Naming White Things"; Farrington, *African-American Art*, xxiii–xxv; Francis, *Making Race*, 15–16.

4. Jones, quoted in Karla Araujo, "Against All Odds," *Martha's Vineyard Magazine*, Nov. 11, 2014.

5. Ibid.

6. A. Philpott, "Lois Jones Exhibits Paintings in Boston," *Boston Globe*, Feb. 3, 1939, 14.

7. Betty Perry, "Loïs Mailou Jones: An Indefatigable Black Woman Artist," *Washington Post*, February 23, 1983.

8. For example, Araujo, "Against All Odds," and Perry, "Loïs Mailou Jones."

Bibliography

Ackah, William. *Pan-Africanism: Exploring the Contradictions; Politics, Identity, and Development in Africa and the African Diaspora*. Aldershot: Ashgate, 1999.

Ahlman, Jeffrey S. *Living with Nkrumahism: Nation, State, and Pan-Africanism in Ghana*. Athens: Ohio University Press, 2017.

Albéca, Alexandre. *La France au Dahomey*. Paris: Hachette, 1895.

Antliff, Mark, and Patricia Leighten. "Primitive." In *Critical Terms for Art History*, 2nd ed., edited by Robert Nelson and Richard Schiff, 217–33. Chicago: University of Chicago Press, 2003.

Apter, Andrew. *The Pan-African Nation: Oil and the Spectacle of Culture in Nigeria*. Chicago: University of Chicago Press, 2005.

Archer-Straw, Petrine. *Negrophilia: Avant-Garde Paris and Black Culture in the 1920s*. London: Thames and Hudson, 2000.

Arnold, Dorothea. *The Royal Women of Amarna: Images of Beauty from Ancient Egypt*. New York: Metropolitan Museum of Art, 1997.

Asquith, Wendy. "Beyond Immobilised Identities: Haitian Art and Internationalism in the Mid-Twentieth Century." In *Kafou: Haiti, Art, and Vodou*, edited by Alex Farquharson and Leah Gordon, 40–43. Nottingham: Nottingham Contemporary, 2012.

Ater, Renee. "Making History: Meta Warrick Fuller's *Ethiopia*." *American Art* 17, no. 3 (Fall 2003): 12–31.

———. "Meta Warrick Fuller's *Ethiopia* and the America's Making Exposition of 1921." In *Women Artists of the Harlem Renaissance*, edited by Amy Kirshke, 53–84. Jackson: University Press of Mississippi, 2014.

———. *Remaking Race and History: The Sculpture of Meta Warrick Fuller*. Berkeley: University of California Press, 2011.

Atwood, Roger. "Senegal's Forgotten Slaves: The Untold Story of Gorée Island." *Archaeology* 65, no. 5 (Sept.–Oct. 2012): 47–51.

Baker, Scott. "From Freedmen to Fine Artists." In *A Proud Continuum: Eight Decades of Art at Howard University*, edited by Carolyn Shuttlesworth, 2–17. Washington, D.C.: Howard University Gallery of Art, 2005.

Baldwin, Davarian. *Chicago's New Negroes: Modernity, the Great Migration, and Black Urban Life*. Chapel Hill: University of North Carolina Press, 2007.

Bandele, Ramla M. *Black Star: African American Activism in the International Political Economy*. Urbana: University of Illinois Press, 2008.

Barley, Nigel. "Sculpture in the Form of a Stylized Serpent (Bansonyi), Baga, Guinea." In *Africa: Art of a Continent*, edited by Tom Phillips, 476. London: Royal Academy of Arts, 1995.

Barnard, Chester I. *Directory of Fellowship Awards for the Years 1922–1950*. New York: General Education Board, 1951.

Barnes, Albert. "Negro Art and America." In Locke, *New Negro*, 19–25.

Bearden, Romare, and Harry Henderson. *A History of African-American Artists, 1792 to the Present*. New York: Pantheon, 1993.

Beardsley, John. *The Quilts of Gee's Bend*. Atlanta: Tinwood Books in association with the Museum of Fine Arts, Houston, 2002.

Beckwith, Carol. "Spirits and Ancestors." In Carol Beckwith and Angela Fisher, *African Ceremonies*, 236–357. New York: Harry N. Abrams, 1999.

Benjamin, Tritobia. "Color, Structure, Design: The Artistic Expression of Lois Mailou Jones." *International Review of African American Arts* (1991): 28–40.

———. *The Life and Art of Loïs Mailou Jones*. San Francisco: Pomegranate Art Books, 1994.

———. *The World of Loïs Mailou Jones: Meridian House International, Washington, D.C., January 28–March 18, 1990*. Washington, D.C.: Meridian House International, 1990.

Bermingham, Ann. *Landscape and Ideology: The English Rustic Tradition*. Berkeley: University of California Press, 1985.

Bernard, Catherine. "Confluence: Harlem Renaissance, Modernism, and Négritude: Paris in the 1920–1930s." In *Explorations in the City of Light: African-American Artists in Paris, 1945–1965*, edited by Audreen Buffalo, 21–27. New York: Studio Museum in Harlem, 1996.

———. "Patterns of Change: The Work of Lois Mailou Jones." Anyone Can Fly Foundation, 2003. https://static1.squarespace.com/static/533b9964e4b098 d084a9331e/t/544d27d5e4b06eca91c0756d/1414 342613095/Bernard_on_Mailou_Jones.pdf.

Berzock, Kathleen Bickford, and Christa Clarke, eds. *Representing Africa in American Art Museums*. Seattle: University of Washington Press, 2011.

Best Maugard, Adolfo. *Method for Creative Design*. New York: Alfred A. Knopf, 1926.

———. "A New Method for Developing Creative Imagination." *University High School Journal* 3, no. 4 (Dec. 1923): 247–55.

Blake, Jody. *Le Tumulte Noir: Modernist Art and Popular Entertainment in Jazz-Age Paris, 1900–1930*. University Park: Pennsylvania State University Press, 1999.

Boas, Franz. *Primitive Art*. Oslo: H. Aschehoug, 1927.

Bocola, Sandro, and Ezio Bassani, eds. *African Seats*. New York: Prestel, 1995.

Boittin, Jennifer. "In Black and White: Gender, Race Relations, and the Nardal Sisters in Interwar Paris." *French Colonial History* 6 (2005): 120–35.

Bowles, John. "African American Artists as Agents of Modernism: A Challenge for African American Art." *Panorama* 4, no. 1 (Spring 2018): https://doi.org/10.24926/24716839.1633.

Bracks, Lean'tin L., ed. *Black Women of the Harlem Renaissance Era*. Lanham: Rowan and Littlefield, 2014.

Brauer, Fae. *Rivals and Conspirators: The Paris Salons and the Modern Art Centre*. Cambridge: Cambridge Scholars, 2013.

Brody, Jennifer. *Punctuation Marks: Art, Politics, and Play*. Durham: Duke University Press, 2008.

Broude, Norma, and Mary D. Garrard, eds. *The Power of Feminist Art: The American Movement of the 1970s; History and Impact*. New York: Harry N. Abrams, 1994.

Brown, Charlotte Hawkins. *The Correct Thing to Do—To Say—To Wear*. Boston: Christopher, 1941.

Brown, Dona. *Inventing New England: Regional Tourism in the Nineteenth Century*. Washington, D.C.: Smithsonian Institution Press, 1995.

Brown, Evelyn. *Africa's Contemporary Art and Artists: A Review of Creative Activities in Painting, Sculpture, Ceramics, and Crafts of More than 300 Artists Working in the Modern Industrialized Society of Some of the Countries of Sub-Saharan Africa*. New York: Division of Social Research and Experimentation, Harmon Foundation, 1966.

Brown, Karen McCarthy. "The Vèvè of Haitian Vodou: A Structural Analysis of Visual Imagery." Ph.D. diss., Temple University, 1975.

Brown, Kay. "The Weusi Artists." *Nka: Journal of Contemporary African Art* 30 (2012): 60–67.

Buick, Kirsten Pai. "Confessions of an Unintended Reader: African American Art, American Art, and the Crucible of Naming." In *The Routledge Companion to African American Art History*, edited by Eddie Chambers, 82–91. London: Taylor and Francis, 2019.

Burin, Eric. *Slavery and the Peculiar Solution: A History of the American Colonization Society*. Gainesville: University of Florida Press, 2005.

Byrd, Brandon R. *The Black Republic: African Americans and the Fate of Haiti*. Philadelphia: University of Pennsylvania Press, 2019.

Calo, Mary Ann. *Distinction and Denial: Race, Nation, and the Critical Construction of the African American Artist, 1920–1940*. Ann Arbor: University of Michigan Press, 2007.

Carmichael, Stokely, and Charles V. Hamilton, eds. *Black Power and the Politics of Liberation*. London: Cape, 1968.

Casid, Jill. *Sowing Empire: Landscape and Colonization*. Minneapolis: University of Minneapolis Press, 2005.

Chambers, Eddie. "The Difficulties in Naming White Things." *Small Axe: A Caribbean Journal of Criticism* 38 (July 2012): 186–97.

Chapman, Chris. *Loïs Mailou Jones: A Life in Color*. Bloomington: Xlibris, 2007.

Clark, VèVè A. "Developing Diaspora Literacy and *Marasa Consciousness*." *Theatre Survey* 50, no. 1 (May 2009): 9–18.

Clarke, Christa. *African Art in the Barnes Foundation: The Triumph of L'Art Negre and the Harlem Renaissance*. New York: Skira Rizolli, 2015.

Clifford, James. "Museums as Contact Zones." In *Routes*, 188–219.

———. *Routes: Travel and Translation in the Late Twentieth Century*. Cambridge: Harvard University Press, 1997.

Colin, Paul. *Le Tumulte Noir*. Paris: Èditions d'Art "Sucess," 1927.

Collins, Lisa Gail. *The Art of History: African American Women Artists Engage the Past*. New Brunswick: Rutgers University Press, 2002.

Collins, Lisa Gail, and Margo Natalie Crawford, eds. *New Thoughts on the Black Arts Movement*. New Brunswick: Rutgers University Press, 2006.

Connelly, Frances. *The Sleep of Reason: Primitivism in Modern Europe*. University Park: Pennsylvania State University Press, 1995.

Cooks, Bridget R. *Exhibiting Blackness: African Americans and the American Art Museum*. Amherst: University of Massachusetts Press, 2011.

Corbould, Clare. *Becoming African Americans: Black Public Life in Harlem, 1919–1939*. Cambridge: Harvard University Press, 2009.

Cosentino, Donald. *Sacred Arts of Haitian Vodou*. Los Angeles: UCLA Fowler Museum of Cultural History, 1995.

Cox, Beverly J., and Denna Jones Anderson. *Miguel Covarrubias Caricatures*. Washington, D.C.: National Portrait Gallery, Smithsonian Institution Press, 1985.

Cran, Rona. *Collage in Twentieth-Century Art, Literature, and Culture: Joseph Cornell, William Burroughs, Frank O'Hara, and Bob Dylan*. New York: Routledge, 2014.

Cullen, Countee. "Heritage." *Survey Graphic: Harlem, Mecca of the New Negro* 4, no. 6 (Mar. 1925): 674–75.

Dagbovie, Pero. *The Early Black History Movement, Carter G. Woodson, and Lorenzo Johnson Greene*. Champaign: University of Illinois Press, 2007.

Daniels, Sadie. *Women Builders*. Washington, D.C.: Associated Publishers, 1931.

Dash, Michael. *Haiti and the United States: National Stereotypes and the Literary Imagination*. New York: Macmillan, 1997.

Davis, Cynthia, and Verner Mitchell. "Eugene Gordon, Dorothy West, and the Saturday Evening Quill Club." *CLA Journal* 52, no. 4 (June 2009): 393–408.

Dayan, Joan. *Haiti, History, and the Gods*. Berkeley: University of California Press, 1998.

Day Moore, Celeste. "Race in Translation: Producing, Performing, and Selling African American Music in Greater France, 1944–74." Ph.D. diss., University of Chicago, 2014.

DeFrantz, Thomas F., ed. *Dancing Many Drums: Excavations in African American Dance*. Madison: University of Wisconsin Press, 2002.

Denenberg, Thomas Andrew. *Call of the Coast: Art Colonies of New England*. Portland: Portland Museum of Art, 2009.

Deren, Maya. *Divine Horsemen: The Living Gods of Haiti*. London: Thames and Hudson, 1953.

Desmangles, Leslie. *The Faces of the Gods: Vodou and Roman Catholicism in Haiti*. Chapel Hill: University of North Carolina Press, 1992.

Diagne, Souleymane Bachir. *African Art as Philosophy: Senghor, Bergson, and the Idea of Negritude*. Translated by Chike Jeffers. London: Seagull Books, 2011.

Donaldson, Jeff. "Commentary." In Jones, *Loïs Mailou Jones*, n.p.

———. "Ten in Search of a Nation." *Black World* 19, no. 12 (Oct. 1970): 80–90.

Driskell, David C., ed. *African American Visual Aesthetics: A Postmodernist View*. Washington, D.C.: Smithsonian Institution Press, 1995.

———. "Introduction: The Progenitors of a Postmodernist Review of African American Art." In *African American Visual Aesthetics*, 1–16.

———. *Two Centuries of Black American Art: Los Angeles County Museum of Art, Sept. 30–Nov. 21, 1976*. Los Angeles: Los Angeles County Museum of Art, 1976.

Driskell, David C., and Tuliza Fleming. *Breaking Racial Barriers: African Americans in the Harmon Foundation Collection*. Washington, D.C.: National Portrait Gallery, 1997.

Dyson, Walter. *Howard University, the Capstone of Negro Education: A History, 1867–1940*. Washington, D.C.: Graduate School, Howard University, 1941.

Earle, Susan, ed. *Aaron Douglas: African American Modernist.* New Haven: Yale University Press, 2007.

——. "The Wide-Ranging Significance of Loïs Mailou Jones." In *Women Artists of the Harlem Renaissance,* edited by Amy Helene Kirschke, 175–204. Jackson: University of Mississippi Press, 2014.

Edwards, Brent Hayes. *The Practice of Diaspora: Literature, Translation, and the Rise of Black Internationalism.* Cambridge: Harvard University Press, 2003.

——. "The Uses of Diaspora." *Social Text* 19, no. 1 (Spring 2001): 45–73.

Engs, Robert Francis. *Educating the Disenfranchised and Disinherited: Samuel Chapman Armstrong and the Hampton Institute, 1839–1893.* Knoxville: University of Tennessee, 1999.

Fabre, Michel. *From Harlem to Paris: Black American Writers in France.* Champaign: University of Illinois Press, 1991.

Fahlman, Betsy. "The Art Spirit in the Classroom: Educating the Modern Woman Artist." In *American Women Modernists: The Legacy of Robert Henri, 1910–1945,* edited by Marian Wardle, 93–115. New Brunswick: Rutgers University Press with Brigham Young University Museum of Art, 2005.

Fahy, Everett, ed. *The Wrightsman Pictures.* New York: Metropolitan Museum of Art, 2005.

Farebrother, Rachel. *The Collage Aesthetic in the Harlem Renaissance.* Surrey: Ashgate, 2009.

Farmer, Ashley D. *Remaking Black Power: How Black Women Transformed an Era.* Chapel Hill: University of North Carolina Press, 2017.

Farrington, Lisa E. *African-American Art: A Visual and Cultural History.* Oxford: Oxford University Press, 2016.

——. *Creating Their Own Image: The History of African-American Women Artists.* Oxford: Oxford University Press, 2005.

Fehrer, Catherine. Introduction to *Overcoming All Obstacles: Women at the Académie Julian,* edited by Gabriel P. Weisberg and Jane R. Becker, 3–12. New Brunswick: Rutgers University Press with the Dahesh Museum, 1999.

Fine, Ruth, and Jacqueline Francis, ed. *Romare Bearden: American Modernist.* Washington, D.C.: National Gallery of Art, 2011.

Finley, Cheryl. "Loïs Mailou Jones: Impressions of the South." *Southern Quarterly* 49, no. 1 (Fall 2011): 80–93.

——. "The Mask as Muse: The Influence of African Art on the Life and Career of Loïs Mailou Jones." In Hanzal, *Loïs Mailou Jones,* 5–73.

Fisher, Susan Greenberg, ed. *Picasso and the Allure of Language.* New Haven: Yale University Press, 2009.

Flam, Jack D., and Miriam Deutch, eds. *Primitivism and Twentieth-Century Art: A Documentary History.* Berkeley: University of California Press, 2003.

Fleming, Cynthia D. "Instructors and Courses in the Museum School, 1876–1935." In *The Bostoninans: Painters of an Elegant Age, 1870–1930,* edited by Trevor J. Fairbrother, 233–35. Boston: Museum of Fine Arts, Boston, 1986.

Ford, Ausbra. "The Influence of African Art on African American Art." In *Visual Arts: Plastic and Graphic,* edited by Justine M. Cordwell, 513–34. The Hague: Mouton, 1979.

Fosdick, Raymond B. *Adventure in Giving: The Story of the General Education Board.* New York: Harper and Row, 1962.

Foster, Hal. "The 'Primitive' Unconscious of Modern Art." *October* 34 (Fall 1985): 45–70.

Francis, Jacqueline. *Making Race: Modernism and "Racial Art" in America.* Seattle: University of Washington Press, 2012.

Franklin, John Hope. *From Slavery to Freedom: A History of American Negroes.* New York: Alfred A. Knopf, 1947. Reprinted by New York: Alfred A. Knopf, 1956. Page references are to reprint.

——. "A Harlem Renaissance." In *From Slavery to Freedom,* 489–511.

Frazier, E. Franklin. *The Black Bourgeoisie: The Rise of a New Middle Class.* New York: Free Press, 1957.

Frederickson, Kristen, and Sarah E. Webb, eds. *Singular Women: Writing the Artist.* Berkeley: University of California Press, 2003.

Frobenius, Leo. *The Voice of Africa: Being an Account of the Travels of the German Inner African Exploration Expedition in the Years 1910–1912.* London: Hutchinson, 1913.

Gaither, Edmund Barry. "African and African American Art: An African American Legacy." In *Art of the Senses: African Masterpieces from the Teel Collection,* edited

by Suzanne Blier, 43–51. Boston: MFA Publications, 2004.

———. "Heritage Reclaimed: An Historical Perspective and Chronology." In *Black Art, Ancestral Legacy: The African Impulse in African American Art*, 17–34. Dallas: Dallas Museum of Art, 1989.

———. Introduction to *Reflective Moments: Loïs Mailou Jones, a Retrospective Exhibition, 1930–1972*, n.p. Boston: National Center of Afro-American Artists / Museum of Fine Arts, Boston, 1973.

———. "Loïs Mailou Jones: Reflections on a Friendship." In Hanzal, *Loïs Mailou Jones*, 13–33.

Garber, Marjorie. *Quotation Marks*. New York: Routledge, 2003.

Garrard, Mary D. "Feminist Politics: Networks and Organizations." In *The Power of Feminist Art: The American Movement of the 1970s; History and Impact*, edited by Norma Broude and Mary D. Garrard, 88–105. New York: Harry N. Abrams, 1994.

———. "'Women Artists' in Los Angeles." *Burlington Magazine* 119 (1977): 530–31.

Gates, Henry Louis, Jr. "The Trope of a New Negro and the Reconstruction of the Image of the Black." *Representations* 24 (Autumn 1988): 129–55.

Gates, Henry Louis, Jr. and Gene Andrew Jarret, eds. *The New Negro: Readings on Race, Representation, and African American Culture*. Princeton: Princeton University Press, 2007.

Greer, Brenna. "Selling Liberia: Moss H. Kendrix, the Liberian Centennial Commission, and the Post-World War II Trade in Black Progress." *Enterprise and Society* 14, no. 2 (2013): 303–26.

Gilroy, Paul. *The Black Atlantic: Modernity and Double Consciousness*. Cambridge: Harvard University Press, 1993.

Goeser, Caroline. *Picturing the New Negro: Harlem Renaissance Print Culture and Modern Black Identity*. Lawrence: University of Kansas Press, 2007.

Golding, John. *Cubism: A History and an Analysis, 1907–1914*. 3rd ed. New York: Harper and Row, 1968.

Goldwater, Robert. *Primitivism in Modern Art*. Rev. ed. New York: Vintage Books, 1967.

Goss, Jared. "Paul Poiret and the Decorative Arts." In Koda and Bolton, *Poiret*, 43–44.

Graham, Otis. *Our Kind of People: Inside America's Black Upper Class*. New York: Harper, 1999.

Greenough, Sarah, ed. *Modern Art in America: Alfred Stieglitz and His New York Galleries*. Washington, D.C.: National Gallery of Art, 2000.

Grossman, Wendy. *Man Ray, African Art, and the Modernist Lens*. Washington, D.C.: International Arts and Artists, 2009.

Guillaume, Paul. *Sculptures nègres: 24 photographies précédées d'un avertissement de Guillaume Apollinaire et d'un exposé de Paul Guillaume*. Paris: Frazier-Soye, 1917.

Haberland, Eike, ed. *Leo Frobenius, 1873–1973: An Anthology*. Translated by Patricia Crampton. Wiesbaden: F. Steiner, 1973.

Hanzal, Carla M., ed. *Loïs Mailou Jones: A Life in Vibrant Color*. Charlotte: Mint Museum of Art, 2009.

Harney, Elizabeth. *In Senghor's Shadow: Art, Politics, and the Avant-Garde in Senegal, 1960–1965*. Durham: Duke University Press, 2004.

Harris, Leonard, and Charles Molesworth. *Alain Locke: Biography of a Philosopher*. Chicago: University of Chicago Press, 2008.

Hayes, Bartlett. *Art in Transition: A Century of the Museum School; Exhibition and Catalogue*. Boston: Museum of Fine Arts, 1977.

Herbert, James D. *Paris, 1937: Worlds on Exhibition*. Ithaca: Cornell University Press, 1998.

Herring, James V. "The American Negro as Craftsman and Artist." *Crisis* 49, no. 4 (Apr. 1942): 117.

Herskovits, Melville J. *The Myth of the Negro Past*. Boston: Beacon Press, 1958. First published 1941 by Harper and Brothers (New York).

Herzog, Melanie. *Elizabeth Catlett: An American Artist in Mexico*. Seattle: University of Washington Press, 2005.

Higginbotham, Evelyn Brooks. *Righteous Discontent: The Woman's Movement in the Black Baptist Church, 1880–1920*. Cambridge: Harvard University Press, 2001.

Hill, Ruth Edmonds, ed. *The Black Women Oral History Project: From the Arthur and Elizabeth Schlesinger Library on the History of Women in America*. Vol. 6. Westport: Meckler, 1991.

Hiller, Susan. *The Myth of Primitivism: Perspectives on Art*. London: Routledge, 1991.

Hills, Patricia. "Cultural Legacies and the Transformation of the Cubist Collage Aesthetic by Romare Bearden, Jacob Lawrence, and Other African American

Artists." In *Romare Bearden: American Modernist*, edited by Ruth Fine and Jacqueline Francis, 221–47. Washington, D.C.: National Gallery of Art, 2011.

Hirshler, Erica. *A Studio of Her Own: Women Artists in Boston, 1807–1940*. Boston: MFA Publications, 2001.

Hoffman, Katherine, ed. *Collage: Critical Views*. Ann Arbor: UMI Research Press, 1989.

Hogu, Barbara Jones. "Inaugurating AfriCOBRA: History, Philosophy, and Aesthetics." *Nka: Journal of Contemporary African Art* 30 (Spring 2012): 90–97.

Huggins, Nathan. *Harlem Renaissance*. New York: Oxford University Press, 1971.

Hultgren, Mary Lou. "Roots and Limbs: The African Art Collection at Hampton University Museum." In *Representing Africa in American Art Museums: A Century of Collecting and Display*, edited by Kathleen Bickford Berzock and Christa Clarke, 44–61. Seattle: University of Washington Press, 2011.

Hultgren, Mary Lou, and Jeanne Zeidler. *A Taste for the Beautiful: Zairian Art from the Hampton University Museum*. Hampton: Hampton University Museum, 1993.

Hunter, Tera. "The Correct Thing: Charlotte Hawkins Brown and the Palmer Memorial Institute." *Southern Exposure* 11, no. 51 (1983): 37–43.

Hurston, Zora Neale. *Tell My Horse: Voodoo and Life in Haiti and Jamaica*. New York: J. B. Lippincott, 1938.

Hutchinson, George. *The Harlem Renaissance in Black and White*. Cambridge: Belknap Press of Harvard University Press, 1995.

Irele, Abiola, ed. *Selected Poems of Léopold Sédar Senghor*. Cambridge: Cambridge University Press, 1977.

Jones, Loïs Mailou. "The Career of an African American Artist." In *Lives of Career Women*, edited by Frances Carp, 43–54. New York: Springer Science / Business Media, 1991.

———. *Loïs Mailou Jones: Retrospective Exhibition "Forty Years of Painting," 1932–1972*. Washington, D.C.: Howard University Gallery of Art, 1972.

———. Papers. Moorland-Spingarn Research Center, Howard University, Washington, D.C.

———. *Peintures, 1937–1951*. Tourcoing: Presses Georges Frère, 1952.

———. "Statement by the Artist." In *Loïs Mailou Jones*, n.p.

Jules-Rosette, Bennetta. *Josephine Baker in Art and Life: The Icon and the Image*. Champaign: University of Illinois Press, 2007.

Kai, Nubia. *AfriCOBRA: The First Twenty Years*. Atlanta: Nexus Contemporary Art Center, 1990.

Karenga, Ron. "Black Cultural Nationalism." *Negro Digest* 13, no. 3 (1968): 5–9. Reprinted in *The Black Aesthetic*, edited by Addison Gayle Jr., 31–37. New York: Doubleday Anchor, 1971. Page references to reprint.

Keller, Sarah. *Maya Deren: Incomplete Control*. New York: Columbia University Press, 2014.

Kendrick, Ruby. "Art at Howard University: An Appreciation." *Crisis* 39, no. 11 (Nov. 1932): 348–49.

Kirkham, Pat, and Shauna Stallworth. "'Three Strikes Against Me': African American Women Designers." In *Women Designers in the USA, 1900–2000*, edited by Pat Kirkham, 123–44. New York: Bard Graduate Center, 2002.

Kirschke, Amy Helene. *Art in Crisis: W. E. B. Du Bois and the Struggle for African American Identity and Memory*. Bloomington: Indiana University Press, 2007.

———, ed. *Women Artists of the Harlem Renaissance*. Jackson: University of Mississippi Press, 2016.

Knappe, Stephanie Fox. "Chronology." In Earle, *Aaron Douglas*, 217.

Knowles, Mark. *The Wicked Waltz and Other Scandalous Dances: Outrage at Couple Dancing in the 19th and 20th Centuries*. Jefferson: McFarland, 2009.

Koda, Harold, and Andrew Bolton, eds. *Poiret*. New Haven: Yale University Press with the Metropolitan Museum of Art, 2007.

Kramer, Hilton. "The 'Primitivism' Conundrum: On 'Primitivism in 20th Century Art' at MoMA." *New Criterion* 3 (Dec. 1984): 1–7.

Krauss, Rosalind E. *The Picasso Papers*. New York: Farrar, Straus, and Giroux, 1998.

Kraut, Anthea. "Between Primitivism and Diaspora: The Dance Performances of Josephine Baker, Zora Neale Hurston, and Katherine Dunham." *Theatre Journal* 55, no. 3 (Oct. 2003): 433–50.

LaDuke, Betty. *Africa Through the Eyes of Women Artists*. Trenton: Africa World Press, 1991.

———. "Loïs Mailou Jones: The Grande Dame of African-American Art." *Women's Art Journal* 8, no. 2 (1987): 28–32.

LaGamma, Alisa. *Heroic Africans: Legendary Leaders, Iconic Sculptures*. New York: Metropolitan Museum of Art, 2011.

"Laura Wheeler Waring." *Journal of Negro History* 33, no. 3 (July 1948): 385–86.

Leighten, Patricia. "Picasso's Collages and the Threat of War, 1912–13" *Art Bulletin* 67, no. 4 (Dec. 1985): 609–30.

Leininger-Miller, Theresa. "A Constant Stimulus and Inspiration: Laura Wheeler Waring in Paris in the 1910s and 1920s." Special issue, *Source: Notes in the History of Art* 24, no. 4 (Summer 2015): 13–23.

———. *New Negro Artists in Paris: African American Painters and Sculptors in the City of Light, 1922–1934*. New Brunswick: Rutgers University Press, 2001.

Lemke, Seiglinde. *Primitivist Modernism: Black Culture and the Origins of Transatlantic Modernism*. Oxford: Oxford University Press, 1998.

Lewis, David Levering. *When Harlem Was in Vogue*. New York: Oxford University Press, 1989.

Lewis, Richard W. *Absolut Book: The Absolut Vodka Advertising Story*. North Clarendon: Tuttle, 1996.

Liberian Centennial Commission. *Centennial and Victory Exposition, Monrovia, Liberia, 1947–1949*. Edited and supervised by Hilyard R. Robinson. Washington, D.C.: H. K. Press, 1946.

Lippard, Lucy R. *The Pink Glass Swan: Selected Feminist Essays on Art*. New York: New Press, 1995.

Lloyd, Jill. *German Expressionism: Primitivism and Modernity*. New Haven: Yale University Press, 1991.

Locke, Alain. "Advances on the Art Front." *Opportunity* 17, no. 5 (May 1939): 132–36.

———. "African Art Classic Style." *American Magazine of Art* 28 (May 1935): 270–78.

———. "The Art of the Ancestors." *Survey Graphic: Harlem, Mecca of the New Negro* 4, no. 6 (Mar. 1925): 673.

———. "A Collection of Congo Art." *Arts* 11, no. 2 (Feb. 1927): 60–70.

———. *Contemporary Negro Art, February 3–19, 1939*. Baltimore: Baltimore Museum of Art, 1939.

———. "Impressions of Luxor." *Howard Alumnus* 2, no. 4 (May 1924): 74–78.

———, ed. "Legacy of the Ancestral Arts." In *The New Negro*, 254–67.

———. *Negro Art: Past and Present*. Washington, D.C.: Associates in Negro Folk Education, 1936.

———. *Negro in Art: A Pictorial Record of the Negro Artist and Negro Theme in Art*. Washington, D.C.: Associates in Negro Folk Education, 1940.

———. "The New Negro." In *New Negro*, 3–16.

———. *The New Negro: An Interpretation*. New York: A. and C. Boni, 1925. Reprinted by New York: Touchstone, 1997. Page references are to reprint.

———. "A Note on African Art." *Opportunity* 2, no. 17 (May 1924): 134–38.

———. Review of *The Magic Island*, by W. B. Seabrook-Harcourt. *Opportunity* 7, no. 6 (June 1929): 190.

———. "To Certain of Our Philistines." *Opportunity* 3, no. 29 (May 1925): 155–56.

Logan, Rayford. "Liberia in the Family of Nations." *Phylon* 7, no. 1 (1946): 5–11.

Macgowan, Kenneth, and Herman Rosse. *Masks and Demons*. London: Hopkinson, 1924.

Marley, Anna O., ed. *Henry Ossawa Tanner: Modern Spirit*. Philadelphia: Pennsylvania Academy of the Fine Arts / Berkeley: University of California Press, 2012.

Martin, Courtney J. "From the Center: The Spiral Group, 1963–1966." *Nka: Journal of Contemporary African Art* 29 (Fall 2011): 86–98.

Martin, Jean Hubert. *Magiciens de la terre*. Paris: Editions du Centre Pompidou, 1989.

Maxwell, Anne. *Colonial Photography and Exhibitions: Representations of the "Native" and the Making of European Identities*. London: Leicester University Press, 1999.

McCluskey, Audrey Thomas. "'We Specialize in the Wholly Impossible': Black Women School Founders and Their Mission." *Signs* 22, no. 2 (Winter 1997): 403–26.

McFadden, Robert D. *Outrage: The Story Behind the Tawana Brawley Hoax*. New York: Bantam, 1990.

Mercer, Kobena, ed. *Cosmopolitan Modernisms*. Cambridge: MIT Press, 2005.

———, ed. *Exiles and Strangers*. Cambridge: Institute of International Visual Arts and MIT Press, 2008.

———, ed. *Pop Art and Vernacular Cultures*. Cambridge: Institute of International Visual Arts and MIT Press, 2007.

———. "Romare Bearden, 1964: Collage as Kunstwollen." In *Cosmopolitan Modernisms*, 124–45.

———, *Travel and See: Black Diaspora Art Practices Since the 1980s*. Durham: Duke University Press, 2016.

Meriwether, James Hunter. *Proudly We Can Be Africans: Black Americans and Africa, 1935–1961*. Chapel Hill: University of North Carolina Press, 2002.

Metraux, Alfred. *Voodoo in Haiti*. New York: Shocken Books, 1972.

Miller, Nicholas. "Primitivist Encounters? African American Painting, Diasporic Objects and the Making of Modern Art, 1927–1997." Ph.D. diss., Northwestern University, 2016.

Mintz, Sidney, and Michel-Rolph Trouillot. "The Social History of Haitian Voudou." In Cosentino, *Sacred Arts of Haitian Vodou*, 123–47. Los Angeles: UCLA Fowler Museum of Cultural History, 1995.

Mirezoff, Nicholas. *Diaspora and Visual Culture: Representing Africans and Jews*. London: Routledge, 2014.

Mitchell, Verner D., and Cynthia Davis. *Literary Sisters: Dorothy West and Her Circle; A Biography of the Harlem Renaissance*. New Brunswick: Rutgers University Press, 2011.

Mjagkij, Nina. *Organizing Black America: An Encyclopedia of African American Associations*. New York: Garland, 2001.

Mooney, Barbara Burilson. "The Comfortable Tasty Framed Cottage: An African American Iconography." *Journal of the Society of Architectural Historians* 61, no. 1 (Mar. 2002): 48–67.

Morrison, Keith. *Art in Washington and Its Afro-American Presence, 1940–1970*. Washington, D.C.: Washington Project for the Arts, 1985.

Moten, Fred. *In the Break: The Aesthetics of the Black Radical Tradition*. Minneapolis: University of Minnesota Press, 2003.

Mudimbe, V. Y. *The Idea of Africa*. Bloomington: Indiana University Press, 1994.

Nadell, Martha. *Enter the New Negroes: Images of Race in American Culture*. Cambridge: Harvard University Press, 2004.

Nardal, Paulette, and T. Denean Sharpley-Whiting. *Beyond Négritude: Essays from Woman in the City*. Albany: State University of New York Press, 2009.

Neal, Larry. "The Black Arts Movement." *Drama Review* 12, no. 4 (Summer 1968): 28–39.

Needham, Maureen. "*Kykunkor, or the Witch Woman*: An African Opera in America, 1934." In *Dancing Many Drums: Excavations in African American Dance*, edited by Thomas DeFrantz, 233–66. Madison: University of Wisconsin Press, 2002.

Nochlin, Linda. "Why Have There Been No Great Women Artists?" *ARTnews* 69 (Jan. 1971): 22–39.

Ogbar, Jeffrey. *The Harlem Renaissance Revisited: Politics, Arts, and Letters*. Baltimore: Johns Hopkins University Press, 2012.

Ongiri, Amy. *Spectacular Blackness: The Cultural Politics of the Black Power Movement*. Charlottesville: University of Virginia Press, 2009.

Ott, John. "Labored Stereotypes: Palmer Hayden's *The Janitor Who Paints*." *American Art* 22, no. 1 (Spring 2008): 102–15.

Ottenberg, Simon. *The Masked Rituals of Afikpo: The Context of an African Mask*. Seattle: University of Washington Press, 1975.

Palmer, Colin. "Defining and Studying the Modern African Diaspora." *Journal of Negro History* 85, nos. 1–2 (Winter–Spring 2000): 27–32.

Peek, Philip M., ed. *Twins in African and Diaspora Cultures: Double Trouble, Twice Blessed*. Bloomington: Indiana University Press, 2011.

Perloff, Marjorie. "The Invention of Collage." In "Collage," edited by Jeanine Parisier Plottel, *New York Literary Forum* 10–11 (1983): 5–47.

Perry, Gill. "Primitivism and the Modern." In *Primitivism, Cubism, Abstraction: The Early Twentieth Century*, edited by Charles Harrison, Gill Perry, and Francis Fraschina, 3–86. New Haven: Yale University Press, 1994.

Phillips, Ruth B. "Masking in Mende Sande Society Initiation Rituals." *Africa* 48, no. 3 (1978): 265–76.

Poggi, Christine. *In Defiance of Painting: Cubism, Futurism, and the Invention of Collage*. New Haven: Yale University Press, 1992.

———. "'The Pasted-Paper Revolution' Revisited." In *Encyclopedia of Aesthetics*, edited by Michael Kelly, 387–92. Oxford: Oxford University Press, 1998.

Poggo, Scopas Sekwat. *The First Sudanese Civil War: Africans, Arabs, and Israelis in the Southern Sudan*. New York: Palgrave MacMillan, 2009.

Polyné, Millery. *From Douglass to Duvalier: U.S. African Americans, Haiti, and Pan Americanism, 1897–1964*. Gainesville: University Press of Florida, 2011.

Porter, James. *Modern Negro Art*. New York: Dryden Press, 1943.

———. "Picturesque Haiti." *Opportunity* 24, no. 4 (Oct.–Dec. 1946): 178–79.

Powell, Richard. *African and Afro-American Art: Call and Response*. Chicago: The Field Museum, 1984.

———. *Black Art: A Cultural History*. London: Thames and Hudson, 2002.

———. *Cutting a Figure: Refashioning Black Portraiture*. Chicago: University of Chicago Press, 2008.

———. "Re/Birth of a Nation." In *Rhapsodies in Black: Art of the Harlem Renaissance*, edited by David Bailey and Richard Powell, 14–33. Los Angeles: University of California Press, 1997.

———. "Rechercher et imaginer l'art 'black' américain depuis 2005." *Perspective: Actualité en histoire de l'art* 2 (2015): 81–94.

Powell, Richard, and Jock Reynolds, eds. *To Conserve a Legacy: American Art from Historically Black Colleges and Universities*. Andover: Addison Gallery of American Art, 1999.

Pratt, Mary Louise. *Imperial Eyes: Travel Writing and Transculturation*. London: Routledge, 1992.

Price, Sally. *Primitive Art in Civilized Places*. Chicago: University of Chicago Press, 1989.

Price, Sally, and Richard Price. *Maroon Arts: Cultural Vitality in the African Diaspora*. Boston: Beacon Press, 1999.

———. *Romare Bearden: The Caribbean Dimension*. Philadelphia: University of Pennsylvania Press, 2006.

Puryear, B. N. *Hampton Institute: A Pictorial Review of Its First History, 1868–1968*. Hampton: Prestige Press, 1962.

Renda, Mary. *Taking Haiti: Military Occupation and the Culture of U.S. Imperialism, 1915–1940*. Chapel Hill: University of North Carolina Press, 2001.

Reynolds, Gary, and Beryl Wright. *Against the Odds: African American Artists and the Harmon Foundation*. Newark: Newark Museum, 1989.

Rhodes, Colin. *Primitivism and Modern Art*. London: Thames and Hudson, 1994.

Rigaud, Milo. *Ve-ve: Diagrammes rituels du voudou*. New York: French and European Publications, 1974.

Rodman, Selden. *Where Art Is Joy: Haitian Art; The First Forty Years*. New York: Ruggles de Latour, 1988.

Rodolitz, Scott, and Arthur Bourgeois. *Remnants of Ritual: Selections from the Gelbard Collection of African Art*. Amherst: Ethnos, 2003.

Rowell, Charles H. "An Interview with Chris Chapman." *Callaloo* 39, no. 5 (2016): 1033–41.

———. "An Interview with Loïs Mailou Jones." *Callaloo* 12, no. 2 (1989): 357–78.

———. "Lois Mailou Jones." *Callaloo* 39, no. 5 (2016): 1017–41.

Rozelle, Robert V., Alvia Wardlaw, and Maureen A. McKenna, eds. *Black Art: Ancestral Legacy, the African Impulse in African-American Art*. Dallas: Dallas Museum of Art, 1989.

Rubin, William, ed. *"Primitivism" in 20th Century Art: Affinity of the Tribal and the Modern*. 2 vols. New York: Museum of Modern Art, 1984.

Rudnick, Lois Palkin. "Modernizing Women: The New Woman and American Modernism." In *American Women Modernists: The Legacy of Robert Henri, 1910–1945*, edited by Marian Wardle, 159–76. New Brunswick: Rutgers University Press, 2005.

Salas, Charles G. *The Life and the Work: Art and Biography*. Los Angeles: Getty Research Institute, 2007.

Schlundt, Christena L. *A Chronology of the Professional Appearances of the American Dancers Ruth St Denis and Ted Shawn, 1906–1932*. New York: New York Public Library, 1962.

Schmidt, Hans. *The United States Occupation of Haiti, 1915–1934*. New Brunswick: Rutgers University Press, 1995.

Schneider, Mark. *Boston Confronts Jim Crow, 1890–1920*. Boston: Northeastern University Press, 1997.

———. "League of Women for Community Service, Boston." In *Organizing Black America: An Encyclopedia of African American Associations*, edited by Nina Mjagki, 264. London: Routledge, 2001.

Schomburg, Arturo. "The Negro Digs Up His Past." *Survey Graphic: Harlem, Mecca of the New Negro* 4, no. 6 (Mar. 1925): 670–72.

School of the Museum of Fine Arts Records, Tufts University Digital Collections and Archives.

Schulman, Daniel, ed. *A Force for Change: African American Art and the Julius Rosenwald Fund*. Chicago: Spertus Institute of Jewish Studies and Northwestern University Press, 2009.

Schwartz, Peggy, and Murray Schwartz. *The Dance Claimed Me: A Biography of Pearl Primus*. New Haven: Yale University Press, 2011.

Senghor, Léopold. *The Foundations of "Africanité" or "Négritude" and "Arabité."* Translated by Mercer Cook. Paris: Presence Africane, 1971.

———. *Hosties noires*. Paris: Seuil, 1948.

Shannon, Helen. "From 'African Savages' to 'Ancestral Legacy': Race and Cultural Nationalism in the American Modernist Reception of African Art." Ph.D. diss., Columbia University, 1999.

Sharpley-Whiting, T. Denean. *Bricktop's Paris: African American Women in Paris Between the Two World Wars.* Albany: State University of New York Press, 2015.

———. "Femme négritude: Jane Nardal, *La Dépêche africaine*, and the Francophone New Negro." *Souls* (Fall 2000): 8–17.

———. *Négritude Women*. Minneapolis: University of Minnesota Press, 2002.

Sherman, Daniel J. *French Primitivism and the Ends of Empire, 1945–1975*. Chicago: University of Chicago Press, 2011.

Sherrard-Johnson, Cherene. *Dorothy West's Paradise: A Biography of Class and Color*. New Brunswick: Rutgers University Press, 2012.

Sims, Lowery Stokes. "Loïs Mailou Jones: From Designer to Artist." In Hanzal, *Loïs Mailou Jones*, 38–39.

———. "Subject/Subjectivity and Agency in the Art of African Americans." *Art Bulletin* 76, no. 4 (1994): 587–90.

Smalls, James. "African American Self-Portraiture: Repair, Reclamation, Redemption." *Third Text* 15, no. 54 (Spring 2001): 55.

———. "A Ghost of a Chance: Invisibility and Elision in African American Art Historical Practice." *Art Documentation: Journal of the Art Libraries Society of North America* 13, no. 1 (Spring 1994): 3–8.

Smith, Katherine. "Haitian Art and Voudou Imagery." In *Kafou: Haiti, Art, and Vodou*, edited by Alex Farquharson and Leah Gordon, 36–39. Nottingham: Nottingham Contemporary, 2012.

Snead, James. "On Repetition in Black Culture." In "Black Textual Strategies Volume 1: Theory," *Black American Literature Forum* 15, no. 4 (Winter 1981): 146–54.

Sterlin, Philippe. *Vèvès vodou*. 2 vols. Port-au-Prince: Editions Philippe Sterlin, 1953.

Stevens, Mary Anne. *The Orientalists: Delacroix to Matisse; The Allure of North Africa and the Near East*. Washington, D.C.: National Gallery of Art, 1984.

Stewart, Jeffrey C. *The New Negro: The Life of Alain Locke*. New York: Oxford University Press, 2018.

Stovall, Tyler. *Paris Noir: African Americans in the City of Light*. Boston: Houghton Mifflin, 1996.

Summerford, Ben I. "The Phillips Collection and Art in Washington." In *The Eye of Duncan Phillips: A Collection in the Making*, edited by Erika D. Passantino and David W. Scott, 607–10. New Haven: Yale University Press, 1999.

Taylor, Brandon. *Collage: The Making of Modern Art*. London: Thames and Hudson, 2004.

Thompson, Krista. *An Eye for the Tropics: Tourism, Photography, and Framing the Caribbean Picturesque*. Durham: Duke University Press, 2006.

———. "Preoccupied with Haiti: The Dream of Diaspora in African American Art, 1914–1942." *American Art* 21, no. 3 (Fall 2007): 74–97.

———. "A Sidelong Glance: The Practice of African Diaspora Art History in the United States." *Art Journal* 70, no. 3 (2011): 6–31.

Thompson, Robert Farris. *Flash of the Spirit: African and Afro-American Art and Philosophy*. New York: Random House, 1983.

———. "From the Isle Beneath the Sea: Haiti's Africanizing Vodou Art." In *Sacred Arts of Haitian Vodou*, edited by Donald Cosentino, 91–119. Los Angeles: UCLA Fowler Museum of Cultural History, 1995.

———. "Translating the World into Generousness: Remarks on Haitian Vèvè." *RES: Anthropology and Aesthetics* 32 (Fall 1997): 19–34.

Tinterow, Gary, and Asher Ethan Miller. "Bashi-Bazouk." In Fahy, *Wrightsman Pictures*, 390–92.

Torgovinick, Marianna. *Gone Primitive: Savage Intellects, Modern Lives*. Chicago: University of Chicago Press, 1990.

Twa, Lindsay. "The Black Magic Island: The Artistic Journeys of Alexander King and Aaron Douglas from and to Haiti." In *Haiti and the Americas*, edited by Carla Calargé, Raphael Dalleo, and Clevis Ronald Headley, 133–60. Jackson: University Press of Mississippi, 2013.

———. "La Diaspora en dialogue: James Porter et Loïs Mailou Jones Pierre-Noël, ou comment écrire l'histoire et l'art haïten." *Gradhiva* 21 (2015): 50–73.

———. *Visualizing Haiti in U.S. Culture, 1910–1950*. Surrey: Ashgate, 2014.

Van Beurden, Sarah. *Authentically African: Arts and the Transnational Politics of Congolese Culture*. Athens: Ohio University Pres, 2015.

VanDiver, Rebecca. "Art Matters: History of Howard University's Art Department, 1921 to 1971." *Callaloo* 39, no. 5 (2016): 1199–218.

———. "Association for the Study of African American Life and History." In *Multicultural America: A Multimedia Encyclopedia*, edited by Carlos E. Cortés, 1:301–3. Los Angeles: SAGE Reference, 2013.

———. "The Diasporic Connotations of Collage: Loïs Mailou Jones in Haiti, 1954–1964." *American Art* 32, no. 1 (Spring 2018): 24–51.

———. "Off the Wall, into the Archive: Black Feminist Curatorial Practices of the 1970s." *Archives of American Art Journal* 55, no. 2 (Fall 2016): 26–45.

Varnedoe, Kirk. "Contemporary Explorations." In Rubin, *"Primitivism" in Twentieth Century Art*, 2:661–85.

Vendryes, Margaret Rose. "Brothers Under the Skin: Richmond Barthé in Haiti." *Journal of Haitian Studies* 10, no. 2 (Fall 2004): 116–34.

Visona, Monica, Robin Poynor, Herbert M. Cole, and Suzanne Preston Blier. *A History of Art in Africa*. 2nd ed. Saddle River: Pearson, 2007.

Vlaminck, Maurice de. "Discovery of African Art, 1906." In Flam and Deutch, *Primitivism and Twentieth-Century Art*, 27–28.

Wadelington, Charles W., and Richard F. Knapp. *Charlotte Hawkins Brown and Palmer Memorial Institute: What One Young African American Woman Could Do*. Chapel Hill: University of North Carolina Press, 1999.

Wagner, Ann. "Lee Krasner as L.K." *Representations* 25 (Winter 1989): 42–57.

Wahlman, Maude. *Signs and Symbols: African Images in African-American Quilts*. New York: Studio Books with the Museum of American Folk Art, 1993.

Waldman, Diane. *Collage, Assemblage, and the Found Object*. New York: Harry N. Abrams, 1992.

Wall, Cheryl. *Women of the Harlem Renaissance*. Bloomington: Indiana University Press, 1995.

Walters, Ronald. *Pan Africanism in the African Diaspora: An Analysis of Modern Afrocentric Political Movements*. Detroit: Wayne State University Press, 1993.

Watson, Steven. *The Harlem Renaissance: Hub of African-American Culture, 1920–1930*. New York: Pantheon Books, 1995.

Webb, Virginia Lee. *Perfect Documents: Walker Evans and African Art, 1935*. New York: Metropolitan Museum of Art, 2000.

Werth, Margaret. *The Joy of Life: The Idyllic in French Art, ca. 1900*. Berkeley: University of California Press, 2002.

Wilder, Gary. *The French Imperial Nation-State: Negritude and Colonial Humanism Between the Two World Wars*. Chicago: University of Chicago Press, 2005.

Wilding, Faith. "The Feminist Art Programs at Fresno and CalArts, 1970–1975." In Norma Broude and Mary D. Garrard, *The Power of Feminist Art: The American Movement of the 1970s, History and Impact*, 32–47. New York: Harry N. Abrams, 1994.

Williams, Adriana. *Covarrubias*. Austin: University of Texas Press, 1994.

Williams, Zachery R. *In Search of the Talented Tenth: Howard University Public Intellectuals and the Dilemmas of Race, 1926–1970*. Columbia: University of Missouri Press, 2009.

Willis, John Ralph. *Fragments of American Life: An Exhibition of Paintings, January 25–March 28, 1976*. Princeton: Princeton University Art Museum, 1976.

Wintz, Cary D., and Paul Finkelman, *Encyclopedia of the Harlem Renaissance*. 2 vols. New York: Routledge, 2004.

Wofford, Tobias. "Africa as Muse: The Visualization of Diaspora in African American Art, 1950–1980." Ph.D. diss., University of California, Los Angeles, 2011.

Woodson, Carter G. *African Heroes and Heroines*. Washington, D.C.: Associated Press, 1939.

Wright, Richard. *Black Power: A Record of Reactions in a Land of Pathos*. New York: Harper and Row, 1954.

Zayas, Marius de. "Statuary in Wood by African Savages: The Root of Modern Art." In Flam and Deutch, *Primitivism and Twentieth-Century Art*, 70–72. Originally published as *Statuary In Wood by African Savages: The Root of Modern Art* (New York: "291" Gallery, 1914). Page references are to reprint.

Zeidler, Jeanne. "Hampton University Museum." In *To Conserve a Legacy: American Art from Historically Black Colleges and Universities*, edited by Richard Powell and Jock Reynolds, 22–23. Andover: Addison Gallery of America, 1999.

Index

Italicized page references indicate illustrations. Endnotes are referenced with "n" followed by the endnote number. All works are by Loïs Mailou Jones unless otherwise attributed.

African American women artists
 art education challenges, 31
 art signing practices , 46–48, 191–92
 employment and gender politics, 59, 62, 152
 exhibitions featuring, 171, 173
 feminism exclusion of, 171, 172
 identity intersectionality of, 9, 10, 150
 institutional exclusion of, 5, 6, 9, 10, 92, 150, 153, 171–72, 173
 Jones's research projects on, 8–9, 171
 magazine covers featuring, 94, 193
 Jones's travel restrictions, 50
African art and aesthetics
 as African American art influence, 3, 37–39, 41–42, 48–50, 72, 73–74, 80–81, 95
 as African American art influence, Jones' lectures on, 165, 169, 200n24, 208n51
 African American knowledge of, 39–40
 African tours promoting, 163
 animal motifs inspired by, 44, 74, 104, 139, 175, 182, 184, 210n118
 art education and influence of, 34–35, 37
 art historical studies on, 154, 158, 193
 book illustrations featuring, 83–84
 contact zones for, 41–42
 diasporic grammar influenced by, 57
 drumming traditions, 73
 European interest in, 37–38, 71, 75, 80, 83
 exhibitions on, 41–42, 73–74, 80, 81, 170, 180–81
 as Jones influence, 8, 22, 57, 93
 masquerade motifs, 44, 180, 182
 outsider perception of, 99
 pedagogical exploration of, 74
 research on contemporary, 132, 153–55, 158
 as textile design influence, 44–45, 46
 See also African art objects; dance, African
African art objects
 function in paintings, 3, 6, 71, 93
 heddle pulleys, 164, 165, 177, 178, 183
 people as, 83, 97, 102–3, 175, 177
 textiles, 45, 46, 71, 131, 161, 178, 182–83
 See also masks; sculptural imagery
African Arts (journal), 158
African Bathers, 82, 82–83
African Contemporary Art (Beier), 158

"African Cultural Presence in America, The" (lecture), 208n51
African diaspora
 as artistic influence, 6, 8, 11–12, 151
 artists as cultural ambassadors for, 116, 129, 132
 as art theme, 69, 80, 81, 83, 95–96
 blackness-in-triplicate representations of, 13, 60, 101, 106, 163, 168–69
 collage metaphors, 145–47
 cultural studies on, 73
 dance traditions, 25–26, 73, 103–4, 112, 173
 diasporic literacy for, 15, 111–12, 121, 159
 encounters with, 8, 75–76, 86–91, 112, 113, 145
 international solidarity movements, 7, 80, 91, 111, 132, 156, 157, 170
 scholarship on art of, 12
 term definition, 12–13
 transnationality of, 12, 67–68, 91, 111, 116, 175
 See also diasporic grammar; diasporic literacy
African Heroes and Heroines (Woodson), 63, 83–84, 84, 85
"African Influence of Afro-American Art, The" (Jones lecture), 165, 169, 200n24
African Negro Art (exhibition), 73–74
"African Presence in America, The" (Jones treatise), 151
Africa series, 181, 181–83
AfriCOBRA (Coalition of Black Revolutionary Artists), 154, 169
Afro-American Artists (exhibition), 157
Afro-Caribbean
 African diaspora networking, 12, 86, 129
 blackness-in-triplicate representations of, 102, 106, 163
 cultural exchange ambassadors for, 116, 132
 women artist research and exhibitions featuring, 9, 171
 See also Haiti
Agaou (Haitian deity), 135, 136
Agouassou Miroi (Haitian deity), 135, 136
Ag'Ya, L' (dance), 73
Aida-Wedo (Haitian deity), 211n142
Aïzan-Véléq“été (Haitian deity), 135, 136
Albéca, Alexandre L. d': *Behanzin* from *La France au Dahomey*, 84, 85
Alhadeff, Maurice, 159
Allen, Tina, 190
Alston, Charles, 140–41, 203n111
American Colonization Society (ACS), 68
American Indian art, 46, 46

Julius Rosenwald Fund, 99, 102, 113, 114

Jumeaux, Les, 177, *177*

Kadja-Bossou (Haitian deity), 135, *136*

Kahlo, Frida, 172

Karenga, Ron (Maulana), 152

Kendrix, Moss, 101

Kennedy, John F., *143*, 144, 206n76

Kenya, 158, 159, 163

King, Alexander, 116

King, Martin Luther, Jr., *143*, 144, 185, *186*, 207n7

Klansmen, 185, *186*

Kota Mbulu-Ngulu reliquary figures, 74

Krasner, Lee, 192

Kraut, Anthea, 112

Kwele heart-shaped face masks, 161–63, *162*

Kykunkor (The Witch Woman) (musical drama), 73

La Baker, 172, *173*–75

LACMA (Los Angeles County Museum of Art), 171–72

Lam, Wilfredo, 121

Lawrence, Jacob, 9, 67, 113, 146, 157

Lawson, Warner, 153–54

League of Women for Community Service (LWCS), 24

Léger, Jacques N., 121

Lewis, Edmonia, 151, 173

Lewis, Norman, 140–41

Liberia

 African American colonies in, 68–69

 centennial anniversary celebrations planned for, *100*, 100–101

 founding and goals of, 101

 murals featuring, 131

 paintings with mask imagery from, *179*, 180

 travels to, 159

 U.S. ambassadors to, 23

Library of Congress, 9

Lie, Jonas, 28

Life magazine, 116, 119

Lincoln, Abraham, *143*, 144

link, defined, 112

Lion, Jean, 89

Lippard, Lucy, 171

Little Paris Studio, 100

lizards, 182, *182*

Lloyd, Tom, 149

Locke, Alain

 African American movements and art theories of, 37–39, 64, 81, 91, 95, 97, 150

 associates, 63, 64, 91

 book illustration commissions, 91–92

 as book illustration resource, 83

 Douglas's Haitian painting critiques, 115

 exhibitions organized by, 92

 Haiti views, 113

 international racial solidarity movement, 91

 teaching positions, 62

 writings of, 38, 91–92

Locke, Donald, 190

Loco Atissou (Haitian deity), *134*, 137, *137*

Loïs Mailou Jones: A Life in Vibrant Color (exhibition), 10

Loïs Mailou Jones: Peintures (retrospective book), 103

Los Angeles County Museum of Art (LACMA), 171–72

Lovers, The, 102, *102*–3

lwas (Haitian deities), 125, 135, *136*, 137, *137*, *138*, 139

LWCS (League of Women for Community Service), 24

lynching, 24, 97

MacNeil/Lehrer News-Hour (television show), 192

Magiciens de la terre (exhibition), 210n131

Magic Island, The (Seabrooke), 116

Magic of Nigeria, The, 158

Magloire, Paul

 portraits of, 122–23, *123*

 resignation and exile, 124

 tourism campaigns and art commissions, 109, 110, 112, 116

Magloire, Yolette, 117, 122, *123*, 123–24, *124*

Makerere College and Art School, 132, 206n78

Making the Brush Behave (O'Hara), *60*, 62

Mande weaving traditions, 183

Man Smoking a Pipe (Cézanne), 96

Marassa (Haitian deity), 135

"March Against Fear" (protest), 152

Margaret Dickey Gallery of Art, 127

Maroons (Saramaka), 183

Marshall, Thurgood, *143*, 144

Martha's Vineyard

 African American property ownership in, 26–27

 vacations and visits to, 7, 8, 19, 26, 27, 59–60

 See also Oak Bluffs, Massachusetts